Seeing All Things Whole

Seeing All Things Whole

The Scientific Mysticism and Art
of Kagawa Toyohiko (1888–1960)

Thomas John Hastings

PICKWICK Publications · Eugene, Oregon

SEEING ALL THINGS WHOLE
The Scientific Mysticism and Art of Kagawa Toyohiko (1888–1960)

*This publication was made possible through the support of a grant from
the John Templeton Foundation. The views expressed in this publication
are those of the author and do not necessarily reflect the views of the
John Templeton Foundation.*

Pickwick Publications
A Division of Wipf and Stock Publishers
199 W. 8th Ave. Suite 3
Eugene, OR 97401

www.wipfandstock.com

ISBN 978-1-4982-0407-1

Cataloging-in-Publication data:

Hastings, Thomas John.

Seeing all things whole: the scientific mysticism and art of Kagawa Toyohiko
(1888–1960) / Thomas John Hastings, with a foreword by J. Wentzel van Huyssteen

xii + 260 p.; 23 cm. Includes bibliographical references and indexes.

ISBN: 978-1-4982-0407-8

1. Kagawa, Toyohiko, 1888–1960. 2. Religion and science. 3. Christianity—Japan—
20th century. 5. Christianity—Japan—biography. 6. Japan—Religion. I. Van Huyssteen,
J. Wentzel (Jacobus Wentzel). II. Title.

BR1306 H37 2015

For Kagawa Tokuaki (1953–2014), *in memoriam*

Contents

Foreword

This remarkable book about the visionary Japanese mystic and intellectual Kagawa Toyohiko is a tour de force in every sense of the word. The key to this book, both theologically and philosophically, is the fact that powerful intellectual developments in Kagawa's later work actually emerged out of the searing reality of Kagawa's painful life, and the introductory chapter develops a narrative for reading the whole work as a chronicle that is both completely illuminating and deeply moving. Against this background we see Kagawa's faith and theology arise out of the void of immense personal suffering, but with a personal tenacity and vision that instantly situates interreligious challenges, as well as interdisciplinary problems in science and religion, within a true Christian vision. Given his broad reading, and the discussion of Karl Barth and Friedrich Schleiermacher in particular, Kagawa not only crosses over into a positive, yet critical and evaluative, reading of Charles Darwin's work, but also goes beyond Darwin in a way that not only suggests solutions for theological problems of evil, theodicy, and cosmic purpose, but also in a way that is stunningly consonant with new, contemporary readings of Darwin in our time. In this way Hastings not only successfully shows that the much-neglected interdisciplinary theme of science and religion is at the heart of Kagawa' work, but also that in his scientific mysticism he has creatively incorporated his background in Reformed theology. At the end, however, it is the redemptive love of Christ that would open a profound dimension to Kagawa's striking personalism, his philosophical holism, and his strong ethical sensibility. What is most remarkable, however, is that what emerges by the end of this book is a man for our times, a living and extremely relevant voice that deserves to be heard in the most contemporary theological and philosophical discussions of our day.

J. Wentzel van Huyssteen
James I. McCord Professor of Theology and Science Emeritus
Princeton Theological Seminary

Acknowledgements

As with our translation of Kagawa's final book, *Cosmic Purpose* (Cascade Books, 2014), this book represents a remarkable collaboration between Japan and the United States. Firstly, I dedicate this book to Kagawa Tokuaki, the recently deceased grandson of Kagawa Toyohiko and former Director of the Kagawa Memorial Hall in Kōbe. Tokuaki and his colleagues always welcomed me as a conversation partner whenever I visited Kōbe. Nearing the end of a heroic three-year battle with cancer, Tokuaki came all the way to Kōbe from Yamanashi Prefecture to attend our public book event and lecture for *Cosmic Purpose* on July 31, 2014. His final words to me were, "Hastings-sensei, besides me, you are the only person who is able to criticize my grandfather Toyohiko fairly." With deep gratitude for this humbling public endorsement, I can only hope this book is worthy of his final benediction. I also want to offer special thanks to Kayama Hisao, former Director of the Kagawa Archives and Resource Center in Tokyo. He and his staff have provided invaluable personal advice and practical logistical support for my research. On this side of the Pacific, I want to offer special thanks to David Vikner, President of the Japan ICU Foundation in New York City, and his trustees and staff, who have welcomed and supported my work as a contribution to their own mission. I also wish to express my sincere gratitude to Iain Torrance, who launched me on my Kagawa research when, as President of Princeton Theological Seminary, he invited me to deliver the Toyohiko Kagawa Lecture in 2011 while I was working next door to the seminary at the Center of Theological Inquiry.

As always, I want to express my thanks and love to Carol, who helped copyedit the manuscript, and our four children, their spouses and children, my mother–in-law Jo Tolley, and our extended family. Finally, I wish to thank several friends, colleagues, and students who have faithfully journeyed with me through three years of research and writing, including Ban Takezumi, Chiba Shin, Joe and Yukiko Dunkle, George Furniss,

Acknowledgements

Furuya Yasuo, Claudia Genung-Yamamoto, Jim Heisig, Inagaki Hisakazu, Barry Jacobs and Susan Berger, Paul Johnson, Kamata Tōji, Kim Seung Chul, Paul Metzger, Eileen and Sam Moffett, Mollie and Lardner Moore, Mark and Cindy Mullins, Haruko Nawata Ward, Rick and Sally Osmer, Carol and Jim Sack, Noriko and Marty Schneidermann, Paul Swanson, Tanabe Kenji, Torigai Keiyō, Wentzel and Hester van Huyssteen, and my students at Princeton Theological Seminary who were the first to hear lectures based on this book.

Introduction

There are many approaches to the preparation of meals, yet if we divide these into two broad categories, we would find those who are adept at beginning with ingredients "on hand" and those who prefer a trustworthy recipe. That is, upon opening the refrigerator door, some immediately begin pondering how to make creative use of the items found there, while others head off to the supermarket with a list of ingredients required by a recipe.

Moving beyond the realm of food preparation and drawing on a key distinction in the Japanese language, let us call the first group "artists" (*geijutsuka*) and the second group "artisans" (*shokunin*). Generally speaking, painters, sculptors, poets, actors, composers, novelists, and so on are considered *geijutsuka*, while potters, *soba* (noodle) makers, woodcarvers, confectioners, and so on are called *shokunin*. Obviously, these distinctions are fluid rather than absolute, since we might easily imagine a potter who is an "artist" or a painter who is an "artisan." With only rare exceptions, both artists and artisans undergo a period of rigorous study or training in some tradition, but if artisans faithfully preserve a tradition, artists push or subvert a tradition's boundaries. Artists seem to possess some intuitive cognitive freedom that enables them to "indwell" the materials at hand and thereby create something new.

To return to the preparation of food, practiced artists and artisans are no doubt equally capable of producing delicious and satisfying meals, yet there is a distinction we make that may help to account in part for that certain "something extra" we attribute to the work of an artist. After tasting the meal of an artist, it may be difficult if not impossible to quickly identify all of the ingredients that went into the production. Indeed, we may feel no need for such a list at all, since the immediate enjoyment of the food eliminates a need for explanation or analysis. Perhaps this is how the experience of eating at the table of a great chef or of being hypnotized by a Vermeer painting or mesmerized by a Bach solo cello suite

has something in common with the loss or expansion of self reported by great mystics, who claim to have experienced a Divine-human union (*unio mystica*) after years of prayer or meditation, or the great scientists, who come upon a historic discovery after years of painstaking observation and experimentation.

In contrast, even before tasting the artisan's meal, we often know exactly what we will eat. Indeed, in "artisanal" restaurants, which seem to be all the rage in our major cities today, the ingredients of each dish are clearly spelled out on the menu. In such cases, cognition anticipates, accompanies, and follows the tasting. Without doubt, this linkage of "first-order" perception and "second-order" cognition has a positive social function, i.e., it may enliven the conversation over dinner. Some take such a list of ingredients as an enhancement while others see it is a distraction. In the latter cases, we choose to be as fully present as possible to the pure experience of the meal in a "non-conceptual" kind of way. This indicates the obvious fact that the work of artists and artisans appeals to different audiences.

Consider the distinction between artists and artisans in terms of direct versus indirect modes of communication. Since the artisan fills in the blanks between immediate experience (perception) and second-level reflections on it (cognition), a direct mode of communication is clearly preferable. In contrast, seeking to free up personal imagination and wonder, the artist opts for indirect modes of expression by combining the materials into a new, unfamiliar shape, and in the encounter with this new creation, we are drawn out of or beyond our selves. Moral revisioning or transformation may be initiated by great art. If direct modes favor description, explanation, or analysis, indirect modes are more at home in the idioms of invented story, poetry, and paradox.

To interject a personal experience for the sake of illustration, one of the formative experiences of my childhood occurred when my Irish Catholic family visited the New York World's Fair in Queens in 1965. Michelangelo's Pietà was prominently on display in the Vatican Pavilion, and after standing in line for some time, we finally found ourselves in front of the sculpture. I recall several slow-moving conveyor-belt walkways set up in front of the masterpiece to keep the throngs moving at an appropriate pace, but there was also a stationary spot from which one could view the statue at some distance. I first filed by with my family and the crowd on the conveyor belt, getting a brief but close-up look at the exquisite white marble depicting a devastated mother bearing the corpse

of her adult son. As a twelve-year-old boy from central Massachusetts, I knew little or nothing about Michelangelo or the Italian renaissance, but I knew the story it evokes. Perhaps to the embarrassment of my parents, I found that I simply could not leave the presence of the Pietà after one quick pass. I felt drawn irresistibly into this horrific yet strangely serene otherworldly scene with a force beyond reason or will.

Without consulting my family, I quickly made my way to the stationary spot to extend my reverie after stepping off the conveyor. I do not recall how long I stood completely transfixed in a state of full concentration on the sculpture and absolutely nothing else, but it must have been several minutes, because I recall my father gently yet firmly urging, "It's time to go, Tommy. Let's go. We have to go, everyone's waiting. There's a lot more to see." This is the kind of "non-conceptual," "in the zone" experience that great works of art sometimes provoke, and my guess is that most readers have had similar experiences, perhaps with a work of art or in a wood, meadow, or by a stream, while others may have cultivated this kind of "pre-conceptual" or "non-conceptual" perception through meditation or prayer.

Given the dazzling achievements of digital technology and our increasing habituation to forms of communication that deliver simultaneously the experience and the commentary on it, it is not at all surprising that indirect modes of communication have fallen on hard times in our public discourse, schools, religion, and theology. Again for the sake of illustration, think of the way we typically exhibit and view great works of art. After paying the steep price of admission and thus feeling obligated to take in as much stimuli and information as possible, we purchase expert description, analysis, and interpretation recorded by art historians or docents, strap on our headsets and set off to follow the numbers on the wall or at least make sure that the number on the digital player corresponds to the number on the wall; a technological innovation intended to deliver a greater sense of agency and choice. This commentary is often excellent and may even enhance the experience, except perhaps when we begin to consider that the experience has been carefully marketed, managed, and mechanized, like the belts for conveying the masses past the Pietà in a timely fashion. Instead of feeling like a happy consumer freely exercising personal agency, suddenly we begin to feel more like the Charlie Chaplain character in "Modern Times" who is ground up by the gears of the machine he is working on. With all due respect to those in the art business who have to respond to market pressures, how can we

expect to truly "see" a work of art when the "packaged experience" rules out adequate time for sight to leap to insight?

Clearly it is possible that fuller perception may occur in spite of marketing, management, and mechanization. And I confess that I have sometimes purchased the headsets out of a desire to "make the most" of the experience, but I have never survived a whole exhibit without tearing them from my head in exhaustion or frustration. The simple point is that great art, like the Pietà or the world of living things or the vast cosmos, has power to hypnotize, mesmerize, and lift us out of ourselves into a "non-conceptual" encounter. Since perception must be free for a genuinely personal encounter to occur, great art will always resist the sort of mechanization whose only goal is efficient consumption. Imagine how Rembrandt or Van Gogh would react if they could slip through time and see the multitudes of intense head-phoned consumers filing past their works on a Sunday afternoon, following dutifully the recordings and numbers, perhaps feeling like they really have gotten their money's worth, yet having little chance of being drawn out of themselves and freed for wonder and vision.

Because they break new ground in the distinct traditions they inhabit, great mystics and great scientists share this "something extra" with the artists. In speaking of spiritual realities, the mystic commonly chooses the idiom of the *via negativa*. In speaking of material realities, the scientist most often announces a new theory in the language of higher mathematics. The *via negativa* and higher mathematics are both artistic means humanity has conceived to describe realities, the truth of which are verified by subsequent experience, in the first instance, and by subsequent experiment, in the second. Just as it would be folly for mystics with no knowledge of the higher mathematics to dismiss science as a pernicious illusion, it is equally ridiculous and unscientific for scientists with no knowledge of the *unio mystica* to dismiss religion as a pernicious illusion. Science and religion have both engendered salient and pernicious outcomes. But if we were able to agree on the deeper aesthetic convergence between the contributions of our greatest religious and scientific innovators, perhaps the rancorous debates between believers and atheists might cease.

Kagawa Toyohiko[1] (1888–1960) was a remarkable Japanese Christian

1. Japanese names are given with the family name first (Kagawa), followed by the given name (Toyohiko), except when they appear in some older English sources.

"scientific mystic," artist, and moral innovator who perceived the cosmos as a great, unfolding drama, which requires the full effort and range of consciousness to be adequately appreciated. Embracing the discrete contributions of religion, science, and ethics, he believed that the dualism at the heart of post-Enlightenment thinking might be overcome by "seeing all things whole." While honoring the theological traditions of the past, he also imagined religion, science, and ethics as partners in an unfolding and purposeful cosmic creation, which he believed was being propelled forward by the full consciousness and practice of the redemptive love of God revealed in Jesus Christ. Espousing what he called "the eternally new religion of Life," he boldly, albeit naively, proclaimed the end to the conflict between the science and religion.

> Science as science has much to contribute to religion. Today, science itself is a great miracle.... The age for thinking science and religion are in conflict is a dream of the past. Through science, the eternally new religion of Life is able to participate in the great enterprise of the creation of the cosmos, which is greater than art.[2]

In spite of this optimism, he was not naïve about the discrete contributions of each enterprise, saying, "Faith teaches us about the fate of humanity, science teaches us about the structure of the universe. Those who fail to recognize this distinction can only end up in a great contradiction."[3]

While some Japanese theologians have negatively characterized Kagawa's approach as "poetic," we believe, on the contrary, that it is precisely his intense artistic sensibility that makes his contribution so fascinating and important.

This once world-renowned evangelist, social reformer, interdisciplinary thinker, and writer lived through the agonizing modernization of Japan during the late Meiji (1868–1912), Taishō (1912–26), and early Shōwa (1926–89) eras. He was not an academic scholar who sits at a desk, reads research in a particular field, writes up lecture notes, and presents the latest iteration to tuition-paying students in a classroom. Rather, he was an evangelist for a faith that could bear the scrutiny of modernity, reading voraciously and often while scribbling notes for his next sermon, lecture, or negotiation. Like the cook we mentioned at the outset, he worked with what was "on hand," guided more by his personal intuitions than

2. Kagawa, *Religion of Life and Art of Life*, 83–84.
3. Kagawa, *Meditations on God*, 5.

by the "recipes" of tradition. Rather than focusing on academic peers in the same field, his message was addressed to an entire nation undergoing profound changes, and he meditated on the momentous issues of meaning and purpose facing modern societies everywhere.

KAGAWA'S STORY AS THE HISTORY OF MODERN JAPAN

Kagawa was the kind of "once in a generation" individual who is acutely sensitized to the perils and possibilities of the age in which they live. While Japan was forging a new identity and emerging as East Asia's first modern nation state, the young Kagawa was struggling to find personal meaning and purpose in the wake of traumatic losses, illnesses, and experiences of shame. Eventually, after a gradual and painful spiritual transformation, he decided to dedicate himself to working with the weakest members of society, developing a heroic sense of vocation to build a humane modern society from the bottom up. In the process, he often proved himself willing to bear the hardest burdens and embody the highest hopes of an entire generation by focusing the powers of his intuition, intellect, and will on one extraordinarily lofty goal. He aspired to become a contemporary exemplar of Jesus Christ, translating his "redemptive love"[4] into concrete action. While sometimes stumbling, from around 1920 until his death in 1960, Kagawa was at the center of every social, democratic, and ecumenical movement in Japan. One would have to look a long time to find a closer convergence of a person's and a nation's history.

James E. Loder, late Professor of the Philosophy of Christian Education at Princeton Theological Seminary, was fond of saying that genuine experiences of spiritual transformation belong not so much to the individual as to the church. But Kagawa would not limit his vision of redemptive love to the individual believer or even to the church, which is one of the reasons he often ran into conflict with established church leaders and theologians. Seeing Christ's cross as the principle of "cosmic repair," he saw its salvific effects extending beyond the individual Christian and the church, beginning with the weakest and forgotten members of society, and reaching out to embrace the entire cosmos. In the case of an epochal and prophetic figure like Kagawa, we think we are justified in expanding

4. 贖罪愛 shokuzaiai.

Loder's aphorism beyond the individual and the church to say that Kaga-wa's story belongs to the modern history of Japan and to all humanity.

Kagawa came of age as Japan was deep in the throes of an identity crisis brought on by the Meiji government's decision to pursue, with all haste, the twin goals of industrialization and militarization in imitation of the Western colonial and imperial powers. Edwin O. Reischauer describes this momentous decision of the Meiji oligarchs, who had managed to overthrow the long-reigning Tokugawa Shogunate with minimal violence.

> Once in control of the national government, the new leaders naturally threw themselves into developing a more efficient national army and navy in close imitation of those of the contemporary West. This was only to be expected of men who were themselves for the most part military men by tradition and early training who had personally experienced the humiliation of being forced to bow to superior Western military might. They were understandably obsessed with the idea of creating a Japan capable of defending against the Occident. At the same time, however, they were surprisingly broad-minded in their approach to the problem, for they realized that to achieve military strength Japan also needed political, economic, social, and intellectual renovation. The concept was epitomized by the popular slogan *fukoku kyōhei*, "rich country, strong military."[5]

The new government seemed to be succeeding in mustering all of Japan's material and human resources in fashioning East Asia's first modern nation state and emergent global empire. Following the promulgation of its constitution in 1889 and the Imperial Rescript on Education in 1890,[6] the creed into which all imperial subjects were indoctrinated from childhood, Japan swiftly marched on to defeat China's Qing Dynasty in 1895, overcome the Russian Navy at the Chinese port of Dalian (formerly Port Arthur) in 1904, and colonize the Korean Empire in 1910. In his interpretation of Japanese and Western approaches to nationalism, Matsumoto Sannosuke suggests:

> Nationalism in Japan was very much the result of "external pressure" by which she was forced into the West-centered family of nations and which in turn caused her people to harbor strong fears and anxieties about their new contact with the alien world.[7]

5. Reischauer, *Japan*, 124–25.
6. See Appendix B.
7. Matsumoto, "Significance," 51.

Kagawa was a brooding and bookish teenager just as his beloved homeland entered the new century with a growing conviction of its power and unique sense of destiny in Asia and the world. According to historian Kano Masanao, this transition from Meiji to Taishō was characterized by the huge problems and changes that came about as the nation "unavoidably harvested the immature fruit" of its successes.[8] The slogan of the time was "change," and Kano comments in regard to Kagawa's best-selling novel *Before the Dawn*,[9] "Both in terms of its title and style, this book symbolizes the turning point from late Meiji to Taishō."[10] Partly in response to the government's top-down imposition of the new national identity, Kagawa and many of his generation were searching for personal, social, and ultimate purpose.

For Kagawa, the national crisis was accompanied by a succession of immensely painful personal traumas, which threatened and almost destroyed his own sense of identity. Having entered elementary school soon after the promulgation of the Imperial Rescript on Education, Kagawa belonged to the first generation reared in a spirit of absolute filial loyalty to the emperor as the inviolable spiritual father of the nation. This sense of love for the emperor persisted. For example, as Japan was rushing into war with China in the 1930s, the pacifist Kagawa was sharply critical of the militarists, on the one hand, but he never uttered or wrote a negative word about the emperor, on the other. Given this background, it is little wonder that he took on the nation's fate as his own and saw his own fate as touching that of the nation.

As a philosophically-minded religious artist and evangelist, he creatively integrated the inherited philosophical and religious resources of Japan with his newly adopted Christian faith, and added the insights of natural science and personalist and vitalist trends in Western philosophy. Clearly favoring philosophy of religion and psychology over systematic theology, Kagawa boldly pursued an understanding of Christian faith that rang true to his personal experience and one he believed was most appropriate given the situation of the tiny Christian movement of Japan. While gifted with extraordinary curiosity and intellectual ability, Kagawa was drawn more toward the primary, intuitive apprehension of a prob-

8. Kano, *Undercurrent of Taishō Democracy*, 12. Kano reference from Kanai, "Practical Christian Ethos," 135.

9. Kagawa, *Before the Dawn*.

10. Kano, *Undercurrent of Taishō Democracy*, 15.

lem than the secondary, detailed analysis of its constituent parts. His *in memoriam* for Nitobe Inazō beautifully captures the disposition Kagawa himself brought to his struggle to fashion a modern religious consciousness in the context of early-twentieth-century imperial Japan:

> "The Eternal Youth," by Kagawa Toyohiko
>
> Your distinct silhouette was huge, was it not?
> In your temperament a global spirit
> Permeated the way of the samurai
> That spirit a little too large
> To be confined to the islands of Japan
> With the years you become younger
> Such a delightful soul!
> From whence came such youthfulness?
> Forever admired eternal youth![11]

THE *AD HOC* ECLECTICISM OF KAGAWA'S WRITINGS

One of the reasons for the scarcity of academic work on Kagawa in English and even in Japanese is the peculiarity of his published writings, which appeared one book or pamphlet at a time during his lifetime, and were subsequently issued as the *Collected Works of Kagawa Toyohiko* in twenty-four volumes in 1964, and then reissued in 1973 and 1982. Since more than 300 writings bearing Kagawa's name were published during his lifetime, the *Collected Works* is actually a selection.[12] Besides works he penned himself, the *Collected Works* include many transcriptions of his speeches, lectures, sermons, and interviews. There is naturally some stylistic disparity between Kagawa's writings and the transcripts of his oral performances. While the latter may preserve the rhetoric of a specific occasion, these often hastily prepared records do not make for easy reading or analysis. This problem can be vexing to the reader since, on aggregate, they tend toward the inspirational, didactic, and aphoristic, and are often repetitive and lacking thematic development. The formidable task of making the entire corpus available, minus the countless redundancies, awaits the work of future researchers.

Unuma Hiroko, one exasperated but determined reader, offers some helpful comments on Kagawa's style with special reference to *Cosmic Pur-*

11. Hamada, "Kagawa and Oceanic Civilization," 64–65.
12. Kagawa, *Collected Works*. Only about twenty of Kagawa's works, mainly novels and spiritual writings, were translated into English editions that are now out of print.

pose (1958),[13] Kagawa's final book and one that is a central focus of the present work:

> We may next consider Kagawa's view of the cosmos through his representative *Cosmic Purpose*. At first glance this book gives the reader the impression of being a systematic construction, which mobilizes the latest philosophical thinking and scientific discoveries. Yet, quite to the contrary, it should more likely be read as a work that brings together findings from various fields into a system with an academic appearance, but actually offers a revelation of the cosmos based on Kagawa's mystical disposition. This may be said of Kagawa's writings as a whole. His primary sources are presented as subjects in the first-person, and even when the first-person is not used directly, they may be read as self-confirming confessions, which, rather than as academic writings, may be more appropriately read as verbal expressions of Kagawa's worldview inspired by mystical experience. This is the reason his writings have often been characterized as "poetic." As a result, if these writings are taken as a speculative, logical system, his real intention will either slip through one's fingers or lead to the kind of unfair assessments of Kagawa we have seen from time to time.[14]

Indeed, even though he was trained in the Reformed tradition that values the careful interpretation of texts, Kagawa never offers a point-by-point exegesis of his sources. It seems he had no interest in constructing a logical philosophical or theological system, yet his mind was a living sponge, speedily and critically absorbing into his meditations ideas from an astounding range of traditions and disciplines. On a surface reading, the writings can sometimes seem like a hodgepodge of contradictions and conundrums. However, extending Unuma's point, it is important for readers to recognize that Kagawa's use of the first person is completely resonant with the long tradition of Christian mystical writing. In her classic work on mysticism, Evelyn Underhill says:

> Where the philosopher guesses and argues, the mystic lives and looks; and speaks, consequently, the disconcerting language of first-hand experience, not the neat dialectic of the schools.[15]

Because this "disconcerting language of first-hand experience" characterizes Kagawa's *ad hoc* and eclectic writings, it is futile to try to finally position his thinking within any single school of thought. Many tributaries

13. Kagawa, *Cosmic Purpose*.
14. Unuma, "The World of Faith of Kagawa Toyohiko," 196.
15. Underhill, *Mysticism*, 24.

flow into the broad river of the consciousness of this "mosaic artist for God."[16]

But, as we will see, he did develop rather early on a holistic or comprehensive "worldview" or interpretive lens that emerged out of his early experiences of personal trauma, broad reading in the philosophy and psychology of religion and the natural sciences, and Christian meditations on the constitutive relations between (1) persons and ultimacy; (2) persons and the natural world; and (3) persons and other persons. For Kagawa, "seeing all things whole" meant always trying to hold together in consciousness the spiritual, embodied, and social dimensions of life within our incomprehensibly vast cosmos. Once a reader grasps Kagawa's personalist, holistic, and ethical perspective, which we will present in chapter 2, what first appears as an unfocused hodgepodge becomes part of a dazzling, kaleidoscopic, religio-aesthetic vision.

We will now turn briefly to the story behind this unusual corpus. With the 1914 publication of *A Study of the Psychology of the Poor*,[17] Kagawa's major "empirical study" which became the subject of harsh criticism after his death, the Christian world in Japan began to learn of this idealistic young evangelist who in 1909 had suddenly departed his dormitory room at the Kōbe Theological School to take up residency in Shinkawa, Kōbe's worst slum. A string of other writings followed, but in 1920 Kagawa was unexpectedly catapulted to national fame after the publication of *Before the Dawn*, his best-selling autobiographical novel. This tale of sorrow, soul-searching, intellectual hunger, Christian conversion, and calling to serve the poor captured the attention of the generation infected by the nascent reformist spirit of the Taishō era. Kagawa and his wife and co-worker Haru decided to donate the royalties from the novel to various social projects and movements,[18] and the huge success of the novel encouraged Kagawa and his disciples to launch what soon became a cottage writing industry to support his expanding social projects.

With the founding the Kōbe Consumer Cooperative in 1920, the now-famous writer, evangelist, and reformer took on an increasingly visible, public role. For example, following a bitter ideological conflict with other

16. Robert Mikio Fukada, "Toyohiko Kagawa: A Mosaic Artist for God."

17. Mutō reports that this work went through nine editions from 1914 to 1923. Mutō, "Commentary on *A Study of the Psychology of the Poor*," 545. Kagawa has been rightly criticized for his use of clearly discriminatory language in this book. We return to this issue in chapter 3.

18. Hamada, "The Legacy of Kagawa Toyohiko."

labor movement leaders in 1921, he founded the *Pillar of Cloud* magazine and the Jesus Band Foundation in 1922, and the Friends of Jesus Society in 1923. Demands on his time further increased when he took on oversight of the relief work in Tokyo's Honjo district following the Great Kantō Earthquake in 1923. Kagawa was now much in demand and constantly on the move from one speaking engagement and negotiation to the next. Typically he was accompanied on these speaking tours by one of his so-called "Five Pens,"[19] dedicated disciples who would transcribe and collate several speeches, lectures, or sermons before receiving Kagawa's final approval to send a new publication to press. In spite of this frenzy of activities, in the five years from 1920 to 1925, twenty-eight books and several translations were published under Kagawa's name. He was a force to be reckoned with, and contemporary international figures such as Albert Einstein and Bertrand Russell met with him on their visits to Japan.

With the 1926 inauguration of the nationwide Kingdom of God Movement, which for several years required Kagawa to speak regularly at evangelistic meetings all over Japan, as well as an increase in invitations from abroad, he had less and less time left for his own writing. Besides the limitations of the heavy schedule, another factor that made writing more difficult was the sporadic recurrence of chronic trachoma, the blinding eye infection he had contracted in the Kōbe slum. Except for some periods of near blindness, he still managed to read with the help of a magnifying glass. Thus, thanks to the tireless efforts of his wife Haru and a growing number of disciples who watched over the work in Kōbe and Tokyo during his long absences, this best-selling novelist had become by default the head of a publishing house, which helped fund a broad range of projects serving his practical program for the reform of modern Japanese society.

To return to the writings, we should picture Kagawa reading, meditating, or jotting down notes on a train, a bus, a boat, or in the reception room of some public hall, school, or church, making last minute preparations and revisions for his next speaking event. While he always remained committed to his primary vocation as a Christian evangelist, his transcribed speeches in fact depict him as a "professorial" evangelist. His "congregation" or "classroom" was the general public, his "disciples" or "students" his fellow citizens. While an animated and inspiring speaker,

19. The "Five Pens" were three men, Kuroda Shirō, Murashima Yoriyuki, and Yoshida Genjirō, and two women, Imai Yone and Yoshimoto Takeko.

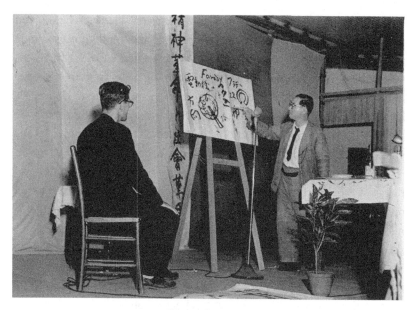

Kagawa lecturing

he would typically employ ink and brush on butcher-block paper to help introduce his more difficult concepts.

A voracious reader, he was especially passionate about the latest developments in natural science, religion, psychology, and philosophy, subjects he believed had both a universal and particular significance for his mostly non-Christian Japanese audiences. In spite of his efforts to explain how these broad interdisciplinary insights cohered with a relatively simple Christian message, his public speeches were sometimes incomprehensible, even to well-educated audiences. Historian Chō Takeda Kiyoko humorously recounts her impression of one of Kagawa's lectures.

> When I was a student, we heard that the famous Christian, Kagawa Toyohiko, was coming to our school, so with throbbing hearts full of expectation, my friends and I went to hear the lecture. However, his unsystematic and rambling talk, which jumped around from biology to something resembling religious philosophy—all of which I simply could not fathom no matter how much I thought about it—left on me a deep impression of confusion about how on earth this person could be so famous![20]

This brings us back full circle to the *Collected Works*. We have discov-

20. Takeda, "Social Thought of Kagawa," 34.

ered that a careful reading of Kagawa's writings on science, religion, and philosophy provides a key to understanding the apparently "unsystematic and rambling" leaps he makes in the public speeches. However fragmentary these written artifacts may appear at first glance, they are essential in understanding the genesis and development of his ideas. Hence, we have given priority to works written directly by Kagawa, while also sifting through the transcripts for portions that touch on the development of his views on science and religion up to *Cosmic Purpose* (1958), his last book.

We have also consulted several out of print English translations of Kagawa's works, comparing them with the Japanese originals, making revisions that seem warranted, and have considered a broad range of relevant secondary literature in Japanese and English. Not surprisingly, academic work on Kagawa is more abundant in Japanese than in English. We have translated relevant passages from Japanese into English, thus making some of this literature available to an English-speaking public for the first time. Our goal throughout has been to offer a balanced, critical appraisal of one of the most remarkable, complex, and still relevant religious figures of the twentieth century.

While this book is a kind of intellectual biography and does open with an introductory chapter on Kagawa's early development, we will focus specifically on his perspective on the relation between science and religion, a theme that has not been adequately addressed in previous work. Since his views on the subject were pretty much established by the end of the Taishō Era (1926), the biographical material presented in chapter 1 focuses on several relevant episodes from Kagawa's childhood, youth, and young adulthood. To English readers who want a more comprehensive account of Kagawa's life and achievements,[21] we recommend Robert Schildgen's *Toyohiko Kagawa: Apostle of Love and Social Justice*. For those who can read Japanese, we recommend Amemiya Eiichi's recent three-volume biography, which lays important new groundwork on the genesis and development of Kagawa's thought and practice. With a special debt of gratitude to Schildgen, Amemiya, and other biographers, we now turn to events in his early life where we will explore the roots of his "scientific mysticism" as a uniquely situated "laboratory" where we see the development and testing of a unique religious consciousness that was a response to personal anxieties and potentials and those of the modern age.

21. See Appendix A for timeline of some of the main events in Kagawa's life.

Finally, a brief biographical note on the author is in order. From 1988 to 2008, Thomas John Hastings was a Mission Co-worker of the Presbyterian Church (USA), working in cooperation with the United Church of Christ in Japan (UCCJ or Kyōdan). He taught at Hokuriku Gakuin Junior College in Kanazawa from 1987 to 1991, Seiwa College in Nishinomiya from 1993 to 1995, and Tokyo Union Theological Seminary from 1995 to 2008. He was a Senior Academic Administrator from 2008 to 2011 and the Houston Witherspoon Fellow in Theology and Science at the Center of Theological Inquiry in Princeton from 2011 to 2012. After Furuya Yasuo, Koyama Kōsuke, and Morimoto Anri, he was the first non-Japanese to be invited to give the Kagawa Lecture at Princeton Theological Seminary in April, 2011. In 2012, upon receiving a three-year grant from the John Templeton Foundation called "Advancing the Science & Religion Conversation in Japan," he was appointed Senior Research Fellow in Science & Religion at the Japan International Christian University Foundation in New York City. With the exception of Kagawa's final work, *Cosmic Purpose*, which was translated by James W. Heisig and edited by the author, he is responsible for all of the translations from Japanese in this volume.

1 Discovering the Holy in the Midst of the Void

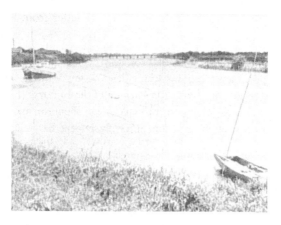

A CHILD OF THE YOSHINO RIVER BASIN

Any attempt to understand Kagawa's "scientific mysticism" must include his difficult childhood and youth as well as his later remembrances of those days. In 1955, just as he was working hard to complete his teleological meditation on modern science, *Cosmic Purpose* (1958), the sixty-six year-old Kagawa wrote a short autobiographical piece called "Leaving My Village" that recounts some of his earliest memories up through his student days at Meiji Gakuin and the Kōbe Theological School. Mutō Tomio, the editor of Kagawa's collected works, reports that following the war, Kagawa was preoccupied with writing his teleology.[1] In a memorial tribute appearing in *Christian Century* in 1960, Richard Drummond comments on Kagawa's post-war public speeches:

> An outstanding characteristic of Kagawa's postwar preaching was his frequent use of illustrations drawn from natural science, a trait mani-

1. Mutō, Commentary on *Cosmic Purpose*, 455.

festing his lifelong deep interest in that subject. Some of his addresses seemed 75 percent science and 25 percent gospel. In this he was poles apart from standard practice in the biblically oriented preaching of the Japanese church and as a consequence was often severely criticized. Kagawa's wide knowledge of natural science, especially astronomy, physics and biology, reached levels rare in nonspecialists.... He was certainly the only man in Japan who on the basis of serious study made an attempt to apply scientific knowledge to the understanding and proclamation of Christian gospel.[2]

So committed was he to bringing science and religion into positive rapprochement that he even rejected an invitation from a major us U.S. publisher to write his autobiography in English. A 1954 letter from Eugene Exman, editor and manager of religious books at Harper & Brothers, reads:

> Dear Dr. Kagawa: While I am sorry that you have decided not to write your autobiography, I am pleased to know that you are putting aside time regularly to write your book *The Purpose of the Universe* [here translated *Cosmic Purpose*]. I am eager to talk to you about the manuscript and hope to see you in Evanston. Sincerely, Eugene Exman.[3]

Given this post-war "obsession," it is reasonable to conclude that the keenly self-conscious Kagawa intentionally focuses on certain life episodes he recalls in "Leaving My Village," as a way of disclosing the development of his quest for what we have called his "cosmic synthesis," a lifelong pursuit that reached its zenith in *Cosmic Purpose*.[4] This is why we have used this autobiographical piece, previously unknown in the English literature, to structure this chapter. Since what autobiographers omit is often as revealing as what they include, we have supplemented Kagawa's retelling in "Leaving My Village" with other primary and secondary sources. Also, to help interpret the convergence of psychological and spiritual trajectories in Kagawa's personal story, we have drawn on the work of James E. Loder.[5]

The first section of "Leaving My Village" is called "A Complicated Family," and it begins with a passing reference to what was surely the most painful and enduring trauma of his life.

While I was lonely, I am grateful that I grew up in Awa's Yoshino River

2. Drummond, "Kagawa: A Christian Evangelist," 824–25.
3. Eugene Exman, letter to Kagawa, 23 April 1954.
4. Kagawa, *Cosmic Purpose*.
5. Loder, *Logic of the Spirit*.

Basin. There I spent the great bulk of the most sensitive period of youth. After the death of both my parents when I was four years old, my stepmother took me in, but the person who cared for me was my step grandmother.[6]

These poignant opening lines suggest that, even in the midst of his bleak sense of abandonment after losing both parents at such an early age, he was discovering or constructing an alternative identity and sense of belonging as a child of nature. More than simply a geographical homeland, the Yoshino and its environs provided the lonely young boy a sheltering matrix, a home or "motherland," which his adopted family was unable to provide. On the banks of this river, he first intuited the probability of a "cosmic synthesis" between the mutable, material realm of nature and the immutable, spiritual realm of purpose.

But his early reveries by the banks of the Yoshino were not by any measure all bliss and romance. In spite of the natural beauty, he perceived a dark shadow that enveloped his adopted home life and the entire village community, as he points out in *The Religion of Jesus and its Truth* (1921):

> Everything was covered in a feeling of moral corruption. Even the serene blue water of the beautiful Yoshino River could not make a human heart serene. From early on, I was a child of sorrow.[7]

Before returning to this growing tension between his sense of gratitude for the matrix of nature, moral apprehension about his surroundings, and spiritual longing, we need to insert a brief word about his birth parents.

At the age of four, Toyohiko suffered in quick succession the double trauma of the deaths of his father, Kagawa Jun'ichi, and Kaō Kame, his birth mother and father's concubine. Born into the Isobe family, who owned a sake brewing company, Jun'ichi had been adopted by the wealthier Kagawa clan, according to a custom common at the time, because they lacked a male heir. During the Tokugawa Era, the Kagawa clan had control of nineteen neighboring villages, so their social and economic standing in Awa society was quite high. As one of the benefits of his adoption, Jun'ichi had received a Confucian-style education, which combined literary and military arts, at the Chōkyūkan, an elite school for the male children of local samurai clans. He had also worked as a government official before opening a shipping company in Kōbe.[8]

6. Kagawa, "Leaving My Village," 91.
7. Kagawa, *Religion of Jesus and its Truth*, 135.
8. Amemiya, *Kagawa Toyohiko's Youth*, 37–40.

Kagawa Jun'ichi Kaō Kame

According to Amemiya, there is some basis for thinking that Kame, Kagawa's mother, had also been born into a samurai family from Kishū[9] who presumably had been forced to send her into the *geisha* world after falling on hard times.[10] But whatever her origins, Kame did manage to find expression for her considerable talents and learning as Jun'ichi's wife, contributing to his business, for example, by teaching company clerks how to read and write.[11] There is every indication that Kame and Jun'ichi provided Toyohiko and his siblings a stable, comfortable, and loving home.

But this world disappeared forever when the forty-four-year-old Jun'ichi died on November 19, 1892, apparently from influenza or dysentery. Schildgen also hints at other possible causes for Jun'ichi's death, saying "drinking and high living may have been contributing factors."[12] Kame died less than seven weeks later on January 3, 1893, soon after the birth of her fifth child. Amemiya comments, "Soon after Jun'ichi died at the young age of forty-four, overwhelmed by sadness and deciding to follow after him, the unfortunate woman died at the young age of thirty-seven."[13] As a concubine, Kame had no rights of inheritance, thus beside the emotional trauma of Jun'ichi's death, she was also facing the likelihood of financial ruin. Whatever her actual psychological condition at the time of his mother's death, one can only imagine the young Toyohiko's anguish as

9. A district in modern day Wakayama and Mie Prefectures.
10. Amemiya, *Kagawa Toyohiko's Youth*, 36–40.
11. Ibid., 40.
12. Schildgen, *Toyohiko Kagawa*, 11.
13. Amemiya, *Kagawa Toyohiko's Youth*, 40.

he tried to come to terms with the sudden loss of his mother, and so soon after his father's death. Recent research suggests that the trauma of losing a parent early in life may be moderated somewhat by the sense of safety and support provided by a loving family,[14] but having lost both parents at once, Kagawa had no such good fortune. His adolescent experience of suicidal ideation, which we will touch on below, is probably not unrelated to the untimely death of his parents. These losses were a personal apocalypse for Kagawa, opening up an early awareness of the void that haunts human life.[15]

Soon after his mother's death, Toyohiko and his older sister were accompanied by one of the clerks of the family shipping company from Kōbe to the family home in Ōasa Village, Naruto City, Tokushima Prefecture, an area formerly called Awa, which is located in the northeast of the island of Shikoku. In *Before the Dawn*, his autobiographical novel, the "Kagawa character" Niimi Eiichi[16] loses his concubine mother as a ten year old. Depicting the departure from Kōbe for Tokushima, he says, "He [Niimi] still recalled his elder sister and himself standing on the deck of the steamer. His thoughts passed to the dark gloomy house where death had separated him from his mother."[17]

From the "dark gloomy house" of separation in Kōbe, Kagawa moved into what he later referred to as "a big house without love."[18] In this way, both the past and future seemed shrouded in a foreboding sense of negation.

14. See Ellis et al., "The Long-term Impact of Early Parental Death," 57–67, and Cas et al., "The Impact of Parental Death on Child Well-being."

15. Sartre, *Being and Nothingness.* The Sartre reference is from Loder, *The Logic of the Spirit*, 124. The possibility of a correlation between severe emotional trauma and dramatic religious conversion seems indicated in some classical stories of conversion (i.e., Luther and Kierkegaard) and calls for closer scientific investigation. See Fleming, "Sensing God's Presence."

16. The Chinese characters for this name are 新見 *Niimi*, literally meaning "new sight," and 栄一 *Eiichi*, literally meaning "glory first." As Amemiya points out in his criticism of Mutō's approach to the novel, it is important to recall that, even though it is an "autobiographical" novel, it is nonetheless a fiction and therefore should not be used to establish historical facts. I refer to it only when it illuminates an established biographical detail. See Amemiya, *Kagawa Toyohiko and the Poor*, 13–16.

17. Kagawa, *Before the Dawn*, 37. In a letter to a Japanese friend, the Irish poet W. B. Yeats praises this translation of Kagawa's best-seller, saying, "I have also read Toyohiko Kagawa's novel … translated into English under the title *Before the Dawn*, and find it about the most moving account of a modern saint that I have met." See Oshima, *W. B. Yeats and Japan.*

18. Schildgen, *Toyohiko Kagawa*, 11.

While he does acknowledge the positive role of his rather strict step-grandmother Sei in his upbringing, he reports that his stepmother Michi hated him. This alleged aversion of Jun'ichi's legal wife toward the child of her husband's concubine is hardly surprising, but it is also likely Kagawa felt some disdain for her in return, as we see in the following recollection. "My stepmother had a weak constitution and was always sleeping in the large *tatami* room at the back of the house."[19] As a fascinating counter-point, in *Before the Dawn*, the Kagawa character Eiichi expresses genuine compassion for his stepmother and strongly criticizes his father for behaving "heartlessly" and "burying the poor woman alive."[20] In "Leaving My Village," Kagawa ads an interesting epilogue to this tortuous story, saying, "After I became an adult, we took care of this stepmother who had despised me, and she requested that I baptize her."[21] Perhaps in Michi's baptism they both were able to finally find some healing of their mutual antipathy.

Turning again to his identification with the natural world and fascination with living things, Kagawa recounts a visit he had made to Kōbe where his older brother had taken over responsibility for the family business. A day trip to the Natural History Museum and Aquarium in Wadamisaki left a particularly strong impression. As soon as he returned home to Tokushima, Toyohiko found a large earthenware *suribachi* that had been abandoned in the garden. After securing Sei's permission to use the big pot as an aquarium, he filled it with water and secured it in place by building around it a mound of dirt. Each day he would go off to the nearby canal or rice fields to catch prawns, carp, pond snails, and killifish, carefully taking home his quarry and releasing them into this improvised aquarium. He also raised katydids and a meadow bunting he had received from his school friend Shotarō. He remarks, "In the morning and evening I enjoyed being alone with these small animals. I think my lifelong avocation for biological research was a gift of my loneliness."[22]

While this connection between "loneliness" and "biological research" may not be immediately obvious, it seems reasonable to assert that these little creatures, which he was free to nurture in the safe space of the gar-

19. Kagawa, "Leaving My Village," 92–93.
20. Kagawa, *Before the Dawn*, 149.
21. Kagawa, "Leaving My Village," 92–93.
22. Ibid., 96.

den, functioned for the traumatized boy as "transitional objects" or prox-
ies for the absent mother-child bond.[23] Stressing the "mediating power"
of such "transitional objects," Loder says that they have

> an almost "sacred quality" and power to bestow security and peace
> when nothing else will....
> They are the creations of the human spirit, symbolically combining
> the known and the unknown, the familiar present state of being and
> the emerging new state. They therefore deal symbolically with the pri-
> mal sense of emptiness echoing back to birth that now surrounds the
> first intentional move away from the mother to a new state of being. [24]

Kagawa had not only experienced the "primal sense of emptiness" of sep-
aration from his mother at birth, but also the absolute separation of her
death. These two negations were aggravated further by the alleged inabil-
ity of his adopted family to provide adequate surrogate care. Hence, the
creatures in the garden opened up the possibility of a new kind of mater-
nal bond that rooted him body and spirit to the Yoshino River basin and
its environs. As we will see, this sense of being linked to the matrix of the
natural world gradually expanded to include the entire cosmos, reaching
all the way out to the cosmic dust and the stars, contracting all the way
in to the atomic and subatomic levels, embracing every level of reality in
between, and touching even on his ultimate sense of union with the cos-
mic will, nothingness, or God. In the section on the "transitional object,"
Loder inserts a theological comment that seems applicable to Kagawa's
situation:

> In the theological area, we also need a concrete image to enable us
> to make the ultimate transition from this life through death into a
> resurrected life. That is, what we need is One whose very existence
> takes both sides seriously and unites in His person the space we must
> traverse.[25]

While Kagawa makes a lot of his loneliness as a child, we should note
that not all of his memories were gloomy. For example, he happily recalls
that his friend Shotarō's grandfather, Sadakichi, showed them how to
make zōri (straw sandals), birdcages, and traps for capturing small birds.
He also took them fishing for mullet in the river and taught them the

23. Winnicott, *Playing and Reality*, 1–25.
24. Loder, *Logic of the Spirit*, 133–34.
25. Ibid., 134.

chant-like *jōruri* that accompanies Bon dances during the mid-August Buddhist festival commemorating the ancestors. Kagawa says,

> When summer came, we would go swimming in the Mazume River, a tributary of the Yoshino, and I remember jumping off the ferryman's small boat. I was able to fully enjoy the benefits of Mother Nature.[26]

Thus, while the rivers, fields, and his beloved pets provided Kagawa an umbilical-like link back to the source of life after the loss of his parents, he also seems to have found genuine human companionship in Shotarō and Sadakichi. In one of his last writings that appeared just four months before he died, the ailing Kagawa recalls going fishing with Sadakichi and comments on how he discovered the Creator through his sense of intimacy with the natural world:

> Ishibashi Sadakichi-san was a kind man who lived just to the west of us. He taught me how to fish and care for small birds. The local elementary school did not teach me, but Sadakichi-san took me by the hand and taught me. He showed me how to bend the fishing pole, place the worm on the hook, and throw the line into the river. Because of this, I really liked Sadakichi-san. While I had been born in the port city of Kōbe, I grew up from the natural inspiration of Awa's Yoshino River. Having spent my childhood years there from four to eleven, I still believe that the best way to come to perceive God is through nature.
>
> The Yoshino River is one of the rare, beautiful rivers of Japan. There is surely no more beautiful river in Japan. Even in the Western world, I'm sure there are not many rivers so beautiful as the Yoshino. Hence, in Tokyo and Osaka, I have promoted the movement to expose children to nature. I completely agree with Rousseau, the writer of *Emile*, who advocated a return to nature as the basis of education. Having been brought up in a farming community, I truly enjoyed nature. Because I knew life in a rural village, I could easily understand the Creator. Japan is not doing a good job of introducing its children to the beauties of nature. The mission of Japan's Sunday Schools is not to teach the Bible in a complicated way, but to teach honestly about nature through the Bible. The discovery of the Creator is the beginning of wisdom. I discovered the Creator as a fifteen year-old. This was the greatest discovery of my entire lifetime.[27]

26. Kagawa, "Leaving My Village," 97.
27. Kagawa, *"Fishing,"* 560.

Religious heritage, moral ambiguity, and *homo religiosus*

Since the Japanese religious and philosophical heritage plays such an important role in the development of Kagawa's thinking, we need to touch briefly on this aspect of his early socialization. Firstly and perhaps most importantly, his father had carefully chosen the two Chinese characters for his given name Toyohiko from two Shintō deities, Toyouke and Sarutahiko,[28] who are enshrined at the Ōasahiko Shrine, three villages removed from the Kagawa family home. Amemiya says Jun'ichi was devoted to these local deities,[29] who also feature in the ancient Japanese mythology. Toyouke appears in the *Kojiki* and Sarutahiko appears in both the *Kojiki* and the *Nihonshoki*,[30] the two eighth-century classics on the mythological roots of Japan and the imperial family. Regarding his father's faith, Kagawa reports he had "abandoned Buddhism and became a Shintoist."[31]

It was surely not an insignificant fact for the young Kagawa, especially after losing both parents, that he had been given a noble Japanese name that was both a link with his father's personal faith and the august mythological origins of the imperial family. In addition to being nurtured as a loyal subject of the emperor, his name may help account for the fact that, while Kagawa opposed Japan's militarism and the government's manipulation of State Shintō, he only had positive words for the emperor and the imperial family.

In Tokushima, his step grandmother, Sei, took it upon herself to guide his early training and reinforce his identity as the "precocious child" of an

Jun'ichi's Handwritten Certificate Declaring Toyohiko's Name

28. 豊受 *Toyouke* and 猿田彦 *Sarutahiko*, hence Kagawa's name 豊彦 *Toyohiko*.
29. Amemiya, *Kagawa Toyohiko's Youth*, 51.
30. 『古事記』 *Kojiki* and 『日本書紀』 *Nihonshoki*.
31. Kagawa, *Christ and Japan*, 104.

elite family. She regularly prodded the young Toyohiko to follow closely in the footsteps of his father, saying, "Since your father was attached to the government, you must also study hard and become a great man."[32] The young boy surely felt the burden of being chosen to fill his late father's shoes and bear the Kagawa name into the future with dignity. As an example of Sei's training, each day as classes let out at his elementary school and the other children were free to run home to play, Toyohiko was sent to Shōin-ji,[33] a local Zen Buddhist Temple, to study the Chinese Confucian classics (*kangaku*). Sei knew that the study of the *kangaku* was an essential fixture in the nurture of elite young men. Toyohiko recalls feeling cheated because he was not allowed to play after school, but later he expressed a sense of remorse that he had read the Chinese characters with little understanding of their meaning as a boy.[34]

Not only was Kagawa among the first generation to be indoctrinated into the modern education system, which was centered on the filial piety of all imperial subjects, he was also among the last generation to study the *kangaku*, a longstanding educational institution that had continued into the early Meiji Era but gradually disappeared by the mid-1890s with the ascendancy of the new pedagogies and subjects of study imported from the modern West.[35] He reports, "The priest taught me carefully in one on one tutorials," but he also admits he could only partially grasp the meaning of the *Analects* of Confucius while being baffled by Mencius's *Doctrine of the Mean*.[36] Nevertheless, he does acknowledge that the Confucian teaching formed the basis of his understanding of right and wrong, saying, "I did accept Confucianism as a legalistic code of conduct, for, as a system, it is more legalistic even than the Mosaic law."[37] Later as a student at Meiji Gakuin, he reread Mencius and was deeply impressed by his philosophy of life. Eventually, like some other Japanese converts to Christianity, he came to be attracted to the ethical idealism of Wang Yangming (1472–1529), a neo-Confucian reformer whose work had been introduced in Japan by Nakae Tōju (1608–48). At any rate, Kagawa had tasted both the old and new pedagogies of Japan.

Kagawa reports that Sei was a very religious person, saying, "My own

32. Kagawa, "Leaving My Village," 94.
33. 正因寺 (臨済宗妙心寺派).
34. Kagawa, "Leaving My Village," 95.
35. Mehl, "Chinese Learning," 48–66.
36. Kagawa, "Leaving My Village," 95.
37. Kagawa, *Christ and Japan*, 104.

childhood faith was deeply implanted in me by my step-grandmother."[38] He recounts an incident when his whole elementary school had to solemnly accompany the body of a young soldier who had been killed in the Russo-Japanese War to the local crematorium, saying, "At that moment, I felt keenly the sorrow of war."[39] He speaks of visiting a nearby Buddhist temple with his friend Shotarō to commemorate the festival for Kūkai or Kōbō Daishi (774–835), the renowned monk and scholar who founded the *Shingon* school of Buddhism to which the Kagawa family belonged.[40]

From childhood, he participated in the daily rituals before the *butsudan*, the Buddhist family altar for commemorating the ancestors. Recounting that daily ritual in 1938, he says:

> as the leading clan in the village, many ancient traditions concerning the family had been passed down to us; and on the *butsudan* was an array of memorial tablets inscribed with *kaimyō* (posthumous names), granted by priests after death to various members of my family. It was my duty from the time I was six or seven years of age to place an offering before these tablets every morning before breakfast. I remember how I would enter the darkened room, light the candles on the *butsudan*, place the offering before the tablets, strike the bell, and then hurry back, for when I struck the bell, a wave of fear, which should be called a fear of death, would sweep over me, and I would be breathless from terror.[41]

Finally, he tells of a long New Year's Day pilgrimage to the Ōasahiko Shintō Shrine, the place from which his father had taken the name Toyohiko. Kagawa also touches these early memories in the fictional *Before the Dawn*:

> He passed the grove surrounding the shrine of the tutelary deity and remembered when he was a young boy how he used to beat the drum at the festival while the young men did the lion dance. This again reminded him that at the children's festival he had himself one year been the leader. He remembered that he and a lot of other children slept at the shrine and had great fun.[42]

38. Kagawa, "Leaving My Village," 97.
39. Ibid., 97.
40. 真言 *Shingon*, meaning "True Word." Devotion to both Shintō and Buddhist faiths is still considered normative in Japan, reflecting the so-called *shinbutsu shūgō* (神仏習合), or merging of the two faiths.
41. Kagawa, *God and the Inspiration of Redemptive Love*, 376.
42. Kagawa, *Before the Dawn*, 62.

From all of this, it is clear that his step-grandmother carefully introduced Kagawa to Shintō and Buddhist religious practices and Confucian ethical teachings in keeping with the customs of privileged rural families. Baptist missionary and Kagawa associate and biographer William Axling describes the effect of these formative experiences:

> Like all the promising boys of that time he was regularly sent to the Buddhist temple to study the Confucian classics and to be drilled in the fundamentals of Buddhist faith. From the Confucian classics he learned the commanding place that filial piety and patriotic loyalty has in the thought-life of his people, and through the Buddhist teachings and its elaborate ritual there was nurtured in his boyish soul a sense of mystic awe and quiet reverence which has become habitual and controlling through the years.[43]

Nevertheless, as he matured he became increasingly critical of the gap he observed between these religious and ethical ideals and the actualities of life in the family and the village. In *God and the Inspiration of Redemptive Love* (1938), he describes the situation in terms of a relation between the family's wealth, a lack of discipline, and lax morals.

> My family and relatives were all wealthy. They owned large factories for the manufacture of indigo dye, and even in the farming villages the people lived comfortably. But because of this, the village was very corrupt and moral standards very low. One can understand how foul with lust the atmosphere was from the fact that at age six or seven I was taught to sing the vulgar love songs of the dancing girls in the brothels. Things were so bad that, even as a boy of nine or ten, and lacking any means of self-discipline or training, I could not but notice the laxity in morals.[44]

In "Leaving My Village," he similarly recalls:

> There was a high degree of sexual excitement among the male youth of our village, and I am embarrassed to say that from childhood I was numbered among them. Until a religious education in sexual morality that fears the Creator is thoroughly introduced in the farming villages, I am afraid this kind of custom cannot be uprooted.[45]

Recalling that his father, after losing a child with his legal wife Michi, had purchased his concubine mother Kame when she was about twenty-years

43. Axling, *Kagawa*, 7.
44. Kagawa, *God and the Inspiration of Redemptive Love*, 382.
45. Kagawa, "Leaving My Village," 97.

old, he adds that his older brother was an "unmanageable profligate."[46] Given this family history, Toyohiko feared that he, too, may "be led away into a future of which no one could predict the outcome."[47] Lacking the presence of an adult male in his immediate family, Kagawa was left to struggle on his own with his nascent sexual desires and other adolescent issues. Perhaps as a residue of this moral identity crisis, his writings abound with an unresolved tension between the ideal and the actual.

But there is one particularly painful experience that Kagawa felt compelled to recall in significant detail in "Leaving My Village." According to the sixty-six year-old, the daughter of the janitor at the nearby Nakaumezume Elementary School had fallen from the top of a waterwheel and, as a consequence of her injuries, had developed pleurisy that required her to be bedridden for several months. One day in the summer of 1898, the ten-year-old Kagawa went to the elementary school grounds with some friends to play, and by then the janitor's daughter was up out of bed and playing there with some of her friends. Glaring at Kagawa and his companions from behind a wooden fence, the girl and her friends reportedly starting taunting the boys, asserting they had no business being there since Nakaumezume was not their school. Kagawa says, "Since I was class monitor in the third class at Ushiyajima Upper Elementary, I paid no attention to them at first. However, when their abuse became excessive, I lightly jabbed the girl with the end of my umbrella and she ran off crying to the house near the school."[48] After two weeks had passed, the girl suddenly started saying that Kagawa had "meant to stab her to death." We will quote at length the most painful part of Kagawa's retelling of this agonizing tale.

> I was then ordered by my step grandmother to go to the girl's house to apologize, so withdrawing from my post office account all of the money I had been saving for years, I put on my summer coat and set off.
>
> I lamented for two days and nights without sleep. In my entire life, I had never been so sad. I had no recollection of poking that first grade girl hard enough to kill her. I knew she had been bedridden with pleurisy for some time. When her sickness became even worse and she started to pin her troubles on me, I truly regretted ever returning to this rural district of Awa. The people of the village knew

46. Kagawa, *God and the Inspiration of Redemptive Love*, 382–83.
47. Ibid., 383.
48. Kagawa, "Leaving My Village," 98.

very well that I was the child of my father's concubine, and I also knew that they would be delighted to see me stumble.

While I knew I was innocent of any wrongdoing, I withdrew 5 yen from my postal savings account, and wrapping it in an envelope, went to the janitor's house to apologize.

Deciding never to return to the village again, I got permission from my step-grandmother for my older brother Tanitsu to accompany me to Kōbe.

While I was away in Kōbe, the girl died as a result of the pleurisy. The grandmother next door said, "You were falsely accused because they could not afford to pay for her medicine."[49]

Commenting on this tragedy in *Before the Dawn*, he says, "Nothing was more painful than being misconceived by others."[50]

This ominous event seems to have been a pivotal turning point in Kagawa's development as *homo religiosus*, a term used by Erik Erikson to refer to figures in whom "religiosity has become definitive for the totality of their lives."[51] At this stage in his development, Kagawa had already experienced the horrific loss of both parents. If our analysis is correct, this trauma was moderated, even if not completely healed, by his sense of being soothed by the river environs and by caring for his menagerie of animals. But now he was afflicted by thoughts of this false rumor spreading among the already inhospitable villagers. Complicated by the maddening experience of being forced to take the fall for a wrong he had not committed, this experience produced a heightened sense of unresolved shame, resentment, and injustice in the young boy, as evidenced by his longing to escape his father's village and never return.

This event seems to have taken on a dramatic, totalizing weight for Kagawa, and we might compare it with similar paternal struggles experienced by Martin Luther or Søren Kierkegaard. Whereas Luther felt he had betrayed his authoritarian father's expectations of him to study law, Kierkegaard worried he had inherited a family curse because his father had allegedly cursed God.[52] Because of the false accusation that had spread like wildfire through his father's home village, Kagawa lost any hope of ever filling his father's shoes and restoring the family name, which had already been tarnished by gossip about the real causes of Jun'ichi's early

49. Ibid., 99.
50. Kagawa, *Before the Dawn*, 63.
51. Loder, *Logic of the Spirit*, 231.
52. Ibid., 234–47.

death and aggravated by the presence of his concubine's son. Feeling he had betrayed the expectations of his deceased father—expectations that were repeatedly communicated to him by his adopted family—the preteen's past seemed haunted by abandonment and death and his future by shame and despair.

As a way of escaping the local village, he was admitted to the Tokushima Middle School[53] a year early, after fudging his date of birth on the application. Since the school was a significant distance from his village, he moved into the school's dormitory. Next, when his elder brother's poor management and intemperance led the family into bankruptcy, Kagawa's intense feelings of abandonment, loneliness, and shame must have been exacerbated by the further public disgrace of the family's financial collapse. As a result, he was forced to spend some time with a distant relative before his uncle finally stepped in and took over tuition payments at the Tokushima Middle School. Looking back, he said, "I just barely managed to graduate."[54] In his final year at Tokushima, he published a notable scientific essay on crabs, which we will mention in chapter 3.

CHRISTIAN BAPTISM AND IDEOLOGICAL FORMATION

In his third year at Tokushima Middle School, Kagawa enrolled in English classes taught by Charles Logan and Harry Meyers, two missionaries of the Presbyterian Church in the United States (Southern Presbyterian) who had planted a church in the city. In *Brotherhood Economics* (1936), his Rauschenbusch Lectures delivered at Colgate-Rochester Divinity School in April 1936, he recalls this encounter:

> There was an American missionary who taught English, so I attended that English class to learn the language. He told me the best way to learn English was to memorize it and gave me a few verses from the Sermon on the Mount to memorize. I also learned the twenty-seventh verse of the third chapter of Luke, "Consider the lilies of the field; they toil not, neither do they spin; yet Solomon in all his glory was not arrayed like one of these." When I began to memorize that verse a new inspiration came to me. This time I found that there is a most mysterious power which makes the plants so beautiful. This power

53. Middle schools followed lower, or ordinary, and upper elementary schools, functioning as the equivalent of today's high schools.
54. Kagawa, "Leaving My Village," 101.

is the Creator. So I began to pray to the Heavenly Father who could make the lilies in the field so pretty. I believed that if I could be like one of these lilies in the field I could be a good boy.[55]

While he had been introduced to Christianity by a Christian teacher named Katayama, who taught at the middle school and ran a dormitory where Kagawa had lived briefly, he says that his "discovery of God was due completely to these two missionaries,"[56] Meyers and Logan. The fifteen-year-old Kagawa was baptized on 21 February 1904.

In "Leaving My Village," he goes on to list some of the books that had helped shape his ideological views before and after entering Meiji Gakuin. His reading list begins with Tolstoy: "After receiving baptism, I felt very encouraged and started studying. One book that deeply inspired me at the time was *A Confession* by Tolstoy. Tolstoy helped to guide the direction of my inner life from that point on. The Russo-Japanese War had already started. But I believed in Tolstoy's pacifism and did not feel any excitement about Japan's success in that war."[57]

Kagawa's public expression of his pacifist convictions are traceable to a dramatic incident that had occurred at Tokushima Middle School soon after his baptism, when he had refused to participate in military training exercises. The government had directed all Japanese schools to hold military training exercises, but one day before these exercises were to begin, Kagawa suddenly blurted out, "I refuse to go to training!" and dropped his training gun in protest, at which point the teacher conducting the exercise reportedly threw Kagawa to the ground. In spite of this extraordinary confrontation with his teacher, Kagawa allegedly still refused to pick up his gun.[58] This public act of protest is all the more significant when one considers Japan was at war and public opinion was not in the least bit hospitable to expressions of anti-war sentiment.

Given the highly charged political atmosphere of the day, it is almost as if the teenage Kagawa imagined he could single-handedly foil the emerging imperialist ambitions of his beloved Japan. Describing the "heightened sense of totality" that accompanies adolescent leaps in cognitive and ego development, Loder says, "The ideological hunger of this

55. Kagawa, *Brotherhood Economics*, 9.
56. Kagawa, "Leaving My Village," 102.
57. Ibid., 102. It bears mentioning that Kagawa wrote "Leaving My Village" in 1955 after already being nominated once for the Nobel Peace Prize in 1954. He was subsequently nominated in 1955, 1956, and 1960.
58. Amemiya, *Kagawa Toyohiko's Youth*, 157.

Kagawa's Draft Essay "On World Peace," Tokushima Mainichi, 1906

period brings adolescents, male and female, into devout commitment to causes."[59] About a year later, the seventeen-year-old Kagawa took his cause to a broad reading public, contributing a serialized essay entitled "On World Peace" to the local edition of the Mainichi newspaper. This thoughtful essay reflects the influence of Christian socialism and especially Tolstoy's humanist writings on nonresistance, which were also deeply influential for Gandhi and Martin Luther King, Jr.

Next he introduces his developing interest in religious philosophy after reading Francis Patton's *A Summary of Christian Doctrine* with Meyers. In this regard, he also mentions Robert Flint's *Theism* and the religious books of Takahashi Gorō, a Japanese Christian well known for his work on the translation of the Bible. He says he was helped to understand Patton's book by reading a pamphlet by De Forest called "World Christianity." Able to freely borrow books from Meyers's library, he reports copying Henry Drummond's treatise on the supremacy of love, *The Greatest Thing in the World*, word-by-word into his notebook.[60] Next he says he completely lost track of time reading Anesaki Masaharu's[61] translation of von Hartmann's philosophy of religion. In thinking about this list, we should note that it was not so much Christian theology, *per se*, but a theistic philosophy of religion that arrested the young Kagawa's attention even before he left for Meiji Gakuin. In passing, he also mentions that Mori

59. Loder, *Logic of the Spirit*, 214.
60. Kagawa, "Leaving My Village," 103.
61. Anesaki was professor at Tokyo Imperial University and is considered the father of religious studies in Japan.

Ōgai's Japanese translation of Goethe's *Faust* awakened in him a sense of excitement about physical love.

Having lost the financial support of his uncle because of his decision to seek Christian ordination, Meyers made a commitment to send Kagawa 11 yen each month, enabling him to enroll at Meiji Gakuin, a private school founded by Presbyterian and Reformed missionaries in Tokyo.[62] There he applied himself to his studies and, it seems even more vigorously, to his extracurricular reading. He comments that he found most of the first-year classes too easy, so he enrolled in higher-level English lectures, taught by the missionaries, on astronomy, economics, and Western history. He wrote his exams in English. He credits his ability to function at a high level in English to the time he had spent with Meyers in Tokushima in individual tutorials. According to Meyers, August Karl Reischauer,[63] professor at Meiji Gakuin, called Kagawa "the most brilliant student he had ever taught."[64]

Amazed by the holdings of the Meiji Gakuin Library, he reports that he devoured multi-volume reference works in the philosophy of religion and the history of philosophy. He then turns the spotlight on a certain thinker, who was to become a decisive influence on his subsequent views:

> Two books that especially influenced me were the English translation of Hegel's *Philosophy of History* and Dr. Bowne's *Metaphysics: A Study in First Principles*. While I sensed that Hegel's philosophy was too optimistic, I came to clearly understand why after reading Schopenhauer. The personalist religious philosophy of Bowne was a gift of the Meiji Gakuin Library for which I gave thanks. I think it is because I encountered this good book at a young age that I have not wavered in my own pursuit of a personalist philosophy of religion from the time I read Bowne's religious philosophy as a seventeen year-old up to the present.[65]

In chapter 2, we will show how the so-called "Boston Personalism" of Borden Parker Bowne opened to Kagawa a "middle way" between philosophical idealism and materialism that resonated with his own instincts.

Also, having identified with the writings of Abe Isoo and Kinoshita

62. Kagawa, "Leaving My Village," 104.

63. The Reischauers were Presbyterian missionaries and parents of Edwin O. Reischauer, the renowned Harvard University Japanologist and Ambassador to Japan from 1961 to 1966.

64. Speer, "Biographical Sketch," 3.

65. Kagawa, "Leaving My Village," 105.

Naoe, Kagawa says he often attended lectures at Tokyo's Kanda Church given by Kinoshita and other Japanese Christian socialists. This ideological association with the pacifist socialists got him into more trouble during his first year at Meiji Gakuin. He recalls:

> After defeating Russia in Meiji 38 (1905), Japanese citizens were completely intoxicated. But as a believer in Tolstoy's pacifism and Christian socialism, I delivered an anti-war speech during a discussion at Meiji Gakuin. I was taken out behind the library, and after being verbally abused by several students, one of the fourth-year students who lived in the dormitory struck me. Because of this, my dormitory life at Meiji Gakuin was very sad.[66]

Sounding a more positive note, Kagawa reports on hearing William Jennings Bryan speak on peace at the Kanda YMCA in Tokyo and also being moved by the speeches of the Salvation Army's General William Booth. In the Spring of 1906, while acting as student chair of the YMCA, Kagawa was asked to interpret the speeches of a certain Dr. Friis from Sweden, as well as an unnamed YMCA representative from India.

Dr. Meyers had been called to teach at the recently opened Kōbe Theological School, and on the advice of his mentor, Kagawa left Meiji Gakuin and its magnificent library in March 1907, and after a brief trip back to Tokushima to accompany Meyers on an evangelistic mission in the Yoshino River Basin, where this story began, Kagawa eventually set off with Meyers to enroll at the more conservative Presbyterian school in Kōbe.

Here we need to mention a pivotal event that Kagawa omits from "Leaving My Village," perhaps because this piece was written for a general rather than a specifically Christian audience. After the evangelistic tour with Meyers and before enrolling at the Kōbe Theological School in the fall semester, Kagawa spent some time working in Toyohashi, a small city near Nagoya. There he met Rev. Nagao Ken, a pastor who lived an exemplary life of love, poverty, and service. Kagawa was deeply impressed by the simple witness of Nagao and his family, and seems to have fallen in love with his eldest daughter.[67] Presumably during a post-war trip to the United States, Kagawa recounts the dramatic experience that occurred in

66. Ibid., 105.

67. Mutō, *A Biography of Kagawa*, 73. Mutō reference from Bickle, *The New Jerusalem*, 49.

the summer of 1907.[68] He had been preaching daily on the streets and was on the verge of collapse. He begins:

> On the fortieth day, at about nine o'clock in the evening, it began to rain while I was still preaching. For a week my voice had been getting weaker and weaker, and when the rain began falling my body was swaying to and fro. At one time I had difficulty in getting my breath. I began to feel horribly cold, but I determined, whatever happened, to finish my sermon. "In conclusion," I cried, "I tell you God is love, and I will affirm God's love till I fall. Where there is love, God and life reveal themselves."[69]

He somehow made it home, but after his fever spiked at 104 degrees, the doctor told him he was unlikely to recover from this severe attack of chronic tuberculosis, which had been first diagnosed when he was thirteen years old. His condition worsened, and fearing the end was near, the doctor suggested he call his friends. Kagawa recalls the scene.

> The sun was setting in the west. I could see its reflection on my pillow. For four hours I prayed, waiting for my last breath. Then there came a peculiar, mysterious experience—an ecstatic consciousness of God; a feeling that God was inside me and all around me. I felt a great ecstasy and joy. I coughed up a cupful of clotted blood. I could breathe again. The fever was reduced. I forgot to die. The doctor came back at nine-thirty. He was disappointed. He had written a certificate for my cremation and feared the people would call him a quack.[70]

We return to this experience in chapter 4 in our exploration of the mystical dimension of Kagawa's "scientific mysticism."

A SUCCESSION OF ILLNESSES AND THE NOVEL

To return to "Leaving My Village," the final section is entitled "Recuperating from Pulmonary Tuberculosis." Here we find a personal tribute to Dr. Meyers and a retelling of events leading up to the publication of his best-selling novel, *Before the Dawn*. The sixty-six-year-old Kagawa reminisces about his relationship with Meyers in the most intimate terms.

68. We should note that this account comes forty years after the event, thus it had the benefit of the kind of rescripting often applied to long-term memories, and perhaps traumatic ones most especially.

69. Bradshaw, *Unconquerable Kagawa*, 82–83.

70. Ibid., 83.

Dr. Meyers loved me like a child. On the evangelistic mission, he and I
shared the same bed. Transcending national boundaries, this love and
kindness has guided me my whole life.

Even when I moved into the slum in Fukiai Shinkawa, Dr. and
Mrs. Meyers always had a plate of food prepared for me. I was never
once refused whenever I went to eat in the Meyers's home. More than
anything else, it was the impression made by the depth of their love
that led me to want to help those troubled ones at the very bottom of
society.[71]

Soon after his arrival at Kōbe Theological School in the fall of 1907,
Kagawa's tuberculosis flared up again, forcing him to be hospitalized
for four months, first at the Kōbe Eisei Hospital and then in the Minato
Hospital in Akashi.[72] Still in need of convalescence, he then went to
Gamagōri, a town on the coast in Aichi Prefecture near Toyohashi. Rent-
ing the simple cottage of a fisherman for nine months, he used his free
time to write the first draft of the novel that eventually became *Before the
Dawn*. Kagawa later claims that this was the happiest time of his life.[73]
The year was now 1908, and he laments that *Before the Dawn* took twelve
years of painful rejections before Kaizōsha finally accepted it for pub-
lication. He concludes his brief autobiography by referencing the best
seller, which became the first novel in Japan to sell more than a million
copies:[74] "I wrote it while hemorrhaging from my lungs, and though I felt
the prose was unpleasant, I decided not to make any changes since I had
written it in a very solemn mood."[75]

Returning to his classes at Kōbe Theological School in October, he
soon had to undergo surgery for empyema, a lung ailment related to his
tuberculosis. After post-operation bleeding reached a dangerous level,
Dr. Meyers and his friends once again gathered around his bed at the
Hyōgo Prefectural Hospital for a farewell prayer meeting. In November,
following yet another surgery, this time at the Imperial Hospital in Kyoto
for tuberculosis-related hemorrhoids, he recuperated under the care of
a pastor in Kyoto and spent his time reading the *Journal of John Wesley*
with great interest.[76]

71. Kagawa, "Leaving My Village," 107.
72. Mutō, "Chronology," 580.
73. Yokoyama, *Biography of Kagawa Toyohiko*, 41.
74. Kanai, "The Practical Christian Ethos in Kagawa Toyohiko," 153.
75. Kagawa, "Leaving My Village," 107–8.
76. Mutō, *Chronology*, 581.

Even though he had been warmly welcomed and supported by the missionaries and had made a confession of Christian faith, it seems that their support was not sufficient to relieve the accumulative weight of the psychological, social, and physical traumas that Kagawa had endured thus far, as listed in the following chronology.

1892–93: Death of both parents

1893: Sent to Awa (Tokushima) to live in "loveless family" with father's legal wife and step grandmother

1898: Falsely accused of attempting to kill the janitor's daughter

1901: Diagnosed with chronic tuberculosis

1903: Family's bankruptcy, uncle takes over payment of school fees

1904: Baptism by Meyers, loses financial support due to opposition of uncle

1905–6: Studies at Meiji Gakuin, roughed up by schoolmates for speech on pacifism, writes essay "On World Peace" in summer of 1906

1907: Leaves Meiji Gakuin to enroll at Kōbe Theological School, suffers life-threatening attack of tuberculosis in summer and experiences dramatic healing, hospitalized again in the fall

1908: Spends nine months recuperating, writes draft of *Before the Dawn*, returns to Kōbe Theological School in October, undergoes two surgeries for tuberculosis-related ailments

In "Leaving My Village," Kagawa leaves off the story in 1908, the year he turned twenty, which is the age of majority in Japan. But it was 1909, his twenty-first year, which turned out to be the dramatic turning point.

Confronting the Void and Following Christ into the Slum

Kagawa's accumulating misfortunes have an almost Job-like quality. He had lost his parents, home, reputation, financial support, and health. His close brush with death in 1907 and the ensuing battle in 1908 with disease-related complications marks a significant milestone in the development of Kagawa's thinking. He references this painful period in the preface to *Cosmic Purpose*, saying, "I began to wrestle with the problem of cosmic evil at the age of nineteen (1907)."[77] In addition to the other painful losses, he was suffering the increasing effects of a disease that often took people's lives. His struggle with "cosmic evil" began not as an abstract philosophical question but as an embodied life and death

77. Kagawa, *Cosmic Purpose*, 29.

struggle. By the time 1909 rolled around, Kagawa found himself staring into the void[78] of what was most probably a clinical depression. The challenge was to find a new home, source of belonging, and vocation. We will turn to his early journals and one other writing, which reveal his obsession with suicidal ideation as he questioned the value and purpose of life.

Yokoyama Haruichi, a close disciple and author of Kagawa's 1959 biography, provides a revealing series of entries from Kagawa's journal in 1909 after he had returned to his studies at the Kōbe Theological School. Commenting on Kagawa's *Weltschmerz*[79] at the time, Yokoyama says, "Kagawa's health was unstable as always. He was studying German, reading Western books, and exerting effort on the path of character formation and evangelical service, but his lung ailment undermined his determination and seemed to block the hope for any future prospects."[80] Here are the ominous journal entries beginning in January, 1909:

> January 20 (Wednesday): There is a movement to ostracize tuberculosis patients. I may be ordered to search for other lodgings.
>
> January 22 (Friday): Returned after German, read Plutarch. Interesting! Dreamt of suicide!
>
> January 23 (Saturday): Western Doctor Daniscome[81] says, "Looks like you're not fully recovered." Seems he does not believe me. I want to commit suicide. Suicide!
>
> January 24 (Sunday): Spent whole day pondering suicide and endurance.
>
> January 29 (Friday): Spent half the day editing chapter 7 of the novel.

To interject, it is in chapter 7 of *Before the Dawn* that Eiichi, the Kagawa character, muses on suicide. Eiichi says:

> "Why am I walking here?" he asked. "It is because I am alive. Why am I alive? I am alive because I am alive. No, it is because I don't want to die that I am alive. No it's not that either. I want to commit suicide, but I don't want to go out into utter darkness. That is why I go on living. I go on living, in fact, like one who has a rope tied round his neck by

78. Intended here to signify all that threatens to negate life.

79. "A weary or pessimistic feeling about life; an apathetic or vaguely yearning attitude." *OED Online*. This sentiment was associated with Romantic poetry and philosophers like Schopenhauer, who was a special favorite of Kagawa's around this time. Amemiya, *Kagawa Toyohiko's Youth*, 199.

80. Yokoyama, *Biography of Kagawa Toyohiko*, 52.

81. In the original, 西洋醫者ダニスコム. Presumably this was a foreign doctor working in Kōbe.

which he is being dragged along. I know that there is no value in life, but somehow there is a stronger hand than death that holds me by the throat and I go on living.... Life seems so terrible. Life!"[82]

Returning to the journal entries:

> January 30 (Saturday): Pattering on about the difficulty of creative work. Read to chapter 17, but I am giving up on this novel. It has not even the least attraction. I cannot grasp why Iijima-kun (classmate) praised it.
>
> April 11 (Sunday): Sad story, sad story.... Is it madness or suicide? Talk about Christianity and such is all a lie. There is no power above economics. Oh, how this oppression wears me down. Tears and more tears just to maintain this weak body.
>
> April 13 (Tuesday): Been sick in bed exactly one month. Suffered financially for a month. Cried and slept all day. Did not go the hospital.
>
> April 14 (Wednesday): I want to study mathematics. I cried again today. Iijima-kun loaned me 2 yen. Divine providence and love. Oh, the patience of Job! The grace of adversity!
>
> May 30 (Sunday): I am in total despair. Despair. Despair, I end by completely doubting the value of living. I cried all night.
>
> May 31 (Monday): Despair, despair, despair, despair, suicide. Humanity is a lie.[83]

These entries indicate that Kagawa was in a dangerous downward spiral. However, his mention of the struggle between "suicide and endurance" and "divine providence and love," and his puzzlement and gratitude for Iijima-kun's praise of his novel and loan are perhaps signs that he had not completely withdrawn into himself.

Following Yokoyama, we now turn to another key piece called *Mu no tetsugaku* ("Philosophy of Nothingness"), which Kagawa published in July 1909. To get the full effect, we will present it in full and follow with comments.

> "Philosophy of Nothingness"
> I want to study mathematics. Yet, having said that, I lack the courage to sell my other books to purchase books on mathematics. When it comes to philosophy, I devour it quickly with great interest since my body is sickly. Yet it does not go that way with mathematics. In this

82. Kagawa, *Before the Dawn*, 71.
83. Yokoyama, *Biography of Kagawa Toyohiko*, 52–54.

way, I wonder what academic field I should pursue. All this increases the burden of my doubts.

Humanity's pleasures and beauties bore me. Naturally I am exhausted by pain. This all makes me weary of existence. I am fed up with an existence that feels like a steel wire being stretched. I am recovering from the momentary agony of love's passion. But of course romantic love cannot be expected to remove my doubts.

Now I face the most frightening kind of doubt. Long ago I worried about the doctrines of the Trinity or confession of sin. The year before last I wondered about the relation of the soul in light of the deterministic evolution of society, and last year, while I put aside the question of society, I struggled about whether or not an individual soul continues after death. I decided that there is sufficient value in the present, but this year I question whether the present has any value at all.

Alas, is there any value in the present? Is the making of airplanes sufficient value for the present? Did God really make this insignificant world? Is our existence an act of God? Is humanity merely the result of the sensual act of human beings?

Even if I have a mind to value myself, or even if the world is a kind of tomb, as long as I say I am living, does that not mean there is actual value in living? Is such a life devoid of value really a life based in God's grace? If it is going to be this kind of life, it's better for me to be annihilated. I cannot forget the delight of losing consciousness with chloroform. I used to say that I lived as if I were ready to die, but now the pain is so great that I cannot live.

To think of myself as God's creation, existence is as nothing and to think of myself as *hotoke*[84] seems troublesome, so I have come to fundamentally doubt the value of existence. Alas, I have come to fundamentally doubt the value of existence.

Why does a human being exist? Alas, the only solution is death, death, death, death....

I am not worried about whether or not the soul dies. Anyway, humanity's serious task is "death."

Human beings are all worthless. The thing of greatest value is death. Compared with death, existence has relatively no value.

But there are those who do not want to die. Such a person is fortunate. Since God does not want to annihilate such a person, this person wants to live. Yet without God such a worthless existence is unthinkable. Here is the greatness of God. God dwells in this worthless life. Even though God is omniscient and almighty, God is able to indwell this worthless world. God lives even in worthlessness.

84. Spirit of the dead in Buddhism.

> Does God not commit suicide? God is also exerting strenuous effort. Alas, like God I will exert a strenuous effort. Alas, God is also suffering. God, God. . . .[85]

Compared to the desolate confessions of the January-May journal entries, the tone of this piece is markedly different. Firstly, we should not underestimate the import of the fact that, by July, Kagawa felt free enough to publicly voice his struggles. There are more questions than conclusions in this piece, suggesting that he wished to start a conversation. Secondly, while expressing his anxiety and ambivalence about career, love,[86] pleasure, beauty, life, God, and death, such struggles are a common part of the adolescent search for identity along the five principle axes of body, ideology, authority, love, and work.[87] Loder says:

> From the standpoint of the status quo sociocultural milieu into which adolescents are being socialized, it is sometimes said that the adolescent suffers from every pathology known to humanity: depression as aggression directed against the self; manic-depressive mood swings; obsessive guilt and compensation; hysteria that appears after long periods of concentration; suicidal thoughts as displaced aggression against one's caretaker; and megalomania, in which the adolescent will now resolve the world's problems.[88]

Further, as an insatiable reader, Kagawa is keenly aware of the literary trends of his day. While Goethe's "love-lorn school of philosophy"[89] had previously enthralled him, the style of "Philosophy of Nothingness" reflects the current literary trend toward naturalism or psychological realism. Finally, Kagawa ends with an invocation of God: "God, God. . . ." Taken together and in hindsight, these seem signs that Kagawa was on the road toward recovery.

But even more significantly, Kagawa glimpses in this brief piece a light that will illuminate the way forward to his broad-ranging ministry as an evangelist, social reformer, and writer. He strikes two major notes that will eventually help to mend his broken heart, inspire his dramatic decision to move into the Shinkawa slum, and serve as the focus for his subsequent ministry.

85. Kagawa, "Philosophy of Nothingness," 368–69.
86. This is presumably a reference to Akiko, the daughter of Rev. Nagao. In *Before the Dawn*, Akiko appears as the character Tsuruko.
87. Loder, *Logic of the Spirit*, 207.
88. Ibid., 204.
89. Kagawa, *Before the Dawn*, 112.

Firstly, he perceives "the greatness of God" in God's decision to "indwell this worthless world." This refers to the downward movement of the incarnation. For Kagawa, the incarnation of God in the person of Jesus Christ into the "worthless world" is the key insight of Christian faith. Soon after his conversion, Eiichi, the Kagawa character in *Before the Dawn*, says, "He thought that Love must be clothed in Flesh.... All things were meaningless unless they took the form of Flesh, hence if God was not represented in Flesh, then to him He was incomprehensible. That is, he saw the Logos, the Incarnation, as the very mystery of religion."[90] In this passage and elsewhere, Kagawa intentionally uses the Buddhist term *keshin*[91] for "incarnation," rather than the Christian theological term *juniku*.[92] While *keshin* literally means "making or becoming flesh," *juniku* means "receiving or taking on flesh." Kagawa's choice of words reflects his strategy of utilizing existing terms from Japan's religious and philosophical heritage and expanding them to include a Christian meaning, rather than introducing a new lexicon that would only further marginalize the Christian message and the already tiny Christian minority. As we will see later, for Kagawa, the incarnation also inspires the scientific impulse to freely explore the "wonders of reality."[93]

Returning to "Philosophy of Nothingness," he then asks, "Does God not commit suicide?" The use of the word "suicide" here is a literary hyperbole depicting Kagawa's psychological condition while also pointing to the suffering of the crucified Jesus Christ. This rhetorical question should not be linked to arguments for divine "passiblity," as in Kitamori's "theology of the pain of God" or Moltmann's theology of the cross. Kagawa had no interest in theological discussions about whether or not God suffers only in the humanity of Jesus Christ or also as God *in se*. In a speech in Shanghai in 1931, Kagawa says, "Jesus Christ did not commit suicide on the Cross. The social ferment forced him to the Cross."[94] In "Philosophy of Nothingness," Kagawa's logic goes something like this: "If God has 'committed suicide,' i.e., entered into our human struggle even to the point of being willing to die on behalf of this 'worthless world,' then I no longer need to commit suicide." Without saying God literally

90. We returned to the original here. Kagawa, *Across the Death-Line*, 145–46.
91. 化身.
92. 受肉.
93. 実在の驚異 *jitsuzai no kyōi*. Kagawa, *Across the Death-Line*, 132. He repeats this phrase several times.
94. Kagawa, "Cross as the Foundation of Social Evolution," 6.

commits suicide, Kagawa answers his rhetorical question by accenting what Christ's death on the cross suggests about the moral intention and consequences of the divine act. "God is also struggling. Alas, like God I will continue to struggle. Alas, God is also suffering. God, God"

Kagawa's word for "struggling"[95] also bears the nuance of "battling" or "exerting strenuous effort." Influenced by the neo-Confucian notion that the intelligible moral order of Heaven may be intuited and practiced by human beings on Earth, Kagawa boldly proclaims, "God is also struggling. Alas, like God I will continue to struggle." In the neo-Confucian view, concrete acts of virtue stimulate and extend virtue in the world. In Christian terms, the God revealed in Jesus Christ, who positively engages the redemptive struggle by indwelling this "worthless world"—even to the point of being willing to die for it—also invites and enables Christ's followers to participate in and thereby extend the benefits of this redemptive love on behalf of others. We see a similar ethical perspective in the New Testament, for example in the Epistle to the Galatians, where Paul writes, "Bear one another's burdens, and in this way you will fulfill the law of Christ" (Gal 6:2). The writer of the Epistle to the Colossians makes an even more startling claim: "I am now rejoicing in my sufferings for your sake, and in my flesh I am completing what is lacking in Christ's afflictions for the sake of his body, that is, the church" (Col 1:24). It is not surprising that this Colossians text becomes a key in Kagawa's ethical interpretation of redemptive love. Later he writes, "Christ, who died for sinners, summons us to become the concrete expression of this redeeming love to the so-called scum of society. In Colossians 1:24 Paul calls us to carry redemptive love on to its God-given goal."[96]

Given Kagawa's many personal struggles, it is all the more remarkable that he discovered in the redemptive love of Jesus an ever-present and renewable source of energy and optimism that motivated him to dedicate his life to the evangelical social reform of Japanese society. Already in "Philosophy of Nothingness" we find the germ of his unique interpretation of Christ's redemptive love, which we will take up in greater detail in chapter 2.

On Christmas Eve, 1909, about six months after the publication of "Philosophy of Nothingness," Kagawa did the unthinkable and thereby made history by inaugurating one of the most remarkable social reform

95. 奮闘する *funtō suru.*
96. Kagawa, *Christ and Japan*, 115.

movements in modern Japan. Loading his clothes and books onto a pushcart, he departed his dormitory at the Kōbe Theological School and quietly moved into a tiny, dark hovel in the Shinkawa slum, reportedly among the worst in the country. What on earth were Kagawa's motivations for this dramatic act?

Suspicious of drawing too close a parallel between Kagawa's actual story and the fictionalized version in *Before the Dawn*, Amemiya criticizes Mutō and others who speculate that Kagawa threw himself into his work in the slum out of a sense of desperation stemming from his psychological and physical condition. Mutō asserts, "Kagawa's move into Shinkawa was precisely because of his desperate state of mind. This desperation sought to break through his despair and negation, the kind of desperation that rushes toward a fierce affirmation."[97] Countering Mutō and others who conflate Kagawa's state of mind with that of his fictional counterpart, Eiichi, Amemiya writes:

> I do not think Kagawa was in such a desperate condition when he moved to Shinkawa. Objectively speaking, his health was showing signs of gradual improvement before the move. As a matter of fact, from the time he moved to Shinkawa, he was never bedridden again by an outbreak of his tuberculosis. In the midst of those severe and rigorous living conditions, and while fighting against heavy odds, he vigorously engaged in activities on behalf of the residents of the slum. Four years later he married Shiba Haru and the following year went to America to study.[98]

We agree with Amemiya, who says that Kagawa entered the slum to preach the gospel "in keeping with a long held desire of his heart."[99] Nevertheless, in light of Kagawa's childhood and youth, the act itself may be understood as a public baptismal reaffirmation, a radical identification with Christ by following him into the depths of this "worthless world" to live and proclaim the gospel among the "least of these," and, if necessary, to die there.

Drummond reflects on the import of Kagawa's move into the slums:

> Kagawa's identification with the incredibly crowded, stinking, criminal misery of that place is one of the truly memorable sagas of our

97. Mutō, *A Critical Biography of Kagawa Toyohiko*, 17. Mutō reference from Amemiya, *Kagawa Toyohiko and the Poor*, 13.
98. Amemiya, *Kagawa Toyohiko and the Poor*, 15.
99. Ibid., 15.

century. He soon learned that almost every resident of Shinkawa had some physical or other handicap causing him to be an inefficient and therefore unwelcome part of the new industrial society. Kagawa, seeing the need for a social system big enough in heart and mind to find both value and use for people who were being cast aside, began his long fight for such a system. He could hardly appeal to a Christian conscience in the ruling classes. Nor could he hope to find a specifically Christian sympathy among the common people. Yet like many other oriental Christians, he profoundly believed in a divine "general" revelation, a revelation, however varying in degree, from God to all men, and one to which he could appeal.[100]

Kagawa had managed to break through the void to perceive a calling to become a practical exemplar of Christ's redemptive love in an industrializing and militarizing nation struggling to find its identity in the modern world. Thomas Berry says that spiritual traditions always emerge out of a "confrontation with terror."

> These traditions are not the ephemeral activities of weak souls with little of that basic courage required to deal with fundamental life issues. These spiritual traditions represent humanity's ultimate confrontation with chaos, with incoherence, with destruction, with the absurd. These are not abstractions, but cosmic powers vastly different and infinitely more effective, more devastating, and more pervasive than those forces we generally think of when considering the evils to which humans are subject.[101]

While Kagawa's "confrontation with terror" began in the succession of traumas of his childhood and youth, his move into the slum is utterly unique in the history of Japan and Japanese Christianity as a public, evangelical confrontation with the "chaos, incoherence, destruction, and absurdities" attending Japan's rush into the industrial age.

As well as the many positive technological benefits of industrialization, which Kagawa recognized and embraced, there was an undeniable shadow side. Kagawa soon learned that the masses of poor tenant farmers who had escaped to the cities in the hopes of securing steady employment were paying too dear a price. With sharp fluctuations in the economy and no social safety net yet in place, the most vulnerable members of society were barely surviving. According to Yamaori Tetsuo, the slums were a starting point for Kagawa's conviction that "something must

100. Drummond, "Kagawa: A Christian Evangelist," 823.
101. Berry, *The Christian Future and the Fate of Earth*, 1.

be done for the poor and weak."[102] While we agree with Yamaori, we also agree with Amemiya's assertion that Kagawa's core motivation was evangelical.[103] As we will see, Kagawa, following John Wesley and other great Christian reformers whom he admired, did not separate preaching and service but believed that service to the poor and weak was an embodied proclamation of the gospel.

Besides his time in the United States from 1914–17, which we will mention in chapter 3, Kagawa spent over ten years living in Shinkawa. Eventually the slum became the headquarters and platform for his numerous activities for the spiritual, social, and economic reform of Japan. Kagawa's confrontation with the shadow side of industrialism also generated an *ad hoc*, holistic vision that joins the personal, social, cultural, economic, political, spiritual, and scientific dimensions of life and consciousness.

Kagawa's search for what Loder calls a "cosmic ordering, self-confirming presence of a loving other"[104] had emerged out of his longing to recover the personal and relational sense of trust, belonging, intimacy, and purpose that had been threatened by the agonizing traumas of his childhood and youth. Having come face to face with the void, he discovered this "cosmic ordering, self-confirming presence of a loving other" in the redemptive love of Jesus Christ, who had willingly entered into and taken on the suffering of a "worthless world." In theological terms, combining the *imitatio Christi* with the *participatio Christi*, Kagawa believed that Christ's redemptive love inspires and enables his followers also to suffer on behalf of others, thereby contributing to the progressive repair of persons, societies, nations, and indeed, the entire cosmos in unity with the divine intention. Christ's redemptive love thus provides the seed, principle, and goal in his own "cosmic synthesis" that would fuse Christian, Buddhist, neo-Confucian, and Western religious and philosophical intuitions and resources with a positive view of modern science, all in an ambitious program aimed at the spiritual and material reform of Japanese society. It is to Kagawa's understanding of the logic of redemptive love that we will turn in chapter 2.

102. Yamaori, "The Return of Kagawa's Suppressed Ideas," 27.
103. Amemiya, *Kagawa Toyohiko and the Poor*, 15.
104. Loder, *Logic of the Spirit*, 90.

2 The Logic of Redemptive Love
Reading Kagawa as Evangelist and Social Reformer

While there are recent signs of a more balanced assessment of Kagawa since the 100-year commemoration in 2009 of his move into the Shinkawa slum, much of the Japanese scholarship in the decades following his death in 1960 was of a critical nature, focusing on certain inconsistencies and prejudices. Given his almost legendary stature, such a process of demythologization was probably inevitable and for the most part healthy. Some of the areas most often held up for criticism were his (1) Views of the *Buraku*, especially as expressed in his 1915 *Study of the Psychology of the Poor*,[1] (2) Alleged modification in his pacifist stance during WWII, (3) Connection with a disastrous Christian settlement in Manchuria, and (4) Support for the government's policy of isolating victims of Hansen's Disease (leprosy). While some of these criticisms may have been anachronistic, these and other areas are legitimate targets for criticism.

As George Orwell wisely advises in his essay on Gandhi, "Saints should always be judged guilty until they are proved innocent, but the tests that have to be applied to them are not, of course, the same in all cases."[2] The test we should apply to Kagawa is the test he established for himself, which was nothing less than to put the redemptive love of Christ into concrete practice. As we should expect of anyone who sets such a lofty goal, there are clear and undeniable failings. Yet, on aggregate, the post-mortem trial of Kagawa tended toward a stigmatization of one of the most remarkable and creative figures in the history of modern Japan.

1. We will touch on this prejudice in chapter 3 as it relates to his troubling use of a "scientific" theory of racial origins that was current when he wrote this early book.
2. Orwell, "Reflections on Gandhi," 5–12.

While taking these criticisms seriously, it is now incumbent on a new generation to carefully examine Kagawa's writings, not only to assess his historical contribution, but also to consider his enduring relevance.

Beyond these criticisms, another reason Kagawa has been forgotten is institutional. Unlike Uchimura Kanzō (1861–30), whose Mukyōkai (Non-Church) Movement still carries on the work of its charismatic founder, Kagawa remained a pastor in a mainline Protestant denomination,[3] and while he launched several new spiritual and social renewal movements, he did not leave behind a critical mass of disciples belonging to any single organization. His relationships with the established churches were strained at best. In his reassessment of Kagawa's theology, Kuribayashi Teruo reflects on the reasons for these tensions between Kagawa and established church leaders and theologians.

> If we think of the boast of Uemura Masahisa, the leader of the Japanese church in the Meiji and Taishō Eras, who said, "My churches don't need the likes of rickshaw drivers or factory workers," Kagawa proclaimed, "The poorest of the poor are the heart of the church. The most obscure must become the treasure of the church," it is no surprise that pastors did not welcome him. When Kagawa said, "Faith is not about intellectually swallowing the creeds," it is no surprise he was not viewed favorably by Japan's systematic theologians.[4]

The established Protestant churches were mostly comprised of well-educated and middle-class congregations located in the major port cities where the missionaries had begun their work, but Kagawa felt called to reach across class and geographical boundaries. Notably, many of Kagawa's "disciples" are still found outside of Christian circles, including, for example, those associated with the consumer cooperative movement he helped to launch.

Drawing on Michael Polanyi's criticism of positivist approaches to scientific knowledge, Scottish theologian T. F. Torrance describes the kind of approach we attempt in this book.

> We develop a form of inquiry in which we allow some field of reality to disclose itself to us in the complex of its internal relations or its latent structure, and thus seek to understand it in the light of its own intrinsic intelligibility or logos. As we do that we come up with a

3. The Church of Christ in Japan (日本基督教会) before the war and The United Church of Christ in Japan (日本基督教団) after the war.
4. Kuribayashi, "Rereading Kagawa's Theology," 55.

significant clue in the light of which all evidence is then reexamined and reinterpreted and found to fall into a coherent pattern of order. Thus we seek to understand something, not by schematizing it to an external or alien framework of thought, but by operating with a framework of thought appropriate to it, one which it suggests to us out of its inherent constitutive relations and which we are rationally constrained to adopt in faithful understanding and interpretation of it.[5]

In our case, the "field of reality" under investigation is Kagawa's approach to the relation of religion and science. Especially because of the unsystematic and eclectic nature of Kagawa's writings, it is tempting to choose some prominent theme, thereby schematizing his thinking according to a single framework that brackets out important factors. One example of this in English is George Bickle's otherwise excellent study entitled *The New Jerusalem: Aspects of Utopianism in the Thought of Kagawa Toyohiko*. Bickle examines "the development of that strand of rational planning that infused Kagawa's perspective of the New Jerusalem" and "the social psychology of Kagawa's mystical religious beliefs and the secular rationalization of his mission in terms of his unique relationship with the Divine." While Bickle laudably takes up the religious dimension, his interpretive framework leads him to completely pass over Kagawa's central principle of *shokuzaiai* or "redemptive love."[6] Our goal is to elucidate the broader scope of Kagawa's thinking by operating "with a framework of thought appropriate to it," which means, first and foremost, to take him seriously as a Japanese Christian evangelist and social reformer who began working with the poor, and after the surprising success of his best-selling novel, gradually took on the Japanese masses as his audience.

A year after launching the ambitious nationwide Kingdom of God Movement, in *New Life through God* (1929) Kagawa describes his core evangelical vocation to endeavor to actualize the love of God among the Japanese people. He says:

> The late Shimada Saburō[7] said, "Without believing in the Confucian Heaven and the Christian God, Japan will fall into chaos." I do not intend to allow Japan to fall into chaos. I am proclaiming the Christian God so Japan will not become confused. We will continue to press on in unity, realizing the love of God through this spiritual movement. We must not only listen, we must act. It is not good that our ears alone

5. Torrance, *Mediation of Christ*, 3–4.
6. Bickle, *The New Jerusalem*, 5.
7. 嶋田三郎 (1852–1923), a former Christian Member of Parliament.

should go to heaven while our souls go to hell. No, we must send both ears and souls to heaven.[8]

To get a sense of the seriousness with which he took this calling as an evangelist and social reformer for the masses, Schildgen describes the results of the Kingdom of God Movement:

> During the next three years, he [Kagawa] estimated that he had preached to more than a million people, of whom 65,000 had signed decision cards. The churches grew by 19,000 a year, and Kagawa felt that with more follow-up work, the harvest of souls would have been much greater. Between June 1928 and June 1929, he spoke at a grand total of 635 meetings attended by more than 270,000, among whom he garnered 13,000 converts. [9]

In spite of these massive efforts, Kurokawa Tomobumi points out that, while progressive pastors supported Kagawa's approach to evangelical social reform, more conservative voices in the churches were soon criticizing the movement for placing more emphasis on social action than the gospel. But Kurokawa concludes that it was the increasingly unstable political situation that worked against Kagawa's efforts:

> While this movement certainly spread broadly into society, in the end it did not go far in penetrating the working and agricultural classes. The main reason for this was the political situation at the time. There was the outbreak of the Manchurian Incident in 1931, and at home the *Ketsumeidan Jiken* (Blood-Pledge Corps Incident)[10] occurred, followed by the May 15 Incident.[11] Japan quickly made preparations for war, and in this kind of situation, the Kingdom of God movement quickly came to an end.[12]

Whatever the relative successes and failures of the actual campaigns, Kuroda Shirō—a close associate and one of the so-called "Five Pens,"[13] who regularly accompanied him on his evangelistic initiatives throughout Japan—insists Kagawa should be seen primarily as an evangelist: "Up until the present, members of the Japanese Christian community have known Kagawa Toyohiko as an evangelist of the poor, a social

8. Kagawa, *New Life Through God*, 99.

9. Schildgen, *Toyohiko Kagawa*, 160.

10. The 血盟事件 *Ketsumeidan Jiken* refers to a 1932 plot to assassinate certain Japanese businessmen and politicians.

11. The May 15 Incident refers to a failed *coup d'état* on May 15, 1932.

12. Kurokawa, "A Historical Assessment of Christian Mission in Japan (III)," 62.

13. See footnote 19 in Introduction.

innovator, and a practitioner of world peace, but they have neglected to see the true character of Kagawa-sensei as an evangelist of Japan."[14] In a similar vein, Sumiya Mikio, former professor of economics at Tokyo University, lay Christian leader, and Kagawa biographer, makes the following comment:

> For twentieth-century Japan, Kagawa Toyohiko is an unforgettable character who must never be forgotten. There are few people who have had such a profound influence, not only in Japan but the world. At the root, it was Christian faith that generated his ideas. Above all else, he was a Christian pastor and evangelist.[15]

We find ourselves in full agreement with Kuroda and Sumiya, finding that Kagawa's approach to religion and science must be understood as a dimension of his primary vocation as a Japanese Christian evangelist and social reformer.

While the descriptor "Christian" is almost always explicit in Kagawa's writings, the descriptor "Japanese" is sometimes explicit, as when he publishes the 1949 *A Reconsideration of Eastern Thought*,[16] but often tacit, and thus must be made more explicit. As we have already stressed, Japan was groping to construct a new identity as a modern nation state through an intense, reflexive interaction with the West, while pondering what might be of enduring value in Japanese traditions, so the question of what in Kagawa's views belongs to Japan and what belongs to the West is not always easy to sort out. Further, as an artistic thinker, Kagawa draws freely on a broad range of Japanese, English, and German sources, often without providing citations. Still, the "intrinsic intelligibility" or "logos" of Kagawa's approach, while never presented in a completely systematic form, gradually comes into view when one patiently wades through the primary sources. And it seems clear that the cornerstone of Kagawa's approach to religion, nature and science, and ethics, is his interpretation of Christ's "redemptive love."[17]

After a section on some of the sources of Kagawa's personalism,

14. Kuroda, *My Research on Kagawa Toyohiko*, Preface. Kuroda quote from Furuya, "Kagawa Toyohiko's Theory of Japanese Evangelism," 242–43.

15. Ibid., 243.

16. Kagawa, *A Reconsideration of Eastern Thought*.

17. Kagawa's term for "redemptive love," 贖罪愛 *shokuzaiai*, is actually more accurately translated "love that atones for sin" or "atoning love." However, since "redemptive love" is the term Kagawa's English translators settled on, we retain it in order to avoid confusion.

holism, and ethical sensibility, we will turn to his interpretation of redemptive love.

PERSONALISM, HOLISM, AND ETHICAL SENSIBILITY

We have already pointed out that Kagawa preferred reading philosophy of religion to systematic or dogmatic theology, nevertheless his thinking is thoroughly permeated by a discernible and distinctive "theo-logic." Questions of how spirituality and religion, nature and science, and ethics and society fit together within the grand scheme of things were always of pressing concern to Kagawa, and gradually these personal concerns find public, evangelical expression. By the time of an immensely productive period of writing after returning to Japan from studies at Princeton Theological Seminary and Princeton University (1914–16),[18] he had pretty much settled on his basic approach to the following three dimensions of life, which he sees as a unified whole in light of Christ's redemptive love: (1) The Spiritual Dimension (persons and the divine); (2) The Cosmic Dimension (persons and nature); and (3) The Ethical Dimension (persons and other persons). Before treating each of these three dimensions and showing how they interpenetrate each other in Kagawa's writings, we need to touch on some of the major sources for the personalism, holism, and ethical sensibility that characterize Kagawa's basic philosophical position. Specifically, we will examine the influence of Borden Parker Bowne as a major source for Kagawa's personalism, the Japanese view of truth and Henri Bergson as sources for his holism, and Nakae Tōju and the School of Wang Yangming as a major source for his ethical sensibility. Since Kagawa read so widely, there are of course many other sources that could be listed as influences, however we have settled on these because they help to elucidate his view of redemptive love and his lifelong search for cosmic purpose.

Personalism

We will first consider Kagawa's personalism. In 1926, during a period of brief blindness brought on by a flare up of the trachoma he had contracted in the slum, Kagawa wrote the following passage entitled, "The Truth of the Person":

18. He actually returned to Japan in 1917.

Truth is for the sake of the human. Without reservation, we may say truth is fully human. Since even that which appears as impersonal truth is itself a fruit of being human, it bears the seal of human nature. Truth cannot escape the human. This is very clear in the Buddhist attempt to ground religion in an impersonal law yet also needing to introduce the ultimate human agency of the Amithāba.[19]

The singular truth that exists in the universe is human nature itself. That which is commonly called the person is the focus of the truth of the universe, and only through the person may the universe be known and its reality intuited as reality itself. Hence there is no problem in saying that truth is the person. All truth leads to the person and the person is the focus of truth, or rather truth itself.[20]

Kagawa sees the person as the embodied and relational center of experience. As we mentioned in chapter 1, as a student at Meiji Gakuin Kagawa had been captivated by the so-called "Boston Personalism" of Borden Parker Bowne (1847–1910), a Christian philosopher who taught at Boston University. Bowne was the major American interpreter of German philosopher Hermann Lotze, with whom he had studied at Göttingen University. Asserting that Kagawa's study of Bowne and Lotze were foundational for his theory of cosmic purpose, Amemiya says:

> According to this testimony of Kagawa himself, the vast majority of books he read in his first year at Meiji Gakuin were related to religious philosophy. Above all else, he points out that Bowne had been strongly influenced by Lotze. By clarifying the ideological influence he had received through these two writers, we believe it is possible to understand Kagawa's own thought and especially the lifelong problem of "cosmic purpose." Bowne and Lotze were among those seeking an integration of natural science and philosophy as a response to nineteenth-century rationalism. That is, the mechanical workings of nature are seen as the means of the realization of God's ultimate purpose. In terms of its structure, this is remarkably close to Kagawa's teleology. It is not difficult to imagine the young Kagawa reading these two books with joy. We may say that the unique religious view of nature Kagawa had held from the time that he wrote "Arming Crabs" as a middle school student continued as the central focus of his thought throughout his life. This is what made him so sympathetic to Bowne and Lotze. And the culmination of all this was *Cosmic Purpose*, his final book. Read in isolation it may seem incomprehensible; however, when considered as part of the process of the development

19. The Buddha of Infinite Light revered in the Japanese Pure Land Sect.
20. Kagawa, *A Few Words in the Dark*, 72.

of Kagawa's thought, it is surprisingly easy to understand and not so unusual.[21]

Specifically, Bowne's metaphysical doctrine of divine immanence positively links the spiritual and physical dimensions of reality in a way that made sense to the young Kagawa. The preface of Bowne's 1905 *The Immanence of God* states this position in dramatic, polemical terms:

> The undivineness of the natural and the unnaturalness of the divine is the greatest heresy of popular thought respecting religion. The error roots in a deistic and mechanical philosophy, and in turn produces a large part of the misunderstandings that haunt religious and irreligious thought alike. To assist in the banishment of this error by showing a more excellent way is the aim of this little book.[22]

It may be surprising to find behind this statement about divine immanence a clear, Christocentric doctrine of revelation. In *Studies in Christianity*, Bowne says:

> The great significance of the Christian revelation, then, does not lie in its contribution to ethics or speculative theology, though it has done something in both of these realms; but rather in this, that back of the mystery and uncertainty of our own lives, back of the apparent aimlessness of much of history, and back of the woe and horror of much more, it reveals God, the almighty Friend and Lover of men, the Chief of burden-bearers, and the Leader of all in self-sacrifice....
>
> Such is the Christian revelation—a revelation of God, of his righteousness, his love, his gracious purpose, and his gracious work....
>
> It is a great spiritual force at the head of all the beneficent and inspiring forces which make for the upbuilding of men and the bringing in of the kingdom of God. If we would know some things we must turn to nature, or to history, or to psychology; but if we would know what God is, and what he means for men, we must come to the Christian revelation, especially as completed in Jesus Christ. Here only do we find the Father adequately revealed.[23]

Kagawa closely followed Bowne's view of revelation and its emphasis on personal meaning over abstract speculation. On the one hand, Bowne opposes a "bald naturalism," or "god of the gaps" position where "God is needed only to explain the outstanding facts which as yet have no natural explanation," and, on the other hand, a "bald supernaturalism, a

21. Amemiya, *Kagawa Toyohiko's Youth*, 200.
22. Bowne, *The Immanence of God*, Preface.
23. Bowne, *Studies in Christianity*, 24–25.

thing of portents, prodigies, and interpositions, spooking about the laws of nature, breaking one now and then, but having no vital connection with the orderly movement of the world."[24] Many scholars working on the relation of science and religion today articulate a position very similar to what we find in nascent form in Bowne.

In contrast to views that deny God or separate God from the cosmos, Bowne and Kagawa see the God revealed in Jesus Christ as immanent in the cosmos. Bowne says:

> The cosmic order is no rival of God, but simply the continuous manifestation and product of the divine activity. There is no longer any reason for being afraid of naturalism, for naturalism is now merely a tracing of the order in which divine causality proceeds. It is description, not explanation.... We are, then, in God's world, and all things continuously depend on him. We should have not to attempt an impossible division between God's work and that of nature, for there is no such division; we have rather to study the method and content of God's work which we call nature, and in which God is forever immanent. Thus the natural and deistic banishment of God from the real world is recalled, and the doctrine of divine immanence is put in its place; yet not an immanence of disorder and arbitrariness, but an immanence of goodness and wisdom and law."[25]

This accent on divine immanence does not mean that Bowne or Kagawa lost sight of divine transcendence, but both are not unaffected by the Kantian reticence to speak with confidence of transcendent realities. Kagawa found in Bowne's personalism a middle way that seemed to draw on the best of aspects of idealism and empiricism as a support for his "scientific mysticism."

Going one step further, Bowne describes his philosophy of personalism in the following three basic postulates:

> First, the coexistence of persons. It is a personal and social world in which we live, and with which all speculation must begin. We and the neighbors are facts which cannot be questioned.
>
> Secondly, there is a law of reason valid for all and binding upon all. This is the supreme condition of any mental community.
>
> Thirdly, there is a world of common experience, actual or possible,

24. Ibid., 28–29.
25. Ibid., 27–28.

where we meet in mutual understanding, and where the business of
life goes on.[26]

From his location in early-twentieth-century Japan, Bowne's personal
idealism, appreciation of the inherently social nature of persons, com-
monsense view of reason, "transcendental empiricism,"[27] and ethical
activism all resonated deeply with Kagawa.

In an article exploring the empirical dimension of Bowne's personal-
ism, Doug Anderson points to a strong emphasis on embodied action,
"self-realization," "moral intuition," and public engagement, saying:

> persons are known to other persons "only in and through deeds"
> effected by the soul acting with and through the body. This mutual or
> reciprocal dependence of body and soul, their interaction, was taken
> by Bowne to be a fact of experience.
>
> Self-realization as Bowne saw it, demanded an engagement with
> the world—a making of changing social institutions that enable fur-
> ther realization. In colloquial fashion he argued that "It takes a pro-
> digious amount of work to keep the world agoing." More specifically,
> he argued, it "involved the development of great social forms, the
> educational facilities, the gathered knowledge, the industrial activi-
> ties, the wise cooperation and organization, and the stored wealth
> without which humanity cannot progress. Not moral correctness, but
> vital fullness, is the deepest aim of life."[28]

This latter description reads almost like a manifesto for Kagawa's myr-
iad social projects, which he undertook on behalf of the poor, children,
workers, women, farmers, and consumers.

We should also note that Bowne's twin emphases on "self-realization"
and public engagement has a striking consonance with the Japanese
neo-Confucian virtues of *kokorozashi*,[29] or holy ambition, and *messhi-
hōkō*,[30] or selfless devotion to a public cause. As we have said elsewhere:

> *Kokorozashi* is a neo-Confucian religio-ethical ideal adapted by the
> Japanese warrior class of *samurai*, indicating a kind of "holy desire,"

26. Bowne, *Personalism*, 24.

27. For a helpful definition of "transcendental empiricism," see Burrow, *Personalism: A Critical Introduction*, 28.

28. Anderson, "The Legacy of Bowne's Personalism," 1–8.

29. The Chinese character, 志/*kokorozashi*, is a compound of the radical for *samurai* (士/warrior) and *kokoro* (心/heart, mind, etc.).

30. The Chinese characters for this phrase, 滅私奉公 *messhihōkō*, implies inten-
tionally negating or sacrificing oneself in service to the public.

an aspiration or ambition to achieve, embody, and transmit a single-minded, selfless, sacrificial devotion and service to one's feudal lord (*Tonosama*). The word also implies strictly disciplined self-cultivation on behalf of what is perceived to be a just cause or noble person. The verb form *kokorozasu* means to determine in one's mind or heart to achieve the ideal of perfect self-mastery and, if necessary, even to be prepared to die for one's lord without the slightest hesitation [Kenkyūsha 1987, 900].... As a public virtue, *kokorozashi* carried with it measurable social affirmations, and the family of a determined warrior would benefit greatly from the household head's sublimation of his personal desires to the pursuit of what was perceived to be a higher communal ideal. [31]

Several Japanese scholars have noted the remarkable convergence of Puritan and samurai ideals in Japanese Protestantism.[32]

In light of this self-acknowledged influence of Bowne's personalism, it seems Kagawa has more in common with American theological liberalism than has been acknowledged. In *The Making of American Liberal Theology*, Gary Dorrien says, "The most coherent school of American liberal theology took its inspiration from the personalist idealism of a single thinker, Borden Parker Bowne."[33] Dorrien helpfully situates Bowne's contribution in relation to the various philosophical influences on theological liberalism in continental Europe.

Having agreed that credible religious claims cannot be based on external authority, the founders of liberal theology argued variously for ethical conviction, religious experience, and metaphysical reason as the basis for theology. The Kantian school argued that religion has its home in the moral concerns of practical reason; Schleiermacher and his followers urged that precognitive religious experience or intuition is the wellspring of religion; the Hegelian school developed a theology from Hegel's metaphysical philosophy of Absolute Spirit. For over a century liberal theology was either Kantian or Schleiermacherian or Hegelian, or a blend of Schleiermacher and Hegel (as in German mediating theology), or a blend of Kant, Schleiermacher and modern historicism (as in the Ritschlian school). For most of the nineteenth century American liberal theology typically appealed to experience or piety, if not to Schleiermacher. In the social gospel era most American progressives took the Ritschlian option, excluding metaphysical

31. Hastings, "Desire for and Use of the Knowledge of God," 207.
32. For example, Furuya and Ōki, *A Theology of Japan*.
33. Dorrien, *The Making of American Liberal Theology*, 286.

reason, or moved through and beyond Ritschlian theology, as in the Chicago school.... The school of personalist idealism centered at Boston University was a synthetic alternative. It affirmed moral intuition *and* religious experience *and* the social gospel *and* metaphysical reason. Hegel was half right, as were Kant, Schleiermacher, Ritschl and the social gospelers.[34]

Kagawa was influenced in part by all of these currents, and especially because of his accent on religious experience and intuition, it is tempting to align him most closely with Schleiermacher. But, we believe it is to the "synthetic alternative" of Bowne's personalism that we must look to understand the easy leaps Kagawa makes between moral intuition, religious experience, social gospel, metaphysical reason, and teleology.[35] It is worth repeating Kagawa's 1955 confession of the lifelong influence of Bowne's religious philosophy. He says:

The personalist religious philosophy of Bowne was a gift of the Meiji Gakuin Library for which I gave thanks. I think it is because I encountered this good book at a young age that I have not wavered in my own pursuit of a personalist philosophy of religion from the time I read Bowne's religious philosophy as a seventeen-year-old up to the present.[36]

As we will see, Kagawa also held on to certain traditional Reformed theological perspectives, so it is not exactly accurate to classify him as an "old-fashioned liberal" under the influence of Schleiermacher.[37]

While more work remains to be done on Bowne's influence, his middle way, synthetic approach, and moral progressivism fit well with Kagawa's own search for a positive rapprochement between religion, science, and ethics as the basis for a healthy modern society. It is not insignificant that Martin Luther King, Jr. was similarly influenced by Bowne's personalism, which he had studied with Edgar S. Brightman, Bowne's successor at Boston University and King's doctoral advisor. Referring to that influence, King says:

This personal idealism remains today my basic philosophical position. Personalism's insistence that only personality—finite and infi-

34. Ibid., 286–87.

35. We will touch on Bowne's influence on Kagawa's view of causality in chapter 3.

36. Kagawa, "Leaving My Village," 105.

37. Drummond says, "Kagawa could be called an old-fashioned liberal; he described his theology as a conscious application of Schleiermacher." Drummond, "Kagawa," 824.

nite—is ultimately real strengthened me in two convictions: It gave me a metaphysical and philosophical grounding for the idea of a personal God, and it gave me a metaphysical basis for the dignity and worth of all human personality.[38]

This philosophical convergence between two of the greatest Christian social reformers of the twentieth century deserves further research.

Holism

Next we will consider Kagawa's holism. Kagawa constantly stresses the importance of "seeing things whole" in order to grasp the deeper beauty, goodness, and truth of any complex matter, even if that means holding together apparently contradictory elements that would be quickly separated out under more analytic approaches. This holistic epistemological disposition or *habitus* is naturally influenced by Japanese cultural traditions.

Abe Masao's article entitled "The Japanese View of Truth" helps us grasp Kagawa's aesthetic fusion of the spiritual, cosmic, and ethical dimensions of life. Abe draws on Nishida Kitarō, founder of the Kyoto School and Buddhist philosopher, who says, in the Japanese way of thinking, reality is most fully and accurately disclosed through actions of "self-emptying" and "not being argumentative." He quotes Nishida's comment on a passage from the *Man'yōshū*[39] that calls Japan "a country where people, following implicitly the way of the gods, are not argumentative."

This means only that argument is not indulged for argument's sake and concepts are not bandied about for their own sake. As Motoori Norinaga[40] explained in *Naobi no mitama*, "It [the way of the gods] is nothing but the way of going to things," which should be taken in the sense of going straight to the true facts of things. Going to the true facts, however, does not mean following tradition out of mere force of custom or acting in direct response to subjective emotions. Going to the true facts of things must also involve what we call a scientific spirit. It should mean following the true facts of things at the expense of self. "Not being argumentative" should be understood as not being

38. King, Jr., *Stride Toward Freedom*, 100. Quote from Steinkraus, "Martin Luther King's Personalism and Non-Violence," 98.

39. An eighth-century collection of ancient poetry.

40. Motoori Norinaga (1730–1801) was the founder of 国学/*kokugaku* (National Learning) that took up the study of ancient Japanese texts as a response to the dominance of 漢学 *kangaku* (study of Chinese texts).

self assertive, but bending one's head low before the true facts. It ought not to be a mere cessation of thinking or readiness to compromise: to penetrate to the very source of things is to exhaust one's own self.[41]

It may surprise readers to find spiritual practices of "self-emptying" and "not being argumentative" as a philosophical strategy that supports a "scientific spirit." Nishida's phrases "going to the true facts of things" and "bending one's head low before the true facts" bear a strikingly similar spirit to Torrance's Polanyian admonition to "allow some field of reality to disclose itself to us" rather than imposing upon it some "external or alien framework of thought." Self-emptying, of course, is a term often used to refer to the "true self" in Zen writings. In *The Social Self in Zen and American Pragmatism*, Steve Odin says:

> Zen Buddhist literature typically describes this true self in negativistic terms like no-self, no-soul, non-ego, or otherwise as self-emptying, self-negation, self-forgetting, self-extinction, and so forth.[42]

In *The Religion of Jesus and its Truth* (1921), Kagawa even portrays Jesus as a master of Zen philosophical methods and virtues, saying, "The Jesus who forgave his enemies on the Cross had mastered the mysteries of life, and therefore it is safe to also say that Jesus had mastered the mysteries of Zen philosophy."[43]

Further, in juxtaposition to Western views that tend to separate cognition from action, typically giving precedence to cognition over action, Abe adds that, in the Japanese epistemology:

> action precedes cognition For just as an individual fact does not follow a universal principle, action does not follow cognition. More strictly speaking, in realization of truth, action and cognition as well as subject and object are not separated from one another, but go together as one. The Japanese term, *makoto*, まこと, 眞, which means "truth," also indicates "sincerity" or "faithfulness" 誠. Literally, *ma* means "true" and *koto* "fact" and "word...." In other words, *makoto* may be said to denote a fact as it is, without modification by human intellect, and at the same time a spirit to express it as it is, at the expense of the ego-self.... In short, *makoto* involves cognitive, moral, and aesthetic truth because in *makoto* god and man, man and nature, man (self) and man (other) are understood to be completely fused.[44]

41. Nishida, "The Problem of Japanese Culture," 279–80.
42. Odin, *The Social Self in Zen and American Pragmatism*, 8.
43. Kagawa, *Religion of Jesus and its Truth*, 145.
44. Abe, "Japanese View of Truth," 3.

Taken together, these comments on self-emptying and not being argumentative, the unity of action and cognition, and the holistic "cognitive, moral, and aesthetic" character of *makoto* help us appreciate the regular leaps Kagawa makes between different epistemological modalities. For example, in *New Life Through God* (1929) Kagawa ponders how we should see human life in the grand scheme of the cosmos:

> After all, what point of view should we take? Should we consider human life from the broad perspective of the whole world or just take it in parts? Taken from the whole, we can get a pretty good grasp of things, but if we look at things narrowly, we are like the frog in the well who is at a total loss or the blind men in Aesop's fable trying to describe an elephant. One feels only the leg and calls it a post, another only the tail and calls it a whip, yet another only the ear and calls it a wooden plank, still another only the torso and calls it a wall, and one more only the tusk and calls it a sword. Each blows off steam from one's own limited point of view. Those who complain about the struggle for existence or sadness and suffering are like these blind men who don't see the big picture. When we open the eye of the *kokoro*,[45] we see that the cosmos is not such a bad place. When this eye that sees all things whole turns only toward outer realities, it does not see, but it does see when it turns simultaneously toward inner realities. That is, when the *kokoro* focuses on the whole cosmos, we understand.[46]

While analytical reason deliberately focuses on a limited field of vision, holistic or synthetic reason seeks to keep the "big picture" in focus. Kagawa believed that we need both modalities, but he feared that the materialist turn in modern philosophy, which is strongly prejudiced toward the analytical mode, would accelerate the spiritual, moral, and economic impoverishment of persons and society. He believed that a "full consciousness" of the cosmos, a consciousness that he sees perfected in Christ, has the power to reverse the modern problematic of radical materialism. Thus,

45. We have deliberately retained the Japanese *kokoro* (心), usually translated as "heart," because it is a multivalent concept encompassing a range of meanings, such as heart, mind, will, emotion, spirit, sense, vitality, etc. My understanding of Kagawa's use of *kokoro* has been enriched by conversation with the creative interdisciplinary scholars at the Kokoro Research Center at Kyoto University; especially Professor Kamata Tōji. Their research focuses on the following three areas: "*kokoro* and body" (mind, brain, and body), "*kokoro* and personal relationships" (emotion, communication, and interaction), and "*kokoro* and lifestyle" (consciousness, values, and life).

46. Kagawa, *New Life through God*, 91.

the development of this "full consciousness," which embraces analytical and holistic reason, was a pressing ethical concern for Kagawa.

Given his natural inclination toward this holistic and activist view of truth, we should not be surprised to find that Kagawa was very attracted to the contrarian teleological ideas of French philosopher Henri Bergson. Bergson rejects what he calls a "radical mechanism" that "implies a metaphysic in which the totality of the real is postulated complete in eternity" and a "radical finalism" that implies that "there is nothing unforeseen, no invention or creation in the universe."[47] Given these caveats, Bergson does support a certain view of finality:

> If there is finality in the world of life, it includes the whole of life in a single indivisible embrace. The life common to all the living undoubtedly presents many gaps and incoherences, and again it is not so mathematically *one* what it cannot allow each being to become individualized to a certain degree. But it forms a single whole, none the less; and we have to choose between the out-and-out negation of finality and the hypothesis which coordinates not only the parts of the organism with the organism itself, but also each living being with the collective whole of all others.[48]

Long haunted by the question of purpose, Kagawa personally took up Bergson's challenge to coordinate "each living being with the collective whole of all others." This lifelong task reaches its ultimate fulfillment in his teleology and final book, *Cosmic Purpose* (1958).

As a rigorous philosophical strategy, Bergson gives center stage to intuition—over intellect—for perceiving the dynamic, surging, "becoming" character of life within "duration." In contrast to intuition, he correlates intellect with space, and pictures it like a knife, dividing things up and then falsely concluding that these logical distinctions represent the full reality. Intuition, which Bergson correlates with time, is much better suited to actively holding onto the continuities and discontinuities of lived experience. Commenting on Bergson's opposition of intuition and intellect, Bertrand Russell says, "The essential characteristic of intuition is that it does not divide the world into separate things, as the intellect does; although Bergson does not use these words, we might describe it as synthetic rather than analytic. It apprehends multiplicity, but a multiplic-

47. Bergson, *Creative Evolution*, 39.
48. Ibid., 43.

ity of interpenetrating processes, not of spatially external bodies."[49] Not surprisingly, Bergson's views appealed to Kagawa's artistic, scientific, and spiritual sensibilities.

In another passage from *Creative Evolution* that speaks directly to Kagawa's own concerns, Bergson positively correlates the philosophical and spiritual quests of humanity:

> These fleeting intuitions, which light up their object only at distant intervals, philosophy ought to seize, first to sustain them, then to expand them and so unite them together. The more it advances in this work, the more it will perceive that intuition is mind itself, and, in a certain sense, life itself: the intellect has been cut out of it by a process resembling that which has generated matter. Thus is revealed the unity of the spiritual life. We recognize it only when we place ourselves in intuition in order to go from intuition to intellect, for from the intellect we shall never pass to intuition.
>
> Philosophy introduces us thus into the spiritual life. And it shows us at the same time the relation of the life of the spirit to that of the body.[50]

We will return to Bergson again, but for now it is clear that his holistic and vitalistic approach ignited Kagawa's imagination because it harmonized so well with the Japanese view of "seeing all things whole."

Ethical sensibility: The way of the activist sage

We will now consider one of the major sources of Kagawa's ethical sensibility. Legendary as the so-called "saint of the slum" or the "Gandhi or St. Francis of Japan," Kagawa was a tireless reformer devoted to improving the spiritual and material conditions of modern society. It is therefore important to touch on the inspiration for his public engagements. Besides the explicit Christian influence, we find a local source for his ethical sensibility and commitments in a particular school of Japanese neo-Confucianism.

While Confucian, Buddhist, Shintō, and Taoist references appear with some regularity in Kagawa's early evangelistic speeches and writings, it is of particular interest that during the U.S. Occupation he published *A Reconsideration of Eastern Thought* (1949), a compilation of some earlier

49. Bertrand, *A History of Western Philosophy*, 798. We should add that, though Russell does a masterful job of fairly presenting Bergson's views, he thoroughly rejects what he calls his "restless view of the world."

50. Bergson, *Creative Evolution*, 268.

writings on these themes. In the Preface, which was written in 1947 when the Japanese were still suffering daily the devastating aftereffects of the war, he writes, "For more than thirty years, I have done research on these traditions from the standpoint of moral psychology and psychoanalysis. This book is a result of my coworkers' edited compilation of my notes and various talks I have delivered based on my reading of many books on the subject."[51] The timing of this publication was auspicious, and the intention perhaps somewhat subversive, since according to Mutō, "Japanese and Eastern things tended to be held in disdain during the MacArthur occupation."[52] In the preface, Kagawa gives free voice to his prophetic, pastoral, evolutionary, apologetic, and evangelical concerns:

> If the wolf became a dog, the tiger a cat, and the caterpillar a butterfly, then there is no excuse for the war-loving biped animal not to become a messenger of heaven! To say nothing of the fact that, even while having various genetic and developmental disabilities, we are the offspring of God and absolutely cannot neglect our calling. Within the religious and philosophical forests that have been cultivated for several thousand years in India, China, and Japan, there is suitably good wood to be used as stock for grafting into the concept of absolute love....
>
> A general survey of Eastern thought shows that, while China begins with the concept of Heaven, this Heaven was not perceived as a messenger of redemptive love. Further, in India, the starting point is in the Rig Veda's discovery of the divine spirit indwelling the human being, which then turns on the search for Nirvana, but only faintly glimpses a salvation that cannot finally reach the reality of redemptive love. A defeated Japan must pursue the path of new life. While this means nothing less than clinging to the supreme love that comes from Heaven, we must not simply wallow in love. If we have been grafted into the love of Heaven, then the rotten part of the old stump must be thrown out. And there is a proper balm that can be applied around the stump where the heavenly sap has rotted out. That balm must be the basic truth of life itself. The love of the cross is that basic truth of life and also the basic truth of Japan's redemption. Christ's personal consciousness of the cosmic consciousness, which is the collective consciousness of redemptive love, is being extended to Japan.
>
> God's extension of the collective consciousness of redemptive love to Japan and the content of this consciousness must be embraced anew, but first it is necessary to discern how the Eastern spirit has

51. Kagawa, *A Reconsideration of Eastern Thought*, 84.
52. Mutō, Commentary on *A Reconsideration of Eastern Thought*, 469.

shaped the legacy and genetic structure of the Japanese spirit. Leaving behind those malignant genes that have been cleansed by God, we must press on only with those Japanese qualities worthy of bequeathing to the world. Under the constraint of this conviction, I have undertaken this reconsideration of Eastern thought from the perspective of redemptive love.[53]

We need to inject a word on the immediate historical context. In late August, 1945, immediately after Japan's surrender, post-war Prime Minister Prince Higashikuni, the uncle of Emperor Hirohito, had appointed Kagawa as an advisor to his cabinet in the hope that Japan's leading evangelist could help restore the nation's public morale. Higashikuni himself seems to have been convinced of the need for the defeated nation to embrace Christianity. Beginning with Higashikuni, Kagawa recounts their conversation:

> Mr. Kagawa, Japan has been destroyed not because we had not a sufficient army, but rather because we suffered the loss of a good standard of morality and engaged in war. If Japan should now seek to revenge itself against the Allied Forces, there would be wars going on permanently in the Pacific Zone. So we need a new standard of ethics, like that of Jesus Christ. Buddhism can never teach us to forgive our enemies; nor can Shintoism. Only Jesus Christ was able to love his enemies. Therefore, Mr. Kagawa, if Japan is to be revived we need Jesus Christ as the basis of our national life. Kindly assist me to put the love of Jesus Christ into the hearts of our people.

Kagawa recalls his response:

> The Prince's words sounded miraculous to my ears, but I replied, "Your Highness, Christianity is not a mere creed or doctrine, nor is it a system of ethics. It is a conviction about God and Christ. It is better for you, yourself, to become a Christian first, and set an example for the nation."[54]

Kagawa's words to Higashikuni reflect his view that Christian ethics are a natural, living extension of a personal faith and not an abstract system of teaching that can be imposed by oligarchs from above. Indeed, as Kagawa had often pointed out, this "top-down" approach had been the fatal error of Japan's nationalists and militarists. It seems that Higashikuni did not accept Kagawa's invitation to become a Christian.

53. Kagawa, *A Reconsideration of Eastern Thought*, 83.
54. Bradshaw, *Unconquerable Kagawa*, 139.

With this background in mind, we will now introduce a Japanese neo-Confucian tradition that Kagawa refers to in *A Reconsideration of Eastern Thought*, which profoundly influenced Kagawa's ethical sensibility. In the early Tokugawa Era, Nakae Tōju (1608–48), a *jusha* (Confucian scholar) from Ōmi Province,[55] underwent a kind of mystical conversion when he turned from his study of Song Dynasty neo-Confucian philosopher Zhu Xi (1130–1200)[56] to Ming Dynasty neo-Confucian philosopher Wang Yangming (1472–1529).[57] In China, Wang Yangming and his followers had offered an intuition-based alternative to the rationalism of the long dominant Zhu Xi School. In an analogous response to Zhu Xi doctrine, which had been officially sanctioned by the ruling Tokugawa Shogunate, Tōju is credited with introducing the Wang Yangming School to Japan. Similarities and differences between the teachings of the two Schools and their reception histories in China and Japan are the subject of much specialized scholarship, but here we limit our discussion to the themes Kagawa mentions.

But first we need to consider why Kagawa felt especially attracted to Tōju and, by extension, the Wang Yangming School.[58] Like Uchimura Kanzō,[59] who had devoted a chapter to Tōju in his 1908 *Representative Men of Japan*,[60] Kagawa had written a short piece entitled "The Religious Thought of Nakae Tōju," which was reissued in *A Reconsideration of Eastern Thought* (1949).[61] There Kagawa makes much of Anesaki Masaharu's proposal that Tōju's "monotheistic piety" may have been influenced by Japanese *Kirishitan*.[62] While such an influence is not impossible, even in the midst of the persecution that was well under way during Tōju's lifetime,[63] Kagawa cannot contain his enthusiasm about Anesaki's more reticent claim. He boasts:

55. Today's Shiga Prefecture.
56. 朱子 (Jp. Shu Shi).
57. 王陽明 (Jp. Ōyōmei*).
58. *Yōmeigakuha* in Japanese.
59. Uchimura (1861–1930) was founder of the Nonchurch (無教会 *Mukyōkai*) movement, which Mark Mullins calls the "fountainhead" of indigenous Japanese Christianity. See Mullins. *Christianity Made in* Japan, 54–67.
60. Uchimura, *Representative Men of Japan*.
61. Kagawa, *A Reconsideration of Eastern Thought*, 132–35.
62. 切支丹 *Kirishitan* is the term used to refer to Japanese Roman Catholic coverts in the sixteenth and seventeenth centuries. Anesaki, *History of Japanese Religion*, 276–78. Anesaki is considered the father of religious studies in Japan.
63. In the early seventeenth century, the Tokugawa Shogunate had made a decision

In Tōju, the School of Wang Yangming and Christianity became one. Yet, this is not the Chinese version of the School of Wang Yangming but a Japanese Christianized School of Wang Yangming. This was then passed on to Kumazawa Banzan,[64] Ōshio Heihachirō,[65] Saigō Takamori,[66] and Yoshida Shōin.[67]... In this way Nakae Tōju left behind an exceptionally great legacy as the pioneer in Japan of the way of the activist sage.[68]

As a leader of a renewal movement within the tiny Christian minority, Kagawa, like Uchimura before him, was understandably attracted to the idea of casting the neo-Confucian Tōju as a kind of Japanese Christian "forebear," so national identity politics clearly plays some role here. But more importantly, Tōju and the Wang Yangming School inspired Kagawa as he pursued his personal calling in "the way of the activist sage."

We now need to introduce a few key terms and themes in Tōju and the Wang Yangming School before turning to Kagawa's interpretation in *A Reconsideration of Eastern Thought*. First of all, in contrast to the rationalistic atheism of the Zhu Xi School, we should not be surprised to find a mystical, non-rational, and even a monotheistic element in Tōju and the Wang Yangming School. As an example of this monotheism, Tōju uses the title "August High Lord"[69] to refer to "the Infinite and yet the Supreme Ultimate."[70] What is the relation between human beings and this "August High Lord?" This question brings us to the doctrine of "innate knowledge" (*liang-chih* in Chinese),[71] a key term Tōju picks up from Wang Yangming. According to Takeuchi, innate knowledge "is not merely reason or intellect, but rather includes something affective."[72] All

to eliminate all trace of Roman Catholic influence, issuing a series of edicts ordering the expulsion of all foreign missionaries and the systematic persecution of the *Kirishitan*.

64. 熊沢蕃山 (1619–91) was a direct disciple of Tōju's Wang Yangming School.

65. 大塩平八郎 (1793–1837), another scholar of Tōju's Wang Yangming School.

66. 西郷隆盛 (1828–77), the so-called "last samurai" and follower of Tōju's Wang Yangming School.

67. 吉田松陰 (1830–59), late Tokugawa follower of Tōju's Wang Yangming School who influenced Meiji leaders.

68. Kagawa, *A Reconsideration of Eastern Thought*, 134.

69. 皇上帝 *Kōjōtei*.

70. 無極而太極 *mukyokujitaikyoku*. Yamashita, "Nakae Tōju's Religious Thought," 311.

71. 良知 *ryōchi* in Japanese. This term may also be translated "intuition," "moral intuition," or "innate ability." It is similar to 良心 *ryōshin*, the Japanese term for conscience, but should not be equated with the Western view of "conscience."

72. Takeuchi, *Conscience and Personality*, 61.

peoples, regardless of class or learning, are thought to possess this innate knowledge. Regarding the effect of this universal spiritual endowment, Yamashita says:

> Tōju universalized the belief in Heaven; regardless of status, anyone could have a direct relationship with Heaven, and all men were equal before God.... Tōju was able to liberate Heaven, the August High Lord, and *T'ai-i shen*, the god of creation, for all people.[73]

By means of innate knowledge, all are gifted with equal access to Heaven, the August High Lord, and creation. In his commentary on the Confucian classic, *The Great Learning*, Wang Yangming speaks of innate knowledge and the "extension of innate knowledge"[74] (*chih liang-chih* in Chinese):

> He who wishes to make his will sincere must extend his knowledge. By extension is meant to reach the limit. . . . The extension of knowledge is not what later scholars understand as enriching and widening knowledge. It is simply extending one's innate knowledge of the good to the utmost. The innate knowledge of the good is what Mencius meant when he said, "The sense of right and wrong common to all men." The sense of right and wrong requires no deliberation to know, nor does it depend on learning to function. This is why it is called innate knowledge. It is my nature endowed by heaven, the original substance of my mind, naturally intelligent, shining, clear, and understanding.[75]

Given Wang Yangming's optimistic view, we should not be surprised to find in Tōju an ethic that came to reject the formal Confucian systems of conduct to which he had formerly adhered.

Yamashita describes the concrete ethical ideal of the activist sage grounded on "innate knowledge" and its extension:

> The good necessarily requires an individual to act on the basis of the judgment of his own innate knowledge. . . . The manifestation of innate knowledge—in other words, the extension of innate knowledge (*chih liang-chih*)—means to respond in accord with time and place, which is the essence of *jitsugaku*.
>
> *Jitsugaku* refers to pragmatic learning, learning useful in actual affairs; it is a learning that issues in positive achievement, a learning that results in action. . . . Tōju called this practical learning the

73. Yamashita, "Nakae Tōju's Religious Thought and its Relation to 'Jitsugaku,'" 315.
74. 致良知 (Jp. *chiryōchi*).
75. Wang Yangming, "An Inquiry on the Great Learning," 278.

"way of adaptation" (*ken no michi*).[76] He wrote: "The metaphor of balance refers to delicately balanced weights.... The sage is one with Heaven.... He is independent in his actions. He is spontaneous. Since the actions of the sage are always in perfect conformity with the way of Heaven, the metaphor of the balances which moves freely aptly symbolizes the activity of the sage...." We can even call this the serenity of mind of one who is in the hands of God. It can be called a religious mentality.[77]

Like Wang Yangming, Tōju's conversion from a formalist ethic to this practical, activist, spontaneous, and intuitive ethic is recounted in his biography. Under the old regime, it seems Tōju's disciples had become legalistic and, according to the biography:

> The personalities of some became so harsh that the bonds of good fellowship were broken even among friends. Master Tōju instructed them: "For a long time I have acted according to the formal codes of conduct. I have recently come to understand that such codes are wrong. Although it cannot be said that the motive of such behavior is the same as the desire for fame and profit, they are similar in the sense that both cause one to lose one's spontaneous original nature. Abandon the form of desire which causes you to adhere to formal codes, have faith in your essential mind, do not be attached to mere convention!" His disciples were deeply moved, and their spirits became healthy and bright again.[78]

Finally, this practical, spiritual ethic reflects Wang Yangming's teaching on "the unity of knowledge and action" (Ch. *chih hsing ho-i*).[79] In contrast to the Zhu Xi School, which stressed obtainment of knowledge before acting, Wang Yangming and Tōju give priority to concrete action or practice over obtainment of knowledge. To sum up, Tōju had introduced a strong monotheistic element, the egalitarian concepts of "innate knowledge" and "extension of innate knowledge," and the spiritual-ethical principle of "the unity of knowledge and action."

We turn now to a section from Kagawa's *A Reconsideration of Eastern Thought* entitled "Innate Knowledge as 'Full Consciousness,'" where

76. 權道.

77. Yamashita, "Nakae Tōju's Religious Thought and its Relation to 'Jitsugaku,'" 318–19.

78. Ibid., 319.

79. 知行合一 *chigyōgōitsu* in Japanese.

he interprets Wang Yangming's teaching, which Tōju had introduced in Japan.

> The three aspects of Wang Yangming's teaching are the law of Heaven,[80] innate knowledge, and the unity of knowledge and action. Of these three, the principle of innate knowledge should be seen as his key doctrine and the basis of his idea of "extension of innate knowledge." He emphasizes this idea in *Instructions for Practical Living*[81] and it must be said that there is nothing in the least bit idolatrous in this notion of Wang Yangming. That is why it found such a deep resonance in the early Meiji Christians Nakamura Keiu and Nījima Jō. *And it is precisely at this point that we have so much to learn from the Eastern heritage.*[82]

Note that Kagawa wants to assure his readers that these neo-Confucian ideas harmonize perfectly with a Christian view.

He continues by saying that the above-mentioned *Instructions for Practical Living* describes the law of Heaven: "Without doubt Heaven comes first, and Heaven itself is innate knowledge, innate knowledge waits for Heaven and follows Heaven's timing, innate knowledge is Heaven itself."[83] This rejection of religious formalism, the notion that we have unmediated access to Heaven, and an ethic that seeks to practice what one preaches has a surprisingly Reformed ring. Kagawa then makes a link between innate knowledge and "full consciousness," which is his term for Christ's consciousness of God and the cosmos and an ethic that fuses knowledge and action, a spiritual consciousness and practical ethic of love, which Christ's disciples are privileged to share: "Wang Yangming's notion of innate knowledge means full consciousness. One cannot grasp the cosmic consciousness without innate knowledge. According to Wang Yangming, one comes to know Heaven through innate knowledge."[84] Kagawa then draws an analogy between Wang Yangming's work in China and his own vocation "to live as a sage" in the midst of the challenges facing modern Japan:

> Further, in Wang Yangming's view of the unity of knowledge and action we can plainly see his unified view of the cosmos, and from this conviction came his single-minded determination to become a good

80. 天理/*tenri* in Japanese.
81. 「伝習録」/*Denshūroku* in Japanese.
82. Kagawa, *A Reconsideration of Eastern Thought*, 99. Italics author.
83. Ibid., 99.
84. Ibid., 99.

person at any cost. All of Chinese society was in disorder at the time Wang Yangming lived. Suzhou was a city of prostitutes. In such a time and place, he earnestly sought to help people and, with the resolve of a soldier, swam against the tide of the Ming Dynasty's intellectual weaknesses. I think we have much to learn from his sense of resolve to live as a sage during a horrible era.[85]

While the concept of "the unity of knowledge and action" is straightforward, Kagawa's reference to Wang Yangming's "unified view of the cosmos" calls for a primary source reference. In the opening of his commentary on the Confucian classic, *The Great Learning*, Wang Yangming writes:

> The great man regards Heaven, Earth, and the myriad of things as one body. He regards the world as one family and the country as one person.... Forming one body with Heaven, Earth, and the myriad things is not only true of the great man. Even the mind of the small man is no different.... Therefore when he sees a child about to fall into a well, he cannot help a feeling of alarm and commiseration. This shows that his humanity forms one body with the child. It may be objected that the child belongs to the same species. Again, when he observes the pitiful cries and frightened appearance of birds and animals about to be slaughtered, he cannot help feeling an "inability to bear" their suffering. This shows that his humanity forms one body with birds and animals. It may be objected that birds and animals are sentient beings as he is. But when he sees plants broken and destroyed, he cannot help a feeling of pity. This shows that his humanity forms one body with the plants. It may be said that plants are living things as he is. Yet, even when he sees tiles and stones shattered and crushed, he cannot help a feeling of regret. This shows that his humanity forms one body with tiles and stones. This means that even the mind of the small man necessarily has the humanity that forms one body with all. Such a mind is rooted in his Heaven-endowed nature, and is naturally intelligent, clear, and not beclouded.[86]

Wang Yangming's personalist, intuitive, egalitarian, and holistic ethic of humanity "forming one body with the myriad of things" has a significant impact on Kagawa's understanding of the harmony of Christian faith and modern science.

In a final passage, Kagawa claims that Tōju and the Wang Yangming School functioned as a kind of *preparatio evangelica* in the Meiji Era:

85. Ibid., 99–100.
86. Wang Yangming , "An Inquiry on the Great Learning," 272.

The Christian converts of the Meiji Era received this kind of preparation. However, since this was mainly a practical view of life, we cannot say there was nothing lacking in their view of the universe. In Christ is the reality of the repair of the cosmos. This was nascent in the Wang Yangming School of Nakae Tōju, as he made clear in his depiction of the Christian God's view of the universe in *The Sacred Scriptures of Deus.*[87] While Nakae Tōju clearly sympathized with Christ, because the time was not ripe he retreated from this pursuit and devoted himself to the Wang Yangming School.

Our world today is in disorder. As we prepare to cope with this time, I believe we have much to learn from the Wang Yangming School.... We must go to Christ through the Wang Yangming School.[88]

As we turn to Kagawa's interpretation of redemptive love, it will be helpful to keep in mind this discussion of Bowne's personalism, the Japanese view of truth described by Abe and Nishida, Bergson's intuitive or vitalistic holism, and the practical spiritual ethic of Tōju and the Wang Yangming School.

We left off our first chapter after touching on Kagawa's early statement of the downward, incarnational movement of "redemptive love" in "Philosophy of Nothingness," penned in the midst of great personal turmoil just six months before moving into the slum. As we examine (1) The Spiritual Dimension (God and persons), (2) The Cosmic Dimension (nature and persons) and (3) The Ethical Dimension (persons and other persons) in light of Christ's redemptive love, we find again and again Kagawa's ten-

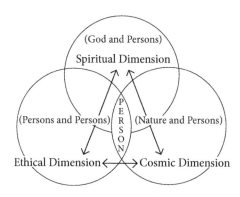

"Seeing all things Whole"

87. デウス神経. This reference to what Kagawa assumes is a Kirishitan text is not clear.

88. Ibid., 100.

dency to try to see the part from the whole and the whole from the part. We might picture this gestalt as three intersecting circles.

THE SPIRITUAL DIMENSIONS OF LIFE: PERSONS AND THE DIVINE

In chapter 1, we saw how Kagawa's conscience had been awakened by the inconsistencies between religious and moral "ideals" and lived "actualities," which he had observed and lamented in his adopted family, the local village, and himself. This sensitivity to the break between "ideal" and "actual," intensified by the traumas of childhood and youth, continued to vex Kagawa his entire life. But he also believed that the Christian gospel had opened up to him a unique and positive response to the problem.

First and foremost, in Kagawa's view of redemptive love, Jesus Christ is the definitive instantiation of the "Life of God" in a concrete, historical "human life." In theological terms, here the economy of salvation begins with God coming to humanity. In *The Religion of Jesus and Its Truth* (1921), Kagawa says:

In true religion, God seeks humanity. This is not a one-way stream where humanity merely approaches God, but where God also must experience a return to humanity. In Jesus the definition of religion has been rewritten. Religion is not just "humanity trusting in God," it is "God experiencing human life on the earth." That is, as Jesus, God experiences the totality of the human. This means that God does not stop with just being God but works the Life of God into the depths of the human *kokoro*.[89] If we do not grasp this news, religion is in danger of fixating only on very superficial matters.

In this sense, the religion of Jesus is unparalleled in the history of religion. God's incarnation[90] in the body of Jesus is one supreme religious experience. If God has thrown off his crown and entered human life as Jesus, a laborer of Nazareth, it is nothing for us to live in the slums.

This signifies no less than the fusion of God and humanity. Free to live both God's Life and human life, it is a life of the highest freedom.[91]

89. See note 45 above.
90. Again, Kagawa opts for the more familiar Buddhist term 化身/ *keshin* for incarnation.
91. Kagawa, *The Religion of Jesus and Its Truth*, 150.

For Kagawa, the incarnation of divine Life in the humanity of Jesus, as we read of him in the New Testament, is axiomatic in the sense that, in Christ, Heaven has been forever linked to Earth, the "ideal" with the "actual," the "absolute" with the "phenomenal," the "spiritual" with the "material." Embodying in human flesh the "full consciousness" of the Creator's loving intentions for the spiritual, material, and moral regeneration and repair of persons, cosmos, and society, Christ enacts these divine purposes in his life, teachings, and most decisively, saving death on the cross. While Kagawa maintains a lifelong interest in and genuine respect for other religious traditions, he also proclaims, "The Almighty has delivered an ultimate word in Christ's redemptive love. Here God tells us finally that 'God is love.'"[92]

At times, Kagawa affirms a rather traditional theory of Christ's atonement, a fact attributable to his training in the old Reformed theology. For example, in *God and the Inspiration of Redemptive Love* (1938), he says:

> Jesus who placed himself under the death penalty on the cross is the perfect apology to God; He has paid in full the price that was due. Indeed! This price was precisely the sacrifice of life in redemptive love. A duet of love and righteousness is played out in this redemptive love that risked death. By extinguishing self and submitting to the severe punishment of God, the price of righteousness has been paid; and by this act of redemptive love for all humanity, love has met its obligations in full.[93]

On the other hand, as practical theologian Sally Brown points out, there are aspects of Kagawa's view of the cross that are more hospitable to those who seek to move beyond the notion of "sacrifice as a mode of Christian behavior." Brown says, "Kagawa finds startlingly fresh meaning in the symbolism of sacrifice and in blood as a source of life."[94] In *Meditations on the Cross* (1931), Kagawa uses illustrations from medical science and engineering to make this point.

> Blood is always circulating in the human body. If there is some weakness, the blood compensates for it. Fever breaks out when there is an injury or a kidney inflammation. If there is damage to a kidney duct, blood flows there and does its work, and hence there is a fever. We call this the metabolic process, but we possess a power for repair beyond

92. Kagawa, *God and the Inspiration of Redemptive Love*, 350.
93. Ibid., 349.
94. Brown, *Cross Talk*, 120.

growth. While passengers on trains are oblivious to this fact, those responsible for maintaining the rails know that the millions of miles of railroad tracks in Japan expand in summer and contract in winter, and thus must be appropriately adjusted twice each year. The function of blood is similar. There would be no progress between Heaven and earth without the role of blood.[95]

Brown comments, "Kagawa emphasizes a contemporary understanding of blood as the gift of life, emphasizing its properties to heal and restore the body."[96]

If Kagawa accepts the neo-Confucian view of the universality of "innate knowledge," one may wonder why the cross of Christ continues to play such a pivotal role in his thinking. Old Testament scholar Namiki Kōichi has written a comprehensive essay entitled "The Book of Job and Kagawa Toyohiko"[97] in which he carefully traces the development of Kagawa's reflections on suffering and evil. According to Namiki, while Kagawa had personally experienced great suffering and witnessed firsthand the harsh realities of life in the Shinkawa slum, his reflections on the horrendous disaster of the Great Kantō Earthquake of 1923 mark a turning point in his view of suffering. While we cannot recount the details of this development here, to show the contrast we will present here without comment two rather long selections from *The Religion of Life and the Art of Life* (1922), published about a year before the earthquake, and from his preface to *Attitudes toward Suffering* (1923), published after the earthquake from the tent barracks in Honjo where he was leading disaster relief efforts in one of the worst hit areas.

Firstly, in the following two sections entitled "The Problem of Evil" and "The Experience of Salvation" from *The Religion of Life and the Art of Life*, Kagawa wrestles with the question of the ontological status of evil, particular occurrences that appear as "evils," evolutionary theory, the personal experience of salvation, and the religion of conscience.

"The Problem of Evil"
 Evil is not real. We must never err on this point. Evil is a process that arises with the presence of values as life progresses. Life itself is not evil. Evil is something sensed as life creates meaning and as

95. Kagawa, *Meditations on the Cross*, 187. The partial English translation used by Brown leaves out the references to the kidney and the trains, but we have included it here to strengthen her point.
96. Brown, *Cross Talk*, 120.
97. Namiki, "The Book of Job and Kagawa Toyohiko," 272–325.

life evolves. That is, evils such as sickness, senility, disability, feeble-mindedness, mental retardation, madness, and death may be seen as "evils" as a preparation for life's purposes, and even if life is understood as something that should evolve, these will be seen as "evils" because they can be thought of as irregularities.

Beyond this, various natural disasters and calamities may be thought of as evils when viewed from the standard of life. Further, things like evil character arise from life's value judgments.

With the development of evolutionary theory, various things have been shown to lack harmony, perfection, or completeness. In this regard I neither teach like Leibniz that this is the best of all possible worlds nor preach Bishop Butler's God of perfection.

In spite of life's disharmonies, incompleteness, and imperfections, I only advocate living boldly above these things. It may be thought of as living by penetrating through the disharmonies or as not worrying about incompleteness and imperfections. Life just springs up, not too concerned with life's tragedies and trials. I do not know what changes have taken place in the universe up to now. Many stars have probably disappeared. Planets have collided with other planets. Comets have collided with other comets. On earth, too, many millions of changes may have occurred repeatedly. In the recent earthquake in China, a mountain was said to have moved 3 *ri*[98] in the form of a wave. Up until now, humanity has seen such movements many times. Yet life has grown by confronting and overcoming such dangers. Life even conquers death itself and extends forward. Death is nothing more than an appendix to life.

Evil does not triumph over life. This is surely not a mistaken view. Religion cannot remove death. But by believing in the God of life, one wins a sufficient victory over evil.

From primitive to more advanced religions, all religious experience affirms that one may triumph over evil through religion. Religion is faith for defeating evil. The only difference is that the lower forms of primitive religions pray for victory over natural evils such as disasters, calamities, and illness, while the higher forms of religion pray for the power to overcome personal evils.

With the advancement of natural science, humanity has learned it may avoid natural disasters and dangers, hence today most pray only in regard to personal evil.

Further, because personal evil is the realm of morality, the healing of personal evils has become the basis for a religious of conscience appearing as a consciousness of atonement. In Christianity, this con-

98. 1.5 kilometers.

sciousness of atonement is taken as a foundation, and there is faith that God has entrusted the power of atonement to Christ.

When the idea of atonement is believed as dogma, one is no different from those who pray to be delivered from natural disasters, but when God gives you power for the renewal of the life of conscience, there is a really strong personal experience through believing. Thus, the idea of atonement is not something to be believed as dogma. It is something that one must personally experience as the surprising reality of moral resurrection. When this is experienced, we can easily understand the religious consciousness that Jesus himself experienced, that is of the God of life who embraces the prodigal, and as the first one awakened to this Father's kindness, as the Savior to tell of this love and to give all for those who wander in sin.

"The Experience of Salvation"
While we cannot solve the problem of evil, the essence of the religion of conscience is to believe one can be saved.

For modern people, the experience of salvation may sound somewhat cowardly. If you speak of evolution it resonates. Yet don't those who are in a debased state wherein they are unable to evolve need an experience of salvation that means a restoration of vitality? Maybe the experience of salvation is cowardly. Yet for those who are saved it is surely the power of God.[99] The religion of life is just a straight path, and if it is only a developmental thing, it does not have the power to overcome evil. But if it is believed to have the power of regeneration, when this is experienced it is the power of salvation that defeats evil. This repeated refraction of religious consciousness functions only in a religion of conscience, and through believing not only in evolution but in the power of the continual evolution implicit in life, evil loses its influence. From a human perspective this may look merely like evolution. But from a divine perspective, this is salvation and in religious terms it is a saved life.

With this experience of salvation from personal evil, the faith of the religion of conscience is then to think that everyone else may be saved. To those who have not had this experience, this is a completely psychological experience and an imperceptible reality.[100]

Here Kagawa strongly affirms the power of life, the personal consciousness of the efficacy of Christ's redemptive work, and the evangelical drive to extend this consciousness to others. This passage shows Kagawa's basic

99. A strong echo of 1 Cor 1: 18, "For the message about the cross is foolishness to those who are perishing, but to us who are being saved it is the power of God."
100. Kagawa, *Religion of Life and the Art of Life*, 61–62.

sympathy with what George Lindbeck calls an "experiential-expressive"[101] view of faith and indicates his desire to bring that view into conversation with evolutionary theory.

Next we present what represents a decisive shift in tone in the Preface to *Attitudes toward Suffering*:

> Standing before the mountain of white bones, I am speechless and moved to tears. The Yasuda mansion, now completely burnt to the ground, seems to recall the spirit of its former lord.
>
> Yet if one pays closer attention, human bone fragments are visible. Recalling the horror of the 34,000 people who were incinerated in an instant, there are no words for me to speak.
>
> It is reported that once the flames engulfed the people's bodies, they were unable to extinguish them in spite of desperate efforts. It is said that all the fallen vomited blood from their mouths.
>
> These 34,000 souls suddenly disappeared forever from the earth like a chalk drawing wiped off a blackboard.
>
> It is heartbreaking to think about it. Human bodies lit up like pine torches, caught up like blazes in a whirlwind, fireballs tossed far away. These are facts that go far beyond pain and agony. It seems an utterly transcendent event!
>
> There is so much here I cannot understand. Yet I still want to believe that, even given this suffering, God is love.
>
> That suffering is a good gift of grace. That even death is the will of God. That all is dissolved and resolved in the bosom of God. Even given all this suffering, I cannot doubt God. I accept all these vicissitudes.
>
> Within omnipotence, there must be some place for the occurrence of suffering. On the day I become God, I would likely create suffering as the opposite of joy. Were I God, I would likely create death as the opposite of life.
>
> Omnipotence means there is no limit to the creation of suffering. The meaning of omnipotence includes the creation of death as well as life.
>
> For there to be a creation of something from nothing, joy from suffering, life from death, there must also be a creation of nothing from something, suffering from joy, and death from life.
>
> For the sake of God, can we really put up a wall of restriction and ask, "Why do you create evil and choose sin?"
>
> The almighty is without restriction. Everything must be possible for God. Suffering and death must be received as gifts from the hands

101. Lindbeck, *The Nature of Doctrine*, 16.

of the almighty. Herein is the mystery of creation. Only life received as a gift from the hand of the almighty—where out of the secret of creation those who mourn and those who hunger and thirst are blessed—only such a life may taste a participation in God's almighty art.

Suffering stands at the terminus of art. The almighty alone can know the significance of this art. Within the art of Life, those who believe in the possibility of change can accept this.

Only those who can believe that it is God who creates suffering can accept it as an art.

Herein is the art of the cross, the art of God that sows suffering and reaps life. One grain of wheat falls into the earth and reaps ten thousand grains.[102]

Those who draw the lot of suffering should see themselves as having drawn the lot of God. You will not know victory by merely brooding over suffering. However, to bear suffering for the sake of God is to make an art of suffering.

The transformation of suffering into beauty begins with the attitude of one's *kokoro*. Everyone sees the cross as sad, unpleasant, and brutal. But in Jesus the carpenter, the cross is the very radiance of ecstasy in that it even sanctifies suffering with a sanctification that leaves nothing behind.

The sanctification of suffering is the final art of God. The one who is able even to defeat suffering is clearly able to defeat all else with joy.

Behold, is suffering not the final art? Does not the one who takes away the world's suffering leave no evil behind?

The suffering of those who take their stand within this world of relativity continues forever. Those who cannot free themselves from the relative do not know the way of defeating evil. Only those who have entered into the secret of the absolute know the secret that defeats suffering. There is no other absolute but Life.

Even when stretched, crushed, and driven into suffering, Life does not fear suffering. To Life, suffering is not the substance of reality; it is but an addition or embellishment.

Those who realize suffering is just an embellishment to Life do not fear it. Even though some break in life seems like a desolation, this cannot be counted as the sum total of suffering. Life is stronger than suffering. Green grass sprouts in the clothing workshop and people gather together in the barracks. Life is stronger than flame.

I do not know how many billions of years have passed since the

102. Kagawa often referred to John 12: 24 when speaking of Christ's cross and the cross-bearing life of the disciple. "Very truly, I tell you, unless a grain of wheat falls into the earth and dies, it remains just a single grain; but if it dies, it bears much fruit."

earth was settled in its place in our solar system. The oceans cooled, the solid ground rose up from the sea, and beyond the earthquakes, volcanoes, and floods, the God of the cosmos who made the amoeba and the human being has never taken the way of retrogression through millions of years of fluctuations.

From the perspective of God, there have perhaps been occasional setbacks. Yet even in such conditions, God has persisted through all the suffering to the successful creation of human beings. At times there were recurring, massive explosions and eruptions that caused the earth's mantle to be enveloped in carbon dioxide, and there were periods when something such as advanced animals could not be produced. Giant lizards [dinosaurs] lumbered across the surface of the earth and pulmonates of hideous appearance scoured the earth. Later when carbon dioxide was dissolved by water, the giant lizards were completely decimated. Even so, God did not despair.

God has never removed his hand from the process of evolution. Young souls, do not despair! Is it not true that God has never once despaired? To him, suffering is the ultimate art.

Jesus of Nazareth saw death as the form of his art. He did not in the least bit draw back from it. To the martyrs, suffering is the culmination of glory.

In such cases, pain completely looses its substance as pain. Pain that can be received with joy is no longer the pain of pain. It is a type of glory.

You youth who are faithful to God, join in the glory of pain! For those who live in God, the suffering of bloodshed is superior to precious jewels. Even if it is the ordinary suffering of ordinary times, suffering is swallowed up and destroyed in victory. For those who are drawn to God, this bitter word [of the cross] is the greatest art.

Friends, do not avoid the bitter cup, but proclaim to God, "Thy will be done!" The day the bitter cup is filled is to know the true art. Be strong, for to those who are strong like God, pain is like the North Star, which is venerated as the art of conscience. Through pain, love comes closest. This we call the truth of suffering. Love that does not pass through pain does not have the character of true love. For love to be refined, it needs the tempering of suffering.

Do not despise the blows of God's hammer of suffering, for the sparks of suffering are the ultimate holy place of art. Only the greatest souls are elected to enter there.

Through suffering, it is good to become an intercessor. The art of suffering is the single way for God to transform human beings. Suffering is a glory borne by the children of God. Those who undergo

suffering climb the final stairway. There God whispers directly into their souls.[103]

These are the tortuous reflections of Kagawa after witnessing firsthand the horrific suffering of the Great Kantō Earthquake. Notice that Kagawa never says that God is the author of sin or evil, but only that divine and human suffering have in Jesus attained a new interpretive viewpoint. This is not a systematic theological treatise, it is a gut-wrenching lament that gropes for a word of comfort in the face of Christ's cross and "the mountain of white bones."

Kagawa was primarily known as a practical-minded Christian evangelist and social reformer. Everyone knew he had lived and worked in the worst slum of Kōbe, where he came to know firsthand the misery brought about by Japan's rapid industrialization and urbanization. What had made Kagawa a celebrated figure at home and abroad was his genuine aspiration to imitate Jesus' love for the poor, to be an activist Christian sage. His first public expression of this lofty spiritual longing came in *Before the Dawn*, the autobiographical novel dealing with his traumatic childhood, brooding adolescence, conversion to Christian faith, and early years in the slum. As we have seen, to Kagawa's great surprise, the novel caught the attention of Japanese readers. Within a few years of publication it had sold over a million copies and made him an instant celebrity.[104] The tale lent authenticity and authority to his aspirations to a life of awakened love, and the Kagawas laudably distributed all of the novel's royalties among their many social projects.[105] But Kagawa was very critical of the "pulpit Christianity" he saw as the dominant form of Protestantism in Japan. Since he believed the witness of Christianity as a religious minority in Japanese society should have more to do with concrete acts of life-giving love than with the abstractions of theological orthodoxy, it is little wonder that he was viewed more as a religious practitioner than as a thinker.

While we should always remember that Kagawa was a practical theological evangelist and not a systematic theologian, his insight into the suffering, redemptive love of Christ is creative but hardly *sui generis* or

103. Kagawa, *Attitudes Toward Suffering*, 97–99.
104. Kanai, "The Practical Christian Ethos in Kagawa Toyohiko," 153.
105. Hamada, "The Legacy of Kagawa Toyohiko and Modernity." 1–7. Kagawa's wife and co-worker Haru played a vital role in all of these projects. See Mihara, "Beloved Wife," 76–86.

unorthodox. His aim was to synthesize moral and satisfactionary theories of atonement, *unio mystica*, *theologia crucis*, and Anglo-American expressions of the social gospel, anticipating in some ways later developments in liberation theology. His view of the person and work of Christ generally falls within what George Hunsinger calls a "middle Christology," wherein "the saving significance of Christ is defined by his spirituality,"[106] but it is neither Schleiermacher's "spirituality of inwardness" nor a neo-Platonic, world-transcending ascent, ecstasy, or glory, but one focused on the hard downward and outward movement of the incarnation and the self-dispossessing, self-giving, suffering, redemptive love of the cross. Kagawa sees the suffering of the cross as God's "ultimate art" and the "culmination of glory,"[107] and it is Christ's suffering for the sin of the world that the disciple contemplates and imitates. In *Meditations on the Cross* (1931), Kagawa says:

> Not imagining a successful Christ, we must deeply meditate on the Christ who, through agony, underwent the ultimate agony on the cross....
>
> Since the *kokoro* of God commutes with the *kokoro* of Christ and the *kokoro* of Christ commutes with the *kokoro* of God, I too must take on the spirit of Christ who died for the failure of humanity and live a life of sacrifice.[108]

Beyond the major note on a "middle Christology" centered on Christ's redemptive love and "consciousness of collective responsibility," there are also times when Kagawa gestures at a "high Christology," which takes a high view of both Christ's person and his work, as when he calls Christ the final word where "God tells us finally that 'God is love.'"[109]

Given this "middle Christology," one might expect Kagawa to be suspicious of the strong accent on divine transcendence, for example, in Barth's early theology, which was all the rage among Japanese Christian intellectuals beginning in the 1920s. While generally steering clear of theological disputes, he comments directly on Barth in a brief passage from *Meditations on Christ* (1932) entitled "The Consciousness of the Transcendent God." He says:

> There is a person named Barth in Germany. A professor of theology

106. Hunsinger, "Salvator Mundi: Three Types of Christology," 50.
107. Kagawa, *Attitudes toward Suffering*, 98.
108. Kagawa, *Meditations on the Cross*, 110, 118.
109. Kagawa, *God and the Inspiration of Redemptive Love*, 350.

at Berlin University, he is causing a big stir in the European religious world, stressing the transcendence of God and insisting that modern civilization has fallen because we no longer believe in divine transcendence. Indeed, there is no lack of a trend in modernity since Goethe to empower human beings and disregard the gravity of God. By making the universe one with God and stressing that human beings can become gods, we have ignored the wonders of creation in God and in divine providence. In response to this problem, Barth of Switzerland is dismantling such mistaken views. In contrast to the thinking of Buddhists and the followers of Goethe, who tend toward pantheism, Christ's saying that he is one with the Father means being conscious of the solemn, transcendent God. We see this in the Sermon on the Mount in Matthew's Gospel where Christ speaks of the Father in heaven. The God Christ believed in and of whom he was conscious is the transcendent God and also his Father, the God of the solemn universe who really exists and One who is "greater than I." Christ thought of his heavenly Father as the loving God, the God who sometimes hides himself, yet the God who is close to humanity.[110]

In the section on the "The Consciousness of the Immanent God" that immediately follows as a counterpoint, Kagawa turns from Barth to offer high praise for John Wesley's *Christian Perfection,* a book he says renewed English and American religion and society and contributed to the eventual abolition of slavery. Kagawa then adds:

While I agree with the transcendent God of the Barthian school, it is wrong to believe we cannot reach God as did those belonging to the moral class system of the late 18th century. In Christ, the Heavenly Father comes close to humanity, and this consciousness with which he fills humanity is called the Holy Spirit. In the thinking of Christ, the Heavenly Father enters into us. It is sad that there is a dullness among scholars in regard to the experience of the Holy Spirit, and they do not know the moment to moment consciousness of God within or the consciousness of God at work in the world. Christ is absolutely clear on this point, and as we read the Gospel of John, or Matthew, Mark, and Luke, we realize they are gospels of the Holy Spirit. While Matthew, Mark, and Luke look at Christ from the outside, John looks at Christ from the inside. Reading an academic essay is different from reading a letter. Letters reveal the inside story, while essays are clothed in ceremonial garb. John's gospel gives you an inside story that you can grasp, and John's Christ is very frank almost to the point of boasting about his clear relation to God. It would be a lie not to touch

110. Kagawa, *Meditations on Christ,* 242.

on this. In John's gospel, the Holy Spirit dwells with humanity. This consciousness is not the attainment of Buddhahood.[111] God dwelling within and without at the same time is what Christianity calls the Holy Spirit. We should not philosophically analyze the experience of the Holy Spirit, but think of it in terms of experience.[112]

Thus, while positively affirming the Barthian emphasis on the divine transcendence, he also affirms the Wesleyan emphasis on divine immanence as having equal biblical warrant.

While it may be tempting to rank Kagawa with a "subjectivist" view of faith, his "personalist" view is actually not so far from the position Barth articulates later in a section of the *Church Dogmatics* iv/i entitled "Faith and Its Object." Addressing the relation of the *pro nobis* ("for us") and the *pro me* ("for me") dimensions of faith, Barth characteristically insists, "Every anthropology and ontology will have its norm and law in Him [Jesus Christ]," thus rejecting what he calls "the usurping invasion of theology by a subjectivist philosophy." Yet, he also concedes:

> It will be acknowledged that Christian faith is an 'existential' happening, that it is from first to last I-faith, which can and should be sung in I-hymns. But there will take place the necessary "demythologization" of the "I" which Paul carried through in Gal. 2: 20: "I live, yet not I, but Christ liveth in me."[113]

As we will see in our discussion of Kagawa's mysticism in chapter 4, he also insists on the Pauline paradox of identity and distinction or what Barth calls the "demythologization" of the "I." For Kagawa and Barth, Jesus Christ himself is the paradigm of the "demythologization" of the "I," and while Barth fixes his gaze exclusively on the dogmatic implications of this term, Kagawa stays focused on the practical theological implications for Christian discipleship and social ethics.

This brings us to another unexpected, but perhaps more important convergence between the views of Kagawa and Barth. As one who had spoken up courageously against his own theological teachers who signed the declaration in support of Germany in wwi and the so-called "German Christians" who supported Hitler's rise to power before wwii, Barth

111. This is an example of the kind of evangelical and apologetic distinction Kagawa makes for the sake of his Japanese hearers and readers. Nevertheless, the positive influence of a Buddhist view of suffering on Kagawa's *theologia cruxis* is a theme that calls for further exploration.

112. Kagawa, *Meditations on Christ*, 243–44.

113. Barth, cd iv.i, 757.

knew that for Christian witness to be vital, it must be grounded in the wrestling of real, flesh and blood communities of faith with the witness of Scripture in their own places and times. Flattered but also puzzled that his theology was so popular in the churches of Asia, Barth addressed a brief pastoral letter to Asian Christians on November 19, 1968, just three weeks before his death on December 10.[114] Acutely aware of the importance of historical and cultural location in Christian witness, Barth seems incredulous that his work would be received with such enthusiasm in Asia: "I am still more surprised that this little piece of theology that I have presented here in my place for future pastors, may now also be of significance for the theology which you in your place are entrusted and engaged. Can the theology, presented by me, be understandable and interesting to you—and how?"[115] Barth then offers two general principles for theology, one on the Subject of theology and one on the disposition of the theologian. In the first instance, he says theology must stick to its "real business" of serving the "living, free, gracious God of Abraham, Isaac, and Jacob—the Father of Jesus Christ." In service to God, a good theologian must in "speaking, thinking, and acting," be "free from all Babylonian captivities."[116] The second principle Barth points to is the need for a good sense of humor:

> A Christian does theology well, when he sticks joyfully, yes with humor to his real business. No boring theology! No morose theologians!... Since a good theologian does not serve himself, but Him, the Father of Jesus Christ, he may look at his fellow men who are loved by God in every case, and even at himself contentedly and hopefully; he may (the more he takes his business seriously!) despite everything, laugh from his heart and even laugh at himself.[117]

114. We should note that he addressed the letter to the South East Asian Christians because it was published in *The South East Asian Journal of Theology*. But clearly he also had in mind the Japanese "Barthians" with whom he had direct or indirect personal contact, such as Kan Enkichi, Ashida Keiji, Takizawa Katsumi, Kuwada Hidenobu, Ōsaki Setsurō, Yamamoto Kanō, and Inoue Yoshio. Alle Hoekema writes:

> Finally, every now and then Japanese and other Asian colleagues worked in Barth's neighborhood, such as Keiji Ogawa who was in Basel during some time. Through such contacts which Barth appreciated very much, he was kept well-informed about theological and ecclesiological developments in Japan. (Hoekema, "Barth and Asia: No Boring Theology," 102)

115. Barth, "A Letter from Karl Barth," 3.
116. Ibid., 3–4.
117. Ibid., 4. We should not be surprised to discover that there is mounting scientific evidence of a strong correlation between a good sense of humor and creativity, health,

Barth continues:

> In my long life I have spoken many words. But now they are spoken.
> Now it is your turn. Now it is your task to be Christians in your new,
> different and special situation with heart and head, with mouth and
> hands.[118]

He then offers "two small friendly suggestions" about how to accomplish
this task. Displaying his own characteristic sense of humor, he begins:

> Say that which you have to say as Christians for God's sake, respon-
> sibly and concretely with your own words and thoughts, concepts
> and ways! The more responsibly and concretely, the better, the more
> Christian! You truly do not need to become "European," "Western"
> men, not to mention "Barthians," in order to be good Christians and
> theologians. You may feel free to be South East Asian Christians.
> Be it! Be it, neither arrogantly nor faintheartedly with regard to the
> religions around you and the dominant ideologies and "realities" in
> your lands![119]

The vital point here is that Christian witness must "responsibly and con-
cretely" embody the cultural subjectivity of speakers and hearers by find-
ing expression in understandable local "words, thoughts, concepts, and
ways." Note that Barth, the great theologian of the Word of God, says ver-
bal translation alone is not enough; the message must also be incarnated
in the local "ways" of the people! This is thoroughly in keeping with his
view that faith will always find a diversity of expressions. In the *Church
Dogmatics*, he says:

> Christian faith can and should be varied. The reason for this is as
> follows. Although its object, the Jesus Christ attested in Scripture
> and proclaimed by the community, is single, consistent and free
> from contradiction, yet for all His singularity and unity His form is
> inexhaustibly rich, so that it is not merely legitimate but obligatory
> that believers should continually see and understand it in new lights
> and aspects. For He Himself does not present Himself to them in one
> form but in many—indeed, He is not in Himself uniform but multi-
> form. How can it be otherwise when He is the true Son of God who is
> eternally rich? Of course, all knowledge of Jesus Christ will have not
> merely its basis but its limit and standard in the witness of Scripture

intelligence, and other factors that contribute to human wellbeing. See Ruch, *The Sense
of Humor*.

118. Ibid., 4.

119. Ibid., 5.

and the proclamation of the Church. It is possible only within this definite sphere. [120]

In his positive but not uncritical engagement with Japanese religion and philosophy and his use of terms that his largely non-Christian audiences would grasp, Kagawa exemplifies this effort to proclaim the gospel in Japanese "words and thoughts, concepts, and ways." Indeed, as a Japanese Christian willing to take on the "dominant ideologies and realities" of his time and place—including the materialist and anti-teleological reception of evolutionary theory—Kagawa may have more in common with Barth than Japanese "Barthians," who take the scholarly high road, steering clear of the messy, concrete, evangelical engagements in the lowlands of contemporary society and culture.

Barth's second suggestion is a reminder to focus, with Christians in all other places and times, on the singular event that glorifies God and announces peace on earth:

> We all—you there and we here—have to believe, to trust and to obey only one Spirit, one Lord, one God. We all—you there and we here—have therefore to proclaim strictly the same: namely simply the one event, in which both at the same time are true: "Glory to God in the highest and peace on earth" (Luke 2:14). Surely, you will have to proclaim the same in your region quite differently—even more: you will have to proclaim the same better than has been the case with us European Christians; for we have again and again not given God the honor and have not stood up for peace on earth. [121]

For Christians everywhere, it is the Jesus Christ proclaimed in Scripture, the first-century Palestinian Jew who is Son of Mary and Son of Man, crucified, risen, and exalted as God's Son to the right hand of the Father. He bears in his person the sacred history of Israel and the gospel message of "Glory to God and peace on earth." It is not some other story, but this particular story enacted in Israel and in Jesus Christ that binds Christians of all cultures and ages together. While Kagawa focuses more on Christ's humanity than his divinity, we have seen that, even when addressing the defeated nation after WWII, his central theme is the redemptive love of God revealed and realized in the cross. The cross of Christ is always the decisive symbol for Kagawa, but not the cross merely as a distant historical event or a forensic transaction between sinful individuals and a vengeful

120. Barth, CD IV.1, 763.
121. Barth, "A Letter from Karl Barth," 5.

God whose honor needs restoring. Christ's cross takes on social meaning as the "consciousness of collective responsibility" and cosmic meaning as the space-time instantiation of the "principle of cosmic repair." Further, the "God consciousness" that Christ embodies in his person does not belong to the past but, through the agency of the Holy Spirit, continues to inspire and transform those who actively devote themselves to mending what is broken in the individual, society, culture, and the natural world.

To reiterate, the revelation of redemptive love in Jesus Christ is the linchpin that joins together Kagawa's views of spirituality, science, and ethics. To fail to see this is to misunderstand the motive, shape, and direction of Kagawa's thinking, evangelical work, and his tireless efforts in fighting poverty, in early childhood education, in medicine, finance, and insurance, in social, labor, agricultural, and cooperative movements, and in world peace. Kagawa's vocation as a Christian evangelist and social reformer is rooted in his discovery of the "final word" of redemptive love in Jesus Christ. In the life and death of the Jewish carpenter of Nazareth, God had spoken a resounding "Yes" to him personally, to humanity, and to the entire cosmos. From the perspective of the downward and outward movement of incarnate and redemptive suffering, Kagawa was confident that the repair of the cosmos is already underway from within. While not divine *in se*, the cosmos has been forever sanctified by Christ as the home where human beings may perceive God's glory. The Christ Event initiates for Kagawa a new understanding of the relationship between persons and God, persons and the cosmos, and persons and persons.

We should add that this incarnation and cross-centered, immanentist view of the humanity of God in Jesus and its consequences for human consciousness is also its limitation. While Kagawa often prefers to use the philosophical term "cosmic will" for evangelical purposes, when using the terms God, Father, or Holy Spirit, he always has one eye fixed on the humanity of Jesus as portrayed in the New Testament. Theologically, it seems he was completely satisfied with the divine accommodation to the humanity of Jesus, and especially considering the many pressing challenges facing modern Japan, was happy to concentrate his energies precisely on the spiritual and ethical challenge of the humanity of Jesus, eschewing all speculation about divine ontology. He leaps seamlessly from Christocentric indicative to ethical imperative. In this sense, his personalism reflects, with some neo-Confucian and vitalist qualifications, a Kantian view of moral faith. In place of theological speculation, he stresses inner religious experience and consciousness oriented

to practical, public, and ethical engagement, and from that coordinating axis, attempts to work out a modern view of the cosmos and science under the aegis of redemptive love.

From these examples, it is clear that Kagawa affirmed while augmenting a more orthodox view of Christ's work and also took with utmost seriousness the personal, subjective experience and consciousness of faith in Christ's cross as the way to bear suffering. His ability to affirm theological positions that may be considered contradictory by others is yet another example of his commitment to "seeing all things whole." The important point here is that Jesus Christ has opened the way for a new relation to God the Creator.

THE COSMIC DIMENSION OF LIFE: PERSONS AND NATURE

When we come to the question of how redemptive love touches on the relation between persons and the cosmos, we first need to consider Kagawa's understanding of the relation between God and nature, or Creator and creation. He drew one of his favorite metaphors for this relation not from the Bible but from Thomas Carlyle's novel *Sartor Resartus*, where the world of Nature is called the "Garment of the Living God." The text of the Carlyle quote reads, "Or what is Nature? Ha! Why do I not name thee God? Art not thou the 'Garment of the Living God'? O Heavens, is it, in very deed, He, then, that ever speaks through thee; that lives and loves in thee, that lives and loves in me?"[122] Carlyle had picked up the "garment" metaphor from Goethe's *Faust*,[123] but unlike Goethe, who followed Spinoza's pantheism, the cradle Scottish Calvinist Carlyle appears to still be wrestling with the God of the Bible. Carlyle's use of the "garment" metaphor elevates both Nature and the person while preserving the theistic distinction. Kagawa's own concerns about the spiritual,

122. Carlyle, *Sartor Resartus*, 130.

123. The sentence is spoken by the *(Erd-)geist* (Earth Spirit) in Scene 1 of *Faust*.

So schaff' ich am sausenden Webstuhl der Zeit:

Und wirke der Gottheit lebendiges Kleid. (v. 508f)

In the translation of Stuart Atkins:

I work at the whirring loom of time

and fashion the living garment of God.

(Atkins, "Faust I & II," *Goethe's Collected Works*, 16)

I wish to thank Professor Johannes Anderegg of the University of St. Galen for this reference.

environmental, and social consequences of industrialism in early-twentieth-century Japan[124] was no doubt influenced by the nature-centered, romantic impulse that drew him to Carlyle, Tolstoy, Ruskin, Emerson and other nineteenth-century writers, but his use of the "garment" metaphor should not be seen as an importation of a quasi-pantheistic, romantic view of nature into Christian faith.

In fact, the "garment" metaphor appears in Calvin himself, whose theology Kagawa had studied at the Kōbe Theological School and Princeton Theological Seminary.[125] In "The Knowledge of God the Creator" (*Institutes* I.v.1), Calvin offers the following comment on Psalm 104:

> Therefore the prophet very aptly exclaims that he is "clad with light as with a garment" [Ps. 104: 2]. It is as if he said: Thereafter the Lord began to show himself in the visible splendor of his apparel, ever since in the creation of the universe he brought forth those insignia whereby he shows his glory to us, whenever and wherever we cast our gaze."[126]

Soon, Calvin's view of "the visible splendor of the Lord's apparel" found more formal expression, for example, in the so-called "two-book theology" (Nature and Scripture) of the 1561 *Belgic Confession*, as follows:

> Article 2: The Means by Which We Know God
> We know God by two means:
> First, by the creation, preservation, and government
> of the universe,
> since that universe is before our eyes
> like a beautiful book
> in which all creatures,
> great and small,
> are as letters
> to make us ponder
> the invisible things of God:
> God's eternal power and divinity,
> as the apostle Paul says in Romans 1: 20.

124. Beyond his work with the poor, labor unions, farmers, and cooperatives, Kagawa was also a proto-environmentalist. For example, in 1922, he wrote a biting satirical novel about industrial pollution in Osaka. See Kagawa, *Conquering the Skies*.

125. In this regard, Drummond mentions Katō Kunio's assertion that "at the basis of Kagawa's life and thought lay the profoundly biblical faith which he had learned at Kōbe Seminary." Drummond, "Kagawa," 824.

126. Calvin, *Institutes of the Christian Religion*, 52.

> All these things are enough to convict humans
> and to leave them without excuse.
> Second, God makes himself known to us more clearly
> by his holy and divine Word,
> as much as we need in this life,
> for God's glory
> and for our salvation.[127]

While we will pass over the theological debates this view has engendered, the plain sense of the words of Article 2 seem to accurately reflect Calvin's core conviction that, while the universe reveals something of God ("eternal power and divinity"), Scripture provides a clearer and more sufficient revelation of God ("God's glory and our salvation"). In pedagogical practice, this "two book" view would presumably give priority to study of the Bible, while also keeping learners' eyes, ears, and minds open to the wonders of the universe and, by implication, a scientific understanding of it. As far as we know, Kagawa never explicitly states his support for the *Belgic Confession* per se, but in his own spiritual practice he demonstrates a love for studying and meditating on Scripture and nature that is consistent with this classical Reformed understanding. In chapter 3, we will consider Kagawa's studies at Princeton Theological Seminary as a decisive step in the development in his positive correlation of the biblical notion of creation and the science of evolution.

Given the "garment" metaphor's accent on the continuity rather than the discontinuity between God and creation, it is not surprising that some wanted to accuse Kagawa of naturalism or pantheism. Here is one response to such real and hypothetical detractors:

> Someone may ask this question: Are God and the universe one? And are God and human beings one? Pantheism takes that stand. But I am not a pantheist. I am an advocate of the Holy Spirit. No, beyond that I am one who rejoices in the Spirit-filled life.
>
> Is the child living in the womb identical to the mother? Although conceived in the mother, the child is a different person from the mother. The mother transcends the child. Still, the child is living in the mother. And the child comes from the mother. In like manner, the absolute God transcends human beings while embracing human beings, and human beings are created by God.
>
> We can think of the relation of God and the universe in the same way. The material world is not itself God. But God transcends it,

127. Reformed Church in America, *The Belgic Confession*, lines 18–36.

dwells in it, and through it manifests himself. I wonder if it is not most appropriate to think of the material world as the garment of God.[128]

We should note a certain resonance here between Kagawa's view and "panentheism." We will return to Kagawa's use of the mother and child analogy in chapter 4.

But beyond controversies surrounding the "garment" metaphor or the "two book" theology, Kagawa saw a positive Christian interpretation of nature as a key missiological issue in Japan, where feelings of awe and intimacy vis-à-vis natural objects is an aspect of the Shintō, Buddhist, and neo-Confucian *ethos*. Nakamura Hajime surveys the tendency in these traditions to "accept the phenomenal world as Absolute," concluding:

> Such a tendency... seems to be still effective among Japanese even in these days when the knowledge of natural science prevails. For instance, the Japanese generally use the honorific expression "o" prefixed to the names of various objects, as in the case of "o-cha" (the honorific wording of tea) and "o-mizu (the honorific wording of water). Probably there is no other nation on earth that uses an honorific expression prefixed to the names of everyday objects. This usage is not to be conceived to be anything extraordinary by the Japanese themselves. We should not regard it merely as an honorific expression, but rather consider it as a manifestation of the way of thinking that seeks a *raison d'être* and sacredness in everything that exists. According to the comments made by Westerners, "everything is Buddha" to the minds of the Japanese.[129]

This expresses well the missiological or evangelical impetus behind Kagawa's conviction that Christian faith must take the scientific investigation of the cosmos seriously. By placing science into conversation with the gospel of redemptive love, he sought to subversively contest this tendency "to accept the phenomenal as Absolute."

He reasons that, since modern science offers a rational, empirical, and systematic investigation of the myriad phenomena of the vast cosmos, a faith that is rooted in the "downward movement" of the incarnation of Christ's redemptive love must be a strong supporter of the scientific quest, as well as a fearless interpreter of the cosmic, teleological, or tacit "upward movement" discernible in scientific evidence. Concerned that foreign missionaries had completely missed this crucial point, Kagawa says:

128. Kagawa, *Meditations on the Holy Spirit*, 345.
129. Nakamura, *Ways of Thinking of Eastern Peoples*, 360.

So closely do the Japanese feel themselves akin to nature and her ways that their thought of God takes on cosmic dimensions. Therefore, to bring home to the Japanese Christ's revelation of God as Father we must teach, as Ostwald does, that matter also has definite direction. We must show, as Driesch does, that there is harmony among organic bodies. We must stress the fact, as J. H. Fabre does, that God's purpose is built even into animal intuition. If we fail to make these things convincingly clear the Japanese will not believe in a God of love. Even the urbanized Japanese are never weaned from nature. A religion, therefore, which fails to interpret nature will not win their allegiance. No matter how much they are taught regarding human love, unless shown that there is love in nature they will not find faith possible.[130]

This passage shows that Kagawa saw the study of science as a key missiological or evangelical issue. According to the logic of redemptive love, Christ's incarnation and cross disclose God's positive embrace of creation and motivate the quest, through science, for a deeper exploration of cosmic purpose. In this quest, science and religion are seen as partners, not adversaries. In *God and the Inspiration of Redemptive Love* (1938), Kagawa asserts that religion needs science just as science needs religion, as both participate in the progressive growth of full (Christ) consciousness.

We cannot understand the cosmos when our thinking rests only on a local view of things. Given such a perspective, we will not understand religion. It is only as we look at all things cosmically that we grasp their hidden potentialities and religion begins to appear. When we get beyond ourselves and are able to reexamine ourselves, we are enabled to leap into the possibilities of the cosmos. That is, when the larger self examines the smaller self, religion springs up. This is why we can say that religion is that which points out the possibilities of the world.[131]

This is yet another call for "seeing all things whole."

Earlier in the same book, Kagawa moves beyond the "garment" metaphor, saying, "the cosmos is the thought of God."[132] He then introduces the "seven principles" that he sees linking spiritual and material realities. While we will treat his view of science in chapter three, here we will look at a long passage from *God and the Inspiration of Redemptive Love* (1938),

130. Kagawa, *Christ and Japan*, 40–41.
131. Kagawa, *God and the Inspiration of Redemptive Love*, 385.
132. Ibid., 352.

since it is one of the clearest expositions of Kagawa's theory that culminates in *Cosmic Purpose* (1958).

While welcoming and marveling at the science of the theory of evolution, Kagawa also sharply criticizes the way it had been used in the nineteenth century to justify the ideological positions of materialism, naturalism, positivism, casualism, ethical humanism, and atheism. Railing against those who hold such positions, he says, "When it came to the question of God, they neatly disposed of it by saying that God does not exist because God cannot be seen with the eye, and by implication, human life is purely accidental, society moves only by mechanistic forces, and economics is thoroughly materialistic."[133]

Kagawa responds to those who hold such literalist views.

> There is something wrong with the view that there is no God because we cannot see God. God is not something to be discovered by the physical eye! That is, we cannot see God only by thinking about the physical world visible to the eye. We cannot see God because we are completely immersed in the God of the cosmos who transcends the physical world. When we are in one part of the earth, we are unable to see the entire earth. As it would be foolish to conclude, based on this limited view, that the earth does not exist, the discovery of God is a simultaneous vision of the unity of the external and internal. Further, there is a need to know that there exists a junction of the external and internal.[134]

While Kagawa's view of the relation of God and the cosmos usually stresses the immanence of God in the incarnation of Jesus Christ and the ongoing work of the Holy Spirit in Christ's followers, here he accents the transcendence of God to try to shake his materialist foes. In other contexts, he takes to task religious leaders whose vision of the whole is similarly obscured by their narrow spiritual perspective. The point, Kagawa says, is the breadth of one's perspective, and God is only found when one is enabled to see all things from a broader, unitive perspective.

Seeking to ground his theory in concepts that have currency in both science and religion, he then introduces the first "element" he locates at the "junction of the external and internal."

> This is first of all "law." Law is neither a thing nor a mechanism. Law is the absolute opposite of chance. While the physical world changes,

133. Ibid.
134. Ibid.

the world of law is invariant. It is precisely here that we may grasp the juncture between the worlds of mind and matter. Law is the wisdom of the vast cosmos, and its eternally constant, fundamental principle.[135]

The point is that both science and religion operate on the presupposition that the universe is governed by certain invariants or constants. A shared task of scientific and religious consciousness is to try to grasp these laws, each from their distinctive viewpoints. At the same time, both scientists and believers should have the humility to admit that the search for the unchanging "wisdom of the vast cosmos" is ongoing and thus incomplete.

Having begun with law, or what is unchanging, he next introduces the dynamic element of energy.

Secondly there is "energy." This is the power that penetrates the external and internal realities of the vast cosmos. Internally, it appears as intellectual or personal power, and externally as physical or chemical power. According to the conclusion of the most recent theory of physics, energy changes whatever appears as matter into waveforms. This is called wave mechanics or quantum mechanics. Because this energy filling the cosmos is always working together with the laws of the cosmos, if we pay attention and listen carefully, we will realize that, just as human words have meaning, the cosmos itself has meaning and no doubt is constantly addressing us. Just as foreign words convey no meaning if we do not understand the language, this is simply a matter of becoming accustomed to hearing them. Just as it would be rash to conclude such words are meaningless simply because we do not understand them, some people see the cosmos simply as a machine and everything in it as chance.[136]

Energy is another term that bridges scientific and religious worldviews. While science uses experiment and observation to investigate the energies of atoms, neurons, or black holes, religion utilizes meditation and prayer to contemplate the divine through the energies of Word, sacrament, spirit, breath, body, silence, wind, water, and birdsong.

Lest Kagawa's placement of the *law* and *energy* at the beginning of his theory be seen as arbitrary, we need to interject a comment here. As well as the use of these terms in both science and religion, this is also a reflection of his knowledge of the neo-Confucian discussions of the cosmological dialectic between 理 (*li* or "principle") and 気 (*ch'i* or vital force).

135. Ibid., 352.
136. Ibid., 352–53.

Yamashita says, "*Li* and *ch'i* were interpreted as the two principles of the formation of the universe."[137] As in China, on one side of this historical debate in Japan were those who gave priority to *li*, represented by the Zhu Xi School, and on the other side were those who gave priority to *ch'i*, represented by Tōju and the Wang Yangming School. As we have already seen, the Zhu Xi School tended toward a secular, rationalist approach to the cosmos and ethics, while the Wang Yangming School preferred an intuitive, or even mystical approach, and Kagawa clearly identifies with Tōju and the Wang Yangming School.

To return to Kagawa's theory, he next takes up and expands the meaning of "selection," a key aspect of evolutionary theory.

> Thirdly is the power of "selection." This is a power penetrating the worlds of mind and matter and filling the cosmos, which is called sifting or sorting in the physical world and the power of discerning good and evil, beauty and ugliness, right and wrong in the spiritual world. The truth of the cosmos is disclosed through this selective power.[138]

To the evolutionary meaning of "natural selection" he adds the dimensions of moral, ethical, or aesthetic selection or choice. The point he wishes to make here is simple, though not necessarily clear. Since human consciousness has presumably been "selected" by evolutionary history, is it therefore not reasonable to treat humanity's moral, ethical, or aesthetic judgments, which have also been "selected" by human consciousness, as positive contributions to a fuller view of the "truth of the cosmos?"

Kagawa only introduces the teleological question after taking the combined perspectives of law, energy, and selection into account.

> Fourthly is the sphere of "purpose." Purpose not only exists in the spiritual world but also in the visible, physical world. There is a reproductive purpose in the stamen and pistil of flowers which people call design. Nature is surely not ruled by chance. While we do not deny chance, chance is limited to an extraordinarily small domain. For example, a car accident is due to nothing more than the slightest degree of change. This is what quantum mechanics clearly teaches. Similarly, contrary to those who say the universe is random, we see its order the more we study it.[139]

As we will see in our discussion of *Cosmic Purpose* in chapter 5, Kagawa's

137. Yamashita, "Nakae Tōju's Religious Thought and Its Relation to 'Jitsugaku,'" 311.
138. Kagawa, *God and the Inspiration of Redemptive Love*, 353.
139. Ibid., 353.

perception of "purpose," "design," or "order" in biology or physics is never intended to counter the science of evolutionary theory. Nevertheless, he does claim that one may catch a glimpse, albeit not the final blueprint, of unfolding purpose, design, or order in the light of the synthesis of invariant law, dynamic energy, and mysterious selection. This perception of purpose or order, Kagawa asserts, is fully consonant with findings in science and a religio-aesthetic worldview that sees the beauty and brutality of the natural world as the "garment" or "thought" of the loving Creator who comes to humanity in the incarnation and life-giving death of Jesus Christ.

Kagawa finally introduces three more elements to complement the four he has already mentioned.

> In addition to this list of four (law, energy, selection, and purpose), I would add three more (change, growth, and life). That is, we have three added to the four, making a total of seven elements. These seven are shared by the two worlds of mind and matter, but they become utterly disconnected within the context of the physical world alone. Some people close themselves up in a physics laboratory, some immerse themselves in the study of economics, others only think about growth or evolution. Of course it is fine to pursue such specialized academic research, but we might as well cease all such pursuits if we were to ever forget that the laws of the universe are uniformly diffused in both the spiritual and the physical realms. Or to put it more clearly, these seven elements are the space at the center of the two worlds of mind and matter, and while they may appear as seven separate elements within the physical world, in the spiritual world they are as a concentrated gathering of focused light. Here they are completely unified. This we call consciousness.[140]

Having made the point that religion needs science, here he says that science also needs a spiritual consciousness which perceives all seven elements "as a concentrated gathering of focused light."

THE ETHICAL DIMENSION OF LIFE:
PERSONS AND OTHER PERSONS

Having established the incarnation of redemptive love in the humanity of Jesus as the inner logic that energizes and sustains the spiritual dimension and glimpses divine purpose in the cosmic dimension,

140. Ibid., 353.

Kagawa now moves on to the challenging ethical imperative. This is expressed in his claim that Christ's redemptive love also transforms his disciples' concrete relations with others. As he took Carlyle's metaphor of nature as the "garment of the living God," in *New Life Through God* (1929) he takes a page from Hegel, saying, "Society is the clothing of the Spirit."

> The German philosopher Hegel says something like the following: "The Spirit is the basis of the state. The state is not the basis of the Spirit. The Spirit puts on the clothing of the state. And this Spirit only exists where there is religion." Society is the clothing of the Spirit. Just as we have clothing fitted to our bodies, society is also a kind of clothing. We do not have society first and then a body, and it takes a great number of people to endeavor to form a society.
>
> Jesus pointed out this truth. Jesus loved people, regenerated them, helped them, and worked for the abolition of poverty. It is on the basis of this fact alone that we form a society, since regardless of how good the laws are, they come to nothing if they are not kept.[141]

The incarnation of Christ, which has forever bridged the gap between the divine and the human, initiates a concrete social ethic based on redemptive love:

> Beneath morality there must be love. And love that embraces a consciousness of the cosmos is a great love that even loves those we dislike. I call this the love of full consciousness. This is Christ's redemptive love. This is a love that compensates for moral imperfections, a love that truly loves even those who are unlovable.
>
> When we reach this point, we are able to grasp the spirit of the cross of Christ. Those lacking a parent's heart do not understand the struggle of caring for a child. Christ was the Son of man, yet because of his passionate love and desire to save others, he awoke to the consciousness of the cosmos or the consciousness of God.[142]

If Kagawa's claim here that "When we reach this point, we are able to grasp the spirit of the cross of Christ" sounds presumptuous or even outrageous, we should recall his interpretation of the words attributed to the apostle Paul in Colossians 1:24: [143] "Christ, who died for sinners, summons us to become the concrete expression of this redeeming love

141. Kagawa, *New Life through God*, 110.

142. Kagawa, *God and the Inspiration of Redemptive Love*, 388.

143. "I am now rejoicing in my sufferings for your sake, and in my flesh I am completing what is lacking in Christ's afflictions for the sake of his body, that is, the church" (Col 1: 24).

to the so-called scum of society. In Colossians 1:24 Paul calls us to carry redemptive love on to its God-given goal."[144]

The synonymous terms "consciousness of the cosmos," "full consciousness," and "consciousness of God" all refer, in the first instance, to the saving, compensating, suffering love for the "unlovable" actualized in Christ's incarnation and cross. Yet Kagawa boldly asserts that Christ's awakened followers also share in Christ's "consciousness of the cosmos," "full consciousness," and "consciousness of God," meaning that they too will be willing to take on the suffering of those whose lives have been damaged by the modern social, economic, and political order.

As early as *The Religion of Jesus and its Truth* (1921), Kagawa asserts:

> The religion of Jesus had one specialty. That is, Jesus limited his religious mission to the sick, the weak, the poor, and the lost sinner. That is, Jesus Christ penetrated the body of the universe from a pathological perspective. I want to consider the enormity of the effort of Jesus and the God he reveals concerning the failures and weaknesses of humanity.[145]

In July, 1930, Kagawa delivered an address in China entitled "Following in His Steps," characteristically emphasizing that Jesus did not just preach or teach about love but concretely practiced it.

> In the sense in which Jesus Christ used the word, the "gospel" means "emancipation." When he went into the synagogue at Nazareth, Christ took the book of Isaiah, and read the following verses: "The Spirit of the Lord is upon me; because he hath anointed me to preach the gospel to the poor; he hath sent me to heal the brokenhearted; to preach deliverance to the captives; and recovering of sight to the blind; to set at liberty them that are bruised; to preach the acceptable year of the Lord" (Luke 4: 18–19). The gospel of emancipation meant five things:
> 1. Economic emancipation (preaching to the poor).
> 2. Psychological emancipation (healing the broken-hearted).
> 3. Social emancipation (preaching deliverance to the captives).
> 4. Physical emancipation (recovery of sight to the blind).
> 5. Political emancipation (setting at liberty them that are bruised).
> The gospel of Christ means not merely individualistic mental healing. It means a healing of everything. It means every kind of emancipation, from all sorts of evil.[146]

144. Kagawa, *Christ and Japan*, 115.
145. Kagawa, *The Religion of Jesus and Its Truth*, 154.
146. Kagawa, "Following in His Steps," 6.

Commenting on this passage, Kuribayashi observes, "Kagawa was a pioneer of liberation theology's 'option for the poor' that caught the world's attention in the 1970s."[147]

In light of the portrayal of Jesus in the Gospels and the egalitarian teaching of Tōju and the Wang Yangming School, Kagawa was relentlessly critical of the established church's individualism, elitism, and formalism and apparent unwillingness to turn like Jesus to the marginalized, forgotten, and poor whose liberation he saw as the sure sign of the evolution of the kingdom of God on earth: "The cross of Jesus means permanent progress toward God's true Kingdom. It means a process of permanent sacrifice by the individual to help lift society up to God's level of consciousness and love."[148] Here we find an example of the creative blending of the biblical symbol of the kingdom of God, the science of evolution, and the neo-Confucian view of the progressive "extension of innate knowledge." Aware of what science was revealing about the age and size of the universe and the emergence and evolution of life out of its constitutive chemical elements, Kagawa felt compelled to reconsider the ethical implications of the Christian Scriptures from the vastly expanded horizon of modern science. Clearly the neo-Confucian ideas we have mentioned above greatly assisted Kagawa in this reconsideration.

On the one hand, inasmuch as he perceived in the cross the sole and sufficient source of the power of salvation and knowledge of God's love, Kagawa's view may be characterized as a thoroughgoing *theologia crucis*. But he did not see the cross as standing only for some event of the distant past whose benefits are passively enjoyed by believers, but rather as an unfolding, progressive, purposeful, world-transforming reality into which all followers of Jesus are called to participate, thereby sharing in the divine movement to repair persons, societies, and ultimately the cosmos. In this view, the redemptive love of the crucified Jesus is recapitulated as his disciples bear in love the pain and suffering of the "least of these." As in the parable of the mustard seed, the Kingdom comes gradually and almost imperceptibly through this progressive and purposive historical process.

Returning to *God and the Inspiration of Redemptive Love* (1938), after quoting the "suffering servant" passage from Isaiah 53:4 and 53:7–8,[149] we

147. Kuribayashi, "Rereading Kagawa's Theology," 54.
148. Bradshaw, *Unconquerable Kagawa*, 105.
149. Isaiah 53:4. "Surely he has borne our infirmities and carried our diseases;

see Kagawa leaping seamlessly again from Christocentric indicative to ethical imperative, admonishing awakened disciples to follow the downward movement of Christ's redemptive love.

> We must note that the commonplace life certainly is not simply a peaceful life. If it is to be a life that saves others, it must be without fail a life that abases oneself in a downward movement. Herein lies the honor of one who suffers: Suffering, sorrow, being beaten, and persecuted. Yet even while undergoing these hardships in the body, the sufferer devotes their energies to others. As a rule, one who saves others must be prepared from the beginning to undergo suffering. One who saves others is compelled to move out from the consciousness of the God of the vast universe into this narrow and twisted world replete with various trials and tribulations. This is the so-called principle of incarnation.[150] But people often miss the point, always thinking of religion as the opposite of the downward movement of incarnation. They mistakenly think of religion only as an upward movement, but one who goes up must come down. They cannot grasp that herein is the meaning of salvation. That is, they cannot understand the principle of incarnation. Without getting hold of the life of suffering and the principle of incarnation, they cannot attain the essence of the life of Christ. I pray day and night that I will never forget this insight.[151]

As one "compelled to move out from the consciousness of the God of the vast universe into this narrow and twisted world replete with various trials and tribulations," we hear a clear echo of a note Kagawa first sounded while staring into the face of the void in his 1909 "Philosophy of Nothingness." To reiterate, "Even though God is omniscient and almighty, God is able to indwell this worthless world. God lives even in worthlessness.... God is also exerting strenuous effort. Alas, like God I will exert a strenuous effort. Alas, God is also suffering. God, God...."[152]

But by the time of *God and the Inspiration of Redemptive Love* (1938), Kagawa has added a mystical note to his ethic of incarnational suffering with God in Christ. Now the follower who shares the divine conscious-

yet we accounted him stricken, struck down by God, and afflicted...." 7–8: "He was oppressed, and he was afflicted, yet he did not open his mouth; like a lamb that is led to the slaughter, and like a sheep that before its shearers is silent, so he did not open his mouth. By a perversion of justice he was taken away. Who could have imagined his future? For he was cut off from the land of the living, stricken for the transgression of my people." (NRSV)

150. Again, he opts for the Buddhist term *keshin* 化身 for incarnation.
151. *God and the Inspiration of Redemptive Love*, 34.
152. Kagawa, "Philosophy of Nothingness," 369.

ness of redemptive love attains "the essence of the life of Christ," being united with the divine reality in the downward movement of redemptive love.

In theological terms, Kagawa's view fuses the *participatio Christi* with the *imitatio Christi*. That is, being united with Christ and participating in his benefits enables the disciple to imitate and thus extend Christ's self-emptying and suffering love to others. Kagawa speaks of sharing "the consciousness of Christ" in terms of a perfection or completion of persons that in turn becomes the power to transform society.

> We must realize the three functions of the love of the heavenly Father that has appeared in humanity: 1) To perfect persons by means of transcendent love; 2) To give grace in the form of an inner love that enables self-reflection and repentance; 3) To express the image of God in human form, which is the most precious gift of all. This was the consciousness of Christ.[153]

The followers of Christ continue to bear the image of God in and for the world. Elsewhere, Kagawa directly links the "consciousness of Christ" to the "consciousness of collective responsibility."[154] In *Meditations on the Cross* (1931), he says:

> This [consciousness of collective responsibility], then, was the secret of Jesus Christ. And this we can fit into our daily lives. And advancing one more step, taking the "filling up of the measure of what is lacking in the suffering of Christ" into our own weakness, we must make Japan's sorrows our own. That is the essence of Christianity. The moment we are saved, we must set ourselves to saving others. The way Christ became the Atoning Lamb was by hanging on the Cross and dying there. Hence, Christianity for me means to dedicate myself to serve others even unto death. I believe that the true way of Christ Jesus is there. Christianity means to save others. That is the way of the Cross, and the true way of Christ.[155]

Again, this "secret" of the "consciousness of collective responsibility" begins in the person and work of Jesus Christ, extends to his disciples, and progressively moves out to embrace others in need. We could say that Kagawa begins with Christ's cross but also takes seriously the personal

153. Kagawa, *God and the Inspiration of Redemptive Love*, 395–96.
154. 連帯責任の意識 *rentai sekinin no ishiki*, which is literally "solidarity-responsibility consciousness," or "consciousness of a responsibility to be in solidarity," but we have translated it as "consciousness of collective responsibility."
155. Kagawa, *Meditations on the Cross*, 97.

crosses of Christ's disciples. While there is always an autobiographical motif present in Kagawa, his personal engagement on so many of the pressing social issues of his time—poverty, labor, agriculture, education, and beyond—surely lent authority to his admonitions to imitate and extend Christ's redemptive love. In this context, we should recall his claim that "Wang Yangming's notion of innate knowledge means full consciousness." It is not surprising that Kagawa's *ad hoc*, artistic blending of orthodox, liberal, Eastern, and Western views seriously vexed some theologians.

After Emperor Hirohito's surrender to Allied forces in August 1945, Kagawa played a major leadership role in the Total National Repentance Movement.[156] In the Preface to a 1947 collection of postwar speeches he gave on behalf of the movement to renew Japan, Kagawa proclaims the "consciousness of collective responsibility" as the only hope for the renewal of his humiliated and defeated nation.

> The principle of cosmic repair is nothing other than the expression of boundless love in sacrifice.... Without the social consciousness of collective responsibility and without the tragic, boundless love that repairs and restores sinners, there is no way to recreate humanity. The great love that created the universe and the consciousness that recreates human life is at work in Jesus.... There has never been a more confusing and dangerous time for Japan and the Japanese people than the present. If we do not see that the way to Japan's renewal is in the cross, Japan will degenerate further and further until it is no more than an island in the Pacific Ocean inhabited by barbarians. Only the cross can unify our people and sustain a renewal of culture and scholarship. Yes! The day when the Japanese people discover that the way to the recreation of life is in the cross, Japan will be regenerated and resurrected.[157]

Just when everything had fallen apart, Kagawa continues to dare to "see all things whole." In one massive metaphorical *furoshiki* (Japanese wrapping cloth), he ties the "principle of cosmic repair" and "tragic, boundless love" of the cross to the ultimate fate of his beloved Japan.

Kagawa's theory of redemptive love fuses spiritual, cosmic, and ethical dimensions and helps us grasp why he devoted so much energy to meditating on the meaning of modern science and working so tirelessly for a just society. Firstly, in his full embrace of humanity in his incarnation

156. 国民総懺悔/*kokuminsōzange*. Schildgen, *Toyohiko Kagawa*, 248.
157. Kagawa, *The Creation of the Universe and the Recreation of Human Life*, 1.

and cross, Christ once and for all instantiates redemptive love in time and space. Christ is the final word where "God tells us finally that 'God is love.'"[158] Those awakened in faith to the "full consciousness" of Christ are now able to view the cosmos with new eyes as the "garment of the living God." This high view of the cosmos supports scientific inquiry and encourages religio-aesthetic meditation on the possible meaning of such inquiry. The ethical imperatives of redemptive love are clear. As Christ's incarnation and cross inspire a high view of the cosmos, so his work among the sick, the weak, the poor, and the lost sinner inaugurates the coming kingdom of God. Christ's followers have the high calling to participate in and thereby extend his ministry, "completing what is lacking in Christ's afflictions for the sake of his body, that is, the church" (Col 1: 24).

While rejecting a Spinozan pantheism that identifies the Immortal with the cosmos with no remainder, Kagawa perceives in the incarnation of Jesus Christ the dynamic, personal agency of God in, above, and through the world of nature. Holding tacitly to a traditional "two books" approach to divine revelation, Kagawa offers a creative Japanese interpretation of redemptive love that supports a constructive rapprochement between the domains of consciousness we call science and religion. Reaching for an anti-reductionist methodological pluralism capable of "seeing all things whole," he freely and boldly contravenes the modern philosophical chasms between the domains of noumenal and phenomenal, ideal and material, spirit and matter. In the next chapter, we will examine the scientific dimension of his "scientific mysticism."

158. Kagawa, *God and the Inspiration of Redemptive Love*, 350.

3 From Crabs to the Cosmos

SCIENCE AS DIVINE REVELATION

The following words of Kagawa from Axling's biography are a programmatic statement of his basic stance as a "scientific mystic."

> I am opposed to setting bounds for the mysterious and seeking truth only through the senses. For me, reason, laws, and mechanical discoveries all belong to the realm of mystery. I believe that nothing has done so much to lay bare the world of mystery as modern science.
>
> The reason science lost the sense of mystery is because it severed relations with life. If once it discovered that there is life at the heart of science and that mechanics, laws, and reason are all handmaidens of life, then it will be clear that these mechanical discoveries, laws, and reason are but windows opening into the world of mystery.
>
> I am a scientific mystic. The more scientific I am, the more I feel that I am penetrating deeply into God's world. Especially in the domain of biology do I feel as though I am talking face to face with God. Through life, I discover purpose even in a mechanical world. Science is the mystery of mysteries. It is the divine revelation of revelations.[1]

Through the personalist, holistic, and ethical lenses of Christ's redemptive love, Kagawa perceives "mechanism, laws, and reason" as "handmaidens of life" and "windows opening into the world of mystery." His assertion that science has "lost the sense of mystery because it severed relations with life" illustrates his conviction of a fundamental unity between *physis*, *bios*, and *anthropos*. Even as the various disciplines in the sciences and humanities were increasingly being treated as autonomous subjects within the modern university, Kagawa held on to an intuition of a deep, complex integration of all fields of human knowledge when viewed through the bifocal lenses of Christ's redemptive love and

1. Axling, *Kagawa*, 161–62.

the ongoing evolutionary history of life and consciousness.[2] He boldly proclaims, "The whole creation is mine. God threw it in when He gave me Christ."[3] Through the sciences, previously obscured secrets of life, the cosmos itself, and, by extension, the "cosmic will" behind it all were being disclosed for human investigation, meditation, art, and ethics. This is why he calls science "the divine revelation of revelations." This "scientific mysticism" that joins faith in God and in the rational intelligibility and progress of life and consciousness in the cosmos is the position he had settled on by the time of the publication of *Spiritual Movements and Social Movements* (1919).

To reiterate, in keeping with Reformed tradition, since the God of creation has been disclosed in the incarnation and suffering of Jesus Christ, Kagawa felt it a sacred obligation for human beings to approach the cosmos as the "garment" or "thought" of God. Christ is the mediator of this "re-enchantment" of the cosmos. Further, he believed that all people are endowed with an "innate knowledge" by which the self may transcend itself by emptying itself, thereby coming to the awareness that we "form one body with the myriad of things." As the supreme exemplar of this full, cosmic, or God consciousness, Jesus Christ is the personification of this innate knowledge, and his reparative suffering for others the means of extending the full consciousness of God's love to all.

In terms of the ground-figure shift of Gestalt psychology, in Kagawa's view of God, cosmos, and humanity, the explicit figure is supplied by the Christian gospel of redemptive love, while the implicit ground is supplied by the neo-Confucian tradition of Wang Yangming, introduced in Japan by Nakae Tōju, as well as other Japanese religious and philosophical influences. Theologically, his use of the language of "consciousness" is partly indebted to Schleiermacher,[4] and Kagawa opts for that term in the conviction that it is faithful to Scripture and appropriate for the context of modern Japan. But Kagawa's sense of "forming one body with the myriad of things," his intense love for nature and science, and his holistic rationality take him beyond Schleiermacher, whose theological project should be seen in its historical and cultural context as an attempt to "legitimate the role of theology in the modern research university."[5]

2. See Appendix C, "Kagawa's View of the Humanities and Natural Science."
3. Axling, *Kagawa*, 167.
4. Schleiermacher, *The Christian Faith*.
5. Osmer, *A Teachable Spirit*, 152.

In contrast, Kagawa freely employs a polyphony of Eastern and Western voices to proclaim a positive role for religion in a society dominated by a view of evolution that tended to be hostile to the spiritual life.

In Kagawa's "unified view of the cosmos" or "cosmic synthesis," the long history of the universe prepares for the startling emergence of life, yet he stresses that we always need to be cognizant of the fact that the universe is still evolving, creation is continuing. Human consciousness plays a key role as the place where the universe becomes conscious of itself. In *Human Suffering and Human Upbuilding* (1920), he says, "We get to watch the great drama of existence for free."[6] Again, toward the end of *Cosmic Purpose*, he proclaims, "We are only halfway through cosmic evolution! The full production is yet to come! And here I sit watching it without even having paid the price of admission."[7] From cosmic dust to the fine-tuning of chemical compounds to the emergence of the earliest forms of life, and through a complex process that embraces inscrutable disruptions and intelligible order, pressing all the way through the myriad forms of life up to *Homo sapiens*, and then reaching what he sees as its highest spiritual expression in the "full consciousness" of Christ, Kagawa finds evidence, if not final proof, for the probability of a deep and mysterious cosmic purpose.

Given such a starting point, he could not help but think that a faith whose ultimate goal is the repair of the entire cosmos through self-dispossessing love should be eager to learn from, meditate on, and interpret contemporary scientific discoveries. Here is a particularly ecstatic instance of such a meditation from *The Science of Love* (1924):

> The cosmos is love in the bud, one vast bud. Thus would I believe, and thus my science-as-art teaches me. The great drama is still in progress; the future yet is long. And love gives meaning to the forward thrust.
>
> Like passionate love the cosmos is a fragrant bud. From love to love, from passion to passion, the mysterious bud of life is borne from here to there like a juggling ball. Only that which is innermost in us may grasp this truth. This is the message of evolution, that the world is still in bud.
>
> I do not know who first believed in the principle of evolution. It was probably not Darwin, or Wallace, or Mendel. Belief in the principle of evolution does not simply mean believing in the Darwinian theories of variation, selection, and the survival of the fittest. Belief

6. Kagawa, *Human Suffering and Human Upbuilding*, 31.
7. Kagawa, *Cosmic Purpose*, 265.

in evolution is faith in the promise of a progressive entrance into an ever-expanding freedom—from seed to shoot, bud to flower, from anthropoid to human, from human to Son of Man. What a courageous faith! The belief that there is a direct line of evolution from amoeba to humankind is a more daring and romantic faith than the belief in the myth of a Creator making something out of nothing.[8]

While Kagawa had been introduced to Christian faith by theologically orthodox Presbyterian missionaries and had studied Reformed theology, early on he also had shown an aptitude for valuing those inherited traditions while also being willing to boldly rethink them in light of a positive engagement with contemporary culture. As an early example of this boldness, his *A History of the 'Life of Jesus' Dispute* (1913), composed in the Shinkawa slum when he was twenty-five years old, was the first book to introduce Albert Schweitzer's classic *Geschichte der Leben-Jesu-Forschung* (1906) to a Japanese readership, just seven years after its original publication. But Mutō later emphasizes that Kagawa's early interest in academic biblical criticism and theology had dramatically waned after publishing this early monograph:

> He had moved beyond the higher biblical criticism of the theologians and was concentrating on developing his own view of Jesus, devoting himself to the practice of redemptive love. When Bultmann's demythologization of the Bible was all the rage in post-war Japan, Kagawa told me in conversation that he was not at all interested in this subject. In his later years, Kagawa was completely taken up with this theory of cosmic purpose and showed no interest in life of Jesus research or biblical criticism.[9]

As well as having the courage to independently consider the import of contemporary developments for Christian faith, he also provoked scientists to be open to religious consciousness and willing to work on cosmology.[10] As an example, a year following the end of WWII he writes in *Guideposts for New Life* (1946):

> There is no religion in Japan's natural sciences, and cosmology is missing. As a result, scientists befriend only other like-minded scientists

8. Kagawa, *The Science of Love*, 205.
9. Mutō, Commentary on *A History of the 'Life of Jesus' Dispute*, 492.
10. In spite of such admonitions by Kagawa and other Japanese religious leaders, Yokoyama concludes that a pattern of "the separation and mutual non-interference of religion and science" has generally continued to prevail in Japan. Yokoyama, "The 'Science and Religion' Problem in Japan," 49.

and attack those who disagree with them, becoming narrow-minded, settling for trivialities and making little progress.

When Mendeleev discovered the periodic table, he expressed joy at having discovered the fundamental Reality of the God of the universe.

Without an awakened religious consciousness, it is not possible to delight in such a discovery....

Shortly before he died, Thomas Edison wrote that it is disastrous for a civilization to have science if it lacks religious piety.

Faraday, who invented the electric motor, and Morse, who invented the telegraph, were assisted by their religious convictions to make these discoveries. Millikan, Compton, Carrel, Weyl, and Einstein make their observations of the universe with a religious conscience, approaching the search for truth with humility.

As a result, if Japan's natural sciences are not constructed on religious convictions, they will not contribute to the rebuilding of the nation.[11]

As conscious beings who personally embody, participate in, and are called to interpret the ongoing evolutionary drama, Kagawa was convinced that humanity needs the positive insights of religion and science, which are both "bred in human consciousness,"[12] in order to more fully comprehend and appreciate our relation to the still undisclosed mysteries of the cosmos and the ultimate mystery of God. His concepts of "religion as art" or "science as art" emphasize the virtues of childlike wonder at the utter miracle of life and self-critical humility in the face of our expanding but severely limited knowledge. He sees wonder and humility as essential virtues for innovative religious and scientific leaders.

Beginning with his first published essay, "Arming Crabs" (1905), we will trace the early development and formation of Kagawa's views on science and search for cosmic purpose.

"Arming crabs" (1905)[13]

This seminal piece was written sometime during the year following Kagawa's baptism in February 1904 and published in *Uzu no ne*

11. Kagawa, *Guideposts for New Life*, 51.

12. Kagawa, *Cosmic Purpose*, 269.

13. We wish to acknowledge our debt of gratitude to Professor Amemiya for his excellent chapter on this essay, and especially for pointing out the seminal import of the crab essay in Kagawa's search for cosmic purpose. This section draws largely on Amemiya's work. Amemiya, *Kagawa Toyohiko's Youth*, 134–55.

(*Sound of a Whirlpool*), a publication of the Friends of Tokushima Middle School. As we saw in chapter 1, these were emotionally trying times for the teenager. In 1903, due to the poor management and alleged moral failures of his older brother, his family had lost everything and been forced to sell the family estate. They could no longer afford Toyohiko's school fees, and after a period of uncertainty and anxiety, an uncle stepped in to help. However, in opposition to the teen's decision to receive baptism and pursue a pastoral vocation, the uncle withdrew his financial support in 1904, leaving Kagawa to depend on the generosity of missionaries Meyers and Logan.

Surmising that "Arming Crabs" was written in Kagawa's final year at Tokushima Middle School while he was still living at his uncle's house, Amemiya sees the essay as a natural extension of the love for living things he had developed as a child of the Yoshino River Basin.[14] In preparation for the essay, Kagawa captured nine species of ocean and river crabs, and after dissecting them, divided them into three categories he had created based on his observations of their shapes. The first group he called "*koban* genus" because it was shaped like an oval Japanese gold coin, the second "*hyōtan* genus" because it was shaped like a gourd, and the third "*hōchō* genus" because it was shaped like a carving knife. The thirteen sections of the seven-page essay are as follows: Preface, Inherited Superstitions Regarding Crabs, Crab Armament, *Koban* Genus, *Hyōtan* Genus, *Hōchō* Genus, Crab Eyes, Crab Pincers, Crab Shells, Crab Eggs, Crab Dwellings, Crab Locomotion, Conclusion.

Kagawa's analysis shows his familiarity with and acceptance of Darwin's theory, but he is also beginning to ponder how to understand the Darwinian notion of "survival of the fittest," as clearly evidenced in the adaptability of the crabs' eyes, armor, pincers, habitat, and speed of movement, in relation to the question of life's purpose. In the preface he writes:

> The theory of the survival of the fittest stresses that the endowment of life is above all else based on the strong winning and the weak losing.
>
> This is the first thing we learn when studying the theory of evolution. However, while those who mindlessly live their lives may feel no need to know that this point has greatly influenced humanity, for those who think about why we have been endowed with life on this earth, it is an essential theme to be researched.
>
> One person may survey the question of why there is life on earth

14. Ibid., 138.

from the background of the survival of the fittest, while another may take a middle way that says something exists because it fits a certain purpose. If we were to take a further step and inquire what on earth this purpose might be, one wonders how the world's great scholars might respond.

A materialist might answer that existence itself is the sole purpose, while an idealist would answer that the purpose is spiritual power. The answer to this kind of question is beyond those of us who are unlearned.

Yet, we know as a fact that both those adapted to the purpose of survival and to the purpose of spiritual power go on to preserve life.

The sixteen-year-old presumably had not yet read Lotze or Bowne, whose philosophies later offered him a middle way between the idealists and materialists. Kagawa then wonders about the question of "purpose" from the perspective of the crab.

If we name this [purpose] the struggle for survival, this seems to indicate the role of crab armor (i.e., its selfishness) in the survival of the fittest that attends this struggle. Given the fact that the crab wears armor and a helmet, has large pincers as weapons, sees at great distances with its binocular eyes, walks four times as fast as an adult human, and makes its castle in the water, all in order to preserve its life from its enemies, we truly must call it a well-fortified specimen.[15]

From the perspective of crab anatomy, ecology, and behavior, Kagawa admits the persuasive power of the evolutionary perspective on the struggle for existence.

This conclusion is not surprising, given the fact that the intellectual world of Japan was then under the sway of a particular reading of evolutionary theory. Following the introduction of Darwin's theory by Edward Morse in a series of lectures in Tokyo in 1877, the books of Darwin, Huxley, Morse, Spencer, Haeckel, and Weismann appeared one after another in Japanese translation.[16] Robert Schwantes also shows that, along with evolutionary theory came scientific rationalism, materialism, and historical relativism, modern ideologies often perceived to undermine the Christian faith of the missionaries and tiny Japanese churches.[17] Still, as Amemiya points out, in this essay written about a year after his baptism, we find an initial gesture toward Kagawa's lifelong search for "cosmic pur-

15. Kagawa, "Arming Crabs," 361.
16. Amemiya, *Kagawa Toyohiko's Youth*, 141.
17. Schwantes, "Christianity Versus Science," 125.

pose" in the phrase, "If we were to take a further step and inquire what on earth this purpose might be, one wonders how the world's great scholars might respond."[18] Several years before falling into the disordered state of mind that took him to the brink of suicide, the young convert was already brooding on questions of meaning in conjunction with the larger purpose of life itself.

Leaving the judgment of the scientific merits of the crab essay to specialists, Kagawa's most remarkable comment comes when he ponders how to relate the evolution of crabs to the evolution of *Homo sapiens*. He writes:

> Generally speaking, while crabs are habitually communal, they are also a species that enjoy a life of struggle for survival and the violent butchery of individuals.
>
> We human beings must consider that, while humanity also prefers the communal life like the crab, is our similar enjoyment of a life of struggle for survival and the violent butchery of individuals sufficient?
>
> While evolutionary theorists claim that *Homo sapiens* was generated solely as a result of the struggle for survival, we must also consider the evolution of altruistic love. It appears that altruistic love has been added from the lower animals and reached its apex in *Homo sapiens*.[19]

Amemiya comments on Kagawa's interjection of the term "altruistic love":

> The evolution of life forms from the perspective of the theory of evolution shows exactly that the strong win and the weak lose according to the law of the survival of the fittest. This law presupposes self-centeredness and self-love arising from self-instinct. Nevertheless, while Kagawa the middle-school student demonstrates that the process issuing in the armament of crabs follows this law of evolutionary theory, he suddenly states that the evolution of humanity does not. This statement about "altruistic love" comes completely out of the blue with no logical development or support. Having become a Christian and taken a stand on biblical faith, this is no more than Kagawa's intuition or sensitivity. If we think about it, this is a Christian view of the theory of evolution. That is, altruistic love must also be an aspect of the process of evolution. The evolution of life is not simply a matter

18. Kagawa, "Arming Crabs," 361.
19. Ibid., 367.

of selfish instinct, but also takes the form of service to and love for others.[20]

Amemiya rightly points out that Kagawa gives no reason for introducing the concept of "altruistic love" here and that it was surely related to his newfound faith, but the suggestion was probably not based solely on his "intuition or sensitivity."

While we do not know if he had already read it, Kagawa was very likely aware of Peter Kropotkin's *Mutual Aid* (1902),[21] which was published in English as a counterargument to Thomas Huxley's essay, "The Struggle for Existence in Human Society."[22] According to Stephen Jay Gould's comments on this historic debate, whereas Huxley had taken a negative view of the struggle for survival in nature and argued for the need of human societies to counter and overcome natural instinct, Kropotkin argued for the presence of cooperation in other animals and the need for human societies to learn from these natural exemplars of mutual aid.[23]

Further, Kropotkin's views on evolution—not his political views as an anarchist—surely would have been welcomed by missionaries in Japan who were facing increasing hostility after the introduction and popularity of Darwin and Darwinian ideas. It is therefore possible that Kagawa would have found a copy of *Mutual Aid* on Meyer's bookshelf. Had he already read Kropotkin by the time of his crab essay, he would have encountered his comments on Ludwig Büchner's *Liebe und Liebes-Leben in der Thierwelt*, which argues for love and sympathy among the animals.[24] Although Kropotkin himself does not use the word "altruism," he does cite Lothar Dargun's work, *Egoismus und Altruismus in der Nationalökonomie*.[25] It is therefore possible that Kagawa's mention of "altruistic love" is indebted to Kropotkin. Even if Kagawa had not already read Kropotkin, because of his early devotion to Tolstoy, he likely would have been aware of the rivalry between Russian and British interpretations of Darwin's theory by the time he wrote "Arming Crabs."

20. Amemiya, *Kagawa Toyohiko's Youth*, 147.

21. This book later exercised a strong influence on Kagawa's cooperative economic theory.

22. Huxley, "The Struggle for Existence in Human Society."

23. Gould, "Kropotkin was no Crackpot," 12–21. Gould confesses that his own views of Kropotkin had changed when he realized that this was part of a larger polemical trajectory in late-nineteenth-century Russia.

24. Kropotkin, *Mutual Aid*, xii.

25. Ibid., footnote 1, 184.

It is also worth noting that, in his 1997 essay, Gould finds himself in agreement with Kropotkin's "basic argument," while adding a revealing caveat:

> More generally, I like to apply a somewhat cynical rule of thumb in judging arguments about nature that also have overt social implications: When such claims imbue nature with just those properties that make us feel good or fuel our prejudices, be doubly suspicious. I am especially wary of arguments that find kindness, mutuality, synergism, harmony—the very elements that we strive mightily, and so often unsuccessfully, to put into our own lives—intrinsically in nature. I see no evidence for Teilhard's noosphere, for Capra's California style of holism, for Sheldrake's morphic resonance.[26]

Had he known about Kagawa's "scientific mysticism," he likely would have added it to this blacklist. What is striking here is not Gould's "cynical rule of thumb," a position that scientists rightly take when carefully weighing evidence. Rather it is his tacit philosophical position, which presumes an absolute demarcation between the world of nature, the human knower, and social values. Kagawa would contest such a view of things, pointing to the commonality between the brains of humans and the "lower animals," which of course Gould would agree with, but also to the possibility of an evolutionary continuum of social and spiritual values such as cooperation or altruistic love. As one might expect, the Gould essay on Kropotkin follows his NOMA ("nonoverlapping magesteria") Principle, an often-quoted norm that seeks to keep science and religion separate. Responding to Roman Catholic teaching, Gould says:

> The text of *Humani Generis* focuses on the magisterium (or teaching authority) of the Church—a word derived not from any concept of majesty or awe but from the different notion of teaching, for magister is Latin for "teacher." We may, I think, adopt this word and concept to express the central point of this essay and the principled resolution of supposed "conflict" or "warfare" between science and religion. No such conflict should exist because each subject has a legitimate magisterium, or domain of teaching authority—and these magisteria do not overlap (the principle that I would like to designate as NOMA, or "nonoverlapping magisteria").[27]

In the end, the teenage Kagawa's assertion in "Arming Crabs" that

26. Gould, "Kropotkin was no Crackpot," 21.
27. Gould, "Nonoverlapping Magisteria," 16–22. The NOMA essay appeared in March, 1997 and the Kropotkin essay in July, 1997.

"altruistic love has been added from the lower animals" is more satis-
fying philosophically and perhaps even more "scientific" than Gould's
approach. If Kagawa could respond to Gould, he may say something
like the following: "Unless we want to maintain an absolute distinction
between *Homo sapiens* and other animal species, should we not also con-
sider 'kindness, mutuality, synergism, harmony' and other social or spiri-
tual values (i.e., 'altruistic love') as aspects of consciousness that should
be explored as evolutionary adaptations?" At the very least, we may say
that this essay on crabs is the first statement of Kagawa's lifelong search
for purpose in a cosmos that seems to offer evidence, on the one hand,
for tooth and claw rivalry, and on the other hand, for altruistic love and
cooperation.

THE VISION FALTERS

In the Preface of *Cosmic Purpose*, Kagawa says, "I began to wres-
tle with the problem of cosmic evil at the age of nineteen."[28] That year was
1907, when he had almost died and two years before the move into the
Shinkawa slum. While his struggle with "cosmic evil" clearly began on a
personal, existential level, the depth and breadth of the struggle increased
exponentially as he confronted the harsh realities of daily life in the slum.
Even his lonely childhood and youth could not have prepared him to deal
with the countless problems he encountered in Shinkawa.

One young woman who visited the Kagawas in Shinkawa offers the
following account of living conditions:

> In the slums were nests of paupers, former criminals, beggars, prosti-
> tutes, drug and alcohol addicts—the wrecks and dregs of society. The
> sorrows and sighs of the defeated, forgotten by the world, lay stagnant
> in the heavy air. On both sides of the alley, hovels, half-buried, slanted
> into the ground. Families of from five to ten persons lived in huddled
> houses six feet square. For about every thirty houses there was a com-
> munity kitchen and a community toilet.[29]

In the summer of 1914, after living more than four years in the slum
and just before leaving for two years of study in the United States, the
twenty-five-year-old Kagawa completed the manuscript for *A Study of
the Psychology of the Poor* (1915), a massive work combining empirical

28. Kagawa, *Cosmic Purpose*, 29.
29. Ishigaki, *Restless Wave*, 150.

research and an essayistic interpretation of the causes and effects of poverty. The Preface, written from far away Princeton, reads like an apology for the book:

> I worked really hard writing this book. Yet, to me it is little more than a small section in one essay. I have long been troubled by the problem of "cosmic evil" and have thought of nothing else for the past several years. Because I was especially captivated by the clash between serious poverty and psychology, I started to gather materials. This book is the result. To my mind, it is no more than several hundred pages dealing with "cosmic evil" from the angle of social suffering, offering a little light on the subject. I do not offer any solution in this book.[30]

On the one hand, Mutō praises this early book as "a work of genius," claiming it should be classed with the likes of Malthus's *Essay on the Principle of Population*, Smith's *Wealth of Nations*, and Darwin's *Origin of Species*.[31] On the other hand, it was fated to become Kagawa's most controversial work for its blatantly negative characterizations of the *Buraku*, a Japanese minority long-victimized by social discrimination.[32] After nine editions, the book went out of print in 1922,[33] but following Kagawa's death in 1960, it became the focus of heated debates about whether or not to remove its discriminatory passages from the *Collected Works*.[34]

The charges against Kagawa are clear-cut. Even though he originally had close ties with some of the leaders of the *Suiheisha*[35] (the movement for *Buraku* liberation), and had lived as a neighbor with the *Buraku* in the slum, when referring to them in this book, he opts for the terms *Etazoku*,[36] a vulgar and derogatory label meaning "tribe of much filth or defilement," and *Tokushuburaku*,[37] a discriminatory term that deliberately singles out the inhabitants of "certain villages." This latter term had already been dis-

30. *A Study of the Psychology of the Poor*, 3.

31. Mutō, Commentary on *A Study of the Psychology of the Poor*, 545.

32. Beginning during the Tokugawa Era, and presumably because they worked in occupations considered ritually impure (i.e., as gravediggers, executioners, tanners, butchers, etc.), the *Buraku* were treated as "outcasts," i.e., completely "other," subordinate to the four-tiered *Shinōkōshō* class-system comprised of *samurai* (士 *shi*), farmers (農 *nō*), artisans (工 *kō*), and merchants (商 *shō*).

33. Kudō, "Kagawa Toyohiko and the *Buraku* Issue," 120.

34. Ibid., 104–6. These sections were removed for the 1981 (third edition) of the *Collected Works*.

35. 水平社.

36. 穢多族.

37. 特殊部落.

carded by the Japanese government in 1912 in favor of the more neutral *Saiminburaku*,[38] meaning "poor villages."[39] Kagawa makes the unfounded claim that "all urban poor could be traced to a *Buraku* origin"[40] and offers the following rationale for this view:

> Speaking from the perspective of slums across Japan, if there are such things as urban slums, it follows that they originate from the *Tokushuburaku*. It is a surprising fact that in Japan there are no slums populated by pure commoners (*Junheimin*).[41] This is true of the seven slums of Kōbe, and true of Kyoto.... It is also true of Osaka and of Nagoya, and it is the same with Tokyo's Mannenchō. The so-called *Ganninbōzu*[42] (street performers acting as priests) are of course one origin for this phenomenon, but many *Eta* also seem to have gathered in these slums. This is even truer in the rural slums. Especially in recent years, *Tokushumin* from the provinces have flowed into the cities, since the equality they find there means less oppression than in their lives in the country. This all makes the urban slum an exceptionally suspicious place, because when you ask a slum resident where they come from, they will never reveal their birthplace.... They are all of the *Etazoku*, and are loath to talk about it.[43]

This biased conclusion is all the more puzzling when one considers that Kagawa knew that those of *Buraku* origin in Shinkawa accounted for only about 2,000 of the estimated population of 5,859 (based on the 1908 census).[44]

Besides his use of discriminatory language, Kagawa offers evidence of differences in language, skin color, emotional makeup, and social customs to support his further claim that the *Buraku* are a different race (i.e., not Japanese). He says, "In light of these surprising facts, I have to conclude that they are descendants of Caucasians."[45] He also claims, "It cannot be denied by anyone that *Tokushumin* are the Japanese Empire's criminal race."[46] Accusing Kagawa of presenting bogus "scientific" evi-

38. 細民部落.
39. Kudō, "Kagawa Toyohiko and the *Buraku* Issue," 108–17.
40. Chubachi and Taira, "Poverty in Modern Japan," 406.
41. 純平民.
42. 願人坊主.
43. Kagawa, *A Study of the Psychology of the Poor*, 85–86.
44. Kudō, "Kagawa Toyohiko and the *Buraku* Issue," 107.
45. Kagawa, *A Study of the Psychology of the Poor*, 98.
46. Ibid., 100–101.

dence from linguistics, anthropology, and genetics to support his case for separate racial origin, Kudō says:

> Kagawa's theory of racial origins is aberrant. After going so far as to say "they are Japan's race of prostitutes," he seems to feel some sense of guilt for the claims he is making and adds, "Fearing I may be making too much of the racial theory, I earnestly desire to consult with the world's anthropologists about my conclusions." Here he leaves off his discussion of racial origins.[47]

While Kagawa's attempts to provide a "scientific" rationalization for the deep-seated historical and cultural prejudice toward the *Burakumin* are disappointing enough, it is his use of the "scientific" notion of "self-selection" that is most disturbing. He glibly states:

> I am by no means pessimistic regarding the improvement of the *Tokushumin*. Actually many of them are already being improved today through the self-selection[48] process of moving into the cities. The modern cities will attract them and besides a remnant race of criminals, the rest will become extinct. Further, it is fortunate that their rate of growth is not as great as the Japanese as a whole, and their vitality is lacking, yet besides their increasing influence among the poor there is no need to be overly concerned, because without a doubt I believe that through the selection principle and education, a virtue even superior to the Japanese norm may be created. Having shared the same bedroom and meals with many *Eta*, I believe this without a doubt. Still, it is a fact that there is still a tendency for racial habits to suddenly appear in a fit of anger. It is at such times that they often commit crimes.[49]

Kagawa's use of the term "self-selection" suggests that, at least at the time of *A Study of the Psychology of the Poor* (1915), he had fallen under the spell of the views of Wallace, Galton, and Spencer, and perhaps most especially Haeckel, whose 1868 *Natürliche Schöpfungsgeschichte* (1868) had been translated as the *History of Creation* in 1876. Given his deep interest in evolution, it is likely Kagawa knew the English translation of Haeckel's book from his two years at Meiji Gakuin. If Haeckel is indeed the source for Kagawa's view of racial origins, it is especially ironic that Kagawa calls the *Burakumin* "descendants of Caucasians," since Haeckel

47. Kudō, "Kagawa Toyohiko and the *Buraku* Issue," 117–18.
48. 淘汰 *tōta* means "selection" as in "natural selection" (自然淘汰 *shizen tōta*). The term implies elimination, culling, and weeding out.
49. Kagawa, *A Study of the Psychology of the Poor*, 103.

actually characterizes Caucasians as a superior race. As Jackson and Weidman point out, "In the *History of Creation*, Haeckel divided human beings into ten races, of which the Caucasian was the highest and the primitives were doomed to extinction."[50] Whatever the origins of his early sympathy with social Darwinism, it is clear that at this juncture Kagawa had not yet picked up on Bowne's and Bergson's criticisms of Spencer.

To bring this discussion back to the concrete reality of the slum, we return to the story of the young woman who visited the Kagawas there. During a tour of the slum, after showing her the dispensary that they had opened with the royalties from the sale of his best-selling novel, Kagawa led her on to the section reserved for the *Burakumin*. As they walked on, the young woman recalled one of his poems about the harshness of life in the slums, and she began to seriously doubt that she would be able to join the Kagawas in their work.

> At suppertime Kagawa said, "If you really want to test yourself, you might go tonight to the slum bathhouse. Do you have the mind to go?" A cold shiver ran down my spine at the idea of going to a public bathhouse of the diseased.... When supper was finished, I was taken by Madame Kagawa to the public bath.... Standing in the bathroom foggy with steam, I closed my eyes and resolutely put one leg into the tub. As my foot touched the bottom of the wooden tub, I felt the smeary slime.... Madame Kagawa, as though swimming, went around the tub greeting people.[51]

Firstly, the fact that the *Buraku* continued to be segregated in the slum indicates the pervasiveness of this prejudice in Japanese society at the time. Secondly, while we should not make too much of the moving account of Madame Kagawa (Haru),[52] it is possible that she did not bear the class prejudice that had obstructed her husband's vision.

We do know that a year before Haru's death,[53] with the publication of the third edition of her husband's *Collected Works* in 1981, the question

50. Jackson and Weidman, *Race, Racism, and Science*, 87.

51. Ishigaki, *Restless Wave*, 153–54.

52. Although Haru had also been born into a *samurai* family (*shizoku* 士族), her family experienced very difficult financial circumstances, with her father having to change jobs several times. Haru worked as a housekeeper and in a factory in Kōbe that printed Bibles before meeting Toyohiko in 1911. They were married in 1913.

53. Though they were the same age, Haru outlived her husband by twenty-two years and, after his death in 1960, bore full responsibility for the many projects they has started.

of whether or not to include the prejudicial statements in *A Study of the Psychology of the Poor* once again became the subject of heated debates. Mihara Yōko draws on Shimada Keiichirō's report of Haru's "immediate and resolute" response to this issue:

> If these issues are being debated in the academic world, would it not be natural for the statements to be published as originally written and then receive the appropriate criticisms? Is it not important to note that this issue was amended and redressed through Kagawa's unceasing activities from the time he wrote the book as a 27 year-old until he died at 72 years-old?[54]

Recalling Orwell's admonition that "saints should always be judged guilty until they are proved innocent, but the tests that have to be applied to them are not, of course, the same in all cases," Kagawa's view of the *Buraku* is a case where his personalist, holistic, and ethical vision falters as a consequence of his own class bias. In spite of his own painful experiences of ostracism and shame as the child of a concubine, the loss of his family's former fortune and status, and his unquestionable personal commitment to improving the conditions of the poor, it seems that the confrontation with the "otherness" of Japan's "untouchables" could not deliver him of his sense of native pride as the son of an elite *samurai* family. While the *Shinōkōshō* class-system[55] of the Tokugawa Era was *de jure* no longer in effect, Kagawa was unable to escape its enduring *de facto* influence. This class bias, in turn, led him to rashly embrace a quasi-scientific "racial theory of origins" and lend tacit support to the "indirect eugenics" of "self-selection,"[56] which of course helped prepare for the subsequent horrors of "direct" eugenic programs promoting forced sterilization and systematic genocide. Jackson and Weidman reflect on the contribution of Haeckel's theory of racial origins to these later developments, saying:

> There was much in Haeckel's Monist worldview that endorsed social Darwinism, indeed, that was proto-Nazi in character. In keeping with

54. Mihara, "Beloved Wife," 86.
55. See footnote 32 above.
56. It is clear that his tacit support for "indirect eugenics" did not end with this early book on poverty. For example, in *The Science of Love* (1924), he says, "The higher a people ascends, the more strictly must be the standard of selection so that the superiority of the race may be maintained." Kagawa, *The Science of Love*, 122. Since these kinds of references appear from time to time in Kagawa's writings, more work remains to be done on the extent of the influence of eugenics.

their religion of nature, Haeckel and his Monists believed that the Germans needed to revitalize their inner racial essence by renewing their contact with nature. True Germans were Aryans, the highest race, but they faced biological deterioration and decay unless they applied nature's law unimpeded in society. This meant that the weak and sickly must be destroyed at birth, that the needs of the individual must be subordinated to the state, particularly to the state's authoritarian power, and that a harmonious organic community, pure in racial essence, must be evolved as a result. A supporter of polygenism and of conflict and struggle between higher and lower races, Haeckel helped make racism scientifically respectable.[57]

While Kagawa's love for nature had a benign origin, his experience in the slums, combined with his early studies of evolutionary science, led him, at least for a time, to endorse spurious and destructive conclusions about Japanese racial purity.

Mutō tries to excuse Kagawa's "appalling" stereotypes of the *Buraku* as "errors of a youthful impetuosity."[58] Some have maintained he was merely repeating commonly held prejudices of the time, which is surely true, and others may want to see his views as an example of the growing international enthusiasm for social Darwinism and eugenics,[59] but the fact remains that, by singling out certain of his fellow Japanese as an allegedly inferior race, Kagawa undermines his early conviction of the need for science and religion to complement each other.

While the methodological pluralism of his theory of redemptive love was admittedly still in embryo when he completed *A Study of the Psychology of the Poor* in 1914, his published views on the *Buraku* are indefensible. Masayoshi Chubachi and Koji Taira rightly conclude:

> Kagawa's uncompromising *Buraku*-determinism for Japan's urban poverty, which he defended vehemently at the expense and character of the people of *Buraku*, is an unfortunate scar in his otherwise praiseworthy career as a social reformer.[60]

As an ironical historical footnote, we would be amiss if we failed to men-

57. Jackson and Weidman, *Race, Racism, and Science*, 87.
58. Kudō, "Kagawa Toyohiko and the *Buraku* Issue," 105.
59. A good examination of the elitist contempt for the masses is John Carey's expose of these views among British literary elites. While Carey does not touch on Japan in this context, Kagawa does make reference to many of the writers Carey mentions; i.e., H. G. Wells, G. B. Shaw, Ezra Pound, James Joyce, E. M Forster, Virginia Woolf, T. S. Eliot and others. Carey, *The Intellectual and the Masses*.
60. Chubachi and Taira, "Poverty in Modern Japan," 406.

tion that Kagawa was often viewed as an inspiration to those battling racial prejudice in different cultural and social contexts. One such international admirer was Francis J. Grimké (1850–1937), also a graduate of Princeton Theological Seminary (class of 1878), and well-known African American church leader and pastor of 15th Street Presbyterian Church in Washington, DC.[61] Grimké offers high praise during Kagawa's 1936 speaking tour to the United States.

> There is no man in all the world today, in my judgment, that shows more of what Christianity can do for humanity than Dr. Kagawa, the noted Japanese Christian....
>
> He seems to know what is going on in the whole range of the world's intellectual activities, in history, in science, in philosophy, in theology, and literature in general—a scholar, a thinker, an omnivorous reader, a prolific writer; and, at the same time, a stupendous worker in the practical affairs of every day life. Wonderful is the only word that I can think of that describes him....
>
> Here is a man of another race that, in the qualities that go to make up greatness of the highest order, is without a superior anywhere.... As this man moves about; as he lives his simple, beautiful, self-sacrificing life of love, he is a standing rebuke to race prejudice, and all narrowness and bigotry based on race or color everywhere.
>
> As Dr. Kagawa goes back to Japan may the American white man learn that God is no respecter of persons; that in every nation he that feareth Him, and worketh righteousness, is accepted with Him.[62]

While one of course may doubt whether Grimké would have been so positive had he known about Kagawa's early statements about the *Buraku*, in light of such an enthusiastic welcome by a leading African American church leader and in agreement with the above-mentioned sentiment of Haru, Kagawa's lifelong partner and closest colleague in ministry, it is entirely appropriate to criticize the "saint of the slums" when he fails to follow the personalist, holistic, and ethical principles of his self-confessed "scientific mysticism," while still acknowledging his many significant contributions.

61. See Woodson, *The Works of Francis J. Grimké*, who observes that "Kagawa had some followers among the Negroes in the United States. Dr. Grimké was an ardent admirer of this Oriental Christian" (1: 553).

62. Grimké, *Dr. Toyohiko Kagawa*. I want to thank Mark Mullins of the University of Auckland for the Grimké reference.

STUDIES AT PRINCETON (SEPTEMBER 1914 TO MAY 1916)

After more than four years of living and working in the Shinkawa slum and a year after his marriage to Haru, Kagawa headed to the United States for a period of intensive study. While in Princeton, Haru attended Yokohama Kyōritsu Gakuen, a "mission school" for training women evangelists and pastors' wives.

Toyohiko at Princeton Theological Seminary (1st row, 3rd from the right)

Kagawa arrived at Princeton Theological Seminary in September 1914,[63] soon after the outbreak of world war in July. Though he was enrolled in the Bachelor of Divinity course at the seminary, it seems he felt he had studied enough theology at Meiji Gakuin and Kōbe Theological College and was eager to enroll in upper level mathematics and science courses at next-door Princeton University.[64] In recognition of Kagawa's interests and abilities, the seminary made certain allowances. Morimoto Anri says:

> It was the year Ross Stevenson assumed the presidency and began to promote the curricular exchange with Princeton University.... He

63. Yokoyama, *A Biography of Kagawa Toyohiko*, 108.

64. "Princeton Theological Seminary (PTS) was established in 1812 after a decision was reached to separate from the College of New Jersey (Princeton University's name at the time). Today, the two independent institutions "have a collegial and support-ive relationship, with some exchange privileges in course enrollment as approved by faculty. The University stands at the center of the Princeton community, but it is not affiliated with the Seminary." Princeton Theological Seminary Website.

Haru at Yokohama Kyōritsu (1st row, 2nd from left)

was exempted from classroom attendance provided that he submitted his final papers.... It seems that the Seminary's generosity did pay off. From these courses [at the university] he learned that the theory of evolution was in perfect harmony with Christianity.[65]

Yokoyama tells the story about the time Kagawa had to sit for an examination that qualified him to enroll as an auditor in advanced biology courses at Princeton University.

Because Kagawa was not officially enrolled at Princeton University, he was required to take a qualifying examination. The exam question required him to list the current bibliography and write a brief summary on the current state of evolutionary theory. Kagawa had been interested in evolution since his secondary school days and had read most of the books on the subject in the Meiji Gakuin Library, so this test question really hit the bull's eye. When he had finished writing and was staring out the window at the barely visible scenery, the exam proctor came in. He took up Kagawa's exam and let out a sound of admiration. Naturally he found Darwin and Lamarck, but also Edmond, Wallace, Johannsen, etc. In fact, Kagawa had listed 41 titles along with their summaries. After a long pause, the exam proctor stared at Kagawa and firmly offered his hand in search of a handshake.[66]

Unfortunately, aside from a passing reference in the April 6, 1936 *Daily*

65. Morimoto, "The Forgotten Prophet: Rediscovering Toyohiko Kagawa," 303.
66. Yokoyama, *A Biography of Kagawa Toyohiko*, 109. While Yokoyama does not mention the source of this story, presumably it was Kagawa himself.

Princetonian, there is no official transcript of the courses Kagawa took at the university. That newspaper article, entitled "Cooperative Groups Subject of Lecture by Kagawa Tonight," says, "While preparing for the ministry at Princeton Theological Seminary, Dr. Kagawa took four advanced courses in biology and mathematics and did graduate work in psychology and philosophy at Princeton."[67] In support of this claim, his official seminary transcript lists "Experimental Psychology" with Dr. Warren and "Algebra and Geometry" with Professor Bennett as two courses he took at the university during his first year (1914–15).[68] We get a further hint from Kagawa himself who says in the Preface of *Cosmic Purpose*, "In July of 1914, with the onset of World War I, I headed for Princeton University where I majored in mammalian evolution."[69] Also, in *New Life through God* (1929), he adds a biographical note about his time in Princeton and his persistent wrestling with a radical view of the struggle for survival, saying:

> In Darwin's theory of evolution, the weak are at a great disadvantage. Not really convinced, I wanted to do some specialized research on the subject. I had read various books on the subject, and at Princeton University I shut myself up in the experimental laboratory to study. I finally came to the conclusion that the reality of the struggle for existence is not as Darwin stated it.[70]

While we do not know which university courses he actually took during his second year in Princeton, they were likely drawn from the graduate level biology courses listed in the catalogue for the academic year 1915–16, as follows: Comparative Anatomy of Vertebrates, Vertebrate Embryology, Histology, Advanced Histology and Neurology, Vertebrate Paleontology, General Physiology, and Genetics.[71] As the books in his personal library also testify,[72] there is no doubt that Kagawa continued to study a broad range of sciences long after his student days in Princeton.

67. "Cooperative Groups Subject of Lecture by Kagawa Tonight," front page. This speech at Princeton University was part of an extensive speaking tour, which focused on his Rauschenbusch Lecture at Colgate-Rochester Divinity School.

68. Henke, Kenneth (PTS Curator of Special Collections), e-mail message to author, March 4, 2011.

69. Kagawa, *Cosmic Purpose*, 29.

70. Kagawa, *New Life through God*, 100.

71. *Catalogue of Princeton University 1915–16*, 1915.

72. See listing in *Kagawa Toyohiko Library: A Preliminary Listing* (Tokyo: Meiji Gakuin University, 1963).

But, in the absence of further documentary evidence, to say anything more about his actual course of study at the university would be to speculate.

However, of special note, at the seminary he took special "Readings Courses" on "Evolution and Its Theological Applications and Effects" and "Evil and Theodicy." The first course was most likely directed by Professor B. B. Warfield and the second could have been directed either by Warfield, C. W. Hodge, or both. According to Kenneth Henke:

> "Evolution and Its Theological Applications and Effects" is listed in the 1915–16 catalogue among the electives as a "Reading Course," not a seminar with regular meetings. According to the catalogue, "studies in special topics may be arranged in any department on consultation with the Professor in charge. This work is conducted by means of assigned reading, under stimulus, direction and advice of the Professor in personal conference." This particular course is with the list of reading courses given "in conference with Dr. Warfield and Dr. Hodge," so the expectation that it was Warfield who directed his reading in this area is quite plausible.
>
> The course on "Evil and Theodicy" is also listed as a reading course "in conference with Dr. Warfield and Dr. Hodge." The Dr. Hodge in question would have been Caspar Wistar Hodge, Jr., grandson of Charles Hodge. He and Warfield shared the work of the Systematic Theology Department, so this reading course could well have been under either or both. I do not think there would be any significant distinction in theology between them, as Caspar Wistar Hodge, Jr. had done his theological studies under Warfield while a student at PTS.[73]

Because of the content of Kagawa's writing following his time at Princeton, we will concentrate here on the course on evolution. While Warfield was a well-known Calvinist and biblical inerrantist, he also took a rather positive view of evolution, a position that challenges the standard contemporary view of the battle lines between religious conservatives and science. With the help of an article coauthored by David Livingstone and Mark Noll, we will explore Warfield's views in some detail to get some sense of their probable influence on Kagawa's thinking.

Livingstone and Noll say, "One of the best-kept secrets in American intellectual history is that B. B. Warfield, the foremost modern defender of the theologically conservative doctrine of the inerrancy of the Bible,

73. Henke, e-mail messages to author, March 4, 2011 and June 13, 2014.

was also an evolutionist."[74] They add, "Exploration of Warfield's writing on science generally and evolution in particular retrieves for historical consideration an important defender of mediating positions in the supposed war between science and religion."[75] They also point out that, though Warfield held Darwin and his achievement in highest regard and wrote extensively on evolution, he also bemoaned his abandonment of theism and rejection of teleology. Warfield's characterization of Darwin as an agnostic tempered his teacher Charles Hodge's famous view of Darwin as an atheist. Livingstone and Noll comment:

> In his lecture "Evolution or Development" Warfield had noted that the atheism that Charles Hodge detected in Darwin's theory was confirmed in "the history of his own drift away from theism as recorded in the recently published Life and Letters of Charles Darwin." In his review essay on this biography Warfield expressed his conviction that the word "agnosticism" best captured the spiritual state into which Darwin progressively fell. Perhaps for that very reason, Warfield found this detailed record of Darwin's spiritual evolution or—perhaps better—spiritual atrophy and associated "affective decline," as it has been called, uncommonly arresting, not least because the individual concerned was one in whom an "unusual sweetness" of character was to be found. If Darwin was an unbeliever, he was still, in Warfield's eyes, a noble figure, albeit of an altogether tragic sort.[76]

With some caveats, we think it is likely that Warfield's "mediating position" helped Kagawa hold on to a Reformed doctrine of creation, as we discussed in the last chapter, while enthusiastically welcoming the insights of modern science.

In 1915 Warfield published a summation of his views on creation and evolution in an essay entitled "Calvin's Doctrine of the Creation," and that year corresponds exactly to the time Kagawa was probably taking the course with him on "Evolution and Its Theological Applications and Effects." This Japanese evangelist with such a great interest in and knowledge of evolutionary theory would have surely impressed Warfield. Livingstone and Noll summarize Warfield's essay and comment on its import as a "mediating position" in the conflict between science and religion:

> After a full career of commenting on questions about the origin of the earth and of species, he concluded a lengthy paper on John Calvin's

74. Livingstone and Noll, "B. B. Warfield (1851–1921)," 283–304.
75. Ibid., 283.
76. Ibid., 296.

view of creation with an interpretation that doubtless represented his own view as well: "All that has come into being since [the original creation of the world stuff]—except the souls of men alone—has arisen as a modification of this original world—stuff by means of the interaction of its intrinsic forces.... [These modifications] find their account proximately in 'secondary causes'; and this is not only evolutionism but pure evolutionism." In other words, Warfield's convictions make him a predecessor of that group of recent conservative Protestants who at once maintain ancient trust in the Bible and also affirm the results of the modern scientific enterprise—a group of not insignificant thinkers routinely erased in triumphalist histories of both scientistic and creationist stripe.[77]

In terms of the influences on Warfield, Livingstone and Noll mention his father William Warfield, a scientifically-minded cattle farmer who drew on Darwin's "natural selection" theory in his book on *The Theory and Practice of Cattle Breeding*, as well as his undergraduate studies with James McCosh at Princeton University, "an early promoter of the compatibility between traditional Christian faith and non-naturalistic forms of evolution."[78] But beyond such personal influences, Livingstone and Noll claim, "Warfield's comprehensive Calvinism was at least as important for his attitude toward science as his specific views on individual theological topics."[79]

Whether or not Kagawa actually read the 1915 essay on "Calvin's Doctrine of the Creation," he surely would have known Warfield's views well and would have been very interested in his esteemed professor's approach to a subject, which he himself had been pondering since "Arming Crabs." Another natural point of convergence between Kagawa and Warfield was their love of animals and extensive knowledge of farming. Between his undergraduate studies at Princeton University and ministerial training at Princeton Theological Seminary, Warfield had worked as the "livestock editor" at the *Farmers Home Journal* in 1873.[80] Also growing up in a farming village, Kagawa was very knowledgeable about local plants and animals. Five years after his studies in Princeton, he helped found the Japan Agricultural Cooperative.[81]

77. Ibid., 284.
78. Ibid., 285.
79. Ibid., 287.
80. Ibid., 291.
81. 日本農民組合 *Nihon Nōmin Kumiai*, founded in 1921.

Returning to Warfield's views on evolution, Livingstone and Noll say it was in the Reformed theological notion of *concursus* that he had discovered a "foundational axiom that would also shape his response to questions of science."[82] In the Reformed tradition, the idea of *concursus* brings together an Aristotelian view of God as "*primum movens* and of providence as a *continuata creatio,* that defines the continuing divine support of the operation of all secondary causes (whether free, contingent, or necessary)."[83] As one application of this idea, Warfield argues for *concursus* and against a theory of dictation to support his doctrine of biblical inerrancy, saying:

> The Scriptures are the joint product of divine and human activities, both of which penetrate them at every point, working harmoniously together to the production of a writing which is not divine here and human there, but at once divine and human in every part, every word and every particular.[84]

Livingstone and Noll add:

> This doctrine had immense philosophical potential for Warfield's understanding of science: simply, the products of natural history could be the consequence—at the same time—of both natural forces and divine action....
>
> Throughout Warfield's career the concept of *concursus* was especially productive for both his theology and his science. Just as the authors of Scripture were completely human in writing the Bible even as they enjoyed the full inspiration of the Holy Spirit, so too could all living creatures (with the exception of the original creation and the individual human soul) develop fully through "natural" means. The key for Warfield was a doctrine of providence that saw God working in and with, instead of as a replacement for, the processes of nature. [85]

As his 1913 work on Schweitzer shows, Kagawa was completely open to so-called "higher critical" approaches to biblical studies, thus, unlike Warfield, he was never wedded to a defense of biblical inerrancy. Yet he would have enthusiastically welcomed Warfield's embrace of a notion that supported a mutual interpenetration of "natural forces and divine

82. Livingstone and Noll, "B. B. Warfield (1851–1921)," 289.

83. Muller, *Dictionary of Latin and Greek Theological Terms,* 76–77.

84. Warfield, "The Divine and Human in the Bible," 547. Quote from Livingstone and Noll.

85. Livingstone and Noll, "B. B. Warfield (1851–1921)," 289, 304.

action" in Scripture and in nature. The idea of *concursus* accords well with Kagawa's holistic integration of faith and science.

Besides the notion of *concursus*, Warfield's critical views on Darwin's rejection of teleology and the resultant advance of scientific materialism may have also had a significant and enduring influence on Kagawa. On this first point, Livingstone and Noll say of Warfield, "He made it clear that evolution could be given a teleological reading, that mechanical explanations in nature were thoroughly consistent with his Calvinistic conception of divine creation, and that evolutionary theory did not rule out the possibility of occasional miracles."[86] They also elaborate on Warfield's concern that Darwin's rejection of teleology contributed to a materialist ideology that undermines an orthodox view of faith.

> Warfield was, nevertheless, concerned lest Darwin's profession of teleological skepticism should engender the suspicion that science was antagonistic to classical Christian faith. And so late in 1888 he summarized his detailed, technical argument from the *Presbyterian Review* treatment of the *Life and Letters* [of Darwin] for the more popular audience of the *Homiletic Review*. This essay appeared under the title "Darwin's Arguments against Christianity and against Religion" in the January 1889 issue. The spread of scientific materialism, the spiritually stultifying effects of mundane empiricism, a naive social-scientific progressivism, and "the crude mode in which religion is presented to men's minds, in these days of infallible popes and Salvation Armies, which insults the intelligence of thoughtful men and prevents their giving to the real essence of faith the attention which would result in its acceptance"—all, Warfield believed, contributed to an unwarranted, but increasingly widespread, perception that science and religion were at war.[87]

Indeed, Kagawa's lifelong engagement with science as a religious leader, which culminates in *Cosmic Purpose*, may be summarized in the following three points that have a surprising consonance with Warfield's views: (1) A critical acceptance of the evolutionary theory of natural selection; (2) A teleological reading of evolutionary history; and (3) A view of mechanism that repudiates radical materialism.

While in the preface of *Cosmic Purpose*, Kagawa draws attention to his studies in "mammalian evolution" during his time in Princeton, the evidence also suggests that his studies with Warfield provided him a positive

86. Ibid., 298.
87. Ibid., 297–98.

"middle way" to negotiate the tensions between biblical faith and modern science. As we will see in the next section, there is little doubt that he deepened his knowledge of science at the university. Yet, while Morimoto claims Kagawa learned that "the theory of evolution was in perfect harmony with Christianity" from his studies at the university, he also would have learned of this harmony at the seminary under the guidance of Warfield. At a time when many Japanese Protestants were becoming Unitarians in light of Darwinist claims, it is probable that Kagawa's studies at Princeton Theological Seminary showed him a way to remain true to the Reformed confession of his beloved missionary benefactors Meyers and Logan, while treating ongoing scientific insights into the natural world as a complementary source of divine revelation.

After being awarded the Bachelor of Divinity degree from Princeton Theological Seminary on 9 May 1916, Kagawa had hoped to enroll in the doctoral program in biology at the University of Chicago. After spending the summer in New York, he actually went on to Chicago for this purpose, but his health was failing and finances inadequate. Fearing a recurrence of tuberculosis, he gave up the idea of further study and went on to Ogden, Utah where he worked with Japanese farmers in order to earn enough money for his return fare. He returned to Kōbe in May 1917 to resume his life in the slum and pursue a thoroughgoing program of evangelical social reform.[88]

Spiritual Movements and Social Movements (1919)

At the end of WWI, the whole world was reeling from the gradual revelation of the horrors that had been wrought by the new machinery of modern warfare. In 1919, the same year W. B. Yeats penned "The Second Coming" and Karl Barth completed his first edition of *Der Römerbrief*, the thirty-one-year-old Kagawa published *Spiritual Movements and Social Movements*. As with *A Study of the Psychology of the Poor* (1915), the preface contains an almost comical apology for his inability to solve the problem of "cosmic evil," as well as a heightened sense of evangelical urgency:

> I am certainly not satisfied with the collection of essays published here. In the near future, I hope to gather my thoughts on cosmic evil into a more systematic form. Yet I am afraid such a synthesis may take

88. Schildgen, *Apostle of Love and Social Justice*, 73–82.

a long time.… The eight million souls sacrificed in Europe cry out in anguish for the inauguration of a new age. I must shape my own reflections for the sake of this coming age![89]

This statement gives a sense of the seriousness with which Kagawa approached his mission. It also suggests that his course at Princeton Theological Seminary on "Evil and Theodicy" had not provided him with an adequate solution to the problem of cosmic evil. Yet, whereas the Yeats poem conjured up a center-less world on the brink of a frightening post-Christian apocalypse, and the Barth commentary hoped to drive the final nail into the coffin of Christendom's theological naiveté, from the midst of the Kōbe slum, Kagawa resisted the temptations of poetic pessimism and theological iconoclasm, gesturing instead at a more optimistic middle way to read the post-WWI *Zeitgeist*. This more positive appraisal of human potential reflects the maturation of his thinking on the complementarity of religion and evolutionary science.

Written within the two years of his return from Princeton, the essays collected in *Spiritual Movements and Social Movements* (1919) are proof of his deepening interest in the implications of post-Darwinian developments in evolutionary theory for the ongoing advancement of more just and egalitarian societies. In the absence of a transcript of his coursework at Princeton University, this book is the best evidence we have of the kinds of courses he likely completed. Kagawa treats a broad range of subjects from an evolutionary perspective that welcomes the contributions of religion and philosophy in moderating the extremes of materialism, physicalism, and casualism. Mutō says, "Drawing on Fabre's research on the struggle for existence and post-Bergsonian views of evolution and teleology, the book is a research essay on evolution itself."[90] He articulates his grand vision for the gradual and progressive transformation of modern societies away from greed and violence toward cooperation and peace. Since this early book presents the "root and trunk" of the approach to science and religion that Kagawa generally held to all the way up to *Cosmic Purpose*, we will treat three selected essays in some detail. These essays show that while his basic concerns remained consistent from the time of the crab study, he was now eager to expand on those concerns after a considerable time for study and reflection in Princeton.

The first essay we will look at is entitled "Fabre's Research on the Strug-

89. Kagawa, *Spiritual Movements and Social Movements*, 261.
90. Mutō, "Commentary on *Spiritual Movements and Social Movements*," 554–55.

gle for Existence." In light of the earlier discussion of "Arming Crabs" and
Warfield's teleological view of evolution, it is not surprising that Kagawa
immediately takes on Darwin's conclusions about the "struggle for exis-
tence" and "purposeless variation."

> When one lives in a cloudy society defiled by the foggy air, the confu-
> sion reaches all the way to one's brain. From our perspective today, it
> is regrettable that Darwin settled only on the "struggle for existence"
> and "purposeless variation" as the key principles for the theory of
> biological evolution, after wandering in the darkness of the uncertain
> statistical analysis of Malthus's *Theory of Population* and Helmholtz's
> physicalist metaphysic.[91]

Passing over the *ad hominem* insult on the effects of the English
weather on clear thinking, Kagawa introduces his assertion that Darwin's
conclusions about the "struggle for existence" and "purposeless variation"
were influenced more by nineteenth-century philosophical trends than
by the scientific data. He repeats this assertion over and over again in his
speeches and writings, and by the time of *Cosmic Purpose*, he has added
Büchner to the list of these alleged ideological influences on Darwin.

> Around the time Charles Darwin published *On the Origin of Species*
> (1859), chemistry in general had not made any progress, and even
> physics had not yet had so much as a glimpse of wave mechanics.
> Consequently, the basic ideas he formulated in his theory of evolution
> followed three current hypotheses: Ludwig Büchner's materialism,
> the mechanism of Hermann von Helmholtz based on a physiological
> science that mainly involved the "imperfections of the eye," and the
> "theory of population" of Thomas Malthus, all of which suggested
> casualism.[92]

In further support of his claim about the sources of Darwin's ideo-
logical views, Kagawa turns to recent findings in genetics and offers an
unreferenced quote from British geneticist William Bateson, who pur-
portedly claimed, "If Darwin had lived twenty-five years longer, he surely
would not have advocated that theory [the struggle for existence]."[93] Dar-
win had died in 1882, and Mendel's ground-breaking work in genetics in
the 1860s had been overlooked until scientists such as de Vries, whom
Kagawa mentions later, rediscovered it at the turn of the twentieth cen-

91. Kagawa, *Spiritual Movements and Social Movements*, 284.
92. Kagawa, *Cosmic Purpose*, 100.
93. Kagawa, *Spiritual Movements and Social Movements*, 284.

tury. On the tantalizing history of science question of why Mendel's work was overlooked for so long, in contrast to Bateson who had claimed Mendel was ignored because "everyone was distracted by the controversy over Darwin's *Origin of Species*," Elizabeth Gasking says:

> One is forced to conclude that Mendel was ignored because his whole way of looking at the phenomena of inheritance was foreign to the scientific thought of his time. Like Darwin, Mendel was a conceptual innovator, with a quite novel way of thinking about species; and until 1900 there was no place in the general framework of biological theory into which his work could have fitted.[94]

Kagawa then spells out his own view of evolution, which recalls our earlier discussions of Kropotkin's response to Huxley and to Warfield's "mediating position." While never questioning natural selection, he vehemently resists the reduction of evolution merely to the struggle for existence. He says, "It is good that Darwin advocated the theory of evolution. Its merits are great. However, from the perspective of social value, to seek an explanation of the whole process in the superficial terms of biting fang and sharp claw leaves an irredeemable stain on his entire achievement."[95] Kagawa musters further support for this judgment by saying that, in spite of the comprehensiveness of the theory, Darwin's research centered only on a tiny fraction of known life forms: "While saying that the bat sucks the horse's blood and black rats chase grey rats, he also says the world of insects is similar, thus claiming that the struggle for existence is the ruling principle in the entire evolution of life."[96] He then cites Henry Drummond, a Scottish evangelist and another early interdisciplinary writer on religion and science, who claims that the evolution of motherly love, care for infants, and other forms of "altruism" among lower animals places certain limits on the struggle for existence. Drummond's *The Ascent of Man* resonated powerfully with Kagawa's own evangelical vocation and intuition of the "naturalness" of motherly love, altruism, and Christ's self-dispossessing redemptive love. In this book, Drummond concludes that "there is nothing in Christianity which is not in germ in Nature."[97] Drummond adds that altruism struggles

to express itself throughout the whole course of Nature.... Only by

94. Gasking, "Why Was Mendel's Work Ignored?" 60.
95. Kagawa, *Spiritual Movements and Social Movements*, 284.
96. Ibid., 284.
97. Drummond, *The Ascent of Man*, 344.

shutting its eyes can Science evade the discovery of the roots of Christianity in every province that it enters.... The Will behind Evolution is not dead; the Heart of Nature is not stilled. Love not only was; it is; it moves; it spreads.... A system founded on Self-Sacrifice, whose fittest symbol is the Leaven, whose organic development has its natural in the growth of a Mustard Tree, is not a thing foreign to the Evolutionist...."[98]

Drummond's monistic approach that argues for a deep, underlying continuity between physical and spiritual realities fits hand in glove with Kagawa's own holistic instincts. After Drummond, Kagawa touches on Kropotkin's research on mutual aid among animals to try to further moderate Darwin's view of the struggle.

Next he triumphantly claims that, with Dutch botanist Hugo de Vries's interpretation of Mendel's work on mutation, Darwin's view has not only been fundamentally overcome, but the origin of the species may now "be seen as arising from the transcendent variation of a deep cosmic will.... Nowadays, the dominance of Mendelism has made us rethink dependence on the delusion of the struggle for existence."[99] In spite of the hyperbole, the nuanced point Kagawa wishes to make here is not that genetics had fully disclosed the secrets of the "deep cosmic will," but only that Mendel and his interpreters had introduced a new level of complexity into evolutionary theory that needed to be seen as a complement to the struggle for survival. Again, for the "scientific mystic," consciousness of the progressively unfolding complexities uncovered by the sciences brings us face to face with the ultimate mystery of the "transcendent variation of a deep cosmic will." In other words, as science reveals more and more about the cosmos, we are reminded of how little we actually know. Again, Kagawa sees wonder and humility as keys to the mutual progress of science and religion.

The historical development from natural selection to genetics is a perfect example of what Kagawa means when he says that ongoing scientific discoveries are revelatory. Recall his self-description as a "scientific mystic":

I am a scientific mystic. The more scientific I am, the more I feel that I am penetrating deeply into God's world. Especially in the domain of biology do I feel as though I am talking face to face with God.

98. Ibid., 345–46.
99. Kagawa, *Spiritual Movements and Social Movements*, 285.

> Through life, I discover purpose even in a mechanical world. Science is the mystery of mysteries. It is the divine revelation of revelations.[100]

For Kagawa, new scientific insights expand without ever dissolving the limits of human knowledge, and the "scientific mystic" welcomes such expansions of consciousness as forays into a closer proximity to the ultimate horizon. We should recall Kagawa first felt he had penetrated into "God's world" by the banks of the Yoshino River. The sense of oneness with the natural environment had diminished his feelings of abandonment and loneliness, and the embrace of nature in turn led him to want to collect and care for his own menagerie of dependent creatures. A sense of being held by "Mother Nature"[101] led him to want to hold other living things. Even before he had encountered the story of Christ's redemptive love, he had intuited the inherent "salvific" or "healing" potentials of life. It is little surprise that he equated "God" with "Life" and came to see the science of biology, which is in essence a progressively evolving discourse on life, as a "divine revelation."

Returning to the essay, having presented evidence from contemporary science that suggests evolution is not entirely "red in tooth and claw," Kagawa next introduces us to the French entomologist J. Henri Fabre, his archetypal scientist. Kagawa tells us that Fabre concentrated his research on the struggle for existence, and after reading his books on insects, Darwin himself had highly praised him as "the inimitable observer."[102] In *New Life through God*, Kagawa adds a biographical note about how he became interested in Fabre. He recalls:

> Ōsugi Sakae, who was later killed by a policeman on September 6, 1923, made a sudden visit to my home when I was living in the slums and brought me an English translation of J. H. Fabre's treatise on entomology.... Until I read that book, I did not know that Fabre was such a great man, nor did I know that the struggle for existence is based on a law of remarkable regulation....
>
> The struggle for existence is certainly a fact, but it is not merely an unregulated confusion of slaughter. We have come to see clearly that there is a path, an orderly limit to it all. A strange temporary pause has been brought to light, and Fabre, who recognized this fact, came to

100. Axling, *Kagawa*, 161–62.
101. When referring to nature, Kagawa often uses the Japanese word 大自然 *daishizen*, which implies personification as in the English expression "Mother Nature."
102. Kagawa, *Spiritual Movements and Social Movements*, 285.

the conclusion that God, the wondrous unifying energy in the depth of life, exists.[103]

Kagawa is moved by Fabre's "passion, diligence, and patience" in observing "life itself." Instead of merely performing dissections in a lab and labeling the specimens, Fabre saw the meticulous observation of creatures and their behavior in their natural habitats as true zoological research. The key phrase for Kagawa is "to research living things exactly as they live."[104] Fabre's observational approach accords well with the Japanese *shizen* (nature) aesthetic, which means, "imposing no assistance; the condition or result of things as they are."[105] The natural environment of Provence was the laboratory where Fabre concentrated on insects and spiders. Saying that Darwin himself did not bring nearly this depth of field observation to *Origin of Species*, Kagawa waxes eloquent about Fabre's work in this pastoral setting, perhaps because it reminded him of his own observations of creatures as a youth in Tokushima. He says:

> Fabre's world is a world of wonder. Fabre's world is the world of insects. There is both love and the blood feud. But Fabre's world cannot be discovered merely by human praise, it is a world where one must struggle to arrive at a tiny hole no wider than 3 mm in diameter, and peering into this world of treasure find there a realm of life, love, and glory. Fabre's world is not the flat, two-dimensional world of the European War, it is a world transcending five or even ten dimensions, a world comprising hundreds of dramatic acts.[106]

The next section introduces Fabre's writings, which Kagawa had presumably read in English translation. He praises the clarity and simple artistic beauty of his writing style: "What I love and find most interesting in his writings is that nature is portrayed as nature.... His inquiring mind crawls right into the instinctive world that takes you into the very heart of nature."[107] The carefully turned phrase—"His inquiring mind crawls...."[108]—signifies the depth of affinity between the observer Fabre and the observed insects. In Fabre, Kagawa sees the personal, embodied, self-dispossessing, and exocentric dimension of the knowing event,

103. Kagawa, *New Life through God*, 100.

104. 生きたものを生きたまま研究する. Kagawa, *Spiritual Movements and Social Movements*, 285.

105. This is the definition for 自然 *shizen* from *Iwanami Japanese Dictionary*, 468.

106. Kagawa, *Spiritual Movements and Social Movements*, 286.

107. Ibid., 286.

108. 潜り込む *mogurikomu*.

which is so decisive for his "scientific mysticism." The conviction here is that the deep intelligibility of complex phenomena is only discernible to those who are willing to go deep. This view, which is influenced by Japanese notions of the active and relational character of knowledge and Bowne's personalism, also anticipates Michael Polanyi's epistemological notion of "indwelling." In *The Tacit Dimension*, Polanyi says, "it is not by looking at things, but by dwelling in them, that we understand their joint meaning."[109]

Kagawa goes on to compare Fabre with Tolstoy, another of his youthful heroes. He says both lived long lives, both disliked Darwin, and both chose to live in a rural district. Their writings are similarly vigorous and plain—both embodied an international spirit, were religious, and wrote for children. But, Kagawa says that their difference lies in the fact that

> whereas Fabre was thoroughly scientific, Tolstoy took an anti-scientific stance. Thus, Fabre's opposition to Darwinism is thoroughly based on the inductions of zoological environmentalism. Tolstoy's opposition to Darwin comes from his passionate moral consciousness. Regarding the scientific opposition to Darwin, Tolstoy said this was not his path and hence not his problem. This is precisely the point where I value Fabre's perspective.[110]

Those who wish to characterize Kagawa as a moralist or romanticist should note well this declaration of his clear preference for Fabre over Tolstoy.

In the next section, Kagawa introduces the following three reasons that Fabre rejected the Darwinist view of the struggle for existence: (1) The struggle transcends food; (2) The struggle transcends survival; and (3) The fine-tuning of instinct. To support the first point, Fabre points to the example of a butterfly that goes without food for seven months. Kagawa says, "While not going so far as to deny the struggle for survival, he [Fabre] found something else at work in the shadows of the struggle, something that implicitly orders, limits, and even mends the struggle for survival."[111]

In support of his second point, Fabre offers the case of the spawning Bembex wasp that curiously does not destroy weaker and bothersome

109. Polanyi, *The Tacit Dimension*, 18. The "joint meaning" in this context refers to the meeting of "proximal" (*from*) and "distal" (*to*) dimensions of the knowing event mediated by the body.
110. Kagawa, *Spiritual Movements and Social Movements*, 287.
111. Ibid., 287.

predator gnats as an example that seems to run counter to the tooth and claw notion of survival. Kagawa quotes the following passage from Fabre's *The Hunting Wasps*:

> Then how is it, I ask myself once more, that the Fly-huntress allows herself to be worried by another of the tribe, by an infinitesimal bandit, incapable of the least resistance, whom she could reach with a sudden rush if she tried? Why not relieve herself of that prey that clogs her movements and swoop down upon those evildoers? What would be needed to exterminate the ill-omened brood that hangs around the burrow? A *battue* would take her a few seconds. But the harmony of the universe, the laws that regulate the preservation of species will not have it so; and the Bembex will always allow themselves to be harassed without ever learning from the famous "struggle for life" the radical method of extermination.[112]

After listing several more examples of insect sacrifice that appear to set limiting conditions on the harshness of the struggle for survival, Kagawa says, "We must conclude that we have moved far away from the Darwinian world of purposeless evolution."[113]

Kagawa then turns to Fabre's third point on "fine-tuning" that seeks to further qualify the standard Darwinian view of the struggle. He says that, rather than seeing instinct as the direct result of the struggle for existence, Fabre's observations led him to conclude that instinct "arises from another kind of mysterious law."[114] Kagawa then recounts Fabre's scrupulous descriptions of the Cerceris, Sphex, and Ammophilae species of hunting wasps that, while spawning, anesthetize their prey to preserve their bodies long enough for their larvae to be able to ingest them fresh. While the descriptions of the technical proficiency of these macabre surgeries is astounding in itself, Fabre further finds that the wasps' means of inducing paralysis optimally minimizes the pain experienced by their hapless victims. Kagawa concludes, "In this way, Fabre discovered from the hunting wasps that the instinct that appears in the biological world not only sets limits on and fine-tunes the struggle for existence, it even seeks to reduce cruelty to the greatest possible extent."[115] He then notes that Fabre saw the "fine-tuning" evident in this law as a challenge to the Darwinian view that instinct is produced by blind accident. Kagawa

112. Fabre, *The Hunting Wasps*, 321–22.
113. Kagawa, *Spiritual Movements and Social Movements*, 288.
114. Ibid., 289.
115. Ibid.

qualifies Fabre's position, saying, "Of course, he [Fabre] recognized that instinct goes through changes and transitions. But, this fine-tuning of instinct meant for him that it cannot be completely determined by an accidental view of natural selection."[116]

Referring to Fabre's last chapter in *The Life of the Spider* entitled "The Geometry of the Epeira's Web," Kagawa says that in his mathematical analysis of the structure of the spider's web, the French entomologist found evidence for an instinctive power that transcends human wisdom and natural selection. There, Fabre concludes, a "universal geometry tells us of a universal Geometrician, whose divine compass has measured all things."[117] Kagawa hastens to add that Fabre was not in any hurry to use the word "God," yet he acknowledged that he had encountered profound mystery in his study of insects.

In the Preface to *The Life of the Spider*, Belgian playwright and Nobel laureate Maurice Maeterlinick says of Fabre:

Waiting for chance or a god to enlighten us, he is able, in the presence of the unknown, to preserve that great religious and attentive silence which is dominant in the best minds of the day. There are those who say:

"Now that you have reaped a plentiful harvest of details, you should follow up analysis with synthesis and generalize the origin of instinct in an all-embracing view."

To these he replies, with the humble and magnificent loyalty that illuminates all his work:

"Because I have stirred a few grains of sand on the shore, am I in a position to know the depths of the ocean?

Life has unfathomable secrets. Human knowledge will be erased from the world before we possess the last word that the Gnat has to say to us....

Success is for the loud talkers, the self-convinced dogmatists; everything is admitted on the condition that it is noisily proclaimed. Let us throw off this sham and recognize that, in reality, we know nothing about anything, if things were probed to the bottom. Scientifically, Nature is a riddle without a definite solution to satisfy man's curiosity. Hypothesis follows on hypothesis; the theoretical rubbish-heap accumulates; and truth ever eludes us. To know how not to know might be the last word of wisdom."[118]

116. Ibid., 290.
117. Fabre, *The Life of the Spider*, 400.
118. Ibid., 33–35.

It was Fabre's "great religious and attentive silence" in the face of the "depths of the ocean" and the "riddle of Nature" that attracted Kagawa. "To know how not to know" was exactly the self-dispossessing message of hope Kagawa wished to convey to the leaders in science and religion at the close of the First World War. Near the end of his chapter on Fabre, Kagawa returns again to the moment at hand.

> His [Fabre's] world is not a world without struggle. Yet if the struggle he saw among living things is not the same as that portrayed by Darwin, it is also not like that seen in wars between human beings. It is a struggle that is fine-tuned, limited, and one regulated by an optimal minimization of cruelty. While he [Fabre] does not proclaim selfless love like Tolstoy and Kropotkin, he acknowledges a world that is fine-tuned and a wise cosmic will, and granting ascendancy to that will, he sought to live his life in conformity to that will.[119]

Kagawa concludes this chapter with a story that Fabre recounts from his own childhood. Since his family was poor, as a young boy he had to take a job as a cathedral bell ringer in order to pay his school fees. This job required donning a white robe and singing incomprehensible Latin hymns. But this experience motivated his study of Latin and the classics, which in turn led to his interest in mathematics, which was his major course of study in university. However, rather than taking up a post in an urban university, he opted for rural life in Provence, devoting himself to his studies of insects where, in Kagawa's words, he "captured the shape of mystery." Kagawa concludes, "He could still hear the cathedral bell in nature's life. And today, we still hear the peal of that bell in his writings and observations."[120]

In contrast to Yeats's dystopian vision of the "rough beast... slouching toward Bethlehem to be born"[121] and Barth's indictment of Christendom's theology and theologians,[122] from the platform of the Shinkawa slum, Kagawa offers a conscientious French entomologist as the embodiment of a religio-aesthetic and scientific disposition who exemplifies the virtues of wonder and humility. Kagawa believed that this open-minded wonder in the face of life offered religious and scientific leaders and their followers a constructive way forward following the desolation of wwi.

119. Kagawa, *Spiritual Movements and Social Movements*, 291.
120. Ibid., 291.
121. Yeats, *The Collected Poems*, 187.
122. Barth, *Der Römerbrief.*

The second essay we will touch on from *Spiritual Movements and Social Movements* is entitled "An Analysis of Teleology." Here again we hear a strong echo of Warfield's teaching, as Kagawa immediately takes Darwin to task for his use of Hermann Helmholtz's work on the "imperfection of the eye" as evidence for an anti-teleological casualism. He says, "Even if the eye is imperfect, this does not prove that 'accident' rules the world. It must be said that Darwin's linkage of the eye's imperfection to the theory of evolution was overly hasty. This led to the result of denying finality, which was an excessive leap."[123]

Kagawa often returns to this point about Darwin's use of Helmholtz. For example, in *Cosmic Purpose*, he says, "Darwin was stimulated by Helmholtz's work on 'imperfection in the eye,' which for him meant that there is no design or purpose behind the lack of perfection. We are left reading him with a sense of desolation."[124]

Kagawa then presents the case of a single-toed ungulate[125] that lived in South America during the Pleistocene Era. It had survived for at least 30,000 years, but because of certain problems with its leg joints, its toe disappeared and the animal became extinct after losing its ability to adapt with this limitation. He says:

> While its foot sufficiently fulfilled the purpose of running, its ability to adapt was lacking. It is very problematic to explain this in terms of accident. It took at least 30,000 years for this animal to develop its wonderful legs, and just as it was almost complete, it seems it was overly specialized for survival, and could not avoid extinction due to a slight problem.... The same may be said about the imperfections of the human eye. Darwin employs a strange logic there. Firstly, he says, "Imperfect things are without purpose," secondly, "The purpose of things that are in progress is unknown," and thirdly, "Cases lacking harmony are purposeless."

Kagawa then returns to his case of the extinct ungulate.

> The purpose of "running" had been fulfilled, but the question of whether an animal is perfectly adapted is a completely different issue. Just because it did not develop perfectly, we do not say that its purpose was not in running but in suddenly becoming extinct. Would this not be as ridiculous as taking only the case of a person who could

123. *Spiritual Movements and Social Movements*, 303.
124. Kagawa, *Cosmic Purpose*, 214.
125. He calls this ungulate レトプターナ *retoputana* or *letoputana*, an ungulate name I could not locate in English or Japanese taxonomies.

not speak and saying that the human tongue had evolved without the purpose of speaking? This kind of paradox occurs because finality is misunderstood and taken too narrowly.[126]

Kagawa's issue with Darwin is what he takes as his naïve conclusion that mechanical imperfection is clear evidence of an absence of purpose. In *Cosmic Purpose*, Kagawa describes his objection in greater detail, saying:

> Darwin was further attracted to the ideas of Hermann Helmholtz and his mechanistic view of the life world. Helmholtz's views on the "imperfections of the eye" relied on a unilaterally mechanistic view of nature. He held that evolution progresses with imperfections present throughout the mechanisms of the natural world. I cannot agree that imperfections mean that the mechanisms themselves come about blindly....
>
> Hermann von Helmholtz has criticized the human sense organs for serious imperfections. Without denying these imperfections, we should not forget how mental capacities step in to compensate. The human eye, like a telescope, has been made with good distance vision, but how about when it is using a microscope? Given its ability to employ all manner of optical devices, does not the simple and imperfectly constructed human eye actually appear to be rather well made? St. Paul writes that "my [Christ's] power is made perfect in weakness" (2 Cor 12:9). The same paradox holds true for human sensation.[127]

We should note that this is one of the only times in *Cosmic Purpose* that Kagawa appeals to a biblical insight. He wants to tie the spiritual insight of a power that is perfected in weakness to the apparent weaknesses or imperfections observed by scientists. Behind Helmholtz's and Darwin's embrace of blind mechanism, Kagawa detects some abstract ideal of perfection (i.e., the ancient Greek ideal or the Newtonian "clockwork" universe?)[128] that quickly runs aground on hard empirical evidence of biological imperfections. Kagawa's point is that the conclusion that some imperfection requires a rejection of finality could only appear in relation to such a culturally biased ideal of perfection. Indeed, given the biological evidence at hand, it seems quite reasonable for Helmholtz and Dar-

126. Kagawa, *Spiritual Movements and Social Movements*, 303.
127. Kagawa, *Cosmic Purpose*, 149, 260.
128. See Reiss, *Not by Design*. Admitting that even Darwin does not escape expressions of purpose, Reiss seeks to liberate evolutionary theory once and for all from all traces of ideas of finality.

win to reject the transcendent ideal of perfection and finality represented by the cultural heritage of Athens or post-enlightenment Germany and England.

However, within Japan's predominantly Buddhist cultural milieu, where the assumed reality of suffering, the causes of suffering, and the quest for means to overcome suffering is woven into the very fabric of daily life, imperfection is not just a given, it is a key aspect of a comprehensive religio-aesthetic view of life.[129] This ideal is embodied in traditional arts, such as flower arrangement[130] and tea ceremony,[131] and seasonal celebrations such as cherry blossom viewing.[132] It is derived from the Buddhist teaching of the "Dharma seals" or the "three marks of existence" (*sanbōin*):[133] "Impermanence,"[134] "suffering,"[135] and "emptiness" or "no-self."[136] Given this cultural difference in the perception of value, it is not surprising that Kagawa has no patience for Darwin's hasty rejection of finality based on apparent imperfections in the human eye. Putting aside the question of whether or not Kagawa accurately depicts Darwin's position or even exaggerates it for his own evangelical ends, there is no question that, especially in light of competing perspectives in biology and the new discoveries in physics on the nature of matter, he was reaching for a more nuanced, post-Newtonian or post-Darwinian teleology, capable of embracing the paradoxes, complexities, and imperfections of life, and most decisively, the ultimate paradox of the self-dispossessing "strength in weakness" revealed in Christ's redemptive love.

After dealing with Darwin's disappointed perfectionism, he then goes on to list seven teleological theories, as follows:

1. Partial Temporal Teleology: This refers to cases where certain things appear and then end up disappearing in the rearing of organisms, such as in a developing egg yolk or *sinus terminalus* when something disappears in a blood vessel in a hatching chick;

2. Partial Spatial Teleology: As in the case of flowers and insects;

129. This ideal is sometimes called *wabi-sabi* (侘び寂び). *Wabi* means "taste for the simple and quiet" and *sabi* means "elegant or quiet simplicity." *Kenkyūsha's New Japanese-English Dictionary*, 1408.

130. 生け花 *ikebana*.

131. 茶道 *sadō*.

132. 花見 *hanami*.

133. 三法印.

134. 無常 *mujō*.

135. 苦 *ku*.

136. 空 *kū*.

3. Temporally Transcendent Teleology: As in the proposal of mammalian zoologist William Patten, the notion that a transcendent purpose has been added to *Homo sapiens*;

4. Spatially Transcendent Teleology: As in the teleology of Thomas Aquinas, this is the notion of an absolute harmony in the biological world, such that the lamb is created for the lion, the cattle for human beings, etc.;

5. Subjective Teleology: As in the ordinary [purposive] actions of human beings;

6. Teleology of Natural Selection as Progressive;

7. Teleology of Heterogeneity as Restricted Variation: While it may seem problematic to even count this as a teleology, this is not the case, since variation is restricted, as in Loeb's idea of heterogeneity wherein restriction gives birth to another restriction, and if variation is temporally determined as a kind of limit, there is no other way to interpret it [but teleologically].

Kagawa does not offer this as an exhaustive list, but as a range of possibilities within which he wants to clarify his own views. As we have learned to expect, he characteristically adopts an eclectic, mediating position:

I have flaws such as the eye, yet as long as I recognize the existence of laws that curtail and repair such flaws, I think that in one sense we may say finality has already been demonstrated. Yet in such a case, I do not adopt early modernity's philosophically subjectivist teleology to interpret the "eye." In various ways, I am compelled to recognize the existence of a kind of progressive purpose in restricted variation, and certainly something like a kind of partial temporal purpose.

Yet, in the case of the eye, I cannot adopt the transcendent or absolute teleologies of Patten or Thomas Aquinas. This would be to transcend the limits of science by trespassing into a too distant metaphysical world. However, if we were to accept objective, progressive purpose, we will realize that it is not accident and chaos that rule the cosmos, but both temporally and spatially, order and law. Once we grasp this point, we can say that the confusion of nineteenth-century metaphysics disappears.[137]

Drawing on elements of the teleologies numbered 1, 6, and 7 above, Kagawa opts for a position that sees God at work in and behind the laws of the cosmos. He rejects the transcendent metaphysics of Patten and Aquinas as not sufficiently scientific. In brief, his teleology is immanent,

137. Kagawa, *Spiritual Movements and Social Movements*, 303–4.

temporal, and progressive. Further, he acknowledges the limits of subjectivism, which of course is different from personalism, and sees variation as restricted. While his examination of mechanism will become more nuanced by the time of *Cosmic Purpose*, he basically holds onto this immanent, progressive, and temporal teleology going forward.

While he does not cite him here, this is one of the clearest examples where Kagawa aligns himself closely with the personalist and immanentist metaphysics of Bowne, whom we introduced in the last chapter as a seminal influence. Eugene Thomas Long explains Bowne's position on "mechanical" versus "volitional" causality:

> Bowne sides with common sense in affirming causality and in distinguishing between mechanical and volitional causality. Mechanical causality may have practical value, says Bowne, but it cannot explain reality. In the mechanical doctrine of causation every present change finds its causality in an infinite regress which it can never explain. In the volitional idea of causation every act is traced to the personal purpose and volition of the agent. In this way, we avoid the problem of infinite regress. Volitional causality is the only causation of which we have actual experience, and only it can account for our experience and the world as the activity of supreme intelligence. According to Bowne, we know that the intellect in its self-conscious activity can maintain uniformity throughout change. And when we extrapolate this to the uniformity of things in general we know that it must be found in the will and plan of God.[138]

While Bowne takes Darwin's challenge to teleology with utmost seriousness, he remains confident that a theistic philosophy has the means to overcome atheism and naturalism. Showing how Bowne's metaphysic of "volitional purpose" goes "well beyond Kant," Rufus Burrow says:

> Bowne lauded the idea of "an immanent purpose of which nature is but the substantial expression."[139] He believed in the continuity of the natural laws; God's working through these rather than violating them; and purpose as the cause of the system of natural laws. Since purpose is immanent in things, these are what they are precisely because of purpose.
>
> Bowne was very much affected by the Darwinian principle of natural selection, although he placed the emphasis elsewhere. For him the crucial point was not the "survival of the fit," but the *"arrival of the fit."*

138. Long, *Twentieth-Century Western Philosophy of Religion 1900–2000*, 206.
139. Bowne, *Studies in Theism*, 149. Quote from Burrow.

For Bowne wondered how an intelligent and purposive being like the person could even arrive in the mechanistic, purposeless, impersonal world of evolutionary theorists like Herbert Spencer. He was more concerned with *how* the fit and unfit arrive.[140] Is there suggestion of an orderly system of living things in the world? Bowne's teleological interpretation of evolution suggests that God is always working through the evolutionary process.[141]

While Kagawa spent more time reflecting on the details of science, his view of causality is essentially the same as Bowne's.

The final essay we will look at in *Spiritual Movements and Social Movements* is entitled, "Post-Bergsonian Evolutionary and Teleological Theory."[142] This piece further reveals the depth of Kagawa's studies in biology at Princeton, as well as his familiarity with contemporary developments across a broad range of fields, especially recent breakthroughs in physics. At this juncture, Bergson's vitalism is already a significant influence on Kagawa, but his is a critical and qualified acceptance.

He begins the essay by stating that twelve years after Bergson's 1907 *Creative Evolution*, "It is clear that Bergson had not, as of yet, pinned down the inner mystery of reality."[143] In support of this assertion he mentions the broad acceptance of de Vries's theory of mutation, J. J. Thompson's discovery of the subatomic electron, and the sudden explosion of research in experimental biology. Further, drawing on recent developments in chemistry and physics, he continues:

> He [Bergson] is especially unclear and weak in his view of matter. For Bergson, matter is somehow static and in a kind of dualism with, or at least opposed to spirit. While the Bergsonian view that "evolution begins with the destruction of matter" is intriguing, such a conjectural expression has been rendered meaningless by what we are taught by the recent theories of the evolution of matter. According to the views of Tilden and Ramsey, "There is nothing as unstable as matter." While Lord Kelvin at first could not believe this idea, he accepted Le Bon's theory as he approached death. From this perspective, Bergson's theory (of matter) becomes somewhat strange.[144]

140. Bowne, *Metaphysics*, 280. Quote from Burrow.

141. Burrow, "Bowne's Contribution to Theistic Finitism," 137–38. Italics are Burrow's.

142. Kagawa, *Spiritual Movements and Social Movements*, 304–7.

143. Ibid., 304.

144. Ibid., 304. These references are to chemists Sir William Tilden and William Ramsey, and physicists Gustave Le Bon and Lord Kelvin.

Kagawa's point is that Bergson's static view of matter does not hold up to the new evidence. While it may seem strange to see biology, chemistry, physics, and philosophy so easily correlated in this manner, in the early twentieth century, academic fields were not as clearly separated as they are today. We have already seen that Fabre had moved from mathematics to zoology. Bergson had also studied mathematics and was up to date in psychology,[145] and Gustave Le Bon, whom Kagawa mentions here, was a psychologist and sociologist as well as a kind of amateur physicist. Le Bon claimed to have discovered an "invisible radiation," which he called "black light," and though some prominent scientists, presumably including Kelvin, accepted his theory, it was later repudiated, a fact Kagawa readily acknowledges.[146]

Continuing his criticism of Bergson's "weak" view of matter, Kagawa turns to Le Bon's 1908 *The Evolution of Forces*. There the atom is portrayed as a kind of universe in miniature, with particles functioning like circling planets or comets within the atom. Le Bon also sees the electron as a pressurized form of ether that later returns to ether. Kagawa comments:

> While Le Bon's view is interesting, it seems to be lacking when seen in light of Sir Oliver Lodge's *The Ether of Space*. In the first place, ether is not something that can be pressurized as Le Bon claims. This notion is an evolutionary heterogeneity. Further, though Le Bon cannot escape the fact that ether itself is never at rest, as J. J. Thompson has pointed out in *Ether and Matter*. Ether moves at the same speed as light, and spins like a top. In this case what happens to Le Bon's theory? This is where my concern arises. And this is where the radical, heckling philosopher posits a four-dimensional theory of ether. If we go this far back we run into Ostwald's theory of energy.[147]

This is a reference to Wilhelm Ostwald's theory of "energism," which claimed energy and not matter as the fundamental substance of the universe. Ostwald "regarded his Energism as the ultimate monism, a unitary 'science of science,' which would bridge not only physics and chemistry, but the physical and biological sciences as well."[148] We need to briefly unpack the internal scientific polemics Kagawa addresses here. Firstly, he wants to show that, while Le Bon may have gotten the structure of the

145. Psychology was typically treated in Philosophy departments until the late nineteenth or early twentieth centuries.
146. Kragh, *Quantum Generations*, 34–35.
147. Kagawa, *Spiritual Movements and Social Movements*, 304.
148. Holt, "A Note on Wilhelm Ostwald's Energism," 386.

atom correct, his view of electrons as pressurized ether does not bear up. Such a fine point may seem like a digression or even an attempt to dazzle his readers with his knowledge of contemporary science, but the occasion for this essay is to bring recent developments in science to bear on Bergson's inadequate view of matter while still holding to what Kagawa sees as his core insight, namely, his notion of "duration." Indeed, in his critical retrieval of Bergson, Kagawa offers a prescient insight and a cryptic speculation. He says:

> Even while I cannot help but imagine the future is dark for me personally, if I am allowed a hypothesis, I think we may consider the innovation of Bergson's "duration" as a type of energy, and taking reality in terms of a "fourth dimension of space," how about thinking of it [duration] as a guide for walking into the future darkness? This is precisely what I would like the thinkers of the world to teach us.[149]

Kagawa's reference to the "dark future" he imagines personally might refer to his ongoing struggles with trachoma, a weak heart, or even his finances, or it even may be a foreboding that his public pacifist stance in the labor movement might lead to martyrdom.[150] The "future darkness" is probably a reflection on the sense of gloom that seemed to be hanging over civilization in the wake of WWI. Whatever the cause of these personal and corporate ruminations on the "dark future," Kagawa's key point is that, even while rejecting Bergson's view of matter, his theory of "duration" should be maintained.

His mention of the "four-dimensional theory of ether" of the "radical, heckling philosopher" calls for an explanation. But first, we need to situate Kagawa's critical retrieval of Bergson within the historical ferment brought on by the earthshaking breakthroughs in atomic physics and quantum mechanics. Before Kagawa wrote this essay, Max Planck had already published his paper on his "constant" in 1900, Albert Einstein's "theory of special relativity" had appeared in 1905, and Niels Bohr had published his "theory of atomic structure" in 1913. Still to come were Ernest Rutherford's discovery of the proton (1919), Arthur Comp-

149. Kagawa, *Spiritual Movements and Social Movements*, 305.

150. In the summer of 1916, Kagawa became aware of the effectiveness of organized labor when he witnessed the peaceful demonstrations of garment workers in New York City. Soon after he returned to Japan in 1917, he became a leader in the labor union movement in the Kansai area, but soon he was rejected by more radical labor leaders who had grown tired of his "doctrines of passive resistance, gradualism, and human love." Schildgen, *Apostle of Love and Social Justice*, 78, 113.

ton's work on x-rays (1923), Louis de Broglie's work on wave properties (1924), Wolfgang Pauli's "exclusion principle" (1925), Erwin Schrödinger's "wave mechanics" (1926), Werner Heisenberg's "uncertainty principle" (1927), and Paul Dirac's joining of "quantum mechanics" and "special relativity."[151]

In the midst of these developments, there was speculation from all quarters about how to deal with the new contention that "There is nothing as unstable as matter." One example of such speculation was the "radical, heckling philosopher" Kagawa mentions. This is a likely reference to mathematician Karl Pearson, whose atomic theory of an "ether squirt" speculates that a fourth, higher dimension of space may seep into our perceptible world of three-dimensions. Pearson says that mathematicians have been pondering the possibility of such a higher dimension for many years.[152]

Kagawa now adds his own speculation to that of Pearson and others. What if, he proposes, we take Bergson's notion of "duration" as a kind of "energy" from a "fourth dimension" that enables us to face the "future darkness?" First of all, Kagawa's assertion of the enduring value of Bergson's "duration" is prescient. Besides the work of French philosopher Gilles Deleuze, who owes much to Bergson's views, Emmanuel Levinas says, "Bergson's theory of time as concrete duration... is one of the most significant, if largely ignored, contributions to contemporary philosophy."[153] While "duration" is a very difficult concept to capture in a few words, we might characterize it as an intuitive consciousness of the dynamic movement of past into future via an ever-new present. Bergson says "duration" "signifies both undivided continuity and creation."[154] Recalling that he rejected "radical mechanism" and "radical finalism," "duration" holds the continuities and discontinuities of past, present, and future in a holistic embrace.

While the meaning of Kagawa's own speculation may not be clear at first glance, his suggestion that "duration" be thought of as a kind of "energy" seeping into our three-dimensional world from a "fourth dimension" may be read as an example of his philosophically-minded biblical

151. CERN website: http: //pdg.web.cern.ch/pdg/cpep/history/quantumt.html. All of the physicists in this list appear in *Cosmic Purpose*.

152. Pearson, *The Grammar of Science*, 322–23. As another example of a "four-dimensional theory," Pearson mentions Clifford's notion of a *wrinkle* in space.

153. Levinas quote from McLure, *Philosophy of Time*, 11.

154. Bergson, *Creative Evolution*, xiv, footnote.

imagination. We saw in the last chapter that Bergson himself was willing to connect philosophy with the spiritual life, saying that a rigorous intuitive philosophical method "introduces us thus into the spiritual life."[155] From the prophets of Israel and the life and teaching of Jesus, Kagawa personally knew the "settling of the unsettled" and the "unsettling of the settled" at the juncture of "things as usual" and "inbreaking newness," *chronos* and *kairos*, despair and hope. Kagawa believed Bergson's "duration" can help guide us in the face of the complexities of modern life and the unknown of the "dark future." While rejecting what he sees as Bergson static view of matter in light of quantum physics, he invites "the thinkers of the world" into a conversation on "duration."

Having presented the genesis and early expression of Kagawa's view of science as a self-proclaimed "scientific mystic," we will now turn to his mystical experience and regular spiritual practice. Without question, a deep and abiding perception of the *unio mystica* with God—especially God as mediated by the humanity of the incarnate Son of God, Jesus Christ, and *perceived through the medium of nature*—energized his unrelenting efforts to transform modern Japanese society according to the high ethical calling of redemptive love.

155. Ibid., 268.

4 God as Life

MYSTICAL INTUTION, METAPHOR, AND "SEEING ALL THINGS WHOLE"

Do not ask me, "Where is God?" God is not some thing to be sought.

God is that which must live. God is alive within my life.

Someone may say they searched for but did not meet God. If God can only be investigated and discovered beyond the universe, then God is not living.

Since God is living, God must live in my innermost being.

Before I seek or investigate God, God is already revealed[1] in my life.

Believing is living.

Doubters doubt, but I am animated and moved as that which is meant to be.

My life is not my own. I merely get to spy in on the progress of the divine drama from the inside of Life.

— Kagawa, *The Religion of Life and the Art of Life*[2]

The whole of creation is mine. My life penetrates to the heart of every created thing. In the kitchen it is one with the spirit of the fire, one with the spirit of the water, and one with the spirit of the blazing range. All things appeal to me. I am merged into everything. I can dwell in the soot in the chimney and find a peaceful place with the flea under the matted straw.

1. For "revealed," Kagawa deliberately opts here for the familiar Shintō or Buddhist word, *jigen* 示現, rather than the Christian term, *keiji* 啓示. On the one hand, he believed that the most effective way to proclaim the gospel in Japan was by utilizing, whenever possible, the inherited cultural lexicon. On the other hand, he wanted to be sensitive to nervous Christians who might worry he was claiming new revelation.

2. Kagawa, *The Religion of Life and the Art of Life*, 83–84.

Set free, I fly upward to the constellation of the Great Bear. I speed from star to star. Or I conceal myself in the depths of my loved one's dressing-mirror. As long as I love the whole creation I can travel about it with the utmost freedom.

"Both Mount Fuji and the Japanese Alps are but wrinkles on my brow. The Atlantic and Pacific are my robes. The earth forms a part of my footstool. I hold the solar system in the palm of my hand. I scatter millions of stars across the heavens. The whole creation is mine. God threw it in when He gave me Christ."

— Kagawa quotation from Axling's biography[3]

The mystics find the basis of their method not in logic but in life: in the existence of a discoverable "real," a spark of true being, within the seeking subject, which can, in that ineffable experience which they call the "act of union," fuse itself with and thus apprehend the reality of the sought Object. In theological language, their theory of knowledge is that the spirit of man, itself essentially divine, is capable of immediate communion with God, the One Reality.

— Evelyn Underhill, *Mysticism*[4]

Intuiting God in immediacy as the Life that infuses while transcending his own life and all life, Kagawa could proclaim without hesitation or embarrassment, "The whole creation is mine. God threw it in when He gave me Christ." As Underhill's depiction suggests, Kagawa's mysticism is primarily inspired by personal, internal, "first order" perception and not inhibited by impersonal, external, "second order" reflection, whether theological or otherwise. Because of this preference, it is easy to find passages in Kagawa's writings that, when taken out of the larger context, make him sound like a religious naturalist, pantheist, or syncretist. However, as we have seen with his tacit acceptance of certain aspects of the older Reformed theology, this preference for "first order" perception should not be taken as disdain for doctrine. Kagawa acknowledged that theology had an appropriate place, but not as a constraint on religious experience or the form of proclamation to his Japanese contemporaries.

Henri Bergson likens this relation between mystical insight and doctrine to that of "molten matter" and "mold," and Kagawa clearly preferred the "fierce glow" of insight to the settledness of careful doctrinal exposition. Bergson explains;

3. Axling, *Kagawa*, 166–67.
4. Underhill, *Mysticism*, 24.

We represent religion, then, as the crystallization, brought about by a scientific process of cooling, of what mysticism had poured, while hot, into the soul of a man. Through religion all men get a little of what a few privileged souls possessed in full.... In this sense, religion is to mysticism what popularization is to science....

Indeed, his [the great Christian mystic's] mysticism itself is imbued with this religion, for such was its starting point. His theology will generally conform to that of the theologians. His intelligence and his imagination will use the teachings of the theologians to express in words what he experiences, and in material images what he sees spiritually. And this he can do easily, since theology has tapped that very current whose source is the mystical. Thus his mysticism is served by religion, against the day when religion becomes enriched by his mysticism. This explains the primary mission he feels to be entrusted to him, that of an intensifier of religious faith. He takes the most crying need first. In reality, the task of the great mystic is to effect a radical transformation of humanity by setting an example.[5]

Especially in the early 1920s, Kagawa was under the influence of Bergson's view of intuition, which refers to a philosophical disposition or methodology that, in contrast to intellect, claims to take the knower into closer proximity to instinct or the fundamental life impulse of the *elan vital*. Whereas Bergson sees analytical intellect favoring the pragmatic, intuition is oriented toward spirit and life itself. In *Creative Evolution*, he says, "from intellect we shall never pass to intuition. Philosophy introduces us thus into the spiritual life. And it shows us at the same time the relation of the life of the spirit to that of the body."[6] Given his intuitive method, it is no wonder that Bergson also accents the power of metaphor to "represent the unrepresentable." Fujita Hisashi says, "In the spiritual, vital, or metaphysical domain, the use of comparisons and metaphors, which suggest that everyday or scientific language is insufficient, is not a detour; rather, we are taken straight to the point to which the image carries us, via 'direct vision.'"[7]

We should therefore not be surprised that Kagawa speaks of Life, cosmos, Christ, and God with a metaphorical freedom and fluidity that may worry those whose faith is centered on doctrinal exposition. He finds the basic justification of this metaphorical approach in the experience of Jesus himself. For example, in *The Inner Life of Jesus* (1924), Kagawa says

5. Bergson, *The Two Sources of Morality and Religion*, 238–39.
6. Bergson, *Creative Evolution*, 268.
7. Fujita and Lapidus, "Bergson's Hand," 116.

that because the religion of Jesus is primarily intuitive, its expression is most appropriately metaphorical.

> The religion of Jesus is the religion of *taiken* [personalized, embodied experience].[8] It is not deduction or induction but a consequence of intuition. It thus follows that, more than any other form of logic, the use of metaphor is the best means of expressing this religious experience.
>
> As a way of explaining life, to say "Life is at any rate hydrogen and oxygen" is not easy to grasp. Instead, it is far superior to use a metaphor and say, "Life is like the springing up of a tree."
>
> Not only in the religion of Jesus, but many metaphors are employed in the Buddhist Scriptures such as the Lotus Sutra and the Blue Cliff Record, which record marvelous religious experiences.[9]

We would therefore only add to Underhill's depiction that, while the basis of the mystical method is life and not logic, the use of metaphor to indicate the intuitive perception of ultimacy does not necessarily imply irrationality. The "direct" personal, embodied perception of the mystics, inasmuch as such perceptions are not delusional or pathological, has always preferred the "indirect" or metaphorical forms of expression of prophecy, imaginative narrative, or poetry. A classical example of this preference is the medieval mystics' enchantment with the enigmatic *Song of Songs*.[10] We should at the very least acknowledge that the writings of the mystics present an alternative "theo-logic" that has long inspired the worship, wonder, and witness of the faithful.

So why do we still confront such negative associations with mysticism? While we cannot go into the complex history of the terms "mysticism," "mystic," or "mystical theology," it is telling that the first definition for "mysticism" in the Oxford English Dictionary is derogatory.

> 1. Freq. *derogatory*. Religious belief that is characterized by vague, obscure, or confused spirituality; a belief system based on the assumption of occult forces, mysterious supernatural agencies, etc.

A second, more neutral definition is then listed, as follows:

> 2. Mystical theology; belief in the possibility of union with or absorption into God by means of contemplation and self-surrender; belief

8. Kagawa chooses the word 体験 *taiken* rather than 経験 *keiken* for "experience" here. In contrast to the more generalized *keiken*, *taiken* implies personalized, embodied occurrences that are not necessarily repeatable.
9. Kagawa, *The Inner Life of Jesus*, 339.
10. See Astell, *The Song of Songs in the Middle Ages*.

in or devotion to the spiritual apprehension of truths inaccessible to the intellect.[11]

Given such a negative stereotype, which must be in part a legacy of Enlightenment rationalism and the acrimonious Protestant-Roman Catholic polemics of post-Reformation Europe, mysticism is admittedly not the easiest subject to handle. Since the term "scientific mystic" may seem an even further muddling of terms, we deliberately took up the "scientific" dimension first in the last chapter, because that qualifier is a key for grasping the particular kind of mystic we encounter in Kagawa. As we turn to Kagawa's mysticism and spiritual practice, we should keep this scientific dimension in mind.

The evidence compels us to conclude that it was the sense of dwelling in and being indwelt by the One Reality that inspired Kagawa to "see all things whole." And it was also a perception of divine love that drove his unswerving commitment to one of the most wide-ranging grassroots programs linking spiritual and social reform in twentieth-century Japan. This assertion is supported by the fact that Kagawa is among a handful of Japanese Christians commonly referenced in general histories of the late Meiji, Taishō, and early Shōwa Eras.[12] Indeed, had the mystical claim not been accompanied by such an impressive record of accomplishments in the spheres of religion, education, cooperative economics, social welfare, medicine, finance, labor, and agriculture, we might easily pass over it as a case of "vague, obscure, or confused spirituality." But long before the string of Nobel Prize nominations that came late in life,[13] evidence abounds for Kagawa's determined efforts to "complete the creation of the human species"[14] by transposing the mystical vision of divine love into concrete public action. As we have already seen, Kagawa often quotes Colossians 1: 24, a key verse that indicates his deep sense of participation in Christ's redeeming love and ongoing mission in the world.

> Christ, who died for sinners, summons us to become the concrete
> expression of this redeeming love to the so-called scum of society. In

11. *OED Online.*

12. As three examples in English, see Hane, *Modern Japan,* Hunter, *The Emergence of Modern Japan,* and Barshay, *State and Intellectual in Imperial Japan.* It is the author's contention that, if more of his works were available in English, there would already be an academic field called Kagawa Studies.

13. He was nominated for the Nobel Prize in Literature in 1947 and 1948, and the Nobel Peace Prize in 1954, 1955, 1956, and 1960. *Nobelprize.org.*

14. Bergson, *Two Sources,* 234.

Colossians 1:24 Paul calls us to carry redemptive love on to its God-given goal: "I am now rejoicing in my sufferings for your sake, and in my flesh I am completing what is lacking in Christ's afflictions for the sake of his body, that is, the church."[15]

As Bergson says of the great mystics, Kagawa took "the most crying need first. In reality, the task of the great mystic is to effect a radical transformation of humanity by setting an example."[16] We propose that it is this holistic fusion of the personal, spiritual, philosophical, and public dimensions of Christian faith that makes Kagawa's case as a "scientific mystic" so compelling.

Several years before North American missionaries began pushing the "Kagawa success story" in their home churches to help legitimatize their own mixed results in Japan, news of this "saint of the slum" had already extended far beyond Japan, especially after the 1920 best-selling novel had rocketed him to celebrity status. For example, in his 1922 *The Rising Temper of the East*, war correspondent Frazier Hunt devotes a whole chapter to Kagawa after a visit to the Shinkawa slum. Comparing him to Gandhi, Hunt writes:

> Something about this man Kagawa of Kōbe makes me think of Mahatma Gandhi. Possibly it is because both are thin, emaciated, almost pitiful figures kept going by the blazing fire of their spirit. I suppose it is in this last—this spiritual fire—that lies the strongest resemblance. I'm sure their hearts beat the same tune. In India they call Gandhi, Saint Gandhi—and I'm certain that if these poor submerged outcasts of Kōbe's underworld and the striving, half educated workers of the great shipyards and factories could make Japanese saints they'd turn their Kagawa into one.[17]

Coming after the Hunt book, Gardner L. Harding's July 1923 piece was the first of more than ninety *New York Times* articles that mention Kagawa up until his death in April, 1960.[18] Harding praises Kagawa's faith as "a species of early Christianity of high tension and perfect simplicity" and compares him to St. Francis and Tolstoy.[19] While we may be tempted to dismiss such high praise from Western writers as romanticism or even Orientalism, the historical record shows that, with the exception of the

15. Kagawa, *Christ and Japan*, 95–96.
16. Bergson, *Two Sources*, 238–39.
17. Hunt, *The Rising Temper of the East*, 94.
18. *New York Times* online archive.
19. Harding, "Powerful Spiritual Leaders Wake Japan from Materialism."

war years when he was effectively silenced, Kagawa never ceased to press the heavenly vision into earthly, public causes. Of course, these causes did not always end happily or successfully. In the case of the *Buraku*, we saw that Kagawa had swallowed too quickly a spurious "scientific" theory of racial origins to justify a cultural prejudice that still held him in its grip. Still, if we take the biblical test that true and false prophets are distinguishable "by their fruits,"[20] we cannot avoid the conclusion that, with certain critical caveats, Kagawa passes the test with flying colors. Minimally, in the spirit of the Letter of James, the works clearly testify to the faith.[21]

THE INFINITE WORLD PEEPING INTO THE FINITE

We still need to explore what Kagawa actually meant by calling himself a "scientific mystic." In a compilation of speeches published as *Meditations on the Holy Spirit* (1934), he speaks of the "mystical" as the perception of the "supernatural" within the context of the "natural world" via "consciousness." He says:

> For example, prayer is one form of desire, but when we pray with firm belief in the God of the universe of Heaven and Earth, we may say prayer is a "supernatural natural" way of life. This we say is mystical. Recently there is a kind of theology proclaimed in Japan that rejects mysticism,[22] but mysticism is the experience of the supernatural within nature. A thing like prayer is the mystery of mysteries, and it is not a theory. The natural man would think it impossible to experience supernatural things in the world of nature, but I do not think so, and the experience of Christ shows it. In the moment Christ received baptism, his life received something that was somehow more than natural. We cannot but think that the supernatural came to be manifested in consciousness within the realm of nature.[23]

Recall that, like Schleiermacher, Kagawa sees Christ as the supreme exemplar of "God consciousness," and due to the merits of Christ, his followers are enabled to participate in and share this "God consciousness" through the agency of the Holy Spirit. As we have already seen, for Kagawa the natural world is the "garment" or "thought" of God and thus,

20. Matt 7:16.
21. Jas 2:14–18.
22. This is a reference to the so-called "Japanese Barthians."
23. Kagawa, *Meditations on the Holy Spirit*, 298.

through the mediation of Christ, a medium of divine revelation to faithful consciousness. He takes an analogy from mathematics to describe the mystical juncture of the natural and supernatural in Christ's own life in the Spirit.

> In mathematics they carefully explain how the infinite, that is the supernatural, pertains to the finite world. In analytical geometry the two ends of a parabola will never meet.... In mathematics it is not a strange thing for the infinite to come peeping into the finite. Speaking logically from the world of mathematics, we can easily imagine the infinite world peeping into the finite.[24]

Since Kagawa shuns speculation about the inner nature of God and instead focuses on the *sensus divinitatis* (absolute) in or through the (relative) world of nature, he feels it is important to offer rational description in so far as this is possible. But when it comes to actual accounts of the mystical encounter, he also knows that analysis and explanation only takes us so far.

In the end, we have to rely on the mystic's claims and life for evidence of the *unio mystica*, and Kagawa did speak of these things from time to time. Beyond an initial unitive encounter, which we will consider below, he claims to have had ecstatic experiences "many times."

> The experience of the Holy Spirit cannot really be expressed in words. I too have had my share of religious exaltation that comes from being bathed in the light many times, and it is an ecstasy that defies description. We intuitively feel an absolute joy, which neither sex nor selfish desire nor covetousness nor fame can ever give us. [25]

Besides such firsthand claims, we also have secondhand reports of Kagawa's spiritual disposition and practice, for example, from close missionary associates Helen Topping, his English secretary, and William Axling, his biographer, as well as from his elder daughter Chiyoko. Topping writes, "Kagawa is a mystic in that his life is frankly built on communion with God. He has always been an early riser, using the early morning hours for his devotions.... He draws his inexhaustible resources from these times of communion with God."[26] Drawing on unreferenced quotes from Kagawa's writings or speeches, Axling entitles a chapter of his biography "A Modern Mystic" and concludes, "Kagawa has developed

24. Ibid., 298.
25. Ibid., 334.
26. Hinder and Topping, Introduction to *Love the Law of Life*, 6.

the technique of discovering and exploring God and of experiencing Him in such a vivid and vital way that God no longer dwells in the marginal recesses of his soul, but fills and illumines and dominates his whole conscious life."[27] Finally, in my January 2013 interview with Kagawa's elder daughter, Chiyoko, I asked if she remembered anything about her father's spiritual disposition or practice. She said, "I never saw him pray, because following the pattern of Jesus, he prayed alone in the night. He prayed until dawn while the rest of us slept."[28]

With Kagawa's self-description as a "scientific mystic" in mind, I then asked Chiyoko why her father was so passionate about the latest findings of modern science, and she responded without hesitation, "He wanted to understand everything God has made."[29] In Kagawa's presumptive theology, everything must be related to God and therefore to everything else, even though the complexities of these relations are often shrouded in mystery, that is, not yet fully disclosed either to religious or scientific consciousness. For Kagawa, the fact of enduring mystery is itself sufficient reason for humanity to continue to wholeheartedly embrace with wonder and humility the distinct yet complementary quests and insights of science and religion. In *Meditations on God* (1930), he offers an axiomatic principle regarding these distinct yet complementary functions of human consciousness:

> Faith teaches us about the fate of humanity, science teaches us about the structure of the universe. Those who fail to recognize this distinction can only end up in a great contradiction.[30]

In other words, religion is oriented toward humanity and science toward the universe, but from his personalist perspective, Kagawa was confident that these orientations overlap at the pivotal point of human consciousness. Especially as emerging discoveries in quantum mechanics were suggesting that matter is itself a dynamic and not a static reality, which appears to necessitate personal observation in order to measure or describe it, Kagawa enthusiastically turned his religio-aesthetic awareness to the momentous new possibilities for correlating the worlds of matter and spirit.

We should note that Kagawa was one of the first in the Christian world

27. Axling, *Kagawa*, 168.
28. Author's interview with Kagawa's daughter Chiyoko.
29. Ibid.
30. Kagawa, *Meditations on God*, 5.

to begin to imagine the implications of the new physics for faith, even if that meant transgressing the boundaries of traditional Christian language about God and creation. For example, in *God and the Challenge of Redemptive Love* (1938), he writes:

> I am of the opinion that the cosmos is a spiritual entity, that material things are nothing more than a form of expression of the cosmic spirit. The attitude of such physicists as De Broglie in wave mechanics, Heisenberg in atomic mechanics, and Schrödinger is inclined more and more in a spiritual direction. According to this view, all matter is waves of light. When light is in progress and for some reason is bent backward, it then appears as matter. Hence the basis of all matter is light. We cannot grasp such a wondrous universe if we look only at its parts. If it were sufficient to stop with the parts, there would be no necessity for cosmic spirit. But because the existence of spirit cannot be denied, there is no reason why we should not construct a worldview here, investigate conscience, and choose paths leading in the direction of new life.[31]

It seemed completely reasonable to Kagawa to presume that the cosmos is geared, first of all, toward the arrival of life, and then to consciousness in order for it to begin to comprehend itself and its purpose. Kagawa assumed that such a life and consciousness-generating cosmos must be at bottom a spiritual entity.

These convictions reached their final expression in his last book, *Cosmic Purpose*, which argues for the probability (not proof) that, when evolutionary history is considered within the vast span of time and expanse of space, the cosmos moves on every level, albeit sometimes by fits and starts, in the direction of life and then to consciousness, overcoming massive obstacles in the achievement of this astonishing purpose. He writes, "I cannot believe events in the natural world are all products of chance. Even if natural events are blind, ultimately they manifest a finality that developed into human consciousness and hence necessitate the examination of the points at which blindness and finality are connected."[32]

Since he recognized that sentience or consciousness had been added from the lower animals, Kagawa did not restrict this emergent endowment to *Homo sapiens*, hence his view is more inclusive and more contemporary than the so-called "anthropic principle." For example, at the beginning of *Cosmic Purpose*, he says, "breaking through the thick and

31. Kagawa, *God and the Challenge of Redemptive Love*, 387.
32. Kagawa, *Cosmic Purpose*, 50.

chaotic fog of the material world, the pulse of life dispatches mammals with consciousness into the world of the spirit."[33]

Since he believed that the "infinite is always peeping into the finite," we should expect to find the scientific dimension just below the surface whenever we examine Kagawa's mysticism, just as we saw that the spiritual dimension is always implicit in his approach to science (i.e., in his depiction of Fabre and other "faithful scientists"). If we picture this relation in terms of the figure-ground shift of Gestalt psychology, science is the ground when religion is the figure and visa versa. Such unrestricted movement between these two spheres is to be expected, since Kagawa sees all dimensions of life artfully interpenetrating each other within the arcs of evolutionary history and redemptive love. This extraordinarily close correlation between the two spheres suggests that Kagawa's "scientific mysticism" may represent something new in the history of Christian thought.

We need to say a little more about the artistic dimension, for in Kagawa's writings aesthetic imagination always complements mystical vision. For example, in *The Religion of Life and the Art of Life* (1922), he speaks of science as an art that inspires the life of faith and worship.

> Science emerges through value. It is a kind of art. Usually, art flourishes in the objective world, but the art of science is something etched deeply into the brain. Science rearranges the cosmos. This is also the creation of a new world. When seen in this way, new science transforms the content of life, thereby becoming a motivation to religious faith and indeed to worship.[34]

In the Preface to a 1950 English translation of excerpts from his writings, Kagawa invites his religious readers to enthusiastically embrace science for spiritual reasons:

> If God has designed nature, then why does religion divorce science from her sanctuary! Embrace mathematics, physics, chemistry, biology, astronomy, meteorology, and sociology as the stained glasses of the window of the temple of God in nature.
>
> My religion is the life with the consciousness reconciled to the Creator of Heaven and earth in the mediation of Jesus Christ.
>
> In agony and sorrow for the miserable lives of the breakable earth-

33. Ibid., 35.
34. Kagawa, *The Religion of Life and Art of Life*, 60.

enware, still I rejoice for having had bestowed on me this everlasting consciousness of Cosmic love and life.[35]

As an exemplar of an "open dynamic religion,"[36] Kagawa felt called to try to awaken his contemporaries to a religio-aesthetic appreciation for the natural sciences as partners in the great cosmic drama. Few of his contemporaries grasped the distinctive evangelical agenda of this "scientific mystic" who proclaimed that, rather than building up walls against science to protect hallowed religious and theological traditions, we should see the latest findings in the sciences as proleptic glimpses into the unfolding intelligibility, complexity, and mystery of the cosmos and the cosmic will.

By calling himself a "scientific mystic," Kagawa intends to identify with and distinguish himself from medieval mystics such as St. Francis of Assisi and Thomas à Kempis. But moving beyond such exemplars, he wants to be viewed as a thoroughly modern mystic eager to take the latest scientific findings into his religio-aesthetic meditations on life in the cosmos and in God.

UNITIVE EXPERIENCE AND SPIRITUAL PRACTICE AS "VIVIPARITY"

While often beginning with a decisive and joyful unitive experience, the life of the great mystics is also characterized by years of disciplined spiritual practice, and Kagawa is no exception. Before turning to his practice, we will briefly recount an often-mentioned, decisive experience, which we already introduced in chapter one. To repeat, in the summer of 1907, the nineteen-year-old Kagawa had been preaching daily on the streets in a slum in Toyohashi, a small city near Nagoya, and was on the verge of collapse. Later he vividly recalled that experience:

> On the fortieth day, at about nine o'clock in the evening, it began to rain while I was still preaching. For a week my voice had been getting weaker and weaker, and when the rain began falling my body was swaying to and fro. At one time I had difficulty in getting my breath. I began to feel horribly cold, but I determined, whatever happened, to finish my sermon. "In conclusion," I cried, "I tell you God is love, and

35. Kagawa, *Meditations*, Preface.
36. Bergson's term from *Two Sources*.

I will affirm God's love till I fall. Where there is love, God and Life reveal themselves."[37]

The doctor told him he was unlikely to recover from this especially virulent attack of chronic tubercular pneumonia. His condition worsened, and fearing the end was near, the doctor then suggested he call his friends to say goodbye. Kagawa recalls the scene:

> The sun was setting in the west. I could see its reflection on my pillow. For four hours I prayed, waiting for my last breath. Then there came a peculiar, mysterious experience—an ecstatic consciousness of God; a feeling that God was inside me and all around me. I felt a great ecstasy and joy. I coughed up a cupful of clotted blood. I could breathe again. The fever was reduced. I forgot to die. The doctor came back at nine-thirty. He was disappointed. He had written a certificate for my cremation and feared the people would call him a quack.[38]

We should note that, while this account probably comes more than forty years after the actual event and thus has the benefit of rescripting, it is similar to the much earlier fictionalized version of the same experience we find in *Before the Dawn*, the best-selling autobiographical novel of 1920.

> Eiichi [the Kagawa character] grasped his own wrist to feel his pulse and was surprised that he could feel nothing. But the duty which God had entrusted to him, which was to realize the spirit of Jesus by work among the poor—for the sake of accomplishing which he wished to spend his life in the slums—convinced him that he would not die. He believed that he had leapt over death and thrust himself into that mysterious world.
> He concentrated his gaze on the reflection of the electric light fixed on the pillar by the alcove. He gazed at it for one minute, two minutes—as long as fifteen minutes—and during that time, in some indescribable way, he felt himself absorbed in the unknown wonders of reality. The point of light on which he concentrated his gaze appeared to him like a rainbow, the room in which he lay like Paradise and the common quilt that covered him like a cloth of gold. It seemed as if he were being held tight by the hand of God the Father—nay, that God was something closer to him than a father—that God dwelt in him. It was a joyful feeling that he was immersed in God. No sooner had

37. Bradshaw, *Unconquerable Kagawa*, 82–83.
38. Ibid., 83.

this joyful feeling come over him than his fever departed and he was surprised to find that his pulse had returned to normal.[39]

While the memory and the fictional account are somewhat different, the sense of great joy and of being indwelt by or immersed in God is the focus of both accounts. We will touch on the import of this initial unitive experience later, but we will turn now to Kagawa's account of silent meditation, which along with the daily reading of Scripture and prayer was a part of his regular spiritual practice.

Kagawa begins his *Meditations on God* (1930) with a description of his personal experience of silent meditation. In spite of its title, *Meditations on God* is actually a presentation of Kagawa's views on the distinct yet complementary approaches of the sciences and humanities. In that book he takes a circuitous approach to God, addressing what he sees as the far more pressing question for modern Japanese, which is why religion should even be taken up as a legitimate pursuit or field of study. Before launching into that more abstract discussion, Kagawa offers a personal account of his practice of silent meditation and ends with a fervent call for his readers to discover their own "innate capacity for meditation." It is worth noting that this Preface was written when the forty-one-year-old Kagawa was traveling all over Japan as the leading evangelist in the Kingdom of God Movement.[40] It is against this frenetic backdrop of an endless schedule of public meetings that Kagawa records one of the clearest depictions of his spiritual practice and ongoing experience of the mystical union. Here is the preface of *Meditations on God* in its entirety:

As one who has learned to go deep into the forest for meditation, I often come away with dew-like drippings from that forest. In the middle of the night, at midday, at dawn, or at dusk, I have learned that the door for meditation is always open. Whether in the electric or steam train, hospital waiting room, prison cell, on the road, everywhere, I am offered a calm resting place in my heart to meditate on Almighty God. It is said that Francis of Assisi meditated and prayed while beholding the sun in broad daylight, and Plato tells us that Socrates would suddenly stop along the road to meditate for several minutes when walking with his disciples. When we read the *Āgama*,[41] it seems the Buddha had the same custom. Jesus withdrew for 40 days and 40 nights to meditate in the wilderness, and spent sleepless

39. Kagawa, *Before the Dawn*, 260.
40. See description of this movement in chapter 2.
41. 阿含経, early Buddhist Scriptures.

nights in prayer and meditation in the mountains of Galilee. Those who draw from the wellspring of meditation experience God dwelling intimately in our hearts. Those who reside in today's clamorous and busy machine civilization and wish to discover that ancient stillness must struggle to enter the realm of meditation. After losing my sight, I was able to come into contact with this sanctuary and know great joy in the discovery of this new fountain.

In times of inactivity or when I lack resources, meditation calls to me from beyond, lifting high the curtain on the divine dwelling place. From backstage, in the night of the typhoon, or the busy tumult of the street, I praise God through meditation. God is my place of Sabbath, my storage battery, and in meditation death and disillusionment vanishes, even the power of suffering is paralyzed. Almighty God even teaches an unlearned[42] person such as I to be content to rest in meditation.

I urge all tired and spiritually debilitated modern people first to return to your innate capacity for meditation, which is prior to seeing, reading, singing, or fighting. The child is in its mother's womb for nine months, simply dwelling with eyes closed, with nothing to read and nowhere to run. The ingenious solution of meditation is that it is the *viviparity*[43] that attaches us to the breast of God. Like the child in the womb, I feel the pulse of God in quiet meditation, I am nourished by God's blood, and with eyes closed I await the day I will dance out into the world of light. Before I take a breath, I live, I move, I am. Ah,

42. The Japanese term for "unlearned person" *mugaku* 無学 is also used in Buddhism to refer to "someone who has attained enlightenment." Japanese readers would catch this paradoxical usage.

A practitioner who has completed the practice of structured meditation and other forms of disciple. An arhat (*arakan* 阿羅漢) who has completed the course of practice—who has already eliminated afflictions. (Skt. *aśaikṣa, aśaikṣya, aśaikṣa-mārga, aśaikṣa-mārga-stha, arhat, arhattva*; Pāli *asekha*; Tib. *mi slob pa*). This is a category found in Abhidharma literature, where it designates a practitioner whose level is distinguished from those still in training (*yūgaku* 有學). (*Digital Dictionary of Buddhism*)

43. Kagawa deliberately choses the word 胎生 *taisei*, "viviparity," which in Japanese has both a biological and Buddhist connotation, as follows:

Uterine birth, born from a womb. Or, a being that is born from a womb. One of the four kinds of births 四生. Before the differentiation of the sexes birth is supposed to have been by transformation. The term is also applied to beings enclosed in unopened lotuses in paradise, who have not had faith in Amitābha but trusted to their own strength to attain salvation; there they remain for proportionate periods, happy, but without the presence of the Buddha, or bodhisattvas, or the sacred host, and do not hear their teaching. The condition is known as 胎宮 *taigū*, the womb-palace. (*Digital Dictionary of Buddhism.*)

this wondrous *viviparity* with earth's great womb and breast! I cannot cease to pray that all humanity will return to this great womb and be reconnected to this blood relation to God.[44]

This description is striking for several reasons. Firstly and not surprisingly, it begins in a natural setting. He speaks of "going deep into the forest," a likely reference to a bamboo forest near the Matsuzawa Church in Tokyo.[45] But gradually the range of Kagawa's meditative practice expands to include every life circumstance. During his childhood in Tokushima, he had spent many hours in solitude by the banks of the Yoshino River and in nearby fields. Now as an adult, he has discovered that "the door for meditation is always open" wherever he finds himself, even in the midst of the "busy machine civilization."

Next, he draws parallels between his personal practice and that of St. Francis, Socrates, Buddha, and Jesus, but does note that, while Socrates and the Buddha meditated, St. Francis and Jesus also prayed in addition to meditating. This distinction may seem trifling, but it is important to Kagawa. For example, in *The Religion of Jesus and its Truth* (1921), he says:

> When all religions are seen in terms of their dispositions, they may be divided into two classes: religions of meditation and religions of prayer. Examples of the first class are Zen and medieval mysticism (even within Christianity, those groups that emphasize revelation tend toward meditation). Among the religions of prayer are the Nichiren and Shingon Buddhist sects; prayer is even part of their esoteric forms. Christianity has been a religion of prayer from the beginning.[46]

We may assume that Kagawa was introduced as a child to the meditative practices of *zazen* (Zen Buddhist meditation) and *seiza* (Confucian meditation) while reading the Confucian classics with the priest at the local Zen temple. In *A Reconsideration of Eastern Thought* (1949), Kagawa expresses his personal preference for *seiza* over *zazen* in the section on neo-Confucian philosopher Wang Yangming.

> Wang Yangming also advocated dedication to self-discipline, and primarily suggested *seiza*, meaning to "be settled" whether one is "silent in the midst of activity or active in the midst of silence." *Seiza* has a

44. Kagawa, *Meditations on God*, 3.
45. His elder daughter Chiyoko mentioned this same forest in her interview with the author.
46. Kagawa, *The Religion of Jesus and its Truth*, 148.

different nuance than *zazen*. While his disciples were to avoid escapist forms of meditation, he said *seiza* was good for quieting one's heart in order to discover Heaven. One Japanese commentator mistakenly comments that Ōyōmei approved the escapist element in Buddhism as he became older.[47]

In the context of our discussion of Kagawa's mysticism, this preference for the practice of *seiza* is not difficult to grasp. Never content to rest in the contemplation of divine love as an end in itself, but always seeking to translate that love into concrete public action, he naturally favored a view of meditation as being "silent in the midst of activity or active in the midst of silence."

Undoubtedly, silent meditation was a key part of the hurried preparations for his next sermon, lecture, interview, or negotiation, but he is typically not content to simply describe his own experience. On the contrary, the evangelical impulse is strong even in this description of silent meditation, as he exhorts his readers to "struggle to enter the realm of meditation." As he imitates Christ, the supreme exemplar of the mystical union or what he calls "full consciousness," he also longs to awaken the mystical impulse in his readers.

But what is the nature of that mystical impulse? Is it something reserved only for a few privileged souls? Kagawa the "scientific mystic" pointedly chooses the technical biological term "viviparity" to depict silent meditation as a natural spiritual practice that restores us to our primal, living, dependency on God. Here is how the Oxford English Dictionary defines this unfamiliar term:

> "Viviparity: " (n.) "The condition or character of being viviparous."
> "Viviparous: " (adj.) 1. "Involving the production of young in a living state." 2.a. "Of animals: Bringing forth young in a live state" and 3.a. "*Bot.* Reproducing from seeds or bulbs which germinate while still attached to the parent plant."[48]

To portray how silent meditation restores the deepest possible intimacy ("blood relation") between persons, the earth (cosmos), and God, Kagawa chooses the metaphor of the enwombed child who "simply dwells with eyes closed, with nothing to read and nowhere to run." He had discovered in the regular practice of silent meditation an ever-available resource for renewal, clarity, and peace of body and mind. Espe-

47. Kagawa, *A Reconsideration of Eastern Thought*, 100.
48. *OED Online.*

cially in light of the growing evidence of the positive health benefits of meditation,[49] it seems reasonable to conclude that, in spite of his weakened physical condition due to early tuberculosis and ongoing struggles with trachoma and heart disease, Kagawa's spiritual practice helps to account for his legendary level of activity as an itinerant evangelist and social reformer.

As an enwombed child cannot exist independently without the sustenance of the mother's placenta, so Kagawa knows he is utterly dependent on God as the place of rest, and he employs the primal maternal metaphors of "breast," "womb," and "pulse" to depict the consciousness of this deep and enduring sense of dependency and peace. Note also the expansion of the metaphor from the "child in its mother's womb," to the "wondrous *viviparity* with earth's great womb and breast," and finally through the great womb to the "blood relation to God." The human body and its extension into the cosmos via consciousness is the vehicle for the most intimate knowledge of God. The movement from life's origin in water, its sustenance by the earth, and its ultimate destiny in the "blood relation to God" may also be an oblique reference to the Christological affirmation of 1 John 5:6–8:

> This is the one who came by water and blood, Jesus Christ, not with the water only but with the water and the blood. And the Spirit is the one that testifies, for the Spirit is the truth. There are three that testify: the Spirit and the water and the blood, and these three agree.[50]

This is not the first time Kagawa opts for maternal images to depict spiritual intimacy with God. In an early devotional piece called "A Heart Fused to God," which introduces the first edition of his *Pillar of Cloud* magazine (1922), he writes:

> Forsake all and return to God, O my soul!
> God alone awaits you in the depth of all depths.
> God is the final finishing line, the ultimate mother.
> Move back through suffering where he awaits you with unchanging
> mercy and love purer than a garden.[51]

Today it is perhaps hard to appreciate how calling God "the ultimate mother" would have been considered heterodox or even heretical by

49. See Siegel, *The Mindful Brain* and Davis and Hayes, *What Are the Benefits of Mindfulness?*

50. NRSV.

51. Kagawa, "A Heart Fused to God," 1.

Protestants in the 1920s, but Kagawa freely employs male and female metaphors in service to the mystical vision. Also, as we suggested in chapter 1, Kagawa had rediscovered in Jesus Christ a "cosmic ordering, self-confirming presence of a loving other,"[52] and having lost his own mother when he was four years old, it seems quite reasonable that he would imagine the God of love as "the ultimate mother."

In *A Reconsideration of Eastern Thought*, Kagawa positively recounts the central role played by women in the spiritual and social history of the Japanese people, beginning with the significance of female Shintō deities in the *Kojiki*, the eighth-century account of ancient matters. Also, drawing on evidence from science, he points out the pivotal leadership of females in ant and bee societies. He elaborates:

> It seems that female-centered civilizations have pressed on toward peace, but in this regard males have not been much help....
>
> For this reason, I am proud of the Japan that formerly had a female-centered life. I am filled with a sense of yearning when I think of our ancestors who lived a cheerful life characterized by a knowledge of Heaven, respect for women, and natural freedom like the sun.[53]

In another especially moving passage from *God and the Inspiration of Redemptive Love* (1938), Kagawa directly mentions his geisha mother, touching on the deepest personal and ethical motivation for his vocation as an evangelical social reformer.

> "Quo vadis, Domine?"[54] (Where are you going?) I hear the voice of Christ as He told Peter He was going back into Rome, echoing once more within the depths of my heart, and I am reminded that even if there is something good, there is no value in it if it leads us to forget to give a cup of cold water to God's little ones. I am a child of vice, and I cannot die till every geisha in Japan is rescued. I see this as my mission. Some people say I preach a social gospel, but they are mistaken. What do I care what you call it? Call it anything you please. I simply engage in the sexual purity movement[55] as a memorial offering to my

52. Loder, *Logic of the Spirit*, 90.

53. Kagawa, *A Reconsideration of Eastern Thought*, 138–39.

54. This story about Peter meeting Jesus comes from the apocryphal *Acts of Peter*. Wishing to escape martyrdom, Peter flees Rome, but turns back to accept his fate after encountering the risen Jesus on the way. As Japan was already at war with China and a deeper conflict loomed, perhaps Kagawa's identification with Peter indicates his own fear that he might face martyrdom for his anti-militarism.

55. The "sexual purity movement" refers to the organized movement to abolish prostitution, which Kagawa and his wife Haru helped to lead along with others.

mother. That is why I bear the cross, and I am sure this is my mission and also my joy. In this way I believe in the eternity of redemptive love.[56]

Cumulatively, the assertions that "The ingenious solution of meditation is that it is the *viviparity* that attaches us to the breast of God," that God is "the ultimate mother," that women have played a decisive role in the spiritual history of Japan, and that his vocation is "a memorial offering" to his deceased mother offer fresh insights that arise from Kagawa's quest for answers to the momentous question of the meaning and purpose of life in the cosmos and in God. Drawing freely on Asian, Western, and scientific sources in his reflections on his meditation practice, Kagawa leaps far beyond the Protestant thinking of his day to assert that meditation and prayer offer modern people an evolutionary advantage that restores us again and again to the ultimate source of Life through our bodies.

"GOD AS LIFE," "BEING-IN-CHRIST," AND SELF-TRANSCENDENCE

To try to get closer to the dramatic results of the unitive experience of 1907, we turn to a section entitled "God as Life" in *The Religion of Life and the Art of Life* (1922). In terms of the immediate historical setting of this work, Kagawa had recently fallen from grace with other leaders of the labor movement in which he had formerly played a leading role. In conflict with those who were willing to use force to achieve their ends, the pacifist, best-selling novelist withdrew from the movement and was condemned by one communist leader as "a patsy for the elite capitalist class."[57] Turning from the cause of urban labor, by 1922 he had begun his work with farmers, started the Kōbe Consumer Cooperative, and launched the Friends of Jesus renewal movement.

Written about fifteen years after his experience of "crossing the death line," "God as Life" presents Kagawa's maturing reflections on mystical participation in God. From Bergson, he imports the notion of an *elan vital* that infuses all life, and that this original instinct or impulse is first accessible to intuition and only secondarily to intellect. In calling God Life, and Life God, Kagawa indicates he has broken through to a direct

56. Kagawa, *God and the Inspiration of Redemptive Love*, 406–7.
57. Kudō, "Kagawa Toyohiko and the Buraku Issue," 114.

experience of the *elan vital*, which Bergson himself comes to see as the energy of God or indeed, God himself.

The following passage from *The Religion of Life and the Art of Life* deliberately evokes the Cartesian *cogito*, and since it sheds light on Kagawa's "scientific mysticism," it is presented here in its entirety. By way of introduction, note an important distinction in the Japanese between the verb "living" and the noun "Life," which is indicated in English with a capital "L."[58]

> This is what my intuitive piety teaches me:
> "I" "believe" I am "living."
> "My" "living" is not solely due to my "power."
> The "Power" of "Life" beyond "me" is my God.
> This is not a trifling theory. It is what I am compelled to believe.
> I first of all begin with "Life."
> This is "Power."
> This dwells within me. But "I" am not the thing itself. I do not in any way think I control "Life" itself. On the contrary, I perceive that "Life" controls me. It is here that I bow down and worship the God of Life.
>
> For this reason I do not believe in any God except the God of "Life." To me, God of Life is the reality of realities and value of values. Rather, it is reality as value and value as reality, revealing the phenomenon and noumenon at once. While someone might say you cannot claim that reality is value, this is a fact in relation to life. This is "Life." It grows, continually changes, and is embodied and stabilized within law. It is what leads the "I" to consciousness. This is not a geometrical absolute but is an absolute in terms of value. This is "Life."
>
> There are those who try to reduce "Life" to matter. But, in such a case, life is not life. It may be a condition or a qualified arrangement but it is not "Life" itself. "Life" is the world that entails "living" and not a world to be debated or reasoned about. It is a world that advances moment by moment.
>
> This may look like a world without any purpose. But, through the consciousness of the "I," it has an inner purpose.
>
> It cannot be present as matter. It is "Power." It is not just nature dwelling in me. Because it is a Power that "transcends" "me," it is supernatural.
>
> If you wonder if it is only "supernatural," it is not only supernatural. It dwells in "me."

58. For "living," he uses the verb 生きて居る *ikite iru*, which means "to live or to experience," and for "Life," he uses the noun 生命 *seimei*, which means "life" or "existence."

> Thus, "I" believe in "Life" as the "God" who dwells in me. This is
> where religious perception approaches the religious object. [59]

First of all, we need to keep in mind the fact that Kagawa is present-
ing his evangelical appeal to a largely non-Christian public. Besides his
use of personalist and vitalist language, he deliberately avoids overtly
Christian language, employing generic terms his audiences could read-
ily grasp. We cannot adequately stress how important it is for Kagawa
to try to proclaim the self-dispossessing love of God he knew in Jesus
Christ in terms his audience would grasp. Indeed, this deliberate avoid-
ance of Christian terms may be interpreted itself as a self-dispossessing
act of love and respect for his audience. Like Kierkegaard, Kagawa opts
for indirect over direct communication to try to awaken faith, and like
Tillich, he brings Christian insights to bear on issues raised by the con-
temporary Japanese context and carefully chooses terms his audiences
would understand. As with Kierkegaard's appeal to post-Christendom
Europe and Tillich's appeal to the existential crisis among intellectuals
in mid-twentieth-century Europe and North America, Kagawa offers his
apologia for the gospel to the fellow citizens of a rapidly industrializing
nation that was busily pursuing the twin goals of material wealth and
military power while seeming to lose sight of the larger spiritual realities
that attend life.

So what is the claim being made here? In place of Descartes's "cogito"
as the basis for epistemological certainty, Kagawa posits "living" in the
consciousness that one is not self-determined but grounded in the tran-
scendent "Power" of "Life." This connection of "living" and "Life" implies
both an identity and distinction reminiscent of the mystical language
the Apostle Paul employs to speak of the new relation, mediated by the
crucified and risen Christ, between "human spirit" and the "Spirit of
God": "For what human being knows what is truly human except the
human spirit that is within? So also no one comprehends what is truly
God's except the Spirit of God. Now we have received not the spirit of
the world, but the Spirit that is from God, so that we may understand the
gifts bestowed on us by God" (1 Cor 2:11–12). We see the same paradox
of identity and distinction in Paul's account of the mystical "being-in-
Christ," as follows: "For through the law I died to the law, so that I might
live to God. I have been crucified with Christ; and it is no longer I who

59. Kagawa, *The Religion of Life and Art of Life*, 50–51.

live, but it is Christ who lives in me. And the life I now live in the flesh I live by faith in the Son of God, who loved me and gave himself for me" (Gal 2:19–20). In his recovery of the "cosmic" framework of Paul's thinking, Albert Schweitzer calls this "Christ-mysticism" or "being-in-Christ" the "prime enigma of the Pauline teaching: once grasped it gives the clue to the whole."[60] Schweitzer says:

> In Paul there is no God-mysticism; only a Christ-mysticism by means of which man comes into relation to God. The fundamental thought of Pauline mysticism runs thus: I am in Christ; in Him I know myself as a being who is raised above this sensuous, sinful, and transient world and already belongs to the transcendent; in Him I am assured of resurrection; in Him I am a Child of God.[61]

Though it may not be clear at first glance, the same thing should be said about Kagawa's perception of "God as Life." Like Paul following his dramatic Damascus Road encounter with the living Christ, after "crossing the death line" Kagawa gradually comes to see his life and indeed all life grounded in, indwelt by, and empowered by the divine Life or Spirit of God, mediated by Christ. In light of the indisputable Christocentrism that characterizes Kagawa's Christian writings, to say "I first of all begin with 'Life'" should be taken as a circumlocution for "I first of all begin with Christ," in the same sense of the *logos* theology of the Prologue to John's Gospel:

> In the beginning was the Word, and the Word was with God, and the Word was God.
> He was in the beginning with God.
> All things came into being through him, and without him not one thing came into being. What has come into being in him was life, and the life was the light of all people.[62]

As always, the Japanese evangelist has his non-Christian audience in mind, so the metaphorical conflation of Christ and Life is justified on biblical and missiological grounds. While Kagawa was influenced by the vitalist philosophy of the day, he characteristically places it and all other conceptualizations in service to his "logic of redemptive love," which we have described as the foundation for his creative synthesis of

60. Schweitzer, *The Mysticism of Paul the Apostle*, 3. The reference to the "cosmic" framework is from the 1998 foreword by Jaroslav Pelican.

61. Ibid., 3.

62. John 1: 1–4.

the spiritual, cosmic, and ethical dimensions of life. Thus, to say "I do not believe in any God except the God of "Life," is a statement of a mystical theology that centers on the humanity and redemptive love of Jesus Christ, the incarnate Son of God. By stressing the God of "Life," Kagawa is also giving witness to his personal experience of being delivered from self-obsession and commissioned to participate in and imitate the self-dispossessing Life of God in Christ. In *The Essence of Religious Education* (1929), Kagawa defines piety, a word he often prefers to "religion," as "a life that does not take the self as the basic unit, and the sense of continually seeing the finite world afresh from the perspective of the absolute."[63]

For Kagawa, the sense of "God as Life," "being-in-Christ," or self-transcendence are never ends in themselves, but such mystical insights always occasion the practice of redemptive love on behalf of others. For example, speaking in China at the 1931 Shanghai Fellowship Conference on "The Ethical Teaching of Jesus Christ," Kagawa says:

> When we know the crucifixion, and the privilege of *living* the crucifixion, the killing of egoism, the killing of the desire to please one's self, then we know the joy of simplicity.
>
> We receive many lessons from Buddhism and from Taoism. Buddhism teaches nirvana, which simply means the casting out or sweeping away of things which are a nuisance. In the teaching of the crucifixion we have the teaching of casting out. And in Taoistic teaching, we have meditation on nothingness. When we consider worldly things as nothing, joy comes to us. And when we meditate on the crucifixion, the principles of Buddhism and of Taoism are fulfilled in the Cross of Jesus. Indeed, the great principles of all the saints and sages are fulfilled in the cross of Jesus.
>
> But we have to practice it. Preaching and practice are two different matters. Many good Christians say, "Christianity is very good. Its philosophy is good." But Christianity is not a philosophy. Christ did not preach philosophy. Christ lived the life of the Cross. I consider that the Sermon on the Mount is very good, but if Christ had not lived the life of crucifixion, our Sermon on the Mount would have meant nothing. And if all Christians will live the life of crucifixion probably no attack will arise against the Church. Because Christians are not living after the example of Jesus Christ we give offence to the inquirers. And I wish that we could manifest or live up to the standard of Jesus Christ. We have to try to do so, to live up to the goal of the crucifixion.[64]

63. Kagawa, *The Essence of Religious Education*, 295.
64. Kagawa, "The Ethical Teaching of Jesus Christ," 36.

While further biblical, philosophical, or theological warrants could be marshaled to support Kagawa's reflections on "God as Life," "being-in-Christ," or self-transcendence, we will turn now to explore two, not-so-obvious reasons why his "scientific mysticism" was and still is seen as anomalous by the established Protestant churches in Japan.

ALTERNATIVE CHRISTIAN *SHOZOKU* AND DIFFERENT THEOLOGY

We have already suggested that a succession of psychological traumas early in life readied Kagawa for later, heightened experiences of spiritual perception as a *homo religiosus*.[65] Moving beyond the psychological level, when viewed in psycho-social or psycho-cultural perspectives, Kagawa's story may be read as a heroic spiritual quest, a kind of Japanese *Pilgrim's Progress*. In this saga, the plot focuses not so much on the unburdening of the hero's self-consciousness of sin but on his attempt to restore a lost or threatened sense of attachment, belonging, or affiliation in a highly stratified culture where attachment, belonging, and affiliation are definitive for identity and, consequently, for mental health and personal survival. This claim calls for further explanation.

The Japanese word *shozoku*,[66] meaning "the place to which one belongs or to which one is subject," embraces all of the nuances of attachment, belonging, and affiliation. The *shozoku* of a businessperson is the company, the *shozoku* of a teacher or student the school or class, the *shozoku* of a religious leader the shrine, temple, or church, etc. Adult Japanese begin formal introductions with an exchange of business cards, saying, for example, "Mitsubishi Bank's Tanaka Kenji," "Tokyo University's Ikeda Keiko," or "Azuma Shrine's Saitō Mariko." That is, one's *shozoku* precedes one's personal name. We might think of the *shozoku* as the corporate identity that grounds the personal identities of a particular group of individuals. But what happens to those who enter adulthood with no defined *shozoku*?

For Kagawa, the death of his parents had led to the intense loneliness of his childhood, his sickness to a near death experience in adolescence, and his shame and alienation to serious depression and suicidal

65. To repeat, this is Erikson's terms for those for whom "religiosity has become definitive for the totality of their lives." Loder, *The Logic of the Spirit*, 231.
66. 所属.

ideation in young adulthood, and while he strongly identified as a youth with certain international literary and ideological fashions, he came of age without concrete membership in any *shozoku*. While not a naturally shy person, circumstances seemed to conspire to make Kagawa a loner in a society that literally has no place—no *shozoku*—for loners.

Hence, Kagawa's overwhelming task was to find or create a new *shozoku* within which he could flourish. It would be no exaggeration to call this a life and death issue. In fact, it is exactly in his overcoming of this personal, social, and cultural quandary that we find in Kagawa evidence of an extraordinarily generative impulse. Referring to an essay by Bergson in which he uses the term "moral innovator" to refer to such exceptional cases, Murakami Ryū says:

> Bergson sees in human beings "the creation of oneself by oneself, the enlargement of the personality by an effort which draws out much from little, something from nothing, and adds incessantly to the richness in the world…." In addition, however, in this article he mentions moral innovators who, themselves "generous," make other people generous through an "inventive heroism," and asserts that attention paid to those innovators, who are nothing but "creator[s] of excellence," will certainly lead to the origin of life, or God.[67]

This seems an appropriate description of Kagawa as a heroic and creative "moral innovator."

Given the power of the *shozoku* in Japan, it is remarkable that, during his voluntary exile in the Shinkawa slum, Kagawa manages to cobble together a completely new sense of attachment, belonging, and affiliation out of earlier and happier experiences in the bosom of the Yoshino River Basin, in the surrogate parental care of the American missionaries, and, most decisively, in the maternal embrace of Christ's self-dispossessing, redemptive love for "the least of these." Christ becomes for Kagawa the "self-confirming presence of a loving other," the "ultimate mother" by whom he is reborn and who frees him to reconstruct his inner and outer worlds. Recalling the discussion of artists and artisans in the Introduction, Kagawa's astonishing innovation and new energy speaks at the very least to the amazing resilience and creativity of the awakened human spirit to make something new out of whatever materials are available at hand.

Beginning with the founding of the *Kyūreidan* in 1910, which became

67. Murakami, "Transmission of Creativity," 46.

Left, Jesus BandHeadquarters, c. 1914 (Kagawa second from right)
Center, Jesus Band Free Clinic
Right, Kagawa in front of *Unchūsha* Headquarters, 1948

the Kōbe Jesus Band in 1914, Kagawa creates *sui generis* a new Christian *shozoku* out of his fledgling efforts in the Kōbe slum, and it is from this platform that he and a growing band of coworkers launch a grassroots program aimed at nothing less than the spiritual and social reform of modern Japan. His break with the Protestant establishment occurs as soon as he takes up residence in the slum. In this bold experiment among the poorest of the poor, he struggled to articulate the Christian gospel in terms that would be recognizable to all Japanese, regardless of social or economic class. Even though he maintained an official affiliation with the Church of Christ in Japan[68] before the war, and with the United Church of Christ in Japan[69] after the war, his formation of this alternative, competing Christian *shozoku* virtually guaranteed that he would always be viewed as an outlier by the established churches.

Kagawa's new movement soon acquired independent institutional status in the early 1920s with the official incorporation of the Kōbe Jesus Band.[70] As soon as he gained national attention for his 1920 best-selling

68. 日本基督教会 *Nihon Kirisuto Kyōkai*, also known as 旧日基 *Kyūnikki*. This is the pre-WWII name for the Japanese Presbyterian and Reformed denomination, which was officially established in 1890.

69. 日本キリスト教団 *Nihon Kirisuto Kyōdan*, which originally brought all Protestant denominations under government control in 1941 and was reconstituted in 1946 as a united church comprised mainly of former Presbyterian, Reformed, Methodist, and Congregationalist churches. It is still the largest Protestant body in Japan today.

70. With the continual expansion of projects, in 1938 the *Unchūsha* (Pillar of Cloud Corporation) was incorporated. Today it is made up of three divisions registered with the Japanese government. The first division is a public utility foundation comprised of the Kagawa Archives and Resource Center, the second division is a social welfare service foundation comprised of nine institutions for handicapped children and adults, sixteen pre-schools, twelve children and family support centers, and thirty-two child welfare residential facilities and children's clubs, and the third division is an

novel, he became the target of criticism from some of the pillars in the Protestant establishment. For example, in 1920, *Kumiai* (Congregational) Church leader Ebina Danjō wrote, "The reason the slums have not disappeared in spite of so many years of Kagawa's efforts is because his project is half-hearted." Kagawa responded:

> The slums have not disappeared because there has been nothing but criticism with few offering a helping hand. If public opinion was aroused and the row houses reformed, the slums would disappear immediately. I am happy because my staying here for so long has made people who had never given this problem a single thought begin to think about the slums.[71]

Given this background, it is not at all surprising that, in spite of his unparalleled contributions to Japanese society, the established churches still do not know what to make of Kagawa and, as we will see, his mystical claims. From the perspective of these churches, he is viewed with suspicion in the first instance because he dared to create in the slum an alternative or competing *shozoku* to that of the well-educated, middle-class, Protestant churches.

It must also be admitted that Kagawa did little to help his cause by regularly offering up criticisms of what he called the established church's excessive individualism, formalism, intellectualism, insularity, and elitism. The following story illustrates the kind of criticism that further distanced this outlier from the established churches.

> Christianity introduced from the West, because of its individualism, fails to understand the group life of the Japanese. This failure has greatly retarded Christian progress in this land. The parents of an eminent actress were murdered by burglars. A Christian pastor called after hearing about this tragedy. He entered very formally by the front entrance and endeavored to comfort her with the tenets of his faith. A Shintō believer also called. She entered by the back door, cleaned up the kitchen and brought order out of the chaos caused by the incident. The outcome was that this actress espoused the Shintō faith. Her reason is interesting. She declared, "Christian teaching is sublime but too difficult for me to grasp. The Shintō believer was kind, not over dignified, and friendly, so I accepted her faith." The Protestantism, introduced into Japan from Europe was strongly intellectualized and

incorporated educational institution comprised of the Matsuzawa Church Kindergarten. *Unchusha.com.*

71. *Liberation* cited in Mutō, Commentary on *Before the Grouse Awakens*, 416.

over-emphasized its theology. This left a gap between Christianity and the uneducated masses. There is danger therefore of it becoming merely the religion of the intelligentsia, a minority group.[72]

Recall Kagawa's *in memoriam* for Nitobe Inazō that subtly captures his own free spirit and status as the perennial outlier. He says:

> In your temperament a global spirit
> Permeated the way of the samurai
> That spirit a little too large
> To be confined to the islands of Japan.[73]

Besides the *shozoku* issue, a second reason for the Japanese churches' inability to appreciate Kagawa and his "scientific mysticism" is the relative lack of attention to the older Reformed theological tradition in which he had been nurtured.[74] As we have shown, after his encounter in Tokushima with Presbyterian missionaries from the United States, Kagawa had studied the older Reformed theology at Kōbe Theological School (class of 1911) and later at Princeton Theological Seminary (class of 1916). These studies would have focused on the biblical languages and texts, the works of Calvin and his interpreters, and the so-called "Westminster Standards."[75] While this may seem a rather narrow range of theological resources, at least up to the time of the fundamentalist-modernist split in the 1920s and 1930s, Presbyterians in the United States seemed able to embrace liberal and conservative theological perspectives within a broad, moderate orthodoxy. As an example, we have seen how Warfield himself had combined biblical inerrancy with an acceptance of evolutionary theory. Kagawa took on evolution, higher biblical criticism, and the personalism of Bowne while holding on to certain aspects of the older

72. Kagawa, *Christ and Japan*, 95–96. After more than 150 years since the first missionaries arrived, Christians still represent only 1 percent of the population, and Protestantism, which accounts for roughly half of those Christians, is viewed as an individualistic religious preference of the educated, urban middle class that continues to seem foreign to most Japanese.

73. Hamada, "Toyohiko Kagawa and Oceanic Civilization," 64–65.

74. When one American Calvin scholar, and the author's predecessor on the faculty at Tokyo Union Theological Seminary, began teaching in Japan in the 1960s, he discovered that Japanese theologians and seminarians knew Barth, Brunner, Tillich, and Bultmann but had little knowledge of or interest in Calvin. This American is credited with introducing Calvin to the students of this leading Protestant seminary.

75. Drawn up by the Westminster Assembly (1643–49), these founding Presbyterian documents include the *Westminster Confession of Faith*, *The Shorter and Larger Catechisms*, the *Directory for Public Worship*, and the *Form of Church Government*.

Reformed theology. Kagawa's liberal evangelicalism represented a historically grounded yet open, progressive theological orientation that would not have been at all unusual within Presbyterian circles, before the fundamentalist and modernists drew sharp lines in the sand that eventually split the American churches and sent ripple effects across the "mission fields."[76]

Instead of the traditional Reformed theology, the "dialectical" or "crisis theology" of Barth had become all the rage in Japan among Protestant intellectuals by the late 1920s and early 1930s.[77] This, of course, was long after Kagawa had completed his theological education, settled on his theory of redemptive love and positive views of the relation of science and religion, and was fully engaged in a growing number of evangelical and social projects. It must also be admitted that, from the perspective of Japan's established churches, European dialectical theology seemed to offer a more positive and intellectually nuanced alternative to the bitter fundamentalist-modernist controversy that was raging in the 1920s in the home churches of the missionaries and centered at Princeton Theological Seminary, the stronghold of Presbyterian orthodoxy and Kagawa's *alma mater*. Hence, not only was Kagawa seen as an outlier for creating an alternative or competing *shozoku* to that of the established churches, his theological views had been shaped in a very different era and theological milieu.

To show how this relates to Japanese theological assessments of Kagawa's mysticism, I will turn briefly to a problematic characterization in an otherwise excellent article by Unuma Hiroko on Kagawa's view of faith. Unuma is fascinated by Kagawa's inner world and clearly recognizes his importance in the history of modern Japan, yet she is puzzled about how to interpret certain unconstrained expressions of his mystical insights. In one section she struggles to sort out Kagawa's conflation of the terms "Life," "Cosmos," and "God" and is especially vexed by a reference to God as "the cosmos-penetrating Almighty." She wonders, "How is the relation between God and the cosmos being thought of here?" Then she charges, "The 'Almighty' in the expression 'cosmos-penetrating Almighty' seems

76. See Longfield, "For Church and Country" and Mulder et al., *The Diversity of Discipleship*.

77. For an early and prescient criticism of certain Japanese Barthians, see Tamura Naōmi, "Barthian Theology and Religious Education," in Hastings, *Practical Theology and the One Body of Christ*, 177–81.

to embrace the sense of a being that fills the cosmos such as we find in pantheism." Unuma continues:

> Also, sometimes as in (Kagawa's use of) the expression "Cosmic Life, or the power of God," it seems that both elements (God and Cosmos) overlap. Further, at times the three terms "God," "Cosmos," and Cosmic Life" are jumbled up and used with hardly any distinction. Still, as in the expression, "The cosmos came about as the expression of the consciousness of God," the cosmos is distinguished as something different from God, and while the two are endlessly adjacent to each other, God is God, and cosmos is cosmos. However, *it is clear that the view of the cosmos we see here is fundamentally different from orthodox Protestantism that sees an absolute break between God and the cosmos as creation.*[78]

While we do not doubt the sincerity of Unuma's anxieties about these alleged conflations, her portrayal of Kagawa's "view of the cosmos" vis-à-vis "orthodox Protestantism" is misleading. Firstly, as we saw in our earlier discussion of Calvin and Warfield, the notion of an "absolute break between God and the cosmos as creation" is decidedly *not* the position of "orthodox Protestantism." For Calvin, Warfield, and, in an amplified way, for Kagawa the "scientific mystic," the heavens are still declaring the glory of God (Ps 19:1). Indeed, had not Calvin himself endorsed astronomical and anatomical investigation as a legitimate exercise of intellectual piety? In a section in the *Institutes* entitled "The divine wisdom displayed for all to see," he says:

> There are innumerable evidences both in heaven and on earth that declare his wonderful wisdom; not only those more recondite matters for closer observation which astronomy, medicine, and all natural science are intended, but also those which thrust themselves upon the sight of even the most untutored and ignorant persons, so that they cannot open their eyes without being compelled to witness them.... To be sure, there is need of art and of more exacting toil in order to investigate the motion of the stars, to determine their assigned stations, to measure their intervals, to note their properties. As God's providence shows itself more explicitly when one observes these, so the mind must rise to a somewhat higher level to look upon his glory.... Likewise in regard to the structure of the human body one must have the greatest keenness in order to weigh, with Galen's skill, its articulation, symmetry, beauty and use. But yet, as all acknowledge,

78. Unuma, "The World of Faith of Kagawa Toyohiko," 3. Italics are the author's.

the human body shows itself to be a composition so ingenious that its Artificer is rightly judged a wonder-worker.[79]

As exemplars of this inquiring, Reformed piety, Warfield and Kagawa ponder the implications of evolutionary theory for Christian faith. Ironically, it was the older Reformed view, and not the Japanese Barthian view, that provided stronger support for a positive rapprochement between God and nature and therefore theology and science. Hence, what Unuma calls "an absolute break between God and the cosmos as creation" shows either a lack of knowledge or a glib dismissal of the older Reformed tradition of the "two books." The "absolute break" here is an apparent reference to Kierkegaard's "infinite qualitative distinction," a term Barth famously took on as a core principle for his crisis theology. This leads us to wonder if perhaps Unuma's understanding of the boundaries of "orthodox Protestantism" may be driven more by ideological constraints than by historical fact. Had she said that Kagawa's "view of the cosmos is fundamentally different from a certain Japanese Barthian view of Protestant orthodoxy," she would have been accurate.

In an earlier essay on Kagawa's view of faith, Unuma tellingly confesses to a certain uneasiness about judging Kagawa according to "an orthodox Protestant view of doctrine," and concludes with a more positive note about the potential contribution of his mystical perception of Life. She says:

> At the very least there is not a little about Kagawa's faith world that does not conform to the common wisdom of orthodox Protestantism, beginning first of all with the various possibilities for interpreting the idea of God based on a traditional confession of faith. For this reason, it is difficult to know how to evaluate Kagawa's Christian thought within the history of Christian thought. However, it will probably not be very productive for coming generations if we simply evaluate or judge Kagawa's Christianity from the perspective of an orthodox Protestant view of doctrine. As the meaning of "life" is currently being freshly reevaluated from a variety of angles, we think that precisely because Kagawa came to a subjective conviction of Christian faith via a fundamentally "personal experience of Life," his view should be ranked as a new creation within the history of Japanese Christianity.[80]

79. Calvin, *Institutes of the Christian Religion*, 1.2.53–54.
80. Unuma, "An Essay on Kagawa Toyohiko with Special Consideration of His Faith World," 240.

One almost has the sense that someone is looking over Unuma's shoulder, making sure her statements are sufficiently critical of Kagawa according to some fixed theological position. But at least she finally acknowledges Kagawa's creative—albeit, from her perspective, heterodox—contribution.

It seems clear that the phenomenon of mysticism, in general, and Kagawa's "scientific mysticism," in particular, cannot be adjudicated fairly on theological grounds. While we may be sympathetic to Barth's cautions regarding mystical excess, simply exporting his account out of the historical and cultural context of mid-twentieth-century Europe into the vastly different religious landscape and thought world of Japan and applying it to Kagawa's mystical vision is to risk obscuring beyond recognition both the vision and the original context of Barth's caution.[81]

Beyond the historical and missiological issues of importing a theological polemic out of the long legacy of European Christendom into Japan, where the legitimacy of Christianity has been contested again and again since the Jesuit missionary Francis Xavier arrived in Kagoshima in 1549, using dogmatic theology to evaluate mystical claims is to commit the conceptual error of giving priority to second-order cognition over first-order perception without providing sufficient warrant for such a choice. Such an approach is clearly not adequate for understanding or assessing mystical claims on their own merits, and it may actually subvert the ancient theological wisdom of *crede ut intelligas* and *fides quaerens intellectum*. In turn, this subversion may be a contributing factor to the curious denigration of religious experience one finds among many Protestants today. Japanese theologian Kuribayashi Teruo has recently made a positive step toward trying to correct this situation, taking Kagawa's ecstatic experience seriously and situating it within the broad history of Christian mysticism:

> Kagawa's experience of supreme bliss is that which began with Paul in the primitive church, continued in the Middle Ages with Saint Francis, Jacob Böhme and into the modern age with Nikolai Berdyaev, Simone Weil, Mother Teresa, Thomas Merton and numerous other mystics.[82]

While Kuribayashi rightly places Kagawa in this broader, mostly "West-

81. See, for example, Barth's criticism of Schubart's *Religion und Eros*. CD, III.4, 125–27.

82. Kuribayashi, "Rereading Kagawa's Theology in the Midst of a Recession," 57.

ern" stream, he does not touch on the decisive "scientific" dimension of his mysticism or its relation to the Japanese religious and philosophical heritage.

Recalling T. F. Torrance's advice, rather than adjudicating Kagawa's mysticism according to some "external or alien framework of thought," we seek to operate "with a framework of thought appropriate to it," taking seriously the claims, especially when evaluated in conjunction with his remarkable record of accomplishments.[83]

KAGAWA AS A GREAT JAPANESE CHRISTIAN MYSTIC

Having provided this overview of the internal background and external reception of Kagawa's mysticism, we will now turn to the problem of how best to approach the phenomenon of mysticism itself, on the one hand, and Kagawa's mystical experience, self-understanding, and the contributions that grew out of that experience and self-understanding, on the other. It seems fair to consider his case in relation to some of the clearest thinking on the subject during his own lifetime. Since Kagawa kept abreast of contemporary developments in the psychology and philosophy of religion, while also contributing to spiritual and social movements in and beyond the Japanese context,[84] the most obvious places to look for help are the classical studies of William James and Evelyn Underhill, and the more philosophical approaches of Henri Bergson and Nishida Kitarō.[85]

In consideration of Kagawa's unique case and these works, we have settled on Bergson's 1932 *Les Deux Sources de la Morale et de la Religion*[86] as the most helpful, though admittedly not uncontroversial, conversation partner. Both as a description of the "dynamic religion" of the "great Christian mystics," and especially in helping us appreciate the strong

83. Torrance, *The Mediation of Christ*, 3–4.

84. For example, Kagawa's works were included in the Religious Boohks Round Table list of 1932, along with "a veritable who's who of interwar religious liberalism." Matthew Hedstrom says, these lists put an "emphasis on new knowledge and its ethos of inclusive and wide-ranging inquiry." Hedstrom, *The Rise of Liberal Religion*, 57, 60.

85. James, *The Varieties of Religious Experience* (1902), Underhill, *Mysticism* (1911), Nishida, *An Inquiry into the Good* (1911), and Bergson, *Les deux sources de la morale et de la religion* (1932).

86. In English, *The Two Sources of Morality and Religion*. We will henceforth refer to it by *Two Sources*. Though we cannot take up the controversy here, the *Two Sources* continues to be a source of debate in the philosophical world.

activist and evangelical element in Kagawa's mysticism, Bergson is the most helpful guide. He also makes an interesting claim that, "mysticism means nothing, absolutely nothing, to the man who has no experience of it, however slight."[87] This can only mean that Bergson himself is admitting some personal experience of mysticism, perhaps in contrast to William James who begins his discussion of mysticism in *The Varieties of Religious Experience* with the famous caveat:

> Whether my treatment of mystical states will shed more light or darkness, I do not know, for my own constitution shuts me out from their enjoyment almost entirely, and I can speak of them only at second hand.[88]

Besides this personal dimension, we also should mention that James, Underhill, and Nishida were all to a greater or lesser extent in dialogue with Bergson's earlier work, and Kagawa's proclamation of "God as Life," which we discussed above, owed much to Bergson's *L'Évolution créatrice* (1907) and *Matière et mémoir* (1908).[89] Further, since Bergson himself saw *Two Sources* as a development of his earlier work, [90] we should not be surprised to find certain conceptual harmonies between the French philosopher and the Japanese evangelist.

Even allowing that most philosophers today would dismiss *de jure* Bergson's positive assessment of mysticism, we hope to show in what follows why his perspective helps us understand Kagawa, specifically, and the great mystics, more generally. We see the value of the *Two Sources* in relation to the occasion of its writing between the two world wars of the twentieth century. From the midst of that historical crisis, Bergson offers a thoughtful meditation on the future of humanity and what, for lack of a better term, sounds in many places like the passionate last will and testament of one of the most creative minds of the early twentieth century.

Before beginning the discussion of the *Two Sources*, here is our conclusion: Kagawa Toyohiko is an exemplar, albeit an imperfect one, of Bergson's ideal of an open, "dynamic religion" that seeks, above all else, to translate the unitive mystical vision of divine love into concrete acts of

87. Bergson, *Two Sources*, 237.
88. James, *The Varieties of Religious Experience*, 379.
89. Kagawa read the English translations of *Creative Evolution* (1911) and *Matter and Memory* (1911).
90. Bergson, *Two Sources*, 249.

love for others.[91] In contrast to the guardians of a closed, static religion, which Bergson ruthlessly dismisses as "a defensive reaction of nature against the representation, by intelligence, of the inevitability of death,"[92] the great mystics seek "to effect a radical transformation of humanity by setting an example."[93] Given Kagawa's extraordinary energy and record of accomplishments, we believe he should be listed with other great Christian mystics such as the apostle Paul, Augustine, Hildegard, Francis, Teresa, Luther, Catherine of Siena, Kierkegaard, Simone Weil, Martin Luther King Jr., Dorothy Day, Thomas Merton, and many others.[94]

But here we must inject an important caveat. What distinguishes Kagawa from this list of mostly "Western" mystics is the obvious but not inconsequential fact that he is Japanese. Even though he was baptized by an American missionary in 1904 within the "westernizing" milieu of the late Meiji Era, we have seen how Kagawa's identity was shaped in decisive ways by the religious and philosophical *ethos* of Shintō, Buddhism, Confucianism, and Taoism. And as we have said repeatedly, swimming against the general tendency of Japanese Protestant leaders, the evangelical social reformer and "scientific mystic" had a positive view of those native traditions. Given this proviso, we will call Kagawa a "great Japanese Christian mystic."[95]

Turning now to the *Two Sources*, Bergson's account of the "complete mysticism" of the great Christian mystics begins with the claim of an activist, evangelical element that sets them apart from earlier forms of mysticism.[96] It is this active element that seriously challenges inherited negative caricatures of the disengaged, world-denying mystic, which are a legacy of the anti-monastic and anti-Catholic polemics in post-

91. Ibid., 228.
92. Ibid., 131.
93. Ibid., 239.
94. Even though Kagawa was a lifelong Presbyterian, the Episcopal Church in the United States of America and the Evangelical Lutheran Church of America have seen fit to honor this great Japanese Presbyterian with a day on their liturgical calendars (April 23, marking the day of his death in 1960). Presbyterians have still not worked out effective ways to honor spiritual exemplars like Kagawa.
95. While the issue of multiple religious identities has always accompanied the intercultural communication of faith, Kagawa's case may be of particular interest today when religious hybridity is clearly on the rise in Europe and North America. See Goosen, *Hyphenated Christians*, and Drew, *Buddhist and Christian?*
96. We should note that Bergson's account of ancient Greek, Hindu, and Buddhist mysticism is thin.

Reformation Europe. Given Bergson's positive reassessment of the great Christian mystics, it is little wonder Jacques Derrida calls him "that great Judeo-Christian."[97] Drawing a distinction between the great Christian mystics and their ancient predecessors, Bergson says:

> There is no doubt that most of them passed through states resembling the various culminating phases of the mysticism of the ancients. But they merely passed through them: bracing themselves for an entirely new effort, they burst a dam; they were then swept back into a vast current of life; from their increased vitality there radiated an extraordinary energy, daring, power of concentration and realization. Just think of what was accomplished in the field of action by a St. Paul, a St. Teresa, a St. Catherine of Siena, a St. Francis, a Joan of Arc, and how many others besides! Nearly all of this superabundant activity was devoted to spreading the Christian faith.[98]

Bergson sees this "vitality" and "active element" in the mystics as their greatest and most enduring contribution. As we have shown, Kagawa was from first to last an active evangelist and social reformer devoted to "spreading the Christian faith," but along with Bergson and contrary to the common view that activism and mysticism are mutually exclusive, we want to posit the wellspring of his social activism in his mystical vision and the ongoing renewal of that vision in his spiritual practice.

Challenging the inherited cultural stereotype of the mystic as an example of a "vague, obscure, or confused spirituality," the contrarian Bergson is puzzled that the mystics should be seen as "mentally diseased." On the contrary, he sees them as examples of "supreme good sense" and "the very definition of intellectual vigor," while also conceding they experience "ecstasies, visions, and raptures" that make it difficult to tell the genuine from the fake.[99] The great mystics warn their disciples of visions, downplaying such experiences "as of secondary importance," while press-

97. Derrida, *Acts of Religion*, 77.

98. Bergson, *Two Sources*, 227–28. To get a sense of Bergson's own sources, his footnote on this page of the English edition is worth quoting.

M. Henri Delacroix, in a book which deserves to become a classic (*Études d'histoire et de psychologie du mysticisme*, Paris, 1908), has called attention to the essentially active element of the great mystics. Similar ideas will be found in the remarkable works of Evelyn Underhill (*Mysticism*, London, 1911; and *The Mystic Way*, 1913). The latter author connects certain of her views with those we expressed in *L'Évolution créatrice*, and which we have taken up again, to carry them further, in the present chapter. See, in particular, on this point, *The Mystic Way*.

99. Ibid., 228–29.

ing with all their might toward the goal of "an identification of the human will with the divine will."[100] In keeping with this view, Kagawa mentions his own experience of ecstasy from time to time, but never as an end in itself. He too is much more interested in the ultimate goal of "identification."

Turning to actual accounts of mystical experience, Bergson says:

> We must first note the fact that the mystics generally agree among themselves. This is striking in the case of the Christian mystics. To reach the ultimate identification with God, they go through a series of states. These may vary from mystic to mystic, but there is a strong resemblance between them. In any case, the path followed is the same, even admitting that the stopping-places by the way are at different intervals. They have in any case the same terminal point.[101]

Without mentioning the classical stages of awakening, purgation, mortification, illumination, and unification, Bergson does delineate a common pattern that begins in a decisive and joyful unitive experience when the gap disappears "between him who loves and him who is beloved." At this point, he says the mystic is compelled by

> an indefinable presence, or divines it through symbolic vision. Then comes a boundless joy, and all-absorbing ecstasy or an enthralling rapture: God is there, and the soul is in God. Mystery is no more. Problems vanish, darkness is dispelled; everything is flooded with light. But for how long? An imperceptible anxiety, hovering above the ecstasy, descends and clings to it like a shadow.[102]

This sounds strikingly similar to Kagawa's account of a "peculiar, mysterious experience—an ecstatic consciousness of God; a feeling that God was inside me and all around me. I felt a great ecstasy and joy."[103] Underhill quotes and then comments on the exclamation of mystical joy in Pascal's *Memorial*:

> "Dieu d'Abraham, Dieu d'Isaac, Dieu de Jacob,
> Non des philosophes et des savants.
> Certitude. Certitude. Sentiment. Joie. Paix."

Pascal's vision of Light, Life, and Love was highly ecstatic; an inde-

100. Ibid., 229.
101. Ibid., 246.
102. Ibid., 230.
103. Bradshaw, *Unconquerable Kagawa*, 83.

scribable, incommunicable experience which can only be suggested by his broken words of certitude and joy.[104]

A vision of light accompanies the sense of joy, and Kagawa focuses on the light in his fictional depiction of the unitive experience. "The point of light on which he concentrated his gaze appeared to him like a rainbow, the room in which he lay like Paradise and the common quilt that covered him like a cloth of gold."[105] Underhill describes similar accounts of "mystic illumination" among the women mystics:

> "The flowing light of the Godhead," said Mechthild of Magdeburg, trying to describe *what* it was that made the difference between her universe and that of normal men. "*Lux vivens dicit*,"[106] said St. Hildegarde of her revelations, which she described as appearing in a special light, more brilliant than the brightness round the sun. It is an "infused brightness," says St. Teresa, "a light which knows no night; but rather, as it is always light, nothing ever disturbs it."[107]

In light of Kagawa's high view of the leadership of women in spiritual and social life, it is not surprising that his experience finds clear precedents among female as well as male mystics.

After the initial unitive experience of joy and light, Bergson says that the mystic then experiences a "vague disquietude," and in rare cases of "complete mysticism," presses through to the desolation of the "'darkest night' of which the great mystics have spoken and which is perhaps the most significant thing, in any case the most instructive, in Christian mysticism. The final phase, characteristic of great mysticism, is imminent."[108] Admitting it is nearly impossible to describe what transpires during this crucial phase, Bergson nevertheless offers a "glimpse of the mechanism" of the mystic soul who longs to become the instrument of God in the world:

> Now it is God who is acting through the soul, in the soul; the union is total, therefore final.... There is a boundless impetus. There is an irresistible impulse which hurls it into vast enterprises....[109]

This pendulum shift from indescribable joy and illumination, through

104. Underhill, *Mysticism*, 189–90.
105. Kagawa, *Before the Dawn*, 260.
106. "The living light speaks."
107. Underhill, *Mysticism*, 249.
108. Bergson, *Two Sources*, 231.
109. Ibid., 232.

a time of deep despair, and finally to a dramatic decision to enact the vision on behalf of others describes accurately the arc of Kagawa's experience between the summer of 1907, when in rapture he narrowly escapes death, and soon afterwards wrestles with the meaning and purpose of life, the existence of God, and is tormented by suicidal ideation, and finally by his drastic decision to hurl himself into the initial enterprise in the Shinkawa slum on Christmas Eve, 1909. In the end, the most sensible explanation for Kagawa's forward progress from the height of ecstasy, through the void of the "dark night," and finally to an intense personal identification with "the least of these" is precisely the presence and perception of some "boundless impetus" or "irresistible impulse."

Bergson speaks of a "superabundance of vitality" and profound humility in the "*adjutores Dei*,"[110] whom he calls "'patients' in respect to God, agents in respect to man." They now feel compelled "to teach mankind" what they have seen, touched, and known: "He has felt the truth flowing into his soul from its fountainhead like an active force. He can no more help spreading it than the sun can help diffusing its light. Only it is not by mere words that he will spread it."[111]

As measurable evidence for this "superabundance of vitality" and the drive "to teach mankind," we may offer Kagawa's launching and ongoing oversight of several new initiatives aimed at spiritual and social reform,[112] which was accompanied by a prodigious literary production in the fifteen-year period (1910–25) following his move into the slum. The writing consists of sixteen religious titles, ten works on social philosophy, philosophy of religion, and science, and fifteen novels or books of poetry.[113] And all of this activity and writing was accomplished during a time that included almost three years in the United States!

What Bergson says of the great mystics is again the most sensible explanation for Kagawa's phenomenal burst of creative activity: "For the love which consumes him is no longer simply the love of man for God, it is the love of God for all men. Through God, in the strength of God, he loves all mankind with a divine love."[114] This is a self-dispossessing love that "embraces all humanity," transgressing the "natural frontiers" of "family or social feeling." Perhaps most especially in the case of one like

110. "God's assistants."
111. Bergson, *Two Sources*, 233.
112. See Appendix A, "Events in the Life of Kagawa Toyohiko"
113. See *Collected Works of Kagawa Toyohiko.*
114. Bergson, *Two Sources*, 233.

Kagawa who had suffered such horrific traumas in his childhood and youth, such a consuming love cannot be attributed easily to some natural "fraternity which started as an ideal" or an "intensification of an innate sympathy of man for man." While the personal traumas probably readied him for liminal experience, in the "entirely new effort" that swept him "back into a vast current of life" there is the suggestion of a radical discontinuity or transcendence, which is best explained by the mystic's conviction that he had been graciously enabled to touch the source of life and love.

Bergson argues for our need to take the mystics' unreserved embrace of humanity more seriously, but not only because they help to renew spiritual and social life. He insists that even the philosophers are indebted to these spiritual pioneers who push the boundaries of biology and culture and pointedly asks, "Would the philosophers themselves have laid down so confidently the principle, so little in keeping with everyday experience, of an equal participation of all men in a higher essence, if there had not been mystics to embrace all humanity in one simple indivisible love?"[115]

The evidence reveals that a boundless energy had renewed Kagawa's life, which had been shattered by sorrow, sickness, and shame, and that this energy had healed him, called him, and commissioned him to serve the purpose of Christ's love in Japan, beginning in the manner of Jesus himself with "the least of these." To repeat, Bergson says, "He takes the most crying needs first. In reality, the task of the great mystic is to effect a radical transformation of humanity by setting an example."[116]

While we have acknowledged and condemned Kagawa's failure to set an example in his earliest interactions with his *Buraku* neighbors in the slum, this failure does not negate his unshakable conviction that he had seen, touched, and known the divine love that seeks the full flourishing of life for all. It is this conviction of divine love that offers the best explanation for the single-minded vocation Kagawa pursued until the end of his life. Speaking of this "mystic love of humanity," Bergson says:

> Coinciding with God's love for His handiwork, a love which has been the source of everything, it would yield up, to anyone who knew how to question it, the secret of creation. It is still more metaphysical than moral in its essence. What it wants to do, with God's help, is to complete the creation of the human species and make of humanity what it

115. Ibid., 234.
116. Ibid., 239.

would have straightaway become, had it been able to assume its final shape without the assistance of man himself. Or to use words which mean, as we shall see, the same thing in different terms: its direction is exactly that of the vital impetus (*l'élan de vie*); it *is* this impetus itself, communicated in its entirety to exceptional men who in their turn would fain impart it to all humanity and by a living contradiction change into creative effort that created thing which is a species, and turn into movement what was, by definition, a stop.[117]

While the rationalist may see only quixotic futility in the mystic's ambitious effort "to with God's help complete the creation of the human species," the evidence shows that, after he crossed the death line, Kagawa Toyohiko was "fired on the world with a velocity not his own."[118]

But the great mystic still faces the daunting task of trying to transmit to others this "mystic love of humanity." Bergson says, "The great obstacle in their way is the same which prevented the creation of a divine humanity. Man has to earn his bread by and with the sweat of his brow; in other words, humanity is an animal species, and as such, subject to the law which governs the animal world and condemns the living to batten upon the living."[119]

Bergson offers "two very different methods" that must both be employed if the vision is to be passed on to others. He says:

The first [method] would consist presumably in intensifying the intellectual work to such an extent, in carrying intelligence far beyond what nature intended, that the simple tool would give place to a vast system of machinery such as might set human activity at liberty, this liberation being, moreover, stabilized by a political and social organization which would ensure the application of the mechanism to its true object.[120]

This first effort "that carries intelligence far beyond what nature intended" requires a kind of "mechanization," which has certain inherent dangers because "it might turn against mysticism."

Among many such efforts along various fronts and besides the lifelong goal of publishing his meditations on teleology in *Cosmic Purpose*,

117. Ibid., 234–35.

118. This phrase is borrowed from Dana Wright's characterization of James E. Loder, our mutual doctoral advisor at Princeton Theological Seminary. Wright and Kuentzel, *Redemptive Transformation in Practical Theology*, 24.

119. Bergson, *Two Sources*, 235.

120. Ibid., 235.

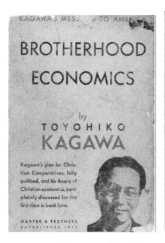

Brotherhood Economics, 1936 (cover and contents)

Kagawa notably pursued this first method of transmission by working on a theory of cooperative economics and founding several consumer, agricultural, financial, and medical cooperatives. As for the background of this effort, in the early 1920s Kagawa had run into conflict with radical labor union leaders for insisting that spiritual reform always accompanies genuine social and economic reform. Coming increasingly under the influence of the gradualist approach of the British Guild Socialists and the cooperative movement of the Rochdale Weavers, he began proclaiming cooperative economics as a positive "third way" between the contemporary alternatives of monopoly capitalism and the Marxist-Leninist version of communism. He believed these opposing economic alternatives were grounded in theories with inadequate spiritual, scientific, and ethical ideals and were therefore powerless to moderate human greed, in the first instance, and violence, in the second.

Besides *Cosmic Purpose*, which is Kagawa's religio-aesthetic meditation on finality, the theory of cooperative economics set out in *Brotherhood Economics* (1936)[121] is perhaps his most comprehensive, albeit idealistic attempt to "carry intelligence far beyond what nature intended," and his clearest vision for "a vast system of machinery such as might set human activity at liberty." The book is based on Kagawa's April 1936 Rauschenbusch Lectures at Colgate-Rochester Divinity School, originally entitled "Christian Brotherhood and Economic Reconstruction."

Against the backdrop of Japan's commencement of hostilities with

121. Kagawa, *Brotherhood Economics*.

China with the Manchurian Incident in 1931 and withdrawal from the League of Nations in 1933, 1936 was a very tense time. In spite of this, typically trying to "see things whole," Kagawa locates the causes of war in a "spiritless economics" and posits a spirit of "brotherhood love" or "mutual aid" as a more adequate spiritual, scientific, and ethical basis for economic activity. He claims the cooperative approach is far superior to the "old economics" of Adam Smith and the "materialist economics" of Marx and Lenin, both of which "divided economics from religious consciousness." Taking an analogy from biology to argue for his holistic approach to complexity, he says:

> As a biological cell grows by separation, but is finally compelled to move as one body, so it was with the society of the nineteenth century. When religion and economics were entirely separated and were regarded as two distinct phases of life, there was no difficulty in treating them as unrelated. That which is true of the cell, however, is true also of society. The two spheres of religion and economics must come together and move as one, otherwise their antagonism will be harmful, as we have seen often enough in this twentieth century.[122]

Again, in the Preface to *Brotherhood Economics*, he draws on his reading of science, proclaiming that recent advances in physics should positively influence economic theory and practice.

> Theories of relativity and quantum mechanics have completely done away with the nineteenth century's conception of matter and brought unyielding determinism into the realm of possibilities! This means that the twentieth-century materialistic capitalism and materialistic communism also must be abandoned. In this book I have tried to open a path to a new social order through a psychological, or conscious, economy.[123]

The connection between biology, quantum mechanics, and economic theory may not be immediately obvious to readers, but it fits perfectly with the scientific mystic's personalist, holistic, and ethical vision. That is, if capitalism and communism are both grounded in a scientifically passé, materialist view of the cosmos, it follows that a more progressive and spiritually satisfying economic alternative is called for, one in closer accord with natural science's triumph over an outdated philosophical materialism.

122. Ibid., 48.
123. Ibid., x.

As we have already seen, Kagawa's views had captivated the attention of many Christians in America. The Rauschenbusch Lectures were accompanied by an extensive public relations effort, organized by Rev. Henry J. Carpenter of the National Association of Church Federations Secretaries, which included a speaking tour of over one hundred American cities![124] In the same month as his Rauschenbusch Lectures, Kagawa spoke on cooperative economics at Princeton University. It was a kind of homecoming for Kagawa, who had studied there twenty years earlier. The front-page article in the school newspaper for the day of his lecture introduces him as the "Japanese Gandhi" and the "Japanese Grenfell,"[125] and extols his many accomplishments.

> Regarded as one of Japan's most influential leaders, Dr. Kagawa has fostered many social and economic movements in his native country. In spite of ill health, he has performed the strenuous task of originating and establishing the Japanese Federation of Labor and the Farmers' National Federation and has also taken a leading part in the battle for universal manhood suffrage and in developing his cooperative plans.
>
> Dr. Kagawa has developed the credit-union movement, created marketing and purchasing services, founded 100 schools for teaching cooperative technique, fostered the slum-clearance movement, established medical cooperatives and cooperative hospitals, organized the fishermen of Japan and has been aiding farmers to extend cooperative methods into all their communities.[126]

A second article the day after the lecture offers the following summary of his talk:

> By way of stressing the need for and development of cooperative movements the distinguished reformer and self-denying leader sketched the history of such action, continually emphasizing the noble part played by the Catholic brotherhoods and their subsequent death at the hands of capitalism which set in at the time of the Protestant Reformation.
>
> He declared that through the work of such men as Saint Benedict, Assisi and Augustine and their orders, labor formed a guild system

124. "Dr. Kagawa Coming Here," *New York Times*, 26.

125. Sir Wilfred Thomason Grenfell (1865–1940), a British medical missionary to poor fishing communities in Labrador who, like Kagawa, had holistically combined spiritual, social, and educational efforts.

126. "Cooperative Groups Subject of Lecture by Kagawa Tonight," *The Daily Princetonian*, front page.

which emphasized initiative and creative artistry, thus making possible the Gothic cathedral. "Today laborers are machines," he stated.[127]

Like the guild socialists, Kagawa stresses the spiritual or monastic roots of the cooperative movement. In essence, he was applying a nineteenth-century criticism of the industrial revolution to the Japanese context.

Kagawa's international popularity was at its peak, and he was exerting a spiritual influence far beyond the humble origins of his movement that had its origins in the Kōbe slum. Kagawa was probably the best-known Japanese in the United States before the war. The *New York Times* on 26 July 1936 reported on the results of his proclamation of the gospel of cooperative economics as a means of bringing about world peace:

> A drive has begun to get persons who heard addresses by Dr. Toyohiko Kagawa, Japanese Christian labor leader, on his recent national tour to join a Christian Cooperative Fellowship in North America.
>
> The fellowship, described as having "a new-world order" as an end, has for its purpose "to further challenge the churches and carry forward a program of education designed to stimulate the building up of the cooperative spirit and purpose in both individuals and economic life."
>
> Scores of communities visited by Dr. Kagawa have already formed groups of Christians to continue studies of cooperatives in relation to churches, according to a letter sent out this week. The campaign is in the hands of an executive committee of twenty-four members who are active in interdenominational church work and the cooperative movement.[128]

But Kagawa's proclamation of the gospel of cooperativism in the midst of the Great Depression was not without its detractors. One notable example was theologian Reinhold Niebuhr. While expressing admiration for Kagawa and his work in Japan, Niebuhr attacks him on theological grounds, saying, "The forces of evil in the world are really greater than either Dr. Kagawa or his liberal followers believe. And history is a more tragic process than they know."[129]

As George Bickle has shown in his critical study of utopianism in

127. "Dr. Kagawa Praises Economic Set-up of Cooperative Groups," *The Daily Princetonian*, front page. The article reports that he spoke before a full chapel at the university, which seats almost 2,000.

128. "Religious Unity Object of a Drive," *New York Times*, 81.

129. Niebuhr, "The Political Confusion of Dr. Kagawa," 6–7. We note that this is just four years after the publication of Niebuhr's classic *Moral Man and Immoral Society*.

Kagawa's social thought,[130] while there is no doubt much of the impracticable in Kagawa's proposals for the transformation of Japanese society, with Bergson's help we have tried to show that these strenuous efforts in the social realm should be seen as an expression of the mystical vision. Whatever the relative merits of cooperativism, for example, what makes Kagawa's efforts at transmitting the vision so compelling is that he did not stop with utopian pronouncements. While proclaiming cooperativism as a more spiritual, scientific, and ethically satisfying "third way," he also helped found several cooperatives whose work continues today, nearly one hundred years later.[131]

The fact that some of these cooperatives have survived, however, should not be taken as a sign that the "mechanical" means of transmitting Kagawa's mystical vision were completely successful. Indeed, notwithstanding his persistent intellectual and practical efforts, his hopes for the triumph of this "third way" were dashed in the lead up to World War II that terminated in Japan's crushing defeat in 1945. Further, secularization in post-war Japan often meant that Kagawa's social projects were lauded with scant reference to their spiritual source. Recently, the cooperatives have made some positive attempts to redress this situation by honoring their esteemed founder and his passionate commitment to practicing the redemptive love of Christ.[132]

Besides the "mechanical" means, Bergson offers the formation of a "spiritual society" as a second, complementary method for transmitting the mystical vision. Referring to such spiritual societies, he says:

> Societies of this kind might multiply; each one, through such of its members as might be exceptionally gifted, would give birth to one or several others; thus the impetus would be preserved and continued until such time as a profound change in the material conditions imposed on humanity by nature should permit, in spiritual matters, of a radical transformation. Such is the method followed by the great mystics.[133]

This statement suggests that Bergson sees the "mechanical" efforts at transmission, which push toward "a profound change in the material conditions imposed on humanity by nature," working hand in glove with

130. Bickle, *The New Jerusalem.*
131. The most noteworthy of these is the Kōbe Co-op, one of the largest cooperatives in the world today with 1.2 million household members.
132. See the website of the Kōbe Co-op.
133. Bergson, *Two Sources*, 236.

the efforts of "spiritual societies." As we have seen time and again, Kagawa shared this same conviction (i.e., that only a complementarity of spiritual and material efforts will produce genuine transformation). Toward the end of *Cosmic Purpose*, Kagawa reiterates this lifelong conviction, saying, "If all of humanity were able to bring purposiveness to full consciousness, they would be able to work together towards world peace, to divert the energy spent on war to organized movements for global cooperation, and then turn their remaining strength to discovery and invention."[134]

As a motivation for the founding of spiritual societies, Bergson introduces an idea, shared by the mystics, which would be considered anathema to those Protestants who place exclusive emphasis on divine initiative and grace and often seem to denigrate or at least not know what to make of the human response in faith. Bergson says:

> The mystics unanimously bear witness that God needs us, just as we need God. Why should he need us unless it be to love us? And it is to this very conclusion that the philosopher who holds to the mystical experience must come. Creation will appear to him as God under-taking to create creators, that He may have, besides Himself, beings worthy of His love.[135]

Indeed, in 1923, two years after the Kagawas had founded the Kōbe

First Meeting of the "Friends of Jesus Society," 1923. Haru, elder son Sumitomo (baby), and Toyohiko (seated 2nd from right in 2nd row)

134. Kagawa, *Cosmic Purpose*, 256.
135. Bergson, *Two Sources*, 255.

Consumer Cooperative, they inaugurated a "spiritual society" called the *Iesu no Tomo Kai* (Friends of Jesus Society) to support the spiritual lives and social service of young Christians. Economist and lay Christian leader Sumiya Mikio says, "This new religious movement was a reform movement in opposition to the churches that had restricted faith to the spiritual world and enshrined the gospel in the church alone."[136]

As we have mentioned, Kagawa maintained his ordination status within the established church and launched his challenge from the platform of his alternative *shozoku*. Here is how an English brochure from 1928 describes the Friends of Jesus Society:

> The Friends of Jesus Society, described recently by Mr. Kagawa as a "Francisco-Jesuit-Protestant Order," revives the loving service of the poor of St. Francis of Assisi, the loyalty to the Church of the Jesuits, and embodies these ideals and others in a practical program of Christian living designed to fit the needs of modern life in Japan. It does not take young people out of the world; it carries the spirit of the monastery into home and office, and makes every common duty an act of worship.... The little group has grown to a thousand and three hundred, about half of whom are women. No special propaganda has been carried on for expansion, and the Society is rather slow to admit new members, requiring a three-years period of novitiate. The first year one is a Friend, the second a Brother, and the third and highest class is that of the Servants. Certain reading is required, including the Old and New Testaments, Bunyan's *Pilgrim's Progress*, à Kempis' *Imitation of Christ*, etc.[137]

Of course, Kagawa knew that the vocation to "carry the spirit of the monastery into home and office" had strong precedent in the ascetically minded Puritan tradition. Indeed, the mostly North American Protestant missionaries to Japan were the heirs of this Puritan tradition. In his chapter on asceticism in *The Protestant Ethic and the Spirit of Capitalism*, Max Weber describes the Puritan view of ascetic vocation as carried "out of monastic cells into every day life."[138] Given this background, it is telling that the mystic Kagawa drew on Roman Catholic exemplars for his Protestant spiritual society. Kagawa was critical of what he called the individualism, intellectualism, and isolationism of the established churches. By the 1920s those churches were showing much more interest in the latest

136. Sumiya, *Kagawa Toyohiko*, 171.
137. *Friends of Jesus*, 2.
138. Weber, *The Protestant Ethic and the Spirit of Capitalism*, 181.

academic theological trends in continental Europe than in developments in the churches in the missionary homeland, so perhaps Kagawa thought they needed to reach back more deeply into the Christian tradition for spiritual inspiration. Whatever his motives, it is not difficult to imagine why Protestant church leaders did not flock to sign up for Kagawa's parachurch group with its "catholic" *ethos*.

Believing that genuine spiritual movements necessarily seek public expression and, conversely, that genuine social reform movements always have a spiritual basis, Kagawa established the following five principles for the Friends of Jesus Society. They unite the contemplative and active dimensions of Christian faith in a simple and remarkable way.

1. Seek piety in Jesus.
2. Befriend the poor and love work.
3. Strive for world peace.
4. Enjoy a lifestyle of purity.
5. Make social service your principle.[139]

While the "Friends of Jesus Society" expanded to include branches in the United States, it never became a mass movement.

In spite of the Reformed reticence about claims of mystical participation or union, as when mystics such as Kagawa perceive the entire cosmos to be indwelt by and to indwell the Divine Presence, or when social reformers like Kagawa take on the pain of the marginalized as the pain of God, thus committing themselves to "lost" causes often at huge personal cost, Kagawa's witness endures as a sign that a robust religious tradition and hence a robust theology will not long survive without aesthetic wonder and ethical commitment grounded in mystical experience and imagination. Kagawa perceived the Divine forgiveness and beauty of Christ's cross everywhere and dared to be a public embodiment and prophetic provocateur of the cruciform Presence, even in the face of illness, ridicule, imprisonment, and the threat of death. On behalf of the love he perceived in the crucified Son of God, Kagawa worked and advocated his whole life for the rights of workers, children, women, minorities, refugees and many others, as Koyama Kōsuke says, at the periphery of an industrializing society that had systematized and rationalized the exploitation of its most vulnerable members.[140] Kagawa had no patience for theologies

139. 1. イエスにありて敬虔なること、2. 貧しき者の友となりて労働を愛すること、3. 世界平和のために努力すること、4. 純潔なる生活を喜ぶこと、5. 社会奉仕を旨とすること。
140. Koyama, "Go and Do Likewise!" 89–110.

that could no longer engender the perception of the Divine Presence in the minutia of nature, in every person, and in the vast cosmos, or any theology that could no longer evoke a vision of the present and coming kingdom of God and a concrete commitment to the transformation of the unjust orders of society.

5 *Cosmic Purpose* (1958)

The Enduring Relevance of Kagawa's
Scientific Mysticism[1]

SEEING KAGAWA'S PROJECT IN A BROADER CONTEXT

Kagawa came of age during the period of accelerated industri-
alization and militarization that supported Japan's rise as East Asia's first
modern nation state during the late Meiji (1890–1912) and Taishō (1912–
26) Eras. We have seen how this period of nation and empire building
was also a time of ideological confusion and innovation, witnessing the
dissolution of many traditional Japanese institutions and the advent of
increasingly specialized ones. Not surprisingly, Japan's leap into moder-
nity generated a host of new problems.

For reasons we have discussed at length, Kagawa was keenly sensi-
tized to the psychological, spiritual, social, and cultural price Japan had
to pay for this transition, as well as to the new opportunities it presented.
His conviction of the need to "see all things whole"—to weave together
the spiritual, cosmic, and ethical strands of modern life—represents a
creative response to personal and national crises that has enduring rel-
evance for persons and societies today who are coping with the increas-
ing complexities of modern life. With reference to the five moments of
Hans-Georg Gadamer's so-called "hermeneutical circle,"[2] we will begin
by reviewing what we have said thus far about Kagawa's unique contribu-
tion.

Firstly, Kagawa took a positive view of the (1) *Pre-understanding* of
his Japanese religious and philosophical heritage, while also conceding
its limitations in light of (2) *"The experience of being brought up short"* by

1. This chapter is an adaptation of the author's introduction to the English transla-
tion of *Cosmic Purpose*.

2. This summary of Gadamer is indebted to Osmer, *Practical Theology*, 22–23.

his own traumas and religious conversion and Japan's national trauma rising from its wholesale adoption of Western science, technology, and education and sudden conversion from an agrarian to an industrial society. Instead of abandoning or bracketing out the omnipresent *ethos* of Japan's cultural heritage, as has been the strategy of many Japanese Protestant thinkers, Kagawa's practical theological vocation to evangelize the masses led him into an *ad hoc* (3) *Dialogical interplay* focused on the three horizons of Christian faith, modern Western science and philosophy, and Japanese tradition. His personalist, holistic, and ethical (4) *Fusion of horizons*, outlined in chapter 2, draws on and reshapes these resources into what may be called a "religio-aesthetic cosmic synthesis." The (5) *Application* of this synthesis issued in countless projects aimed at spiritual and social renewal and a massive literary output.

In line with his gradualist and holistic answer to the threats that accompanied Japan's headlong plunge into modernization, Kagawa's "cosmic synthesis" attempts to hold together the material and spiritual, contingent and unconditional, random and intentional, continuous and discontinuous, and empirical and non-empirical dimensions of human experience and knowledge. As we have seen again and again, he was determined to "see all things whole," swimming against the tide of the growing specialization and fragmentation of human knowledge under the aegis of the modern research university. Given his wide-angled vision, it is hardly surprising to find Kagawa calling for a sustained collaboration between the natural sciences and human sciences at the very time that academic disciplines were becoming more and more specialized and cut off from each other. As he notes, for example, in *Meditations on God* (1930), "Religion should be explored in terms of the humanities, but it also embraces the cosmology of the natural sciences."[3]

Following his return from his studies in Princeton in 1917, Kagawa found himself embroiled in bitter conflicts both with labor leaders who advocated revolution, on the one hand, and with conservative church leaders encouraging an individualistic piety, on the other. In response, his "middle way" sought to combine social and spiritual movements as vital public partners in the creation of a healthy modern society and church. However, as we hinted in the last chapter, it must be acknowledged that, after his death in 1960, it became clear that Kagawa did not leave behind a sufficiently critical mass of disciples in Japan or abroad

3. Kagawa, *Meditations on God*, 12.

who were prepared to carry forward his "scientific mysticism." Some may conclude that this failure to institutionalize his "charism" indicates a fatal flaw. Conversely, it may be just as legitimate to interpret Kagawa's quick "disappearing act" as the fitting final performance of one whose life was riveted on the self-dispossessing and redemptive love of Christ, which he liked to reference with the words of Jesus from John's Gospel: "Very truly, I tell you, unless a grain of wheat falls into the earth and dies, it remains just a single grain; but if it dies, it bears much fruit."[4] For the reasons we have mentioned, it is unlikely that Kagawa's "scientific mysticism" will ever receive a fair hearing by the established churches in Japan, therefore we propose that his contribution should be evaluated within the broader context of modern Japanese history, religion, and thought and situated in conversation with similar religious innovators in other places.

COSMIC EVIL, SCIENCE, RELIGION, AND MODERNITY

We will focus this final chapter on a consideration of *Cosmic Purpose*, the last book, "life work," and teleology of this great "scientific mystic." From the loss of his parents, lonely childhood and youth by the Yoshino River, conversion to Christian faith and "adoption" by foreign missionaries, studies at Meiji Gakuin and Kōbe Theological School, sickness and dramatic healing, move into the slum, studies at Princeton Theological Seminary and Princeton University, and the launching of several evangelical social reforms, to his maturing reflections on science, religion, philosophy, cosmic purpose, and social reform, the story we have presented thus far culminates in *Cosmic Purpose*. In part one of his three-part essay on this unique book, Roman Catholic scholar Kishi Hideshi calls Kagawa "the sole cosmological thinker in Japan" who has constructed in *Cosmic Purpose* an "evolutionary doctrine of creation."[5] While we agree with Kishi's characterization of Kagawa, we think *Cosmic Purpose* does not fit easily into any recognizable theological genre.

On one level, the book purports to be the result of Kagawa's lifelong struggle with "cosmic evil." In the Preface of *Spiritual Movements and Social Movements* (1919), he had addressed the subject of "cosmic evil" in the context of the post-WWI situation, saying:

I am certainly not satisfied with the collection of essays published

4. John 12: 24. In 1931, he published a novel of this title, *A Grain of Wheat*, 15/24.
5. Kishi, "Understanding Cosmic Purpose," 2, 8.

here. In the near future, I hope to gather my thoughts on cosmic evil into a more systematic form. Yet, I am afraid such a synthesis may take a long time.... The eight million souls sacrificed in Europe cry out in anguish for the inauguration of a new age. I must organize my own reflections for the sake of this coming age![6]

With the help of Namiki's analysis of *The Religion of Life and the Art of Life* (1922), we will summarize what Kagawa meant to signify by his use of the term "cosmic evil." First of all, as he observed the world of nature, he was aware of the working of a great "cosmic will" driving the evolution of life. Namiki describes Kagawa's position, saying:

Evil is a phenomenon that occurs whenever life is extended. If we take a position that sees fullness of life as the ultimate value, then sickness, senility, disease, death, physical disabilities, mental disabilities are all seen as evil. Evil is not a reality, because whether something is evil or not depends upon a human perspective. Evil is a phenomenon perceived in the process of the working of the cosmic will in propelling the evolution of life.

To further amplify this point we may say the following: Phenomena that may be enumerated have a certain existence. The evolution of life involves "irregularities." These are seen as evil. When viewed from the standard of life, various kinds of calamities, natural disasters, and even an evil character are thought of as evil. Yet, if seen from a reverse angle, we may say that such evils clarify the value of evolving life. Evil is an expression of life. Life is the subject, therefore it is fruitless to begin by thinking about evil, which is the predicate. Everything has its origin in life. God is the creator of life, this God lives in me, and I am given life. Believing in God is to comprehend life in this way. "Before I seek or call upon God, this God is revealed in my life."[7] "Life even extends in conquering death. Death is no more than an appendix to life."[8]

When we focus on the "evil" Kagawa felt he had to combat, it was surely not limited to personal human suffering, but it was multidimensional, including "cosmic evils" such as calamities and "social evils" produced by monopoly capitalism.[9]

It took Kagawa nearly fifty years to gather his thoughts on cosmic evil,

6. Kagawa, *Spiritual Movements and Social Movements*, 261.
7. Kagawa, *The Religion of Life and the Art of Life*, 47.
8. Ibid., 61.
9. Namiki, "The Book of Job and Kagawa Toyohiko," 285–86.

for in the preface of *Cosmic Purpose*, he adds the following biographical note:

> I began to wrestle with the problem of cosmic evil at the age of nineteen. Around 1912 I called on Dr. Mizuno Toshinojō of Kyoto University to inquire about studying atomic theory. In July of 1914, with the onset of World War I, I headed for Princeton University where I majored in mammalian evolution. After that I stole some time from my preoccupation with social movements in Japan to continue my study of "the universe and its salvation." At the time of the China incident the secret police put me in solitary confinement in Shibuya, Tokyo, for my involvement with the peace movement. I was subsequently transferred to Sugamo Prison, where I passed my time reading books on the evolution of mammalian skeletons.[10]

Ironically, *Cosmic Purpose* actually does not treat the subject in great depth, but it is likely that Kagawa's lifelong "wrestling with the problem of cosmic evil" had as much to do with his meditations on the brutal and catastrophic extinction of countless species, the horrific loss of life that occurs during natural disasters, the deliberate neglect of the poor and weak members of society, and other challenges of evolutionary and human social history as with the problem of theodicy in light of his personal struggles. As we saw in chapter 2, his cruciform view of "suffering as the ultimate art" deepened as he reflected on the disaster of the Great Kantō Earthquake of 1923 and he concluded, "There is so much here I cannot understand. Yet I still want to believe that, even given this suffering, God is love."[11]

On a more explicit level, however, *Cosmic Purpose* is a sustained essay on the probability of purpose discernible in the stuff and structure of the natural world. Challenging the materialism of Charles Darwin and the casualist claim of H. G. Wells that "we must give up any idea that evolution is purposeful," Kagawa assembles a veritable who's who of prominent scientists—from physics, Helmholtz, Sommerfeld, Bohr, Planck, Heisenberg, and Yukawa, from astronomy and astrophysics, Hubble and Eddington, from chemistry, Avogadro, Mendeleev, Ostwald, and Gay-Lussac, from biochemistry, Oparin, Pauling, and Henderson, from mineralogy, Vernadsky, from genetics, Mendel, from physiology, Szent-Györgyi, and from biology, Darwin, Fabre, Driesch, and Dürken and

10. Kagawa, *Cosmic Purpose*, 29.
11. Kagawa, *Attitudes toward Suffering*, 98.

many others—to present what he believes is a clear-cut case for "initial purpose" in the vast span of evolutionary history from the atom to the emergence of life, mind (consciousness), social construction, and cosmic consciousness. He concludes:

> If we distinguish initial purpose from final purpose, we may yet be able to know something of its structure. On the basis of that judgment, we may make the following six statements:
>
> 1. There is purpose in the cosmos.
> 2. Cosmic purpose is directed towards *life*.
> 3. The purpose of life is directed towards *mind* (consciousness).
> 4. The individual mind is social and directed towards construction.
> 5. The social *mind* oriented to construction is en route to a historical evolutionary development and an awakening to cosmic consciousness.
> 6. This orientation awaits the assistance of the spirit that made creative evolution possible.

Taken as a whole, Kagawa is confident that the evidence points to the presence of "initial purpose," yet he takes the *via negativa* on the question of "final purpose," surrendering with Dante to the "impenetrability of (final) cosmic purpose."[12] This more modest suggestion of "initial purpose" in the natural world will be disappointing to those looking for conclusive proof of finality in nature. However, at the very least, the self-proclaimed "scientific mystic" hoped that his religio-aesthetic reflections on the astonishing emergence of life, mind (consciousness), social construction, and cosmic consciousness would provoke a renewed sense of amazement and wonder in his readers, regardless of their personal religious beliefs. Indeed, as Kagawa conducts the reader through his detailed presentation of an astounding range of scientific theories, the words "amazing" and "wonder" appear more than thirty times.

Here are the Contents of *Cosmic Purpose* with its the three main sections, each of which includes three chapters:

PART ONE: Directionality in Natural Selection

1. Natural Selection and Directionality
 The principle of natural selection
 Opening and closing in natural selection
 Laws governing selection
 Oparin's materialism

12. Kagawa, *Cosmic Purpose*, 268.

The unfolding of conscious purpose

9. Cosmic Evil and Its Salvation
 The final end of creative cosmic evolution
 The dawn of the universe
 Cosmic evil and its salvation

Briefly, the sweep of Kagawa's teleology moves from a general discussion in Part One of what he calls "directionality" in natural selection. Kagawa grounds his conclusion of "initial purpose" in a "bottom-up" examination of the actual stuff of the universe and its progress in the vast span of evolutionary history, hence this first section presents a recitation of evidence for directionality from physics, chemistry, mathematics, astrophysics, biology, and geology. Drawing heavily on the work of Lawrence Henderson, Part Two focuses on biology, physiology, and the environment, and moves through an examination of the structure and mechanism of cells, enzymes, proteins, genes, and DNA, concluding with a discussion of the adaptation and survival of organisms. Part Three finally presents Kagawa's modest proposal of "initial purpose" and, drawing on the philosophy and psychology of religion, offers a perspective that limits chance and mechanism with the goal of undermining the conclusions of casualism and materialism. Taken as a whole, the argument moves from matter and mechanism, to the emergence and growth of life, and finally to the emergence of consciousness and the moral imperative for awakened or "cosmic consciousness" to "see all things whole." On the surface, the text reads like an encyclopedic catalogue of scientific evidence for the emergence of life and consciousness out of the particles, atoms, and molecules, but the catalogue is interrupted again and again by expressions of religio-aesthetic amazement by a "scientific mystic" who knows himself to be a living, embodied consequence of and conscious participant in this great, unfolding cosmic drama.

Kishi speaks to this aesthetic feature of *Cosmic Purpose*, saying it represents a "theory of cosmic beauty," that "stresses the evolution of beauty penetrating plants, animals, and human beings."[13] We have seen how Kagawa's religious and artistic instincts had been awakened by his friendship with the birds, bugs, and fish of the Yoshino River Basin, and it was this primal impulse that guided his maturing reflections on the complementarity of the spiritual, scientific, and ethical search for indications of the "cosmic will." As Kagawa puts it elsewhere, "The aesthetic impulse at

13. Kishi, "Understanding *Cosmic Purpose*," 3.

work in the cosmic will ascends all the way to human beings.... Beauty should be sought and grasped as the impulsive reality underlying the cosmic will."[14]

Persuaded by the rationality of evolution, Kagawa imagined that all knowledge—of the natural world, persons, and ultimate reality—was also evolving. Like Teilhard de Chardin, he held to the ongoing evolution of spirit and therefore also of religion. We see this openness to new light, for example, in Kagawa's comparison of evolution and the theological doctrine of *creatio ex nihilo*, when he proclaims, "The belief that there is a direct line of evolution from amoeba to humankind is a more daring and romantic faith than the belief in the myth of a Creator making something out of nothing."[15] Elsewhere, Kishi compares these two unique evolutionary Christian thinkers of the twentieth century, saying, "Teilhard and Kagawa were men not only of the same era but of the same mind. Both saw the cosmos as a stage on which the drama of a mysterious (or mystical) evolution is being played. At the culmination of cosmic evolution Teilhard places the 'Omega point,' Kagawa 'purpose.'"[16]

While Kagawa grappled with the significance of developments in the natural sciences for religion, he also questioned the significance of fresh religious and philosophical insight for the sciences. This "two-way trafficking" may be seen, for example, in the few opening pages of *Meditations on God* (1930) where he refers to Galileo, Schleiermacher, Hegel, Comte, Marx, Strauss, Haeckel, Lombroso, Eucken, Kropotkin, Bergson, and Russell, concluding that:

> whereas faith teaches us about the fate of humanity, science teaches us about the structure of the universe. Those who fail to recognize this distinction can only end up in a great contradiction.[17]

Thus, he accepted the modernist division of labor for religion and science, but not without insisting on the need for interdisciplinary work. "We must pay closer attention to the complexities of the world and preserve the habit of gazing at the universe from different axes."[18] Believing that the sciences and religions of humanity would have much to gain

14. Kagawa, *Spiritual Movements and Social Movements*, 325–26, quoted in Kishi.

15. Kagawa, *The Science of Love*, 205.

16. Kishi, "The Religious Aspects of Cosmic Consciousness," 1536.

17. Kagawa, *Meditations on God*, 5.

18. Ibid., 22. See Appendix C, "Kagawa's View of the Humanities and Natural Sciences."

from taking each other more seriously, Kagawa dared to "see things whole" in an age when things seemed to be falling apart.

The positive fusion of his native spiritual and philosophical heritage, his adopted Christian faith, and his interest in modern science and philosophy transformed Kagawa's native capacity for "seeing things whole" into a habitual disposition that affected everything he wrote. Again, swimming against the strong tendency of Japanese Protestant theologians to steer clear of issues raised by Japanese culture, religion, and philosophy, he acknowledges a positive synthesis of Asian emptiness, European theism, and modern science at the conclusion of *Cosmic Purpose*:

> From ancient times people have set out to explain salvation from cosmic evil in one of three ways. First is India's religious way, the idea of emptiness. Second is the theistic approach to salvation that developed in western European thought. Third is the modern scientific attempt to banish cosmic evil.
>
> I do not find these three to be incompatible. Each of them was bred in human consciousness. Nishida Kitarō recognized the conscious efficacy of the idea of "nothingness." In the Middle Ages, Nicholas of Cusa acknowledged "zero" algebraically. The modern quantum mechanic physicist Hermann Weyl has followed the same line of thought. We are right to eliminate the idea of a meaningless void, but I am speaking of opting for "zero" as a way to think of removing cosmic evil. Moreover, the third path of science's banishment of evil, in its modern meaning, also requires our utmost efforts.
>
> There are, however, limits to human strength that leave us no other solution than to recognize the dependence of everything on an absolute cosmic will that has prepared, a priori, the strength for human beings to survive and for evolution to develop.[19]

It bears keeping this synthesis of "emptiness, theism, and science" in mind while plowing through the dense technical parts of *Cosmic Purpose*. In the final analysis, despite its imposing range of scientific discovery and insight, the book's enduring value does not lie in its science. Rather, it represents a lifetime of deliberations, some more compelling than others, by one of the most remarkable religious figures of the twentieth century, on the perennial quest for purpose in a vast, beautiful, and mysterious cosmos where shadow, suffering, and evil exists alongside light, flourishing, and goodness. *Cosmic Purpose* is thus a sustained meditation by

19. Kagawa, *Cosmic Purpose*, 269.

a great Japanese Christian mystic on the implications of contemporary findings in natural science.

eeeee## THE LOGIC OF FINALITY

Along with his search for a "cosmic synthesis," as early as *The Religion of Life and the Art of Life* (1922) Kagawa began to articulate his basic theoretical framework, the so-called "logic of finality" elaborated in *Cosmic Purpose*.[20] In chapter 2, we examined a long passage from *God and the Inspiration of Redemptive Love* (1938) that introduces this "logic" as the link between spiritual and material reality. This functions as a kind of "grammar" for his meditations on complexity and serves as an interpretive key to *Cosmic Purpose*, allowing him to describe the origin, development, and stabilization of the purposive mechanisms he sees at work throughout the universe. The "logic" finally enables him to connect *life* to *purpose* through an alignment of the following progressive stages or movements that appear together or separately throughout the book:

life → *energy* → *change* → *growth* → *selection* → *law* → ***purpose***

Rather than focus on the individual terms, Kagawa typically argues that a synthetic approach is required in order to grasp the reality of cosmic purpose:

> When disassembled and analyzed, purpose becomes incomprehensible. Purpose is synthetic and only becomes clear in its actual assembly.[21]

While the terms are partly indebted to Darwin's theory of natural selection and partly to Bergson's vitalism,[22] Kagawa employs the "logic" in an attempt to break through natural selection to a teleological interpretation. In particular, he takes issue with Darwin on the relation between selection and purpose, noting that "Darwin acknowledged selection but denied purpose. I consider this a fundamental contradiction in his thought."[23] Kishi comments on this point:

20. Ibid., 257.
21. Ibid., 196.
22. In a 1931 lecture delivered in China, Kagawa says, "We believe that behind matter there are seven principles in life. Behind matter there's life! The philosophy of vitalism leads up to faith in God." Kagawa, "The Application of the Cross to Society," 10–11.
23. Kagawa, *Cosmic Purpose*, 215.

The main concept in Kagawa's *Cosmic Purpose* is 'the directionality of natural selection.' For Kagawa, evolution has a direction that moves toward a purpose. The complexity that occurs within selection, that is, the complexity of selection, generates a movement from matter to life and from life to consciousness.[24]

Kagawa seeks to overcome this alleged contradiction in Darwin by offering accumulative evidence for his logic of finality in the intricate operations of selection that physics, mathematics, astronomy, astrophysics, chemistry, mineralogy, biochemistry, genetics, biology, physiology, and psychology show to be present at every level of reality.

Although Kagawa alludes to the logic of finality early on in *Cosmic Purpose*, he does not explain it until the last part of the book. It may be that he assumed Japanese readers would recognize the idea from his earlier writings and lectures.[25] In Part Three, "Knowledge of Cosmic Purpose," we find the clearest statement of how the logic of finality functions as an integrated and purposive structure:

> In order to realize a purpose, simple though it might be, five elements are necessary: energy, change, growth, selection, and law. These five are complementary, but it is energy that first sets the pursuit of purpose on its way. Energy accepts change, grows into purpose, eliminates all sorts of obstacles, selects the best path and method for the purpose, preserves adjustment to the surrounding conditions and environment, and protects the various arrangements and conditions that allow it to ascend to its goal. These five factors together manifest the *power of life* within the living world.[26]

These lines help clarify some of the more esoteric examples that appear in earlier sections of the work, as when he sees the logic of finality at work in chemistry, astrophysics, and biology:

> From the standpoint of ligand field theory, the sun is plus and the earth is minus. Or again, taking the constellation Sagittarius as a galaxy in the solar system, if the surrounding area is a plus and revolves around it, then we should think of it as a moving thing with a minus form. As simple as this sounds, the organization of the cosmic mecha-

24. Kishi, "Understanding *Cosmic Purpose* (1)," 7.

25. For example, in *Meditations on the Cross* (1931), he calls it "the seven basic elements of truth" and utilizes it to interpret the meaning of Christ's cross. *Meditations on the Cross*, 96–97. In *Brotherhood Economics* (1936), he calls it the "seven elements of value." Kagawa, *Brotherhood Economics*, 26–31.

26. Kagawa, *Cosmic Purpose*, 192.

nism through simple selection is unimaginably complex. In terms of *energy*, simple selection becomes directionality, the "+" and "–" of axial selection. *Change* involves the plus and minus of chemical combination; *development*, a choice between moving forward and standing still. In the world of *life* sexual differentiation appears; in the world of *law*, a choice between affirmation and negation comes into play. Here again, as simple as this may seem, when we combine the work that goes on at the level of energy, change, development, law, and life with simple selection, we have a world whose complexity defies imagination.[27]

SCIENTIFIC BACKDROP

In the midst of the storm gathering after the Manchurian Incident of 1931 and Japan's withdrawal from the League of Nations in 1933, Kagawa collaborated with Nakamura Shishio on a translation of Sir James Jeans's *The New Background of Science* (1933). In the preface he expresses his great excitement over the new physics as represented by such figures as de Broglie, Schrödinger, Eddington, Heisenberg, Millikan, Compton, and Einstein. He characterized it as "undergoing a conversion from nineteenth-century materialism to idealism"[28] and saw Jeans's book as a fitting sequel to Friedrich Albert Lange's *Geschichte des Materialismus und Kritik seiner Bedeutung in der Gegenwart*,[29] which Kagawa had also translated in 1929 with the help of another colleague. "Whereas Lange had combated materialism from a neo-Kantian perspective, we must not ignore the progressive development in the new physics (explored in Jeans's book) that leaves philosophical logic aside and counters materialism on the basis of the content of physics itself."[30]

His certainty that a selection principle in atomic physics had dealt a crushing blow to the old materialism runs like a golden thread through *Cosmic Purpose*:

> The dialectical materialism and materialistic views of history of Marx and Engels were expounded roughly at the same time as Darwin was writing and while atomic physics was still in its infancy. In later years

27. Ibid., 50. See also the chart on page 64 detailing the theory of adaptability in the internal environment.
28. Jeans, *The New Background of Science*. Translated by Kagawa and Nakamura, Preface.
29. Lange, *History of Materialism and Criticism of its Present Importance*.
30. *The New Background of Science*, preface.

the presence of a selection principle in the material world would be discovered and recognized as governing the atomic realm, something that did not occur to Marx and Darwin, not to mention the older critical philosophy of Kant.[31]

The final words of Kagawa's Preface to Jeans's book touch again on the spiritual motivations behind his lifelong love of science:

I have certainly never rejected science. On the contrary, I have stressed that science is itself a window to the spirit. My hope is that through ever more solid work in the laboratory, Japan's natural scientists will break through to the true nature of cosmic reality. In this way, they will come to discover that, in the end, the material universe is an expression of the universal spirit. In anticipation of that day, I offer this book to my Japanese readers."[32]

While Kagawa was critical of scientism, which he saw as an antiquated ideology, these words reveal his strong, albeit somewhat naïve belief that dispassionate scientific research would eventually contribute to a more nuanced, aesthetic, and open-minded interpretation of the appearance, growth, and purpose of life within the vast reaches of the cosmos.

As already mentioned, Darwin's theory of natural selection provided the immediate occasion for *Cosmic Purpose*, but more specifically, it was the way H. G. Wells had interpreted evolution in his best-selling *The Science of Life* that really drew Kagawa's ire. In the opening pages of *Cosmic Purpose*, Kagawa quotes Wells's comments on the philosophical implications of evolution.

Variation is at random; selection sifts and guides it, as nearly as possible into the direction prescribed by the particular conditions of environment. Once we realize this, *we must give up any idea that evolution is purposeful.* It is full of apparent purpose; but this is apparent only, it is not real purpose. It is the result of purposeless and random variation sifted by purposeless and automatic selection.... *When we reach man, evolution does in part become purposeful.* It has at least the possibility of becoming purposeful, because man is the first product of evolution who has the capacity for long-range purpose, the first to

31. Kagawa, *Cosmic Purpose*, 102.

32. *The New Background of Science*, preface. Kagawa completed *Cosmic Purpose* before the big bang theory had gained widespread acceptance, but one can easily imagine how such a momentous breakthrough would have led him to posit a macrocosmic selection principle corresponding to that of the atomic realm and strengthened his core argument for a directionality that implies initial purpose.

be capable of controlling evolutionary destiny. Human purpose is one of the achievements of evolution.[33]

In addition to trying to overcome Darwin's materialism, *Cosmic Purpose* is an unrelenting refutation of Wells's conclusions that variation is "random" and evolution is "purposeless." Kagawa points out what he sees as a glaring contradiction in Wells's notion of a "purposeless and automatic selection" that somehow engenders purpose "when we reach man": "We may note that although Wells rejects finality at the beginning of life, he eventually comes to affirm it. How does he account for the contradiction, to which Bertrand Russell also draws our attention in a broader context?"[34] Kagawa cannot abide this implicit denigration of the long span of time and the many fits and starts—from cosmic dust, atoms, molecules, and ultimately to the advent of myriad forms of life within a supportive environment—that finally made way for the appearance of consciousness and *Homo sapiens.*

Also, John Partington points out that Wells's phrase, "controlling evolutionary destiny" is in fact a slightly veiled reference to his enthusiastic support for eugenics. Partington says, "Although Wells thus still denies the possibility of creating the perfect human (on the basis that perfection equates to a lack of change inconsistent with evolutionary principles), he nonetheless includes in *The Science of Life* a brief discussion of the possibilities of positive eugenics for the future of humanity."[35]

It is likely that, by the time he wrote *Cosmic Purpose*, Kagawa was aware of Wells's support for "positive eugenics." As we saw in chapter 3, before his advanced studies in science and theology at Princeton, Kagawa himself had given tacit support for a non-interventionist or "negative eugenics" in *A Study of the Psychology of the Poor* (1915). Since we have not found evidence anywhere in Kagawa for "positive eugenics," it is regrettable that he had not been more explicit in *Cosmic Purpose* about his rejection of Wells's extremist views. Such a move might have softened the posthumous criticisms.

Returning to *Cosmic Purpose*, in a later discussion of the relative mer-

33. Kagawa, *Cosmic Purpose*, 39, from Wells et al, *The Science of Life*. Italics author.
34. Kagawa, *Cosmic Purpose*, 39.
35. Partington, "H. G. Wells's Eugenic Thinking of the 1930s and 1940s," 75. The connections between evolutionary theory and various theories of genetic superiority require far more extended treatment.

its of mechanistic, vitalistic, and holistic biological theories, Kagawa's exasperation with Wells reaches its height:

> In order to realize the purpose of an individual, an assembly in the form of segmentation is also needed, as is a progressive development. Without an appreciation of teleology how can such assemblage and progression be explained? Mechanical views of life deny immanent purpose, neo-vitalism affirms immanent purpose in each part of the cell, and holistic generational dynamics makes their integration primary. As for those who, in arguing for a holistic biology, deny finality outright, I would reckon them as having fallen back into a neo-mechanistic position. I find the complete failure of H. G. Wells's *The Science of Life* on this count deplorable. After hundreds or even thousands of descriptions of the amazing adaptability of the biological world, he has the nerve to conclude that it is the result of chance.
>
> Can there be *chance* with *adaptability*? Is there chance that includes sifting and selection? Is chance with law and regulation possible? The logic of Wells is so riddled with contradictions that one can only stand dumbfounded and shocked at its audacity. Those who engage in science need to be a bit more honest. Standing before the marvelous existence of nature, must we not declare our willingness to renounce prejudice and learn humbly?[36]

While Kagawa does not offer explicit reasons for his opposition to Wells, we may surmise that he found his claims "deplorable" for several reasons. In Japan, where spiritual and ethical values center on the ritual expression of gratitude for the benefits of nature and reverence for one's forebears, Wells's claim sounds like an expression of anthropocentric hubris. This may be due to a not-so-obvious difference in the two thinkers' cultural conceptions of time. If time is generally perceived in modern Europe or North America as a future-directed arrow, thus supporting an "ethic of progress and possibility," in Japan time is generally perceived as an endowment from the past, leading to an "ethic of inheritance and faithful transmission." Reverence for ancestors (*senzo*), elders (*senpai*), and teachers (*sensei*), key factors in Japanese religious piety and social ethics, helps engender a strong consciousness of indebtedness to the past.[37]

Given this cultural context, when Kagawa the "scientific mystic" con-

36. Kagawa, *Cosmic Purpose*, 165–66.

37. All three terms (先祖 *senzo*, 先輩 *senpai*, and 先生 *sensei*) begin with the character 先 *sen*, meaning "previous" in the sense of "coming before."

templates the appearance of life in the vast span of evolutionary history, he quite naturally extends this "ethic of inheritance" beyond the advent of *Homo sapiens* and all the way back to our ultimate origins in early life forms, proteins, compounds, elements, atoms, and cosmic dust. Kagawa sees all of these inorganic and organic antecedents as constituents of our embodied existence in the present. This "ethic of inheritance" helps account for the fantastic voyage of Kagawa's *Cosmic Purpose* from the atoms to self-consciousness and explains how he was among the first to ponder that the universe makes us what and who we are. When considering the wonder of the evolution of life, Wells opts for blindness over finality, but Kagawa's "logic of finality" holds blindness and finality together: "I cannot believe events in the natural world are all products of chance. Even if [discrete] natural events are blind, ultimately they manifest a finality that developed into human consciousness and hence necessitate the examination of the various points at which blindness and finality are connected."[38] When it comes to the advent of life, Wells's assertion of purposelessness is diametrically opposed to Kagawa's conviction of a continuity, which goes further to embrace discontinuity through the finely tuned mechanisms of selection.

This is a good example of how Kagawa's religious and philosophical reflections were nurtured within the Shintō, Buddhist, and neo-Confucian *ethos* of his childhood and strengthened by his conversion to Christianity. Unlike other Japanese Protestant leaders, who assiduously followed the latest theological trends in Europe (especially Germany) and North America, Kagawa preferred writers like Tolstoy, Ruskin, Bergson, Bowne, and others who resonated more closely with his own religious and philosophical sensibilities. Since such personal convictions bear so heavily on Kagawa's motives for writing *Cosmic Purpose*, it is of interest to note how he expressed these convictions in postwar Japan.

THE POSTWAR MILIEU

Under its Information Bureau and National Mobilization Law, Japan's wartime government had exercised strict control over the flow of information. As the situation gradually eased during the post-war US Occupation (1945–52), a range of formerly suppressed ideas flooded in to fill the void left by the nation's humiliating defeat and loss of a common

38. Kagawa, *Cosmic Purpose*, 50.

national purpose. Because of his wide-reaching international associations and longstanding advocacy of peace, Kagawa had been arrested for questioning by the imperial military police (*kempeitai*) in 1940 and again in 1943. But following the emperor's announcement of surrender on August 14, 1945, he was immediately thrust back into the public spotlight with his proposal to the prime minister's cabinet of a campaign for Total National Repentance[39] and his rapid engagement with forces hoping to rebuild Japan's spiritual and moral life.[40] As a leader in the Movement for a New Japan, he gave hundreds of talks in the years immediately following the war. To reiterate, in the Preface to a 1947 collection of several of these postwar speeches, there is an almost apocalyptic sense of urgency in the scientific mystic's proclamation:

> The principle of cosmic repair is nothing other than the expression of boundless love in sacrifice.... Without the social consciousness of collective responsibility and without the tragic, boundless love that repairs and restores sinners, there is no way to recreate humanity. The great love that created the universe and the consciousness that recreates human life is at work in Jesus.... There has never been a more confusing and dangerous time for Japan and the Japanese people than the present. If we do not see that the way to Japan's renewal is in the cross, Japan will degenerate further and further until it is no more than an island in the Pacific Ocean inhabited by barbarians. Only the cross can unify our people and sustain a renewal of culture and scholarship. Yes! The day when the Japanese people discover that the way to the recreation of life is in the cross, Japan will be regenerated and resurrected.[41]

The mood of national crisis, coupled with Kagawa's commitment to finding renewed purpose in the self-dispossessing, redemptive love of the cross, help us understand further why he could not allow Wells's view on "purposelessness" to go unchallenged. We have seen again and again that the core motivation behind all his work was evangelical. Mutō reports that Kagawa's constant mantra in his postwar lectures, sermons, and interviews was "I must write my theory of cosmic purpose!"[42] He was so thoroughly dedicated to the completion of his teleology, that he even rejected an invitation from a major American publisher to write an auto-

39. 国民総懺悔 *kokumin sōzange*.
40. Schildgen, *Apostle of Love and Social Justice*, 248.
41. Kagawa, *The Creation of the Universe and the Recreation of Human Life*, 1–5.
42. Mutō, "Commentary on *Cosmic Purpose*," 455.

biography in English. It is against this backdrop that early on in *Cosmic Purpose* Kagawa sets up Wells as his key "denier of finality" and returns to him more than ten times in the course of his argument, marshaling every resource at his disposal from a range of prominent scientists to refute Wells and offer a comprehensive counterargument for "initial purpose."

As Kishi's characterization of Kagawa as "the sole cosmological thinker in Japan" indicates, *Cosmic Purpose* burst on the scene as a complete anomaly. For the reasons we have discussed previously, his fellows Protestants were less than enthusiastic. Not even Mutō, the editor of Kagawa's collected works, knew quite what to make of it. He says, "Aside from the question of what contribution this book may make to research, we may call it evidence of the intellect of the kind of figure who appears only once in a century.... It is an intellectual autopsy of Kagawa's brain."[43] Further, in an otherwise sympathetic 1966 biography of Kagawa, Sumiya Mikio, professor of economics at Tokyo University and lay Protestant leader, offers the following comments on *Cosmic Purpose*:

> It is clear that *Cosmic Purpose* represents Kagawa Toyohiko's worldview and philosophy of nature. It is clear that this is the logic that had supported all of the activities of his entire life—from the slums to the social reform projects and the Kingdom of God Movement.
>
> Through this teleology, Kagawa conceived of a great intellectual system covering all fields from the natural sciences, social sciences, and even theology. At the same time this attempt was a failure. Kagawa's is a practical philosophy supported by poetic expression. Thus, while not lacking in conviction, *Cosmic Purpose* lacks scientific argumentation. Despite its copious references to the scientific theories of others, its own theoretical proposals are little more than an interpretation of nature Kagawa had come to on his own.[44]

In hindsight, Sumiya's summary dismissal of the book may say more about his own views than about Kagawa's meditations on teleology. To begin with, Kagawa makes no pretense of offering "scientific argumentation." Quite the contrary, in the preface he describes his approach as arising from a "new, artistic interest in the structure of the universe," and adds, "I would like to make public portions of my view of the universe and appreciation of its artistry."[45] Kagawa was reflecting as a philosophically and aesthetically minded religious leader on new developments in

43. Ibid., 457–58.
44. Sumiya, *Kagawa Toyohiko*, 198.
45. Kagawa, *Cosmic Purpose*, 29.

science with which he was very familiar, but he did so always and self-consciously as a serious lay reader and not as a specialist.

A less obvious reason for Sumiya's rejection of Kagawa's meditation on the scientific data is related to the adoption and development of the modern university in Japan. The model of a university based on scientific research had been introduced in Japan as a means of building East Asia's first modern nation state on the foundations of Western learning.[46] Edwin Reischauer observes:

> The educational system, unlike those of the West, was thus almost created *de novo*, and except for some missionary institutions and private universities (which did not compare in prestige with the imperial universities), it was almost entirely in government hands. Thus it was free of the aristocratic and religious domination of many Western educational systems of the time. It was, in fact, a far more rationalized, secular, and state-oriented educational system than existed at that time in most of the West.... It was tailored to meet the national needs foreseen by the leaders: a literate working and military force, a broad group of technicians, and a small leadership elite produced by the imperial universities.[47]

Whereas the legacies of the medieval, renaissance, and modern research universities were organically interwoven in the development of European and North American education, by adopting *de novo* the modern Western system in the Meiji Era, Japan made a gradual but decisive break from earlier humanistic forms of learning such as we find it in the academies of Chinese Learning (*Kangaku Juku*).[48] We have seen that Kagawa was among the last generation of Japanese to study in both a *Kangaku Juku* and in the new public educational system. Hence, his mental habits were partly shaped by neo-Confucianism, an influence he acknowledges and affirms. Since the younger Sumiya (1916–2003) took for granted the curriculum of the modern research university with its departmentalizing of human knowledge into independent academic specialties, he was not able to excuse, let alone understand, the scientific mystic's bold incursions into areas believed to be the exclusive reserve of scientists.

Although it is difficult to define the genre of *Cosmic Purpose*, the book

46. 洋才 *yōsai*.

47. Reischauer, *Japan: The Story of a Nation*, 137.

48. 漢学塾 *Kangaku Juku*. See Mehl, *Private Academies of Chinese Learning in Meiji Japan*.

is perhaps best classified as a kind of "public natural theology." It is easy to see why Sumiya, a member of the Protestant establishment so wedded to a Barthian rejection of natural theology as absolute for all times and places, would have no theological sympathy whatsoever for Kagawa's approach. However, as baffling as *Cosmic Purpose* has been to Protestant intellectuals like Sumiya, a Roman Catholic scholar like Kishi was able to offer a much more positive reading. While Kagawa remained a Protestant his whole life, this fact may indicate a strong yet tacit "catholic" impulse in this great Japanese scientific mystic, especially when combined with his choice of Francis, à Kempis, and Ignatius as models for his Friends of Jesus Society, and his positive engagements with the Japanese religious and philosophical heritage.

Also, while unique in the Japanese literature, *Cosmic Purpose* finds itself more naturally in the company of other works of his time, such as Lecomte du Noüy's *Human Destiny*, Gustaf Strömberg's *The Soul of the Universe*, Fred Hoyle's *The Nature of the Universe*, and George Ganow's *The Creation of the Universe*, all of which Kagawa mentions. What sets Kagawa apart from these international works, it bears repeating, is that he does not write as a scientist but as a "scientific mystic."

EVOLUTION, GOD, COSMIC WILL

While Kagawa was highly critical of Darwin's bias toward philosophical materialism and his rejection of teleology, he was also an ardent advocate and lifelong student of evolutionary theory. His "logic of finality" shows that Darwin's theory helped frame every facet of his thinking. And as a review of the books in his library demonstrates,[49] Kagawa was much more interested in the latest books on science than in those on theology. And yet, he made no apology for his clear religious convictions:

> Everything that humanity studies—science, economics, politics—belongs to cosmic consciousness. Religion never contradicts science. Science is merely another window for consciousness. To me the theory of evolution has never been contradictory to the idea of creation. Scientists may study the phenomena of life but they cannot create or alter the laws and conditions governing these phenomena. God has given the laws and conditions.[50]

49. *The Library of Kagawa Toyohiko.*
50. Bradshaw, *Unconquerable Kagawa*, 103.

This is not to say that *Cosmic Purpose* can be read as a proof for the existence of God in any traditional sense. In fact, the word *God* only occurs twice in the book, both times in a neutral context. When referring to the ultimate mystery behind evolutionary history, Kagawa characteristically opts for the more neutral philosophical term "cosmic will," as we see at the close of the book:

> Besides discovering cosmic purpose, I believe we have to entrust development from here on to an absolute will that has bestowed it with purpose. If that is in fact the case, it makes no sense not to do so. I hold that awakened human consciousness should seek out the support of that transcendent cosmic will in its very struggle to bring everything out into the open.[51]

Kagawa's choice of a philosophical term should not be taken to mean he had abandoned his Christian faith in his final years. It is rather another gesture of respect in addressing a population of whom 1 percent is Christian and whose background is much more likely to be Shintō, Buddhist, agnostic, or atheist. His was a "public natural theology" in that it aimed at including the broadest possible readership by focusing on scientific findings of common public interest. By the same token, we may consider the book an example of what Thomas Nagel calls a "natural teleology" that takes the evolutionary emergence of consciousness and reason with utmost seriousness. In Nagel's words, "The teleology I want to consider would be an explanation not only of the appearance of physical organisms but of the development of consciousness and ultimately of reason in those organisms. But its form can be described even if we stay at the physical level."[52] For readers who are believers, Kagawa's faith convictions will surely help fill in the broader background of his quest for purpose, and this book attempts to do just that. But those like Nagel who reject theism but are unconvinced by the neo-Darwinians also may read *Cosmic Purpose* with appreciation.

Similarly, in spite of the fact Kagawa uses the word "design" over fifty times, and even once uses "intelligence" in relation to "design," the standpoint of *Cosmic Purpose* should not be confused with what is known today as an argument for "intelligent design," at least in its anti-Darwinian forms, or any other theological attempt to refute the theory of evolution. Quite the contrary, Kagawa finds purposeful design in and through

51. Kagawa, *Cosmic Purpose*, 269.
52. Nagel, *Mind and Cosmos*, 92.

the myriad natural processes that fund evolutionary history. To cite just a few examples of how he discerns "design" in the theories and discoveries of physics, biology, chemistry, and mathematics:

> When he made this discovery (of the periodic table), Mendeleev noticed a wonderful design that reinforced his belief in the truth of the universe.[53]

> Chance is also transformed into design by making use of discontinuity in the realm of whole numbers.[54]

> The universe we inhabit is one of integral geometry and integral mechanics. It is a realm to which purpose-oriented selection has been added and must therefore be thought of as emerging with a "design."[55]

> Were atoms not endowed with design, cells would lack the capacity to adapt and to organize the nervous system and sense organs.[56]

> Darwin was stimulated by Helmholtz's work on "imperfection in the eye," which for him meant that there is no design or purpose behind the lack of perfection. We are left reading him with a sense of desolation.[57]

> Whether we search the inorganic world or inquire into the organic world, we find a design for the appearance of life, whose scale surpasses intelligence and law. One can only bow one's head at the ingenious planning of the universe. The universe appears to be a careless collage of elementary particles, but when we look closely at the atoms that make it up, we cannot but find ourselves up against an *intelligence* hidden in the background.[58]

Where others may see random chance and purposelessness, Kagawa perceives a deep order, complexity, and beauty in and through the natural world—but never in order to refute evolution.

As a refreshing contrast to the endless hostilities between religious and scientific literalists, *Cosmic Purpose* offers neither a religious ideology to trump evolution nor an evolutionary ideology to trump religion. Rather, it takes the contributions of science and religion seriously and sees their insights into the self-conscious wonder of life as complementary. That there is something rather than nothing, that evidence for directionality points to the probability of an as yet undisclosed *telos* in the evolutionary

53. Kagawa, *Cosmic Purpose*, 73.
54. Ibid., 83.
55. Ibid., 85.
56. Ibid., 197.
57. Ibid., 214.
58. Ibid., 265.

drama—these are facts too large to be encompassed by either religion or science on its own. *Cosmic Purpose* is Kagawa's last endeavor to awaken in readers headed toward a nihilistic materialism a renewed sense of awe before the emergence and flourishing of life and consciousness in the immensity of this universe in the making.

All of this clears him of the suspicion of engaging in unscientific arguments to deny evolution. Indeed, Kagawa wants to be taken seriously as a modern "scientific mystic" and thinker who rejects astrology and "all superstition regarding numbers." In this connection, he agrees with Arrhenius's rejection of Tycho Brahe's kind of "natural theology" and uses it to lead into his own approach to finality.

> The primary mistake here is understanding this kind of astrology as purposive. It seems to me superstitious to ascribe to the extreme arguments advanced by Tycho, who went too far in mixing up the laws of physics with those of physiology and psychology.
>
> The affirmation of finality we have in mind here is of a different sort. I will insist throughout on a developmental process in which the principles of selection in nature, combined through organic chemistry, make life possible. And I will further insist that it is this world of life that, in turn, makes up a purposive world through the organization of the nervous system.[59]

As for numbers, he has this to say:

> The ancient Egyptian philosopher of mathematics Ptolemy tried to ground philosophical principles in numbers. Strong hints of his influence are present in Plato and Aristotle. I would like to recall those traces and then take the further step of obliterating all superstition surrounding numbers so that, grounded in the image of the universe we have received from modern physics, we may discover a new standard for integral ratios from the viewpoint of the principle of natural selection.[60]

Kagawa bases his argument for purpose on the "bottom-up" evidence found in modern physics, biology, and chemistry.

ANTINOMIES, COSMIC EVIL, AND FINAL PURPOSE

As a basis for offering a perspective on "cosmic evil," *Cosmic Purpose* pays a great deal of attention to overcoming what Kagawa calls

59. Ibid., 41.
60. Ibid., 66.

the Kantian "cosmology of antinomies"[61] between determinism and free will, matter and spirit, and chance and purpose. On the one hand, his holistic approach allows him to bind the antinomies together in a complementary relationality, reflecting similar neo-Confucian approaches to the dialectic between *li* (principle) and *ch'i* (material force).[62] On the other, by always stressing the limiting function of a "field" within which freedom, spirit, or purpose operates, he clearly assigns a marginal control to the field. It would seem that, despite his best efforts, he cannot avoid mechanistic determinism altogether. Needless to say, many scientists and philosophers today take a similar position in limiting free will, spirit, or purpose to a small field of operation within a mostly determined universe.

On the hotly debated subject of determinism versus free will, Kagawa makes only one theological statement and it also tips the scales in favor of determinism: "Theologically, Calvinistic determinism and Arminian free will theory can be harmonized if seen as the free will of variation within a field."[63] This statement clearly favors the Calvinist side of the debate. To debilitate will or reduce it to a variation within a determined field would result in a certain loss of freedom. If freedom is circumscribed, it ends up as something less than or other than freedom. Hence, in spite of his lack of patience with theological debates, this statement provides further evidence for our earlier claim that he remained to the end a Presbyterian under the partial sway of the classical Reformed theology he had studied in Kōbe and Princeton. Taken together with certain tacit Taoist, Buddhist, and neo-Confucian tendencies in his other writings, Kagawa's Calvinism cannot avoid the impression of a modified mechanistic determinism that does just that.

While seeking a vitalistic view of mechanism and purpose that prepares for and is enhanced by life, he describes the subtle working of mechanisms—from the atomic level up through chemistry, biology, and psychology—which embrace a wide range of contingency. By finally limiting freedom, however, he seems prematurely to impose the working of a certain *deus ex machina* on the yet to be disclosed ultimate *telos* of the evolutionary drama. We would at least expect Kagawa to allow for the possibility that future research in astrophysics, subatomic physics, chem-

61. Ibid., 198–205.
62. See discussion in chapter 2.
63. Kagawa, *Cosmic Purpose*, 243.

istry, or neuroscience may reveal the existence of a hitherto inconceivable degree of freedom that would moderate if not overturn deterministic perspectives.

Kagawa's view of "cosmic evil" operates in a similar way as "slippage" (*zure*)[64] or gaps in the "field" of natural selection that ultimately serve some higher integration or purpose. For a book that claims to be a reconsideration of "the problem of cosmic evil from the perspective of cosmic purpose," the elder Kagawa has surprisingly little to say about the matter. This may be another example where he takes the reader's knowledge of his earlier work for granted. Yet, from a Christian theological perspective, his remarks represent an inadequate description of the evil or nothingness that Barth, for example, describes as a kind of threat to God and by extension to humanity, a chaos or absurdity that has no ontological status of its own but which is nonetheless real as a kind of "impossible possibility." According to Barth, only the transcendent, uncreated One, and not any selective purposive mechanism within the natural order, can deal adequately with nothingness (*das Nichtige*).[65] In the person of Jesus Christ, God has made just that gracious decision to free creation from futility.[66] Here, Kagawa's lifelong attention to the reparative, redemptive love of Jesus Christ calls for more adequate theological treatment.

Having transported readers back and forth between the microcosm and the macrocosm several times on what may only be described as a comprehensive quest for purpose within us, around us, and beyond us, we are left with the question: *When all is said and done, what does Kagawa see as the final purpose of the cosmos?* As we have already stated, his answer is to align himself with Dante in mystical silence before "the impenetrability of cosmic purpose." Kagawa says:

> In his *Divine Comedy*, the medieval Italian genius Dante resigned himself to our inability to answer the question of the final purpose of the cosmos:
>
>> ... for that which you ask lies so deep within the abyss of the eternal statute that it is cut off from every created vision. And when you return to the mortal world, carry this back, so that it may no longer presume to move its feet toward so great a goal. The mind,

64. Ibid., 213.

65. Barth, "God and Nothingness," CD III.3, 289–368. We should note that Barth's view of *das Nichtige* is not the same as the Japanese view of "nothingness" as expressed, for example, by Nishida and the Kyoto School philosophers.

66. Rom 8:19–21.

which shines here, on earth is smoky, and therefore think how it
can do below that which it cannot do, though heaven raise it to
itself. (*Paradiso*, canto 21)

Such was Dante's surrender to the impenetrability of cosmic purpose,
and I find I must agree with him.[67]

And so the scientific mystic joins the ranks of the contemplatives in the
Seventh Heaven, where the long sought after heavenly vision is finally
"cut off from every created vision."

The horizon against which Kagawa paints his religio-aesthetic vision
is as wide as the cosmos itself, but only that wide. On the possibility of a
"cosmic will" behind or above the cosmos, he remains silent in this last
book, even though he speaks of divine transcendence elsewhere. Theo-
logical difficulties that arise when divine freedom and will are set against
the presence of the *imago Dei* in the created world do not seem to have
troubled him. While one is awestruck at the original and thoroughgoing
attempt of *Cosmic Purpose* to discern purpose at every point in evolu-
tionary history, it is hard finally to agree with Kishi that the book offers
an "evolutionary doctrine of creation." For Kagawa, theological reflection
is ultimately sacrificed on the altar of mystical vision. Whatever the aims
of the book, the lack of substantive reference to the Creator disqualifies it
as a contribution to the theology of creation.

What, then, has this scientific mystic's "public natural theology" or
"natural teleology" to contribute to the dialogue between science and
religion? Kagawa had hoped to lay to rest once and for all the philo-
sophical materialism he saw behind Darwin's theory of evolution, and
to elaborate a universal "logic of finality" to overturn Wells's views on
"purposelessness" and "chance." Obviously his hopes were not realized
on either count. Nevertheless, *Cosmic Purpose* adds a distinctive Japanese
voice to the ongoing search for positive alternatives to radical material-
ism and its view of evolutionary history as nothing more than the pur-
poseless workings of random chance.

What Kagawa has accomplished in *Cosmic Purpose* and his entire
project is very much in the spirit of Thomas Berry's essay "The Wisdom
of the Cross" and Ervin Lazlo's book, *Science and the Reenchantment of
the Cosmos*. Berry says:

We have grown so accustomed to viewing the natural world in terms
of scientific equations and economic values that we hardly realize

67. Ibid., 267–68.

how indifferent we have become to the spiritual dimension of the universe....

The simple truth is that most of us no longer live in a sacred universe. This lack of a sacred context of existence causes us to feel alienated from and even antagonistic toward the natural world. We experience the world about us as a collection of "natural resources" for our economic exploitation, or simply as the surrounding "environment" of the human. Our experience of the universe as the presentation that divine reality makes of itself to human understanding is almost completely lost. Even when we view the distant mountains or look out over the oceans or see the stars at night, what we experience is a momentary exaltation of spirit, not the sense of a pervasive divine presence with decisive control over our lives.[68]

On a somewhat more positive note, Lazlo says:

The reenchantment of the cosmos as a coherent, integral whole comes from the latest discoveries in the natural sciences, but the basic concept itself is not new; indeed it is as old as civilization. In ages past the connectedness and wholeness of the world was known to medicine men, priests, and shamans, to seers and sages, and to all people who had the courage to look beyond their nose and stay open to what they saw. Theirs, however, was the kind of insight that comes from mystical, religious, or aesthetic experience and was private and unverifiable—even if it appeared certain beyond doubt. Now, in the first decade of the twenty-first century, innovative scientists at the frontiers of science are rediscovering the integral nature of reality. They lift the private experiences that speak to it from the domain of unverifiable intuition into the realm of verifiable public knowledge.[69]

Seeing all things whole, Kagawa Toyohiko and his work stands as an early and prescient effort to recapture the consciousness of the "pervasive divine presence with decisive control over all life" by coupling "private experience" and "public knowledge" under the rubric of "scientific mysticism."

POSTLUDE: "ALL LIFE RETURNS TO CHEMICAL ELEMENTS"

In "Returning to Heaven," the posthumous will and testament he had requested to be read at his wake at Matsuzawa Church on April 25 1960, Kagawa compares life on earth to an algebraic equation with

68. Berry, "The Wisdom of the Cross," 83.
69. Lazlo, *Science and the Reenchantment of the Cosmos*, 2.

variable factors—yet also accompanied by an invariable "root." Here is an excerpt from his words to his mourners.

> The intentions of the Creator of the universe cannot be changed by human whim or will. Though this multidimensional world appears complex, it is really not complex when factored down to the divine "root." Here is a world of immortal love, which is even capable of transforming evil into purity.
>
> All life returns to chemical elements, and the atoms are indestructible. There is no fear in those who believe human beings are made from these indestructible entities. Laws and energy are immortal. The principle of "Life" and the realm of "purpose" are immortal. The immortal transcends the world of gathering and scattering, linking us to the eternal. Let us therefore put aside our timidity and be joined to this eternal love. For there is heaven, there the Absolute is hidden behind the relative world.
>
> Heaven dwells within us. I am returning to the heaven that indwells even this heart of mine. It drives out all fear, all danger, death, and misfortune. The fabricated personal world—the world of spirit—is eternal like the fabrication of the air. Though unseen, the air still does its work. And beyond death, the Spirit communicates the heavenly mission. I believe in the immortality of spirit.[70]

Characteristic of Kagawa's apophatic reticence to say more than he felt warranted about the inner life of God, these simple and hopeful words avoid the appeals to theological orthodoxy or religious piety so common at the time of death. As a lifelong student of science, Kagawa knew well that mathematics is the "language of science," so he is trying to be as precise as possible about how he sees the relation between a particular "life" and transcendent "Life," or between human "spirit" and Absolute "Spirit."

Beyond the metaphor of the mathematical equation, his "final" final words touch on two core themes that clearly express his vision as a "scientific mystic" and may not be so obvious to readers at first glance. Firstly, he proclaims the power and presence of an immortal and transformative love, which is active within this variable world while simultaneously transcending it as its invariable "root." While not naming Christ, this indirect form of expression reflects his high view of the incarnation of God's redemptive love in Jesus Christ. Secondly, the saying "All life returns to chemical elements. . . ." shows that he took with the utmost solemnity the actual stuff out of which life has evolved. At first glance this may seem

70. Kagawa, "Returning to Heaven," 451.

to lean toward naturalism or even materialism, but nothing could be further from Kagawa's intention. In fact, the phrase "All life returns to chemical elements," especially taken in its original setting at his own wake, may be heard as a contemporary rendering of Genesis 3:19, ". . . for dust thou art, and unto dust shalt thou return"; a standard phrase used in Christian funeral liturgies. It is as if Kagawa is saying, "Since science has revealed the composition and properties of dust, we should update the old religious language to fit our modern consciousness." But notice how he then leaps from the chemicals to "immortality" through law, energy, life, and purpose, the key terms in his "logic of finality." This kind of indirect communication had always been a key part of his missional strategy that sought to make the gospel appeal to the Japanese masses in the shared language of the people rather than in imported theological terms.

While of course recognizing the immense value of analytic distinctions between organic and inorganic compounds, Kagawa also wanted his mourners to ponder the fact that the very same elements comprising the cosmic dust and the galaxies also comprise our bodies and those of all animal species. As we might expect, he ends where he had began so long ago—with the vitalist and personalist positions that claims Life and Purpose are behind matter. For Kagawa, scientific descriptions of distinctions between inorganic and organic worlds are thus a motivation and not a hindrance to religious and philosophical meditation on the deeper relationality of inorganic and organic worlds.

In an age when Christian theology is seen by many as an intramural exercise of theologians engaging in impenetrable debates with other theologians, and hence a discourse largely cut off from the publics of society, culture, academy, and even the churches, Kagawa reminds us that there remains an ongoing and pressing apologetic task for Christians to seek positive ways to bring the gospel into conversation with the intellectual and cultural currents of the day and to bring the intellectual and cultural currents of the day into conversation with the gospel. Kagawa's witness as a scientific mystic and artist is a clarion call to a practical and robust commitment to the two-way trafficking of this demanding, never-ending apologetic task. Acknowledging the failures as well as the successes engendered by his tireless efforts to renew Japanese society, Kagawa was an extraordinary exemplar of the "demythologization" of the self, and his apologetic vision was prophetic in as much as he grasped a future that was as yet not present, embodying a radical hope of an activist spiritual wisdom grounded in and reflecting Christ's redemptive love.

Robert Mikio Fukada, retired career United Methodist missionary to Japan and Professor Emeritus of Doshisha University School of Theology in Kyoto, has beautifully captured Kagawa by calling him "a mosaic artist for God."[71] Fukada's parents had been members of the earliest band of Kagawa's co-workers. Kagawa had baptized Fukada and celebrated his marriage to Laura, so he has an intimate and perhaps unrivaled knowledge of the man. In this book, we have focused on the religious and scientific aspects of Kagawa's mosaic, but could not overlook how these aspects must always be seen in relation to the holistic vision and high ethical calling that inspired Kagawa's imagination and motivated his constant activity. Fukada says, "He [Kagawa] argued for the ultimate perfection of the incarnational process of the redemptive love in a person,"[72] and quotes Richard Drummond's assessment of Kagawa's impact on Japanese society, as follows:

> Perhaps the most historically significant aspect of Kagawa's career was the fact that as a Christian he informed the moral conscience of a largely non-Christian nation probably more than any other of his countrymen in the twentieth century. The ethical awareness, the social ideals, and to a very appreciable extent the spiritual understanding, of the Japanese people in the present generation are, in my judgment, owed to Kagawa as a nation rarely owes its inner life to one man.[73]

As one who knew him so well, it seems fitting to close with Fukada's personal assessment of this great Japanese Christian mystic and artist who dared to see all things whole.

> Kagawa was far from perfect. He was a man of self-confidence, but at times that confidence had something of an overtone of egoism, or at least it appeared that way to some people. His quick analysis of urgent issues and situations and his rapid concrete responses had a conceptual foundation, but sometimes resulted in inadequate examination of available data and arbitrary actions. He had an amazing ability to stimulate and nurture people, whether they were educated, cultures, religious, or not, and to mobilize them to work for a wider society and for the good of the poor and oppressed. An advocate of controversial causes, he remained an appealing person. He aroused people's consciences and at the same time presented visions and methods for cop-

71. Robert Mikio Fukada, "Toyohiko Kagawa: A Mosaic Artist for God," 23.
72. Ibid., 34.
73. Drummond, *A History of Christianity in Japan*, 241.

ing with what was dehumanizing them and their neighbors. But he, at times, had an emotional reaction against certain ideas and people and rejected them with harshness. He was basically a poet, creative and imaginative, not merely in the literary sense but in his outlook on life and in his life of faith in the all-embracing love of God. He pursued an ideal, dreamed dreams, and continuously attempted to portray visions of people and the world living in freedom and peace. And yet he sometimes lacked critical awareness of historical trends in Japanese society.... He possessed an almost sentimental sense of intimacy toward the emperor and never made any critical comment about him or about the imperial system and powers that use that system for self-interest and power accumulation....

He resisted with passion a fragmentalization of persons. For him there was no dichotomy between body and spirit, between science and religion, between emotion and reason. All of these were brought into the service of the ultimate goal of the reign of God. He approached life with the sensitivity of a talented artist. He saw jewels in each person, and by reproaching and battling the sins of human beings attempted to uplift the precious gifts of a child of God to make a mosaic art of beauty and sturdy usefulness. There was an overflowing sense of optimism in him that God's will shall come to full bloom. Love as the fuel of the social system will be in full flame when each human being discovers that God has a plan for him or her and gives each gifts to carry out that task. Naïve optimism? Maybe so. But for Kagawa a new life in Christ was an unquestionable reality, and he held high his torch of hope in the reign of God even in the darkest hour of human alienation and national catastrophe.[74]

74. Fukada, "Toyohiko Kagawa: A Mosaic Artist for God," 37–38.

Events in the Life of Kagawa Toyohiko

YEAR	AGE	EVENT
1888		Born July 7 in Kōbe, the second son of Kagawa Jun'ichi and Kaō Kame, father's concubine
1892–93	4	Both parents die, moves to Tokushima to live with father's legal wife
1901	13	Diagnosed with pulmonary tuberculosis
1902	14	Studies English with Southern Presbyterian missionary Charles Logan
1904	15	Baptized by Presbyterian missionary Harry Meyers
1905	16	Graduates from Tokushima Middle School; enters Theological Preparatory Course at Meiji Gakuin in Tokyo
1906	17	Essay "On World Peace" published in Tokushima Mainichi
1907	18	Leaves Meiji Gakuin and enrolls at Kōbe Theological School
1909	21	Moves into Shinkawa slum to share the gospel and live among the poor while striving to improve their living conditions
1913	25	Marries Shiba Haru
1914	26	Enrolls at Princeton Theological Seminary; Haru attends Kyōritsu Gakuin in Yokohama
1916	28	Receives B.D. degree from Princeton Theological Seminary
1917	29	Returns to Japan and Shinkawa slum to continue evangelism and social reform work
1918	30	Joins the Yūaikai (Christian labor union), and becomes a leader in the Kansai District

YEAR	AGE	EVENT
1919	31	Launches the Consumer's Cooperative Movement and the Osaka Cooperative Society
1920	32	Founds Co-op Kōbe; bestseller Before the Dawn is published
1921	33	Helps plan strike at Kawasaki and Mitsubishi Shipbuilding; founds Friends of Jesus and Japan Agricultural Cooperative
1922	34	Publishes first issue of Pillar of Cloud magazine; founds Kōbe Jesus Band
1923	35	First annual retreat of the Friends of Jesus Society held at Gotemba; moves to Tokyo to help lead earthquake relief efforts
1925	37	Announces "One Million Souls for Christ Movement"; establishes Osaka Shikanjima Settlement House
1926	38	Founds Eto Tokyo Consumers' Cooperative; launches "Kingdom of God Movement"; moves to Nishinomiya
1927	39	Begins Rural Gospel School in Nishinomiya; founds Edo East Consumers' Cooperative (predecessor of JCCU)
1928	40	Founds Nakano Credit Union in Tokyo (precursor of micro financing) and organizes National Anti-War League
1929	41	Turns down request to be Tokyo City Social Welfare Division Head, but accepts part-time commission; moves from Nishinomiya to Matsuzawa (Tokyo)
1930	42	Founds Takane Rural Gospel School in Gotemba
1931	43	Tokyo Medical Consumer Cooperative; founds Matsuzawa Church and Matsuzawa Kindergarten
1933	45	Founds Japan Cooperative Education Association for training leaders for the cooperative movement
1934	46	Begins "Kinship Movement" for hungry
1936	48	Eto Tokyo Consumers' Cooperative begins Nutritious Food Distribution
1937	49	Invents "Constellation Cards" to teach astronomy to pre-school children
1938	50	Unchūsha ("Pillar of Cloud") incorporated; becomes chairman
1940	52	Detained eighteen days for questioning by military police for anti-war stance
1941	53	Goes to USA on Peace Mission to try to prevent rush to war
1943	55	Imprisoned in Kōbe for anti-war stance
1945	57	Denounces American firebombing of civilian populations
1946	58	Becomes a member of the Commission on Food Planning; nominated for Imperial Diet; begins The Christ Weekly newspaper; promotes Movement for a New Japan; accompanies Emperor Hirohito on public tour

YEAR	AGE	EVENT
1947	59	Concludes term as Chairman of the National Agricultural Cooperative; nominated for Nobel Prize in Literature (again in 1948)
1950	62	Visits West on evangelistic tour
1952	64	Chairs World Asian Federation, Hiroshima
1958	70	Publishes last book, Cosmic Purpose; attends Southeast Asian Meeting of the International Cooperative Federation in Kuala Lumpur as Japan's Representative
1960	71	Dies at home in Kamikitazawa, Tokyo, on April 23

APPENDIX B

Imperial Rescript on Education

Know Ye, Our Subjects:

Our Imperial Ancestors have founded Our Empire on a basis broad and everlasting and have deeply and firmly implanted virtue; Our subjects ever united in loyalty and filial piety have from generation to generation illustrated the beauty thereof. This is the glory of the fundamental character of Our Empire, and herein also lies the source of Our education. Ye, Our subject, be filial to your parents, affectionate to your brothers and sisters; as husbands and wives be harmonious, as friends true; bear yourselves in modesty and moderation; extend your benevolence to all; pursue learning and cultivate arts, and thereby develop intellectual faculties and perfect moral powers; furthermore, advance public good and promote common interests; always respect the Constitution and observe the laws; should emergency arise, offer yourselves courageously to the State; and thus guard and maintain the prosperity of Our Imperial Throne coeval with heaven and earth. So shall ye not only be Our good and faithful subjects, but render illustrious the best traditions of your forefathers.

The Way here set forth is indeed the teaching bequeathed by Our Imperial Ancestors, to be observed alike by their descendants and the subjects, infallible for all ages and true in all places. It is Our wish to lay it to heart in all reverence, in common with you, Our subjects, that We may all attain to the same virtue.

Kagawa's View of the Humanities and Natural Sciences

Kagawa offers the following chart depicting the distinctions between the natural sciences and humanities (where he places religious studies):

NATURAL SCIENCES	HUMANITIES
objective (outer)	subjective (inner)
problem-centered	intuitive
descriptive	critical
empirical (inductive)	deductive
intellectual	affective and volitional
physical	psychological
mechanistic	purposeful
probable	orderly
deterministic	selective (weeding)
stable	developmental (historical)
dynamic	living

Note: While religion should investigate things in terms of the humanities, it includes a natural-science-based view of cosmology.

He then asks the question, "Are the theory evolution and doctrine of creation in conflict? (the differences)"

EVOLUTION	CREATION
variable	fixed
blind	purposeful
materialistic	psychological
temporal	spatial
accidental	conditional

The next chart is called "A Harmony of the Theory of Evolution and the Doctrine of Creation."

EVOLUTION	CREATION
scientific	humanistic
teleological (connotative)	teleological (transcendent)
objective	subjective
temporal	spatial
weeding	selective

The final chart, entitled "A Harmony of Evolutionary and Religious Cosmologies," presents materialist and idealist perspectives along an evolutionary continuum, with the emergence of biological and psychological life gradually giving way to the spheres of the personal and real.

EVOLUTIONARY COSMOLOGY				RELIGIOUS COSMOLOGY	
pure materialism psychological				*personal*	*real substance*
matter ——— energy———energy			L	will	goodness
accident——— law———law			I	wisdom	truth
mechanism—— weeding——selection				emotion	beauty
determination — evolution——growth			F	progress	providence
blind——— purpose——purpose			E	ideal	perfection

– from Kagawa, *Meditations on God* (1930)

Bibliography

Kagawa Toyohiko zenshū 賀川豊彦全集 [Collected works of Kagawa Toyohiko]. 24 vols. Tōkyō: Kirisuto Shinbunsha, 1981–83.

Works by Kagawa cited from the Japanese

Ai no kagaku 愛の科学 [The science of love]. In *Collected Works of Kagawa Toyohiko*, vol. 7.

Anmoku sekigo 暗中隻語 [A few words in the dark]. In *Collected Works of Kagawa Toyohiko*, vol. 22.

"Busōseru kani" 武装せる蟹 [Arming crabs]. In *Collected Works of Kagawa Toyohiko*, vol. 24.

Hinminshinri no kenkyū 貧民心理の研究 [A study of the psychology of the poor]. In *Collected Works of Kagawa Toyohiko*, vol. 1.

Hitotsubu no mugi 一粒の麦 [A grain of wheat]. In *Collected Works of Kagawa Toyohiko*, vol. 15.

Iesu no naibuseikatsu イエスの内部生活 [The inner life of Jesus]. In *Collected Works of Kagawa Toyohiko*, vol. 1.

Iesu no shūkyō to sono shinri イエスの宗教とその真理 [The religion of Jesus and its truth]. In *Collected Works of Kagawa Toyohiko*, vol. 1.

Kagawa Toyohiko bunko 賀川豊彦文庫 [Kagawa Toyohiko library: A preliminary listing]. Tōkyō: Meiji Gakuin University, 1963.

"Kami ni tokeyuku kokoro" 神に溶け行く心 [A heart fused to God]. *Kumo no hashira* 雲の柱 1 (1922) 1–12.

Kami ni tsuite no meisō 神に就いての瞑想 [Meditations on God]. In *Collected Works of Kagawa Toyohiko*, vol. 3.

Kami ni yoru shinsei 神による新生 [New life through God]. In *Collected Works of Kagawa Toyohiko*, vol. 5.

Kami to shokuzaiai no shigeki 神と贖罪愛の感激 [God and the inspiration of redemptive love]. In *Collected Works of Kagawa Toyohiko*, vol. 3.

Kirisuto ni tsuite no meisō キリストに就いての瞑想 [Meditations on Christ]. In *Collected Works of Kagawa Toyohiko*, vol. 3.

Kūchū seifuku 空中征服 [Conquering the skies]. In *Collected Works of Kagawa Toyohiko*, vol. 15.

Kunan ni taisuru taido 苦難に対する態度 [Attitudes toward suffering]. In *Collected Works of Kagawa Toyohiko*, vol. 2.

"Mu no testugaku" 無の哲学 [Philosophy of nothingness]. In *Collected Works of Kagawa Toyohiko*, vol. 24.

Ningenku to ningenkenchiku 人間苦と人間建築 [Human suffering and human upbuilding]. In *Collected Works of Kagawa Toyohiko*, vol. 9.

"Sakana Tsuri" 魚釣り [Fishing]. In *Collected Works of Kagawa Toyohiko*, vol. 24.

Seimeishūkyō to seimeigeijutsu 生命宗教と生命芸術 [The religion of life and art of life]. In *Collected Works of Kagawa Toyohiko*, vol. 4.

Seirei ni tsuite no meisō 聖霊に就ての瞑想 [Meditations on the Holy Spirit]. In *Collected Works of Kagawa Toyohiko*, vol. 3.

Seishinundō to shakaiundō 精神運動と社会運動 [Spiritual movements and social movements]. In *Collected Works of Kagawa Toyohiko*, vol. 8.

Shinseikatsu no dōhyō 新生活の道標 [Guideposts for new life]. In *Collected Works of Kagawa Toyohiko*, vol. 13.

Shisen wo koete 死線を越えて [Across the death-line]. Tōkyō: Kaizōsha, 1920.

Shūkyōkyōiku no honshitsu 宗教教育の本質 [The essence of religious education]. In *Collected Works of Kagawa Toyohiko*, vol. 6.

"Ten ni kaeru" 天に帰る [Returning to heaven]. In *Collected Works of Kagawa Toyohiko*, vol. 24.

Tōyōshisō no saiginmi 東洋思想の再吟味 [A reconsideration of eastern thought]. In *Collected Works of Kagawa Toyohiko*, vol. 13.

Uchū no mokuteki 宇宙の目的 [Cosmic purpose]. In *Collected Works of Kagawa Toyohiko*, vol. 13.

Uchūsōzō to ningensaisōzō 宇宙創造と人生再創造 [The creation of the universe and the recreation of human life]. Tōkyō: Kamiizumi Shoten, 1947.

"Waga mura wo saru" わが村を去る [Leaving my village]. In *Wakaki hi no shōzō* [Portraits of younger days], edited by Mainichi Shinbun, 91–108. Book Editors Division. Tōkyō: Mainichi Shinbunsha, 1955.

Works by Kagawa cited from English translations

Kagawa, Toyohiko. *Across the Death-line*. Translated by I. Fukumoto and T. Satchell. Kōbe: Japan Chronicle, 1922.

"The Application of the Cross to Society," *Friends of Jesus* 4.2 (1931) 10–14.

Before the Dawn. Translated by I. Fukumoto and T. Satchell. New York: Doran, 1924.

The Challenge of Redemptive Love. Translated by Marion R. Draper. New York: Abingdon, 1940.

Brotherhood Economics. New York: Harper & Brothers, 1936.

Christ and Japan. Translated by William Axling. New York: Friendship, 1934.

Cosmic Purpose. Translated by James W. Heisig, edited with an Introduction by Thomas John Hastings. Veritas. Eugene, OR: Cascade, 2014.

"The Cross as the Foundation of Social Evolution." In *Special Edition of Friends of Jesus* 4.2 (1931) 6–9.

"The Ethical Teaching of Jesus Christ," *Friends of Jesus* IV/2 (1931) 34–43.

"Following in His Steps," *Friends of Jesus* 4 (1931) 6.

Love, the Law of Life. Translated by F. Fullerton Gressitt. Chicago: Winston, 1929.

Meditations. Translated by Jiro Takenaka. New York: Harper & Brothers, 1950.

Meditations on the Cross. Translated by Helen F. Topping and Marion R. Draper. Chicago: Willet, Clark & Company, 1935.

Meditations on the Holy Spirit. Translated by Charles A. Logan. Nashville: Cokesbury, 1939.

New Life through God. Translated by Elizabeth Kilburn. New York: Revell, 1931.

The Religion of Jesus. Translated by Helen F. Topping, with a biographical sketch by Robert E. Speer. Chicago: Winston, 1931.

Other works cited

Abe, Masao. "The Japanese View of Truth." *Japanese Religions* 14 (1986) 1–6.

Amemiya Eiichi 雨宮栄一. *Mazushii hitobito to Kagawa Toyohiko* 貧しい人々と賀川豊彦 [Kagawa Toyohiko and the poor]. Tōkyō: Shinkyō, 2005.

———. *Seishun no Kagawa Toyohiko* 青春の賀川豊彦 [Kagawa Toyohiko's youth]. Tōkyō: Shinkyō, 2003.

Anderson, Doug. "The Legacy of Bowne's Personalism." *The Personalist Forum* 8 (1992) 1–8.

Anesaki, Masaharu. *History of Japanese Religion*. London: Kegan Paul, 1930.

Astell, Ann. *The Song of Songs in the Middle Ages*. New York: Cornell University, 1990.

Axling, William. *Kagawa*. New York: Harper & Brothers, 1946.

Barshay, Andrew E. *State and Intellectual in Imperial Japan: The Public Man in Crisis*. Berkeley: University of California, 1988.

Barth, Karl. *Church Dogmatics*. Edited and translated by Geoffrey Bromiley. Edinburgh: T. & T. Clark, 1956.

———. "No Boring Theology." *South East Asia Journal of Theology* 11 (1969) 3–5.

———. *Der Römerbrief*. 1st ed. Edited by Hermann Schmidt. 1919. Reprint. Zurich: TVZ, 1985.

"The Belgic Confession." Reformed Church in America Website: https://www.rca.org/sslpage.aspx?pid=362.

Bergson, Henri. *Creative Evolution*. Translated by Arthur Mitchell. New York: Holt, 1911.

———. *The Two Sources of Morality and Religion*. Translated by R. Ashley Audra and Cloudesley Brereton. Garden City, NY: Doubleday, 1935.

Berry, Thomas. *The Christian Future and the Fate of Earth*. Edited by Mary Evelyn Tucker and John Grim. New York: Orbis, 2009.

Bickle, George B. *The New Jerusalem: Aspects of Utopianism in the Thought of Kagawa Toyohiko*. Tucson, AZ: University of Arizona, 1976.

Bowne, Borden Parker. *The Immanence of God*. Boston: Houghton Mifflin, 1905.

———. *Metaphysics*. New York: American, 1926.

———. *Personalism*. Boston: Houghton Mifflin, 1908.

———. *Studies in Christianity*. Boston: Houghton Mifflin, 1909.

———. *Studies in Theism*. New York: Phillips & Hunt, 1879.

Bradshaw, Emerson O. *Unconquerable Kagawa*. St. Paul: Macalester Park, 1952.

Brown, Sally A. *Cross Talk: Preaching Redemption Here and Now*. Louisville: Westminster John Knox, 2008.

Burrow, Rufus. "Bowne's Contribution to Theistic Finitism." *The Personalist Forum* 13 (1997) 122–42.

———. *Personalism: A Critical Introduction*. St. Louis: Chalice, 1999.

Calvin, John. *Institutes of the Christian Religion*. Edited by J. T. McNeill. Philadelphia: Westminster, 1960.

Carey, John. *The Intellectual and the Masses: Pride and Prejudice among the Literary Intelligentsia 1880–1939*. Chicago: Academy, 1992.

Carlyle, Thomas. *Sartor Resartus*. New York: Frederick A. Stokes, 1893.

Cas, Ava et al. "The Impact of Parental Death on Child Well-being: Evidence from the Indian Ocean Tsunami." *National Bureau of Economic Research* 19357 (2013) 1–26.

Catalogue of Princeton University 1915–16. Princeton University, 1915.

CERN Website: http://pdg.web.cern.ch/pdg/cpep/history/quantumt.html.

Chubachi, Masayoshi, and Taira, Koji. "Poverty in Modern Japan: Perceptions and Realities." In *Japanese Industrialization and Its Social Consequences*, edited by Hugh T. Patrick and Larry Meissner, 391–437. Berkeley: University of California, 1976.

"Cooperative Groups Subject of Lecture by Kagawa Tonight: World-Famous Christian Reformer to Talk on Movement in Japan at 8 in Chapel." *The Daily Princetonian*, 7 April 1936, 1.

Davis, Daphne M., and Hayes, Jeffrey A. "What Are the Benefits of Mindfulness? A Practice Review of Psychotherapy-Related Research." *Psychotherapy* 48 (2011) 198–208.

Derrida, Jacques. *Acts of Religion*. New York: Routledge, 2002.

Digital Dictionary of Buddhism. Online: http://www.buddhism-dict.net/ddb/.

Dorrien, Gary. *The Making of American Liberal Theology: Idealism, Realism, and Modernity, 1900–1950*. Louisville: Westminster John Knox, 2001.

"Dr. Kagawa Coming Here." *New York Times*, 22 January 1935, 26.

"Dr. Kagawa Praises Economic Set-up of Cooperative Groups: Noted Japanese

Reformer Proposes This as Christian Means to Overthrow Capitalism." *The Daily Princetonian* 8 April 1936, 1.

Drew, Rose. *Buddhist and Christian? An Exploration of Dual Belonging.* London: Routledge, 2011.

Drummond, Henry. *The Ascent of Man.* New York: Pott, 1904.

Drummond, Richard H. *A History of Christianity in Japan.* Grand Rapids: Eerdmans, 1971.

———. "Kagawa: A Christian Evangelist." *Christian Century,* 77 (1960) 823–25.

Ellis, Jackie et al. "The Long-term Impact of Early Parental Death: Lessons from a Narrative Study." *Journal of the Royal Society of Medicine* 106 (2013) 57–67.

Exman, Eugene. Letter to Kagawa, 23 April 1954. Tōkyō: Kagawa Archives and Resource Center.

Fabre, J. Henri. *The Hunting Wasps.* Translated by Alexander Teixeira de Mattos. New York: Dodd, Mead, and Company, 1919.

———. *The Life of the Spider.* Translated by Alexander Teixeira de Mattos. New York: Blue Ribbon, 1912.

Fleming, Nathaniel H. "Sensing God's Presence: Understanding Religious Epiphany as a Social Experience." B.A. thesis, Princeton University, 2012.

Fujita, Hisashi, and Lapidus, Roxanne. "Bergson's Hand: Toward a History of (Non)–Organic Vitalism," *SubStance,* 36 (2007) 115–30.

Fukada, Robert Mikio. "Toyohiko Kagawa: A Mosaic Artist for God." *The Princeton Seminary Bulletin* 10 (1989) 23–38.

Furuya Yasuo 古屋安雄. "Kagawa Toyohiko no nihon dendōron" 賀川豊彦の日本伝道論 [Kagawa Toyohiko's theory of Japanese evangelism]. In Kagawa Archives, ed., *Kagawa Toyohiko in Japanese Christian History,* 242–63.

Furuya Yasuo 古屋安雄 and Ōki Hideo 大木英夫, *Nihon no shingaku* 日本の神学 [A theology of Japan]. Tōkyō: Yorudansha, 1989.

Gasking, Elizabeth B. "Why Was Mendel's Work Ignored?" *Journal of the History of Ideas* 20 (1959) 60–84.

Goethe's Collected Works: Princeton Classics (Book 2). Edited and translated by Stuart Atkins. Princeton: Princeton University Press, 2014.

Goosen, Gideon. *Hyphenated Christians: Towards a Better Understanding of Dual Religious Belonging.* New York: Lang, 2011.

Gould, Stephen Jay. "Kropotkin was No Crackpot." *Natural History* 106 (1997) 12–21.

———. "Nonoverlapping Magisteria." *Natural History* 106 (1997) 16–22.

Francis J. Grimké, "Dr. Toyohiko Kagawa." Luce #250, Special Collections, Princeton Theological Seminary Libraries, Princeton, N.J.

Hamada, Yō 濱田陽. "Kagawa Toyohiko no isan to gendai" 賀川豊彦の遺産と現代 [The legacy of Kagawa Toyohiko and the present day]. In *Nihon shūkyō gakkai happyō shiryō* 日本宗教学会発表資料 [Materials of the Japanese Association for Religious Studies] (2008) 1–7.

———. "Kagawa Toyohikoto Kaiyōbunmei: Shisen to daishinsai wo koete" 賀川豊彦と海洋文明——死線と大震災を越えて [Toyohiko Kagawa and oceanic civilization: Beyond the death line and the great earthquake]. In *Shūkyō to shakai kōken* 宗教と社会貢献 [Contributions of Religion and Society Study Group], 1 (2011) 53–77.

Hane, Mikoso. *Modern Japan: A Historical Survey*. Boulder: Westview, 1986.

Harding, Gardner L. "Powerful Spiritual Leaders Wake Japan from Materialism: Tenko Nishida, a Twentieth-Century Buddha, in His Self-sacrificing Life, Stirs Million with his Preaching of the Golden Rule—Toyohiko Kagawa Feared by the Government for His Work in the Slums." *New York Times* 22 July 1923.

Hastings, Thomas John. "The Desire for and Use of the Knowledge of God in Christian Theology." In *City of Desires—A Place for God?*, edited by Ganzevoort et al., 205–14. Zürich: Lit Verlag, 2013.

———. *Practical Theology and the One Body of Christ: Toward a Missional-Ecumenical Model*. Grand Rapids: Eerdmans, 2007.

Hedstrom, Matthew. *The Rise of Liberal Religion: Book Culture and American Spirituality in the Twentieth Century*. Oxford: Oxford University Press, 2012.

Henke, Kenneth. Email messages to author. 4 March 2011 and 13 June 2014.

Hoekema, Alle. "Barth and Asia: No Boring Theology." *Exchange* 33 (2004) 102–31.

Holt, Niles R. "A Note on Wilhelm Ostwald's Energism." *Isis* 61 (1970) 386–89.

Hunsinger, George. "Salvator Mundi: Three Types of Christology." In *Christology: Ancient & Modern*, edited by Oliver D. Crisp and Fred Sanders, 42–59. Grand Rapids: Zondervan, 2013.

Hunt, Frazier. *The Rising Temper of the East*. Indiana: Bobbs-Merrill, 1922.

Hunter, Janet E. *The Emergence of Modern Japan: An Introductory History Since 1853*. London: Longman, 1989.

Huxley, Thomas. "The Struggle for Existence in Human Society." In *Huxley's Collected Essays* Vol. IX, 193–236. London: Macmillan and Co., 1894.

Ishigaki, Ayako. *Restless Wave: My Life in Two Worlds, A Memoir*. 1940. Reprint. New York: Feminist Press, City University of New York, 2004.

Iwanami kokugo jiten 岩波国語辞典 [Iwanami Japanese dictionary]. Tōkyō: Iwanami, 1988.

Jackson John P., and Nadine M. Weidman. *Race, Racism, and Science: Social Impact and Interaction*. New Brunswick: Rutgers University, 2005.

James, William. *The Varieties of Religious Experience: A Study in Human Nature*. New York: Longmans, Green and Co., 1922.

Jeans, Sir James Hopwood. *The New Background of Science*. New York: Macmillan, 1934. Translated into Japanese by Kagawa, Toyohiko 賀川豊彦, and

Nakamura, Shishio 中村獅雄. *Kagaku no shinhaikei* 科学の新背景 [The new background of science]. Tōkyō: Kōseisha, 1934.

Kagawa Archives and Resource Center, ed. *Nihon kirisutokyōshi ni okeru Kagawa Toyohiko: Sono shisō to jissen* 日本キリスト教史における賀川豊彦——その思想と実践 [Kagawa Toyohiko in Japanese Christian history: His thought and practice]. Tōkyō: Shinkyō, 2011.

Kanai, Shinji 金井新二. "Kagawa Toyohiko ni okeru jissennteki kirisutokyō no ētos" 賀川豊彦における実践的キリスト教のエートス [The practical Christian ethos in Kagawa Toyohiko]. In Kagawa Archives, ed., *Kagawa Toyohiko in Japanese Christian History*, 127–56.

Kano, Masanao 鹿野政直. *Taishō demokurashī no teiryū* 大正デモクラシーの底流 [The undercurrent of Taishō democracy]. Tōkyō: NHK, 1973.

Kenkyūsha's New Japanese-English Dictionary. 4th ed. Tōkyō: Kenkyūsha, 1987.

King, Martin Luther, Jr. *Stride Toward Freedom: The Montgomery Story*. New York: Harper & Row, 1958.

Kishi, Hideshi. "The Religious Aspects of Cosmic Consciousness: A Comparison of Pierre Teilhard de Chardin and Toyohiko Kagawa." *Christian Century* 87 (1970) 1533–36.

Kishi, Hideshi 岸英司. "Uchū no mokuteki rikai no tame ni (1)" 「宇宙の目的」理解のために (1) [Understanding *Cosmic Purpose* (1)]. *Kagawa Toyohiko kenkyū* 賀川豊彦研究 11 (1987) 2–8.

———. "Uchū no mokuteki rikai no tame ni (2)" 「宇宙の目的」理解のために (1) [Understanding *Cosmic Purpose* (2)]. *Kagawa Toyohiko kenkyū* 賀川豊彦研究 12 (1987) 2–8.

———. "Uchū no mokuteki rikai no tame ni (3)" 「宇宙の目的」理解のために (3) [Understanding *Cosmic Purpose* (3)]. *Kagawa Toyohiko kenkyū* 賀川豊彦研究 13 (1987) 2–8.

Kōbe Co-op Website: http://www.kobe.coop.or.jp/about/toyohiko/index.html.

Koyama, Kosuke. "'Go and Do Likewise!' Toyohiko Kagawa's Theology in the Periphery." *The Princeton Seminary Bulletin* 26 (2005) 89–110.

Kragh, Helge. *Quantum Generations: A History of Physics in the Twentieth Century*. Reprint. Princeton: Princeton University Press, 2002.

Kropotkin, Peter. *Mutual Aid: A Factor in Evolution*. London: Heinemann, 1902.

Kudō, Eichi 工藤英一. "Kagawa Toyohiko to buraku mondai: Suiheisha to no sekkin to rihan" 賀川豊彦と部落問題——水平社との接近と離反 [Kagawa Toyohiko and the *buraku* issue: Closeness and estrangement from the Suiheisha]. In Kagawa Archives, ed., *Kagawa Toyohiko in Japanese Christian History*, 103–26.

Kuribayashi, Teruo 栗林輝夫. "Fukyō no naka de Kagawa no shingaku wo saidoku suru" 不況の中で賀川の神学を再読する [Rereading Kagawa's theology in the midst of a recession]. *Quarterly AT* 15 (2009) 53–62.

Kuroda, Shirō 黒田四郎. *Watashi no Kagawa Toyohiko kenkyū* 私の賀川豊彦研究 [My research on Kagawa Toyohiko]. Tōkyō: Kirisuto Shinbunsha, 1983.

Kurokawa, Tomobumi 黒川和文. "Nihon ni okeru kirisutokyōsenkyō no rekishitekikōsatsu III" 日本におけるキリスト教宣教の歴史的考察 III [A historical assessment of the Christian mission in Japan (III)]. *Bulletin of Aichi Educational University* 53 (2004) 59–68.

Lange, Frederick Albert. *History of Materialism and Criticism of its Present Importance*. London: Trübner, 1881.

Lazlo, Ervin. *Science and the Reenchantment of the Cosmos*. Rochester, VT: Inner Traditions, 2006.

Lear, Jonathan. *Radical Hope: Ethics in the Face of Cultural Devastation*. Cambridge: Harvard, 2006.

Lindbeck, George A. *The Nature of Doctrine: Religion and Theology in a Postliberal Age*. Philadelphia: Westminster, 1984.

Livingstone, David N., and Noll, Mark A. "B. B. Warfield (1851–1921): A Biblical Inerrantist as Evolutionist." *Isis* 91 (2000) 283–304.

Loder, James E. *The Logic of the Spirit: Human Development in Theological Perspective*. San Francisco: Jossey-Bass, 1998.

Long, Eugene Thomas. *Twentieth-Century Western Philosophy of Religion 1900–2000* Handbook of Contemporary Philosophy of Religion. Dordrecht: Springer, 2003.

Longfield, Bradley J. "For Church and Country: The Fundamentalist–Modernist Conflict in the Presbyterian Church." *Journal of Presbyterian History* 78 (2000) 35–50.

Matsumoto, Sannosuke. "The Significance of Nationalism in Modern Japanese Thought: Some Theoretical Problems." *Journal of Asian Studies* 31 (1971) 49–56.

McLure, Roger. *Philosophy of Time: Time before Times*. London: Routledge, 2011.

Mehl, Margaret. "Chinese Learning (*kangaku*) in Meiji Japan (1868–1912)." *History* 85 (2000) 48–66.

———. *Private Academies of Chinese Learning in Meiji Japan: The Decline and Transformation of the Kangaku Juku*. Copenhagen: NIAS, 2003.

Mihara, Yōko 三原容子. "Aisai: Haru no sawai, shakai no saiwai" 愛妻——ハルの幸い、社会の幸い [Beloved wife: The happiness of Haru and the happiness of society]. In *Think Kagawa: Tomo ni ikiru* Think Kagawa——ともに生きる, 76–87. Tōkyō: Matsuzawa Shiryōkan, 2010.

Morimoto, Anri. "The Forgotten Prophet: Rediscovering Toyohiko Kagawa." *The Princeton Seminary Bulletin* 28 (2007) 292–308.

Mulder, John M., et al. *The Diversity of Discipleship: Presbyterians and Twentieth-Century Christian Witness*. Louisville: Westminster John Knox, 1991.

Muller, Richard A. *Dictionary of Latin and Greek Theological Terms*. Grand Rapids: Baker, 1985.

Mullins, Mark R. *Christianity Made in Japan: A Study of Indigenous Movements*. Honolulu: University of Hawai'i, 1998.

Murakami, Ryu. "Transmission of Creativity: An Essay on the Aesthetics of Henri Bergson." *AESTHETICS* 13 (2009) 45–57.

Mutō, Tomio 武藤富男, ed. *Hyakusannin no Kagawa den* 百三人の賀川伝 [A biography of Kagawa by 103 people]. Tōkyō: Kirisuto Shimbunsha, 1960.

——. *Hyōden: Kagawa Toyohiko* 評伝・賀川豊彦 [A critical biography of Kagawa Toyohiko]. Tōkyō: Kirisuto Shinbunsha, 1981.

——. *Kagawa Toyohiko nenpyō* 賀川豊彦年表 [Chronology of the life of Kagawa Toyohiko]. In *Collected Works of Kagawa Toyohiko*, vol. 24, 575–624.

——. "Kaisetsu–Hinmin no kenkyū" 解説・貧民心理の研究 [Commentary on *A Study of the Psychology of the Poor*]. In *Collected Works of Kagawa Toyohiko*, vol. 8, 545–54.

——. "Kaisetsu–Kirisutoden ronsōshi" 解説・キリスト伝論争史 [Commentary on *A History of the 'Life of Jesus' Dispute*]. In *Collected Works of Kagawa Toyohiko*, vol. 1, 491–504.

——. "Kaisetsu–Raichō no mezamuru mae" 解説・雷鳥の目醒むる前 [Commentary on *Before the Grouse Awakens*]. In *Collected Works of Kagawa Toyohiko*, vol. 21, 415–19.

——. "Kaisetsu–Seishinundō to shakaiundō" 解説・精神運動と社会運動 [Commentary on *Spiritual Movements and Social Movements*]. In *Collected Works of Kagawa Toyohiko*, vol. 8, 554–57.

——. "Kaisetsu–Tōyō shisō no saigenmi" 解説・東洋思想の再吟味 [Commentary on *A Reconsideration of Eastern Thought*]. In *Collected Works of Kagawa Toyohiko*, vol. 13, 469–76.

——. "Kaisetsu–Uchū no mokuteki" 解説・宇宙の目的 [Commentary on *Cosmic Purpose*]. In *Collected Works of Kagawa Toyohiko*, vol. 13, 455–69.

Nagel, Thomas. *Mind and Cosmos: Why the Materialist Neo-Darwin Conception of Nature is Almost Certainly False*. Oxford: Oxford University Press, 2012.

Nakamura, Hajime. *Ways of Thinking of Eastern Peoples*. Honolulu: University of Hawaii, 1964.

Namiki, Kōichi 並木浩一. "Yobuki to Kagawa Toyohiko" ヨブ記と賀川豊彦 [The Book of Job and Kagawa Toyohiko]. In *Yobuki no zentaizō* ヨブ記の全体像 [A holistic view of Job], *Namiki Kōichi chosakushū* 並木浩一の著作集 [Collected writings of Namiki Kōichi], vol. 1, 272–325. Tōkyō: Nihon Kirisuto Kyōdan, 2013.

New York Times Online Archive: http://query.nytimes.com/search/.

Niebuhr, Reinhold. "The Political Confusions of Dr. Kagawa." *Radical Religion* 1 (1936) 6–7.

Nishida, Kitarō 西田幾多郎. *Nihonbunka no mondai* 日本文化の問題 [The problem of Japanese culture]. In *Nishida Kitarō zenshū* 西田幾多郎全集 [Collected works of Nishida Kitarō], vol. 12. Tōkyō: Iwanami, 1966.

——. *Zen no kenkyū* 善の研究 [An inquiry into the good]. Kyōto: Kōdōkan, 1911.

Nobel Prize Websites: http://www.nobelprize.org/nomination/literature/

nomination.php and http://www.nobelprize.org/nomination/archive/
peace/nomination.php.

Odin, Steve. *The Social Self in Zen and American Pragmatism*. New York: SUNY, 1996.

OED Online. June 2013. Oxford University Press.

Orwell, George. "Reflections on Gandhi." *Partisan Review* XVI (1949) 85–92.

Oshima, Shōtarō. *W. B. Yeats and Japan*. Tōkyō: Hokuseido, 1965.

Osmer, Richard Robert. *A Teachable Spirit: Recovering the Teaching Office of the Church*. Louisville: Westminster John Knox, 1990.

———. *Practical Theology: An Introduction*. Grand Rapids: Eerdmans, 2008.

Partington, John S. "H. G. Wells's Eugenic Thinking of the 1930s and 1940s." *Utopian Studies* 14 (2003) 74–81.

Pearson, Karl. *The Grammar of Science*. London: Walter Scott, 1892.

Polanyi, Michael. *The Tacit Dimension*. Gloucester, MA: Peter Smith, 1983.

Reischauer, Edwin O. *Japan: The Story of a Nation*. New York: Knopf, 1970.

Reiss, John O. *Not by Design: Retiring Darwin's Watchmaker*. Berkeley: University of California, 2009.

"Religious Unity Object of a Drive," *New York Times*, 26 July 1936, 81.

Ruch, Willibald, ed. *The Sense of Humor: Explorations of a Personality Characteristic*. Berlin: de Gruyter, 2013.

Russell, Bertrand. *A History of Western Philosophy*. New York: Touchstone, 1945.

Sartre, Jean Paul. *Being and Nothingness*. London: Methuen, 1957.

Schildgen, Robert. *Apostle of Love and Social Justice*. Berkeley: Centenary, 1988.

Schleiermacher, Friedrich. *The Christian Faith*. Edinburgh: T. & T. Clark, 1956.

Schwantes, Robert S. "Christianity versus Science: A Conflict of Ideas in Meiji Japan." *The Far Eastern Quarterly* 12 (1953) 123–32.

Schweitzer, Albert. *The Mysticism of Paul the Apostle*. Baltimore: John Hopkins, 1998.

Siegel, Daniel J. *The Mindful Brain: Reflection and Attunement in the Cultivation of Well-Being*. New York: Norton, 2007.

Steinkraus, Warren E. "Martin Luther King's Personalism and Non-Violence." *Journal of the History of Ideas* 34 (1973) 97–111.

Sumiya, Mikio 隅谷三喜男. *Kagawa Toyohiko* 賀川豊彦 [Kagawa Toyohiko]. Tōkyō: Iwanami, 2011.

Takeda, Kiyoko 武田清子. "Kagawa Toyohiko no shakaishisō" 賀川豊彦の社会思想 [The social thought of Kagawa Toyohiko]. In Kagawa Archives, ed., *Kagawa Toyohiko in Japanese Christian History*, 32–61.

Takeuchi, Osamu, S.J. *Conscience and Personality: A New Understanding of Conscience and Its Inculturation in Japanese Moral Theology*. Chiba: Kyōyūsha, 2003.

Torrance, Thomas F. *The Mediation of Christ*. Colorado Springs: Helmers & Howard, 1992.

Uchimura, Kanzō. *Representative Men of Japan*. Tōkyō: Keiseisha, 1908.

Unchusha Website: http://unchusha.com/.

Underhill, Evelyn. *Mysticism*. New York: Doubleday, 1990.

Unuma, Hiroko 鵜沼裕子. "Kagawa Toyohiko no shin no sekai" 賀川豊彦の信の世界 [The world of faith of Kagawa Toyohiko]. *Theological Studies in Japan* 52 (2013) 195–203.

———. "Kagawa Toyohiko shiron: Sono shin no sekai wo chūshin ni" 賀川豊彦試論——その信の世界を中心に [An essay on Kagawa Toyohiko with special consideration of his faith world]. In Kagawa Archives, ed., *Kagawa Toyohiko in Japanese Christian History*, 221–41.

Weber, Max. *The Protestant Ethic and the Spirit of Capitalism*. New York: Scribner's Sons, 1930.

Wells, H. G., et al. *The Science of Life: A Summary of Contemporary Knowledge about Life and its Possibilities*. London: Waverly, 1929–30.

Winnicott, D.W. *Playing and Reality*. Routledge: London, 1971.

Wright, Dana R., and John D. Kuentzel, eds. *Redemptive Transformation in Practical Theology: Essays in Honor of James E. Loder, Jr*. Grand Rapids: Eerdmans, 2004.

Wang, Yangming. "An Inquiry on the Great Learning." In *A Source Book in Chinese Philosophy*, translated and compiled by Wing-Tsit Chan, 271–80. Princeton: Princeton University, 1963.

Warfield, B. B. "The Divine and Human in the Bible." In *Evolution, Scripture, and Science: Selected Writings*, edited by M. A. Noll and D. N. Livingstone. 51–58. Grand Rapids: Baker, 2000.

Warfield, William. *The Theory and Practice of Cattle Breeding*. Chicago: Sanders, 1889.

Woodson, Carter G. *The Works of Francis J. Grimké*. 4 vols. Washington, DC: Associated, 1942.

Yamaori, Tetsuo 山折哲雄. "Appakusareta Kagawa shisō no kaiki: M. Ganjī wo koeru mono" 圧迫された賀川思想の回帰——M. ガンジーを越えるもの [The return of Kagawa's suppressed ideas: how he surpasses Gandhi]. *Quarterly AT* 15 (2009) 26–36.

Yamashita, Ryūji. "Nakae Tōju's Religious Thought and Its Relation to 'Jitsugaku.'" In *Principle and Practicality: Essays in Neo-Confucianism and Practical Learning*, edited by Wm. Theodore de Bary and Irene Bloom, 307–33. New York: Columbia University Press, 1979.

Yeats, William Bulter. *The Collected Poems of W. B. Yeats*. New York: Scribner, 1996.

Yokoyama, Haruichi 横山春一. *Kagawa Toyohiko den* 賀川豊彦伝 [A biography of Kagawa Toyohiko]. Tōkyō: Kirisuto Shinbunsha, 1959.

Yokoyama, Teruo 横山輝雄. "Nihon ni okeru 'kagaku to shūkyō' mondai" 日本
における〈科学と宗教〉問題 [The "science and religion" problem in Japan].
In *Kagaku, kokoro·, hūkyō* 科学·こころ·宗教 [Science, *kokoro*, and religion],
49–68. Nagoya: Nanzan Institute for Religion and Culture, 2007.

Cumulative Index

Made in the USA
Middletown, DE
06 August 2022

70702983R00156